CITY

BASKETBALL IN NEW YORK

GAME

CITY

BASKETBALL IN NEW YORK

Edited by William C. Rhoden
Foreword by Walt "Clyde" Frazier

GAME

First published in the United States of America in
2020 by
Rizzoli Electa
A Division of Rizzoli International Publications, Inc.
300 Park Avenue South
New York, NY 10010
www.rizzoliusa.com

in association with
Museum of the City of New York
1220 Fifth Avenue
New York, NY 10029
www.mcny.org

For Rizzoli Electa:
Publisher: Charles Miers
Associate Publisher: Margaret Rennolds Chace
Editor: Ellen R. Cohen
Production Manager: Alyn Evans
Managing Editor: Lynn Scrabis

For the Museum of the City of New York:
Director of Publications: Susan Gail Johnson
Assistant Editor: Eryn Mathewson
Design: WeShouldDoItAll

Printed in China

2020 2021 2022 2023 2024 / 10 9 8 7 6 5 4 3 2 1

ISBN: ISBN 978-08478-6762-2
Library of Congress Control Number: 2019914623

Visit us online:
Facebook.com/RizzoliNewYork
Twitter: @Rizzoli_Books
Instagram.com/RizzoliBooks
Pinterest.com/RizzoliBooks
Youtube.com/user/RizzoliNY
Issuu.com/Rizzoli

Page 12:
139TH ST. COURT, 2010,
photograph by Bobbito García

Page 13:
HIGHBRIDGE PARK, 1942,
photographer unknown

Page 14:
MCNALLY PLAZA PLAYGROUND, 1937,
photographer unknown

Page 15:
BALL PLAYER WEARING A LAMAR ODOM NBA JERSEY, 2003,
photograph by Bobbito García

Page 16:
CBS BASKETBALL FINAL GAMES, MADISON SQUARE GARDEN, March 1970,
photographer unknown

Page 17:
JEREMY LIN #17 of the New York Knicks gets the rebound
against the Toronto Raptors on March 23, 2012,
photograph by Ron Turenne

Page 190:
163RD ST. BETWEEN AMSTERDAM & EDGECOMBE AVENUES, 2010,
photograph by Kevin Couliau

Page 191:
RUCKER TOURNAMENT, 2004,
photograph by Bobbito García

Page 192:
ANTHONY HEYWARD, a streetball player known as "Half Man
Half Amazing," watching the Kevin Bushell Pre-Teen
Basketball Classic, Bedford-Stuyvesant, Brooklyn, 2003,
photograph by Bobbito García

CONTENTS

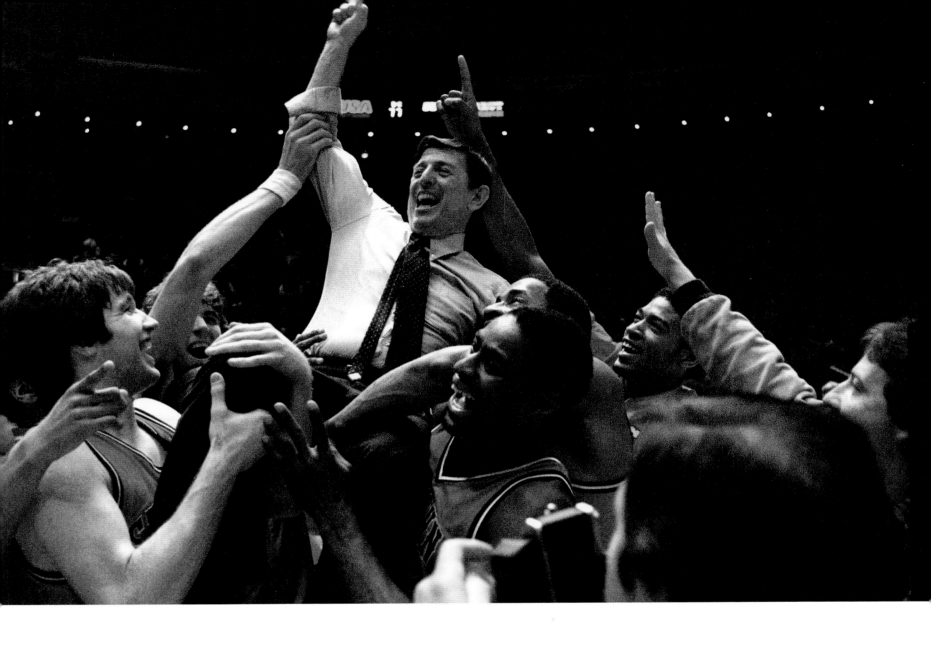

↑ ST. JOHN'S COACH LOU CARNESECCA AND TEAM celebrate victory
in the Big East Conference, March 12, 1983,
photograph by Paul Burnett

DIRECTOR'S FOREWORD

WHITNEY W. DONHAUSER

Basketball was born in a Springfield, Massachusetts, YMCA in 1891, but its real history is a New York story. Basketball in New York is more than just a game played in glittering professional arenas or storied high school and college gymnasiums—it is a game played by countless New Yorkers on street corners and playgrounds. The city has been home to legendary NBA stars, from Dr. J to Carmelo Anthony, but also to asphalt heroes like Joe "The Destroyer" Hammond, who made their mark in the city's playgrounds. And, as this book makes clear, the "city game" is played with a style all its own.

City/Game: Basketball in New York accompanies a major exhibition presented at the Museum of the City of New York in the spring of 2020 exploring the saga of neighborhoods, public spaces, and a shared sports culture that cuts across race, ethnicity, class, and even language. The exhibition is made possible in part by the National Basketball Players Association Foundation, Crystal McCrary and Raymond J. McGuire, Estee Tobaly and Henry Swieca, Elizabeth R. Miller and James G. Dinan, Nathan Romano, Mitchell S. Steir/Savills, Heather and William Vrattos, Andrea London, and other generous donors.

Huge thanks go to editor William C. Rhoden, who, with the diligent assistance of Eryn Mathewson, brought together an all-star team of writers and basketball greats, who each contributed their own perspective on what makes New York City the mecca of basketball. Working closely with exhibition curator Lilly Tuttle, the Museum's Deputy Director and Chief Curator Dr. Sarah M. Henry, and Director of Publications Susan Gail Johnson, and with the help of Eddie Hock and Rachel Horowitz, Bill has truly brought the city's game to life on these pages. The dynamic design by WeShouldDoItAll brings together all the action, sweat, and passion of the city's game as it's played on asphalt or hardwood, on the street, or in the arena.

In addition to Bill and the authors, several of whom served on the exhibition's advisory committee, the project has benefited from the contributions of exhibition consulting scholars Marc Aronson and Onaje X. O. Woodbine, and advisers Kevin Baker, Mike Deland, Dan Klores, Josh Krinsky, Jeff Lane, Milton Lee, Robert Lipsyte, and M. Dianne Murphy. In addition, we are grateful for the assistance of the exhibition's honorary committee: Val Ackerman, Mel Davis, Dr. David Hollander, Jonathan Hock, Terri Jackson, Lucille Kyvallos, Spike Lee and Tonya Lewis Lee, Nancy Lieberman, Nicole and Branford Marsalis, Steve Mills, John "Butch" Purcell, Michael Rapaport, Barry "Slice" Rhorssen, Michele Roberts, Bill Stephney, David Stern, Kenneth Stevens, and Rod Strickland.

It has been a pleasure, as always, to collaborate with Rizzoli Electa, and we are grateful for the steady hand of Ellen R. Cohen in producing this one-of-a-kind look at New York's game.

WHITNEY W. DONHAUSER is the Ronay Menschel Director and President of the Museum of the City of New York.

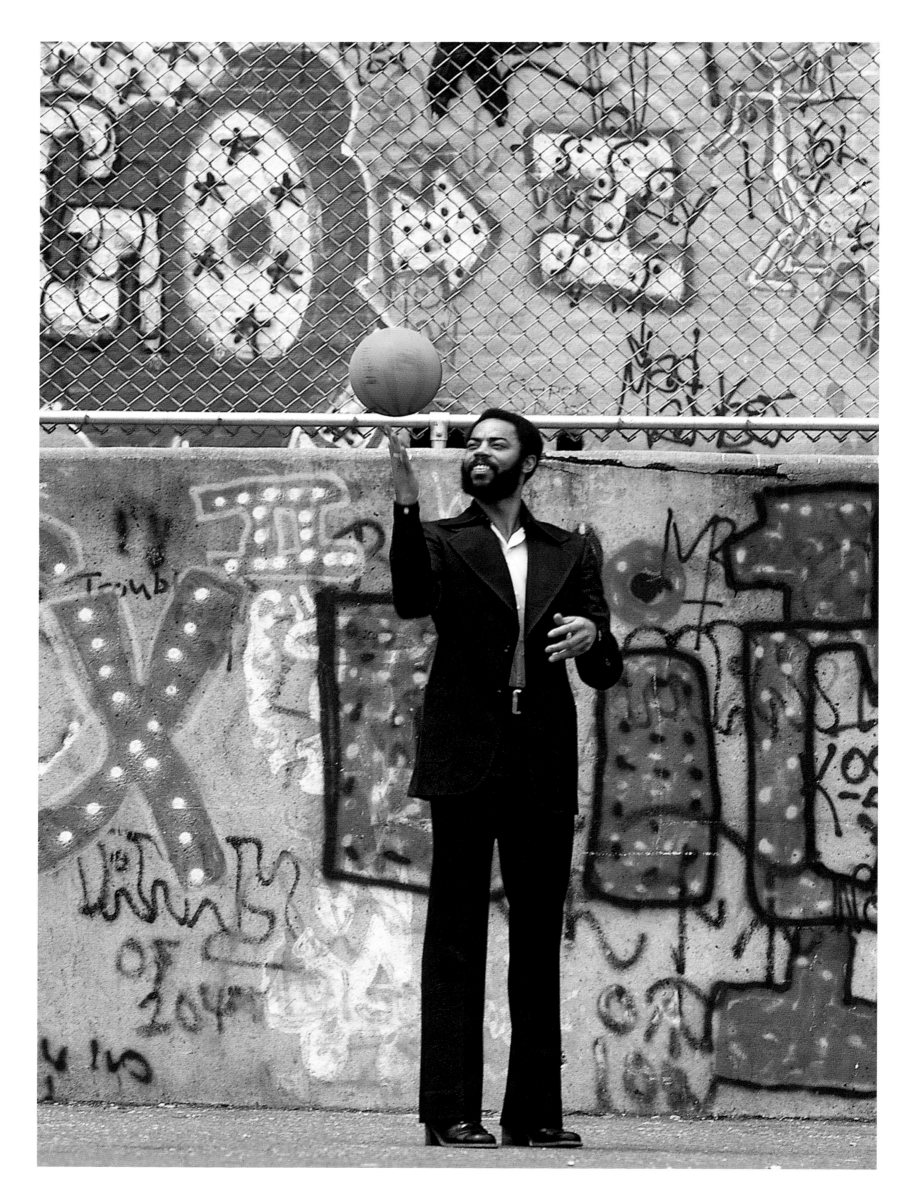

FOREWORD BY WALT "CLYDE" FRAZIER

I got my first taste of New York City's passion for basketball in 1967 when I was playing college ball at Southern Illinois University and we played in the National Invitation Tournament, the last college basketball games to be played at the old Madison Square Garden.

The college game was bigger than the pro game at the time. A pro team like the Knicks had to play doubleheaders to attract attention.

For two weeks we drew 18,500 people for every game. When I saw the way people here reacted to basketball I started wishing I could be drafted by the Knicks. Coming from Georgia, you couldn't read one page on the sports pages about basketball. Everything was football. But here we were in New York and you got five, six pages, a whole section about basketball.

It was incredible.

As it turned out, I was drafted by the Knicks that year and I saw the passion firsthand.

Although I am from Atlanta, I was embraced by New York.

Why? I think it was my cool, my style.

People thought I was cool because I had a poker face when I played the game. I never really showed a lot of emotion and I was clutch. When the game was on the line I could come up with big baskets, I could come up with the steal. And then there was the fashion aspect of what I did. The way I carried myself—the Rolls-Royce, the mink coats. So not only was I talking about it, but I was doing it as well. I became the envy of a lot of guys, I was doing what a lot of the guys had dreamed about, wishing they could do, in the greatest city in the world.

What makes New York the mecca of basketball?

Is it New York's legendary playgrounds? The world-famous arenas? The hype?

All that is part of it, but mostly New York is the mecca because of the people. New Yorkers love basketball like no one else. It's the way they follow the game, the way they embrace everything, including basketball. It's the way they show pride.

That's why New York is the mecca of everything, because of the way the people who come here from all over show respect and pride and honor for the people who play the game or do whatever they do.

I also think it's about winning.

Winning is key in New York City.

Winning allowed me to become Clyde.

Before we were winning I was dressing well but nobody focused on it. As a rookie I wasn't playing well, so to pacify myself I used to go shopping. Go out and buy clothes. I wasn't playing well, but I still looked good. Nobody focused on that until we started winning; winning is the catalyst.

I remember when I was a rookie I was injured to start the season, so I was on the injured list. I used to be in the stands watching the game, and I was like, these people are crazy, man, when they start yelling, and screaming, and cursing at people. In the old Garden, you had to walk a long way to get to the locker room. So people would be on both sides of the wall. They'd be calling you all kinds of names. I used to call my friends and tell them I never saw anything like these people. These people are crazy.

But I grew to love that stuff because I saw what it could do to the opposing team. I saw a lot of pro guys lose it for a moment. Like in the championship game, I saw Jerry West lose it for a moment. And that gives you confidence. I stole the ball from him, he came down, he fouled me, I saw him get pissed off and lose it. Then you'd go, "Man, we got these guys." Like the cowboy movies when they kill the chief Indian. The Indians got to try to regroup. So that's what the Garden would do. Like the time we came from 18 down, 18 down to beat the Bucks. Oscar Robertson, Kareem go

10 minutes without a basket, without a point. You could just see it sometimes, these people start yelling and screaming, and it wasn't choreographed.

We won the NBA championship in 1970, came back to the finals in 1971, and we won our second title in 1973.

These were tumultuous times, civil unrest, the war in Vietnam.

We provided an outlet for people, on Tuesdays and Saturdays fans could forget about what was happening in the world and go and cheer for the Knicks. Everything stopped on Tuesdays and Saturdays when the Knicks were playing. Our team was integrated, the fans didn't see color. We had DeBusschere, we had Bradley, but Frazier and Reed were the most popular guys on that team in New York City.

When you win in New York City the people never forget you. I can go to any grade school, there is going to be one kid at least who knows who Walt Frazier is, or Willis Reed, or who has heard of us. Fifty years later people are still talking about the team, what we did.

But it's not just the Knicks or pro basketball that make New York the mecca. A place like Rucker Park in Harlem makes New York the mecca as well.

I played there as a rookie. I was on a team with Willis Reed, the Knicks' captain at the time.

Willis was my mentor, he had a team, so he was like, "Hey Frazier, come on man, you're going to be playing with us at the Rucker."

I knew nothing about the Rucker. I was naive.

I never saw anything like it. It was like a circus, a video game.

I saw all these people and all of the hoopla and stuff, and I couldn't believe it.

People were hanging all on the fence, all up on the buildings. I think Wilt Chamberlain had played in the game before. You could hardly get on the court. There was no room. It was like being a gunslinger in the old West. They were after me, I was the number one pick, so these guys all wanted to show me up. I was like, "Who are these guys? I never heard of any of these guys." These guys are jumping all over the rim. Obviously, coming from Atlanta we never had anything like that. Atlanta, the South, is all about football. We just have guys come by and play pickup games, but nothing of the magnitude like the Rucker where you had guys who actually have been in the pros coming back, playing the game. The Rucker was a savior for guys that didn't make it to the NBA. The Rucker gave these guys that did not make it hope. Like Helicopter and Pee Wee Kirkland, all these guys.

That was a scene I'll never forget; I can remember that like yesterday. The Rucker was important for me because it showed me what New York was about. New York is styling, profiling.

What makes New York still the mecca is not the buildings or the arenas or the playgrounds and parks.

We can go to Rucker Park right now; it's not intimidating. You see this little court and you'll say: "This was the Rucker?"

I can take you to Madison Square Garden, it's not intimidating when nobody's in there. But when it gets people in there, when it gets New Yorkers in there, and the people start yelling and screaming, it's a different world.

New York was the mecca of basketball and it still is. What makes New York the mecca is the people.

WALT "CLYDE" FRAZIER was a Knicks star for 10 seasons starting in 1967 and played a decisive role in the 1970 and 1973 championships. Knicks captain Willis Reed once told *Sport* magazine, "It's Clyde's ball, he just lets us play with it once in a while." Known for his cool style both on and off the court, today Frazier provides color commentary for the Knicks.

← WALT "CLYDE" FRAZIER, East Harlem, 1970,
photograph by Walter Iooss

9

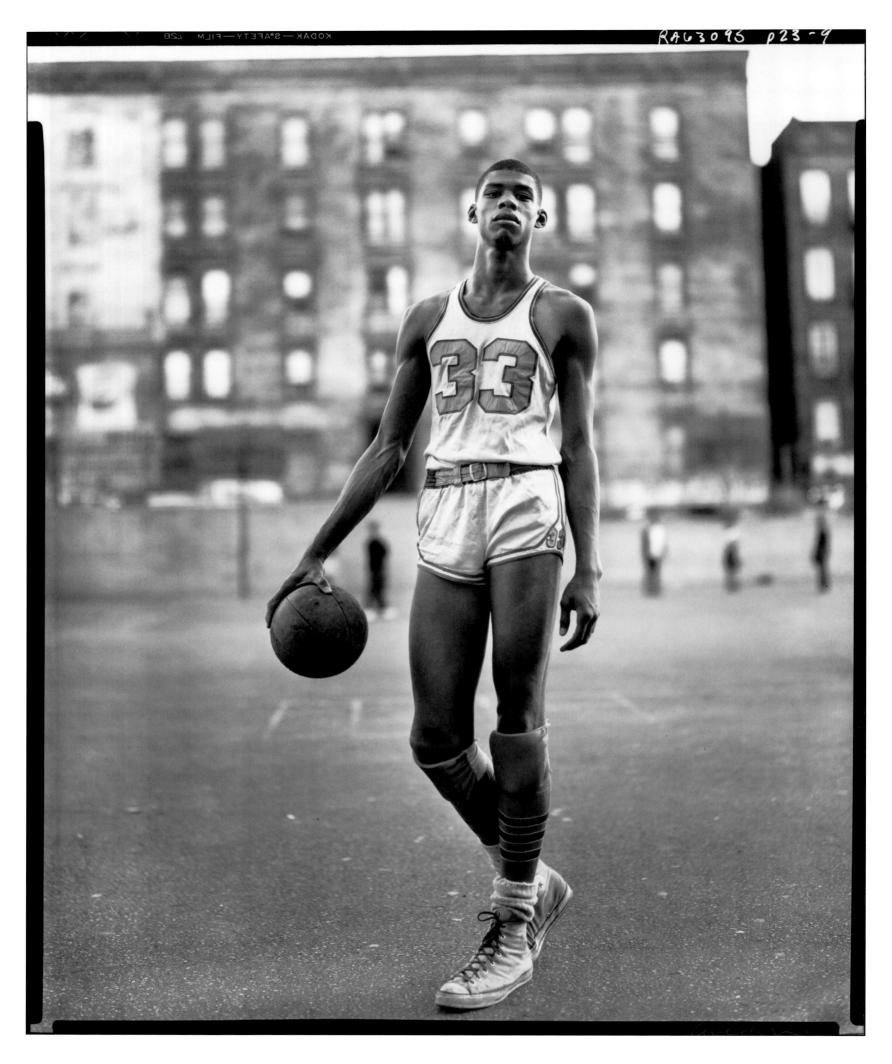

↑ **LEW ALCINDOR**, 61st Street and Amsterdam Avenue, New York, May 2, 1963, photograph by Richard Avedon

CITY/GAME: BASKETBALL IN NEW YORK

THE MECCA OF BASKETBALL

INTRODUCTION BY THOMAS BENDER

Though I was raised in California, my grandparents lived in Brooklyn, New York. Our family made three trips there as I was growing up. My uncles and cousins told me about the courts and pickup games in Flatbush, where most of them lived. By the time I was in high school, I somewhat hesitantly joined. It was new to me. Back home, in my San Francisco suburb, basketball activity outside of school centered around a hoop over the garage. This was commonplace in suburbia.

Obviously, these two localities produced radically different ways of playing basketball and following the game. The activity on the courts of New York City evoked the culture, social experiences, and politics of the place. On hardtop courts, a metropolitan multicultural world came together in a special yet common space to play and watch the city game. Levels of talent were as diverse as the neighborhoods they played in; there was room for all.

My first academic position was in Wisconsin. The chair of the department, who knew I played college basketball in California (though he didn't know I'd been part of the infamous MSG era that hosted games between college teams from across the country, and that in my sophomore year at Santa Clara University, we played New York University [NYU] in a doubleheader at the old Madison Square Garden), handed me a book—*The City Game: Basketball from the Garden to the Playgrounds* by Peter Axthelm. He said that since I had been hired to teach the history of cities, I might want to read this book. He was right.

When I joined the faculty of NYU in 1974, I was a hop, skip, and jump from the West 4th Street courts. There I was able to witness what Axthelm evoked in his book. The quality of players and games varied depending on the day and hour. At its peak, especially on weekends, the competition was intense. Remarkable players did their thing on the court while enthusiastic crowds were glued to the fence. When I walked past the West 4th court after teaching a course on the history of cities, the opening words of Axthelm's book came to mind:

Basketball is the city game

Its battlegrounds are strips of asphalt between tattered wire fences or crumbling buildings; its rhythms grow from the uneven thump of a ball against hard surfaces.
It demands no open spaces or lush backyards or elaborate equipment. It doesn't even require specified numbers of players; a one-on-one confrontation in a playground can be as memorable as a full-scale organized game.

While amateur to virtually professional talent dominated street courts, professional basketball flourished at Madison Square Garden. The iconic arena came to be known as the mecca of basketball in the 1930s. By the 1970s the Knicks displayed the remarkable mix of Bill Bradley, Walt Frazier, Phil Jackson, Earl Monroe, and Dave Stallworth. Later, another era emerged with Patrick Ewing, Mark Jackson, Charles Oakley, and Kiki VanDeWeghe.

During this era, New York basketball was known for its unique combination of street and polished, stylish and aggressive, drafted and undrafted. All talent. That style has since gone well beyond New York City and even beyond the United States. From city courts and playgrounds, to college and professional basketball, the game is being internationalized. With increasing gender, ethnic, and racial diversity, the game also truly mirrors the essential character, the diversity that makes New York, *New York*.

Today, the Brooklyn Nets and New York Liberty have joined the Knicks to define what professional play looks like in the city. With the signing of Kyrie Irving and Kevin Durant, the Nets may put New York City on track to reclaim NBA glory.

Basketball players, fans, historians, and journalists have served as advisers to the *City/Game* exhibition at the Museum of the City of New York, and several of those advisers also authored chapters in this book. Their essays bring a deep knowledge of the entanglement of New York City and basketball: how the city and the game influenced the other. They also highlight the places, people, and styles of play that shaped New York's city game.

If you take nothing else from the essays and the exhibition, the thing to understand about New York City basketball is that there is a place for everyone, whether you were born and raised here—or a transplant like me.

THOMAS BENDER is University Professor of the Humanities and Professor of History emeritus at New York University. Among his books are *New York Intellect: A History of Intellectual Life in New York City, from 1750 to the Beginnings of Our Own Time* and *The Unfinished City: New York and the Metropolitan Idea*.

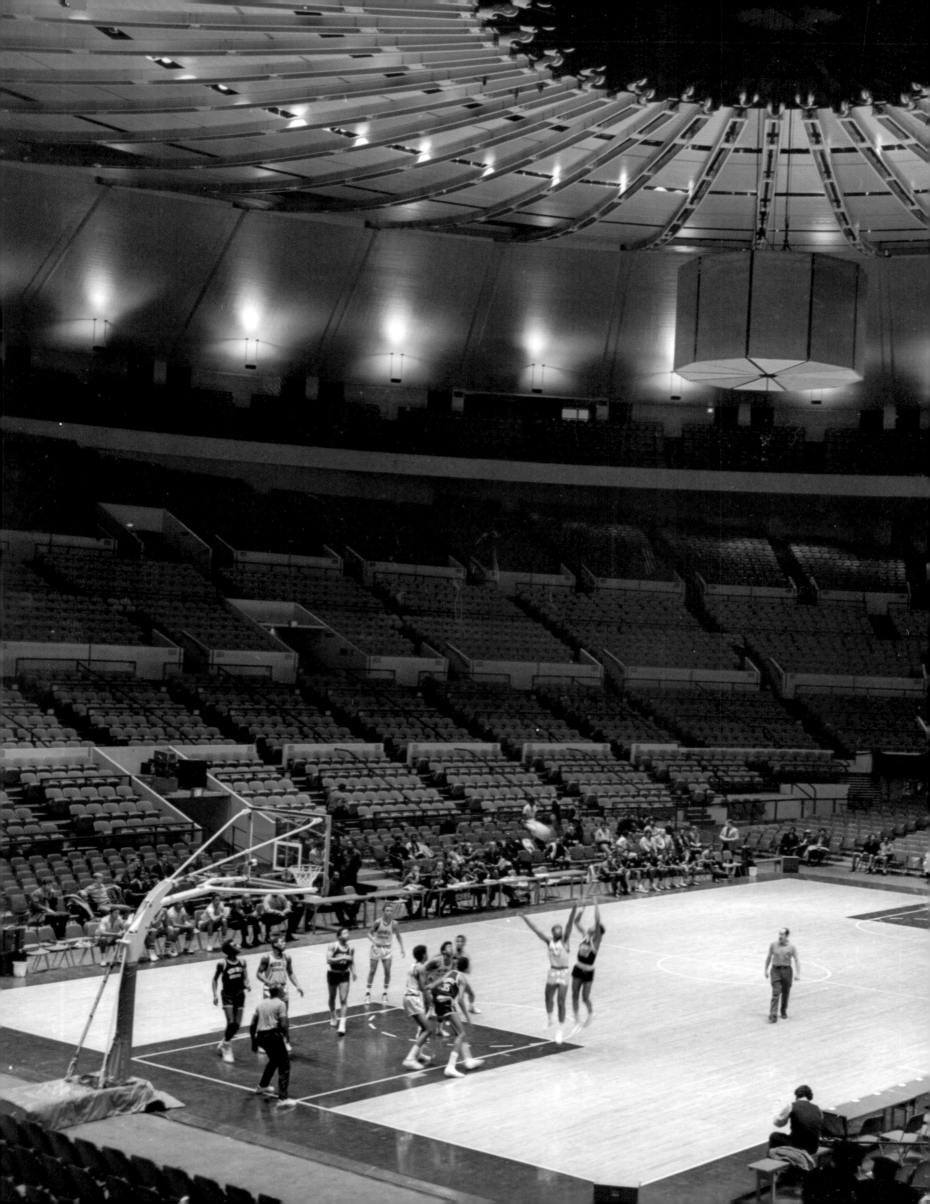

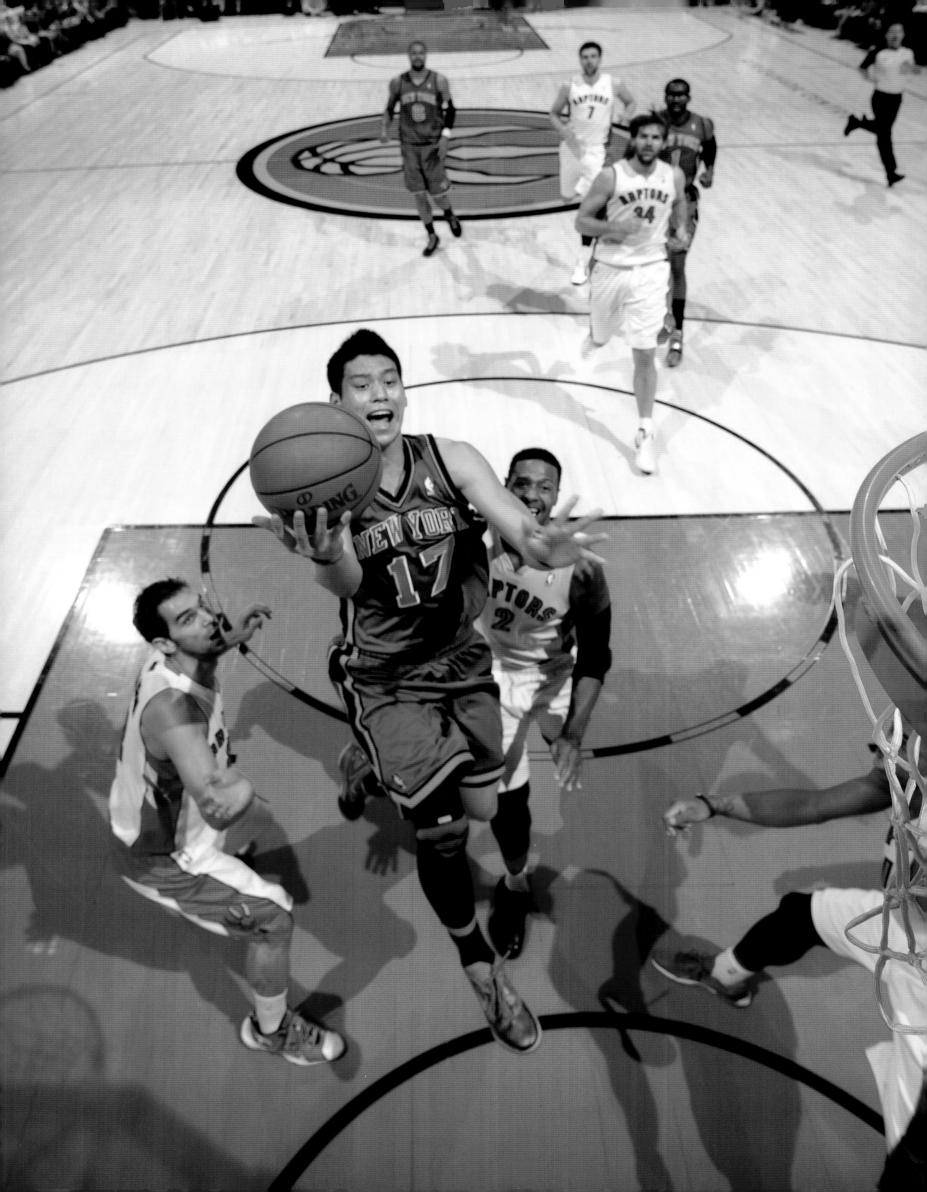

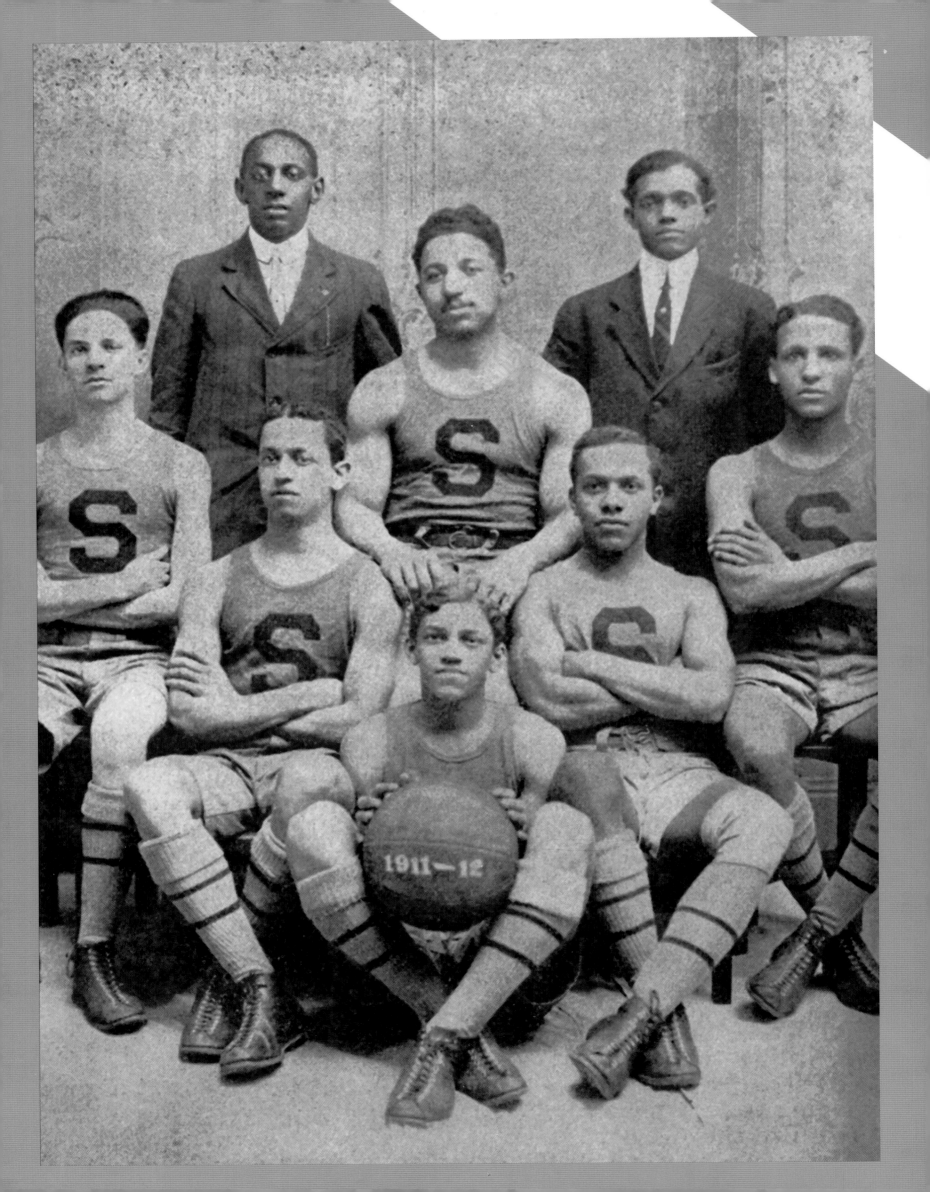

MANHATTAN TAKES BROOKLYN: NYC'S FIRST BLACK FIVES MATCHUP

CLAUDE JOHNSON

When I first began giving voice to the rich forgotten history of early African American basketball teams back in 1996, I was living in Brooklyn not far from where Barclays Center, home of the Brooklyn Nets, is located today. That inspired me to share the story below, which I hope lends context not only to the appropriateness of the arena but also about the long and uniquely New York City–related trajectory of the game.

On the cold and rainy Wednesday night of November 13, 1907, a lively crowd of African American spectators was gathered in the predominantly white Bushwick section of Brooklyn, New York, deep in the heart of the borough. They were inside a handball facility there known as the Knickerbocker Court. A sporting event was scheduled to begin "promptly at 8:40 PM." But these "more than 100 enthusiastic persons" hadn't come to witness handball. As they settled in, only a few tense moments remained before the opening tip-off of a historic basketball duel. It was more than just Brooklyn versus Manhattan. This would be the first official game ever played between two fully independent, formally organized all-black basketball squads.

Seated and standing, onlookers and rival clusters of vocal fanatical supporters known as "rooters" surrounded the basketball court at floor level and in raised bleachers. The home team was the Marathon Athletic Club—sports arm of the Carlton Avenue Colored Branch of the Brooklyn Young Men's Christian Association (a.k.a. the Carlton Y). The branch had opened in 1902 and operated out of a three-story brownstone on Carlton Avenue between Fulton Street and Greene Avenue in Fort Greene. It had a reading parlor, a billiard room, and living quarters, but lacked a gymnasium. That didn't stop the club's president, an African American stenographer named Clarence Lucas, from persuading Carlton Y members to organize a basketball squad.

The visiting squad was the St. Christopher Club, representing St. Philip's Protestant Episcopal Church, one of the country's oldest and most prestigious African American congregations. It was located in the Tenderloin District on West 25th Street, a predominantly black section of Midtown known for its rampant crime, vice, police corruption, and "moral decay."[1] The club began in 1896 as a Bible study program aimed at keeping African American youth off the seedy streets surrounding the church.

The rivalry between the two boroughs was no secret. By 1907, Brooklyn's population was exploding. Though the majority of residents in the growing and prosperous borough were of German, Irish, or Italian descent, Brooklyn was also a thriving hub for African Americans.[2] "As soon as Negro men amass a comfortable fortune," the *New York Times* observed in 1895, about the exodus of African Americans from Manhattan, "they move from this city across the East River, because they can find in Brooklyn more economical and satisfactory investments."[3]

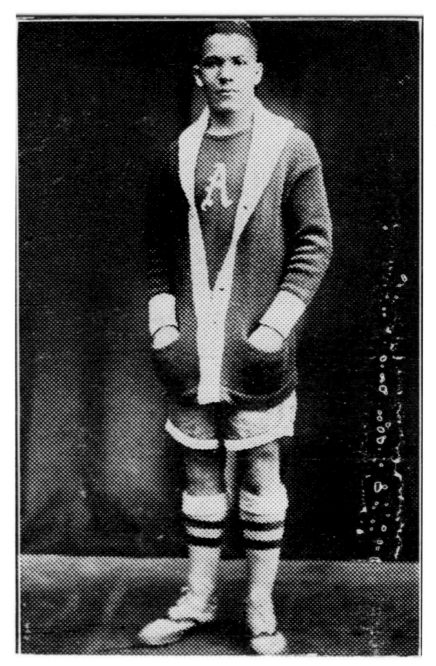

↑ **ALPHA PHYSICAL CULTURE CLUB TEAM MEMBER,**
from a schedule for the 1915–16 season

The game venue, located on Gates and Knickerbocker Avenues, was a high-ceilinged, one-story, wood-framed, gravel-roofed structure built in 1900. "The new court is well constructed and has a finely polished floor of selected hardwood," reported the *Brooklyn Eagle* the day after its grand opening. "Three large skylights furnish ample light," the report continued, adding that, "a gallery is being built around the court capable of accommodating three hundred spectators." [4]

A brawny 20-year-old African American referee named Chester Moore strolled to center court and blew his whistle. As the starting players grouped around him on the hardwood for the jump ball to start the game, there was more than pride at stake. It was more than just Brooklyn versus Manhattan. Basketball had been introduced to blacks on a wide-scale organized basis for the first time just three years earlier. A black gym teacher, Edwin Bancroft Henderson, taught the game to his students in the racially segregated Washington, DC, public school system. His pupils had scrimmaged on playgrounds, in schoolyards, during phys ed, and in intramural competition, but not against outside teams. So, like any innovation, new endeavor, or milestone by African Americans, this game was seen as progress for the race.

The athletes got into position. Then Moore, wearing a white short-sleeved button-down shirt with a bow tie and a black armband, tossed the basketball high into the air above the mid-court circle. The momentous game was underway.

Seconds later, a Spalding "Official No. M Basket Ball" whipped back and forth as St. Christopher and Marathon players sprinted to various spots on the floor, according to their positions. [5] "Guards should be particular to remember that it is their function to guard first, last and all the time," experts advised. The left guards and the right guards played near their own baskets, with the exception that whether on offense or defense, "there should be one guard in the backfield all of the time." [6] Despite the emphasis on hard-nosed defense, players were warned, "the rules are strict against roughing it, not with the idea of making the game ladylike, but to make it as skillful as possible." Once a team got possession of the ball, the guard advanced it with a pass up court to the left or right forward, one of his teammates on offense who played near the opponent's basket.

Each field goal resulted in a stoppage of play and a jump ball at center court. A center's main responsibility was to win this tip, in order to control as many possessions as possible throughout the game.

The action was fierce. "It's your business to play ball every minute until the whistle blows," was a typical coaching reminder. [7] Yet wild shots were frowned upon. "It takes no headwork to throw a basket," experts insisted, "but it does take headwork to get the ball to a position where it can be easily caged by an accurate thrower." This was crucial because the Amateur Athletic Union's (AAU) rules declared

that a player who had already dribbled could no longer score a field goal, a regulation it added in 1900. [8]

The loyal rooters waved pennants and cheered every conceivable accomplishment. A completed pass, a few dribbles in a row, and, above all, any field goal, were considered outrageously spectacular.

Everything was done in careful compliance with the strict rules set by *Spalding's Official Amateur Athletic Union Basket Ball Guide for 1906–07*—considered the game's Bible. It governed equipment, officiating, and conduct. AAU rules mandated use of the "Official No. M Basket Ball" manufactured by A.G. Spalding & Bros., the powerful sporting goods supplier with branch offices in every major American city. [9] A referee could void any game in which this regulation was violated. In fact, Spalding was the official supplier of the sport itself, making not only jerseys, shorts, footwear, socks, and knitted warm-up tops but also backboards, rims, score books, and even referee whistles. [10]

The game itself did not go very well for the Brooklyn team. They lost embarrassingly, 31–1. "It was to be seen that the St. Christophers outclassed their opponents entirely as to size and weight," wrote Lester Aglar Walton, a 28-year-old African American reporter for the *New York Age*. "The Marathons were unable to steady themselves during any part of the second half, and the red and black jerseys of the St. C's were all over the court." This was the first time the prominent *New York Age* had included sports. As editor of the paper's "Music and Stage" column, Walton covered the game because basketball and athletics among blacks were so new that they still fell into the category of *amusement*. [11]

This matchup was the first pairing of a round-robin styled series of contests arranged between New York City's three original African American basketball clubs. The Smart Set Athletic Club, also of Brooklyn, the Marathon Athletic Club, and the St. Christophers were to play one another twice. Its ambitious organizers called this series the Olympian Athletic League.

Though set up for basketball that night, the building was home to the Knickerbocker Handball Club of Brooklyn and was originally built for that sport. Handball was the borough's most popular athletic activity, especially among immigrants from Ireland, and was affectionately called "the oldest Irish pastime known." [12] Brooklyn was dotted with courts like these, nicknamed "handball alleys." The roll call at Knickerbocker Handball Club meetings included the surnames Shea, O'Donnell, Sheehan, and Murphy, among others. Its owner was an Irishman and former saloonkeeper named Peter Shannon, who, in a true measure of handball's popularity, tore down his once-popular pub, Shannon's Saloon, to make way for the new pastime paradise. Its grand opening on July 10, 1900, was said to be "the largest that has ever taken place on any hand ball court in this city." [13]

Yet throughout New York City four-wall handball was losing in popularity to the single-wall outdoor version of the game, a style that

IT'S YOUR BUSINESS TO PLAY BALL EVERY MINUTE UNTIL THE WHISTLE BLOWS.

endures today at most city playgrounds. Facing shrinking demand for indoor handball, the Knickerbocker Court began renting to outside groups like the Irish American Democratic Union, the Ladies Liberty Association, and now, the African American basketball team of the Marathon Athletic Club.

Considering the long and deadly history of Irish immigrant violence against black New Yorkers, renting to the game's African American organizers was highly provocative. But this fact was overlooked. Financial pressure coupled with demand for the sport outmaneuvered social tensions. Though unnoticed at the time, the historical significance of this mutually beneficial breakthrough cannot be overstated. That night, finding common ground became a permanent aspect of basketball.

Despite the lopsided score, Walton recognized that this had been a groundbreaking event for African Americans, an achievement so sensational that the actual result was beside the point. Everyone was still learning—players, coaches, managers, and officials as well as spectators and even newspapermen. All were enthusiastic, supportive, and forgiving.

In fact, thanks to an emerging telegraphy network connecting many African American newspapers throughout the country to one another, this historically important basketball game made national headlines. The *Indianapolis Freeman*, for example, included a version of Walton's article under a headline that showed the genuine excitement and pride that the event in Brooklyn had inspired:

COLORED BASKETBALL TEAMS IN BIG CONTEST
New York Teams Engage in Great Struggle for Victory[14]

If a 31–1 score was seen as a "great struggle for victory," then imagine the level of excitement about the sport that would grow and expand in the days and months and years to come. The mood was jubilation. Basketball had caught fire.

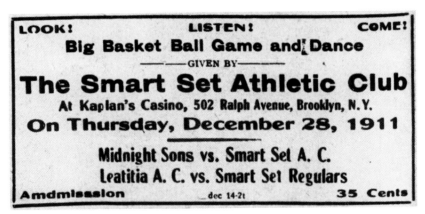
↑ **ADVERTISEMENT** for the Smart Set Athletic Club, 1911

CLAUDE JOHNSON is an author, historian, writer, and founder of the Black Fives Foundation, a 501(c)3 public charity whose mission is to research, preserve, showcase, teach, and honor the pre-NBA history of African Americans in basketball.

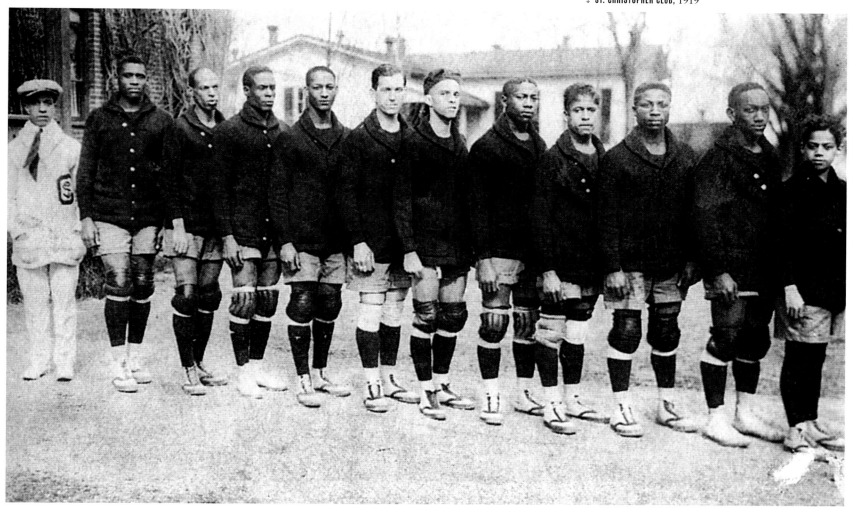

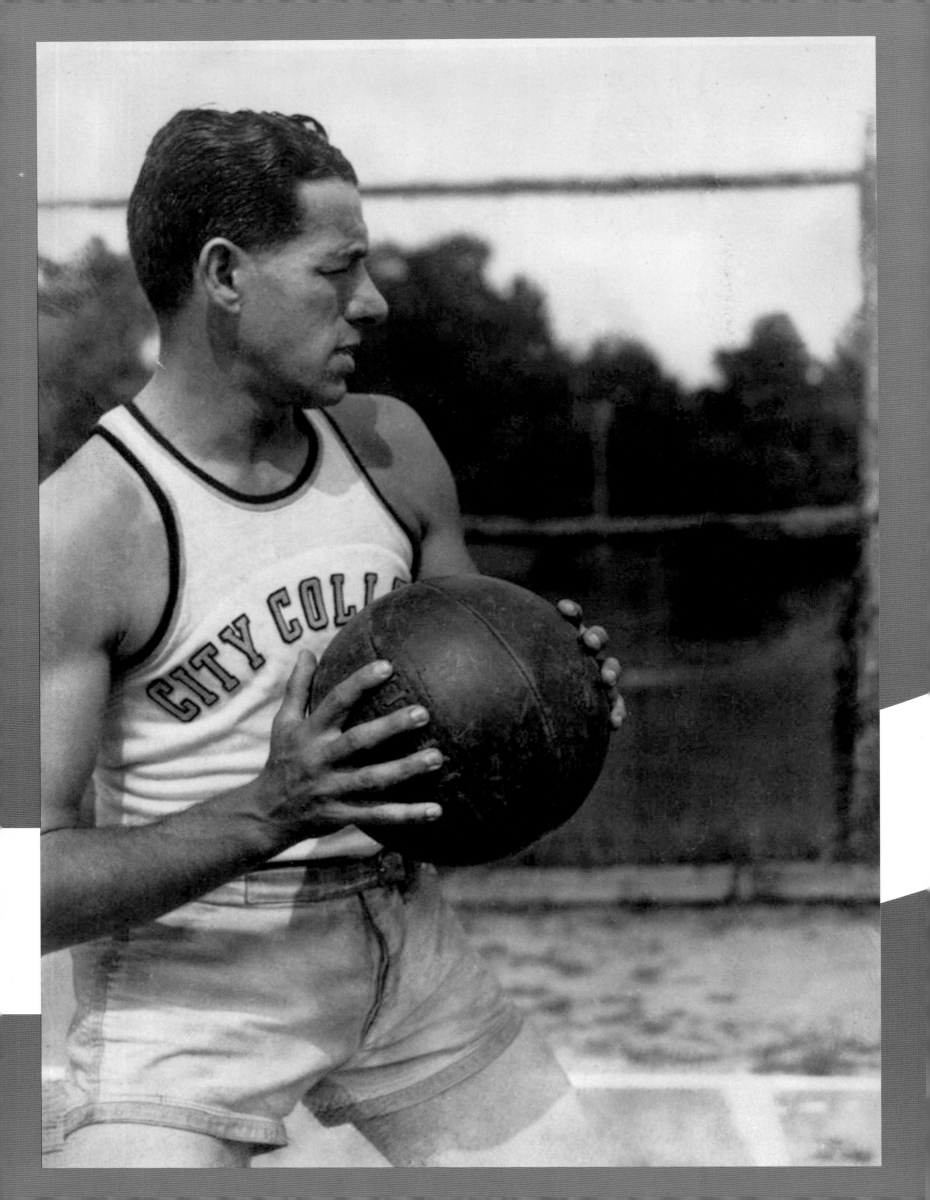

MR. BASKETBALL: NAT HOLMAN INVENTS THE CITY GAME

WILLIAM GIBBONS

I am a native of Detroit, but Julius "Dr. J" Erving was my favorite NBA player. On tape delay after the local news aired, CBS televised the 1980 NBA Finals. I watched him hang through the air—soaring on one side of the rim, then coming around on the other side for a reverse layup.[1] He was smooth and he was cool. I would copy his moves and emulate his artistry and the improvisational style of his game in my backyard, at St. Cecilia's gym, at Country Day, and at Southwestern High School. A decade later, with a Dr. J finger roll and the ball handling skills and toughness of the Detroit Pistons Isiah Thomas, I took my hoop game to New York to compete in the "mecca of basketball."[2] I discovered basketball is a "city game"— where the rules are universally understood, yet the aesthetics are uniquely New York.

In the 1990s, New York basketball was a major part of the fabric of the city. The Yankees weren't winning yet and Pat Riley's Knicks were regularly in the Eastern Conference Finals. On and off basketball courts in 1994, I listened to Knicks fans talk trash and watched Spike Lee hype the Madison Square Garden crowd.

"New York is the mecca!"
"New York produces more players in the NBA!"
"The best point guards come from New York!"

I find myself asking: "Is Madison Square Garden still the mecca of basketball? And who is the most influential basketball player to come out of New York City?" People are quick to mention Tiny, Kareem, Cousy, Holzman, but I remind those who would listen: Nat Holman deserves a place in the conversation, too.

Holman was to basketball what Babe Ruth was to baseball, what Jack Dempsey was to boxing, and what Red Grange was to football in the Golden Age of Sports in the 1920s. His contemporaries acknowledge that he was one of the great playmakers and coaches of his era. Known as "Mr. Basketball," Holman was one of the most accomplished athletes in the first half of the twentieth century. In addition to being a Hall of Fame player on a Hall of Fame team, the Original Celtics, Holman was the only coach to win the NCAA and National Invitation Tournament (NIT) in the same season. Yet today, few people have ever heard of Holman or written about the unique position he holds in sports. His story offers a look at the early history of basketball, particularly New York City basketball.

From humble beginnings as a playground legend on the Lower East Side of Manhattan to becoming the head basketball coach at City College of New York (CCNY), he had a unique perspective on how the game should be played. Holman transformed the sport into a game of finesse and skill—as a player during the barnstorming era, and as a coach in the 1940s.[3] He adopted a one hand jump shot, the mobile big man, and the organized fast break at City College.[4] He practiced and coached a brand of basketball that stressed the

↑ NAT HOLMAN (FAR RIGHT) AND FUTURE KNICKS HEAD COACH JOE LAPCHICK (LEFT OF HOLMAN) with the Original Celtics Basketball Team, undated, photographer unknown

fundamentals—a strong defense and sharp passing to find the open man. The selfless contribution to a common goal was his theme.

The history of Nat Holman is actually the history of basketball. He was born on October 19, 1896, just five years after Dr. James Naismith invented basketball. His family would change his surname from Helmanowich to Holman, on the advice of Holman's older brother. The son of Russian Jewish immigrants, the seventh of ten children, and the fourth oldest of the boys, Holman was raised in the overcrowded neighborhood of the Lower East Side. He and his brothers avoided the gangs, delinquency, and other temptations of the Bowery by playing sports. Basketball was his refuge and settlement houses, playgrounds, schoolyards, and the Young Men's and Young Women's Hebrew Association (YM-YWHA) were his sanctuaries and basketball proving grounds. These courts became a safe place for Holman, his brothers, and his peers as they invented and perfected a street-smart style of basketball in New York known as the city game.

"We were city kids and basketball is our game," Holman recalled. "Much like it is the game of the city kids today. You don't need much equipment and you don't need nearly the space."

Holman blossomed early as a natural athlete. He was 135 pounds, thin, gangly, and knock-kneed. At 10 years old, he stood 5'11"—dominating his peers with his size and ball-handling ability. By the age of 12, he was competing against professional players. His first coach, James Ginnerty, was a playground instructor in Seward Park. He introduced Holman to his first organized professional game with the Roosevelt Big Five, a settlement house team on the Lower East Side. "Those guys knew how to move the ball and move the body," Holman explained. "These men played in small gymnasiums where you had to move fast. You couldn't just stand around. Everything was free, voluntary movement."[5]

Playing for the social clubs and settlement houses helped Holman develop and refine his game. "The settlement houses played a significant role in the life of every Jewish youngster on the Lower East Side. They provided us with homes away from home. There were a variety of sports and cultural activities, plus functions."[6]

When Holman attended Commerce High School in September of 1912, he had an established reputation as a great, all-around athlete. His athletic accomplishments followed him in elementary and middle school, where he won championships in basketball and soccer and was a talented baseball pitcher. Holman actually turned down an offer from the Cincinnati Reds to pitch in their farm system, and instead entered the Savage School for Physical Education, but continued his all-around athletic career playing professional basketball on weekends.

After graduation he accepted a job as a tutor at the City College of New York's Hygiene Department. Additionally, he was responsible for coaching the school's varsity soccer and baseball and freshman basketball teams.

Holman went on to play 17 years of professional basketball with nearly as many teams. He began his professional career in 1917 when he was still attending the Savage School for Physical Education. He made his debut with the New York Knickerbockers Big Five, earning $10 for an afternoon and evening doubleheader. In 1921, after years of barnstorming, Holman signed an exclusive contract to play with the Original Celtics.

Founded as an Irish settlement house team on Manhattan's West Side (Chelsea) in 1914 as the New York Celtics, the team disbanded during World War I and reorganized in 1918 as the Original Celtics.[7] Not only were they the dominant team of the 1920s, but they helped develop the way the game is played today. Their speed, aggressive play, excellent ball handling, and switching defense were new for the times. This type of play would become the standard.

Holman was a household name and the Celtics' highest paid player at $12,500 per season. His spontaneous, constant-motion style and cutting without the ball helped the Celtics win an average of 110 games a year barnstorming. In 1959, the Original Celtics team was enshrined into the Basketball Hall of Fame, and in 1964, Holman was inducted as a player. His reputation was comparable to other great champions of the 1920s, such as Babe Ruth, boxing's Jack Dempsey, golf's Bobby Jones, and tennis great Bill Tilden.

One of the Celtics' biggest rivals and most formidable on-court opponents was the all-black Harlem Renaissance Big Five (a.k.a. the Harlem Rens). They were a professional basketball team named after the Harlem Renaissance Casino Ballroom. The teams had legendary battles. Playing a similar style, the Celtics and Rens met in 1925 for the first time, splitting six games. The teams renewed their rivalry in 1929, with a Celtics victory over the Rens. In front of 10,000 people, they won 38–31 in the 21st Regiment Armory in New York City. The rivals met competitively for the last time in 1933. The Celtics ended the Rens 88-game winning streak with a one-point victory.

Eventually, the Celtics disbanded in 1928 for lack of competition. They were so good for so long that interest waned. In seven years, the Celtics won over 1,000 games and lost fewer than 100. Thousands came to watch games that sold out arenas, armories, and dance halls. In the 1921–22 season, the team went on an unbelievable winning streak of 93 straight games. After the players were disbanded to other teams, Holman played for five more years with the Chicago Bruins and the Syracuse All-Americans. The Celtics did reunite briefly in the 1930s, without Holman, but age had caught up with them.

During this time, Holman also coached collegiate basketball at CCNY. Holman imparted to his players the ball handling, speed, and passing techniques that became known as the "city game." His system was based primarily on conditioning, teamwork, moving without the ball, and making short passes. His players were also trained to improvise and learn the fundamentals thoroughly.

WE WERE CITY KIDS
AND BASKETBALL
IS OUR GAME.

"There was a certain chemistry," Floyd Layne, who was coached by Holman at CCNY, once told me. "We meshed right in with the concept of the game. We moved in concert. A key feature of the Holman style was constant movement. If one of us got tired and couldn't run up and down the court anymore, Coach told us to get gas [take a brief rest on the bench]."

Eventually, the culmination of a great coaching career coincided with his defining moment. He helped achieve something that had never been done before or repeated since. It was the spring of 1950 and in a seven-game, eighteen-day stretch, City College defeated the top collegiate teams in the country to win college basketball's Grand Slam top postseason honors—the NIT and NCAA tournaments—in the same year. Few teams were ever able to attempt, let alone best this feat. The two tournaments play simultaneously. At the end of the 1970 season, college teams were prohibited from playing in both tournaments.

The true greatness of the 1950 season lay not just in winning a double championship in the same year, but in Holman's molding of five New York City kids to play as one. The team consisted of not one, but five outstanding players. Senior Irwin Dambrot and sophomores Ed Roman, Al Roth, Ed Warner, and Floyd Layne were from different neighborhoods around New York City.

What Holman was able to do here was quite remarkable given that CCNY was not the type of school expected to produce such a strong team or record. Located in Harlem, it was considered the poor man's Harvard in the 1940s—only accepting New York City residents with at least a B average. Never blessed with an abundance of talent that other colleges had, City College had no dorms and offered no scholarships. It was the one place where poor New York City residents could get a free and excellent education.

But as is typical in sports, CCNY's domination and glory did not last. A year after Holman led the basketball team to its zenith, evidence broke of a major point-shaving scandal. Seven players from the double championship team had accepted bribes from gamblers to control the scores of games, winning by fewer points than the oddsmakers' point spreads.

Holman claimed he cautioned his players to stay away from gamblers and to inform him of any offers of a bribe. "Coach explained to us," Ed Warner remembers, "that we should keep clean. He told us to stay away from gamblers, to keep our noses clean, and to keep our records clean. He said if we were ever approached by gamblers to report it to the authorities."[8] However, his warnings were ignored. City College's star players on the 1949–50 team were shaving points. Ed Roman, Floyd Layne, Ed Warner, Al Roth, Norm Mager, Irwin Dambrot, and Herb Cohen were earning thousands of dollars dumping games.

Eventually, these seven players were unofficially called the "CCNY 7" and pleaded guilty to conspiracy to fixing games. Al Roth was sentenced to a six-month jail term in a workhouse, but the

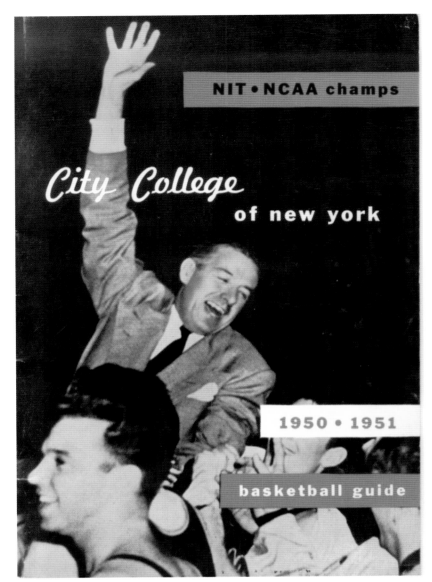

↑ CITY COLLEGE BASKETBALL GUIDE, 1950–51

HE TOLD US TO STAY AWAY FROM GAMBLERS, TO KEEP OUR NOSES CLEAN, AND TO KEEP OUR RECORDS CLEAN.

sentence was suspended with the approval of the District Attorney, when Roth promised to join the Army. Irwin Dambrot received a suspended sentence because Judge Streit felt he had realized the enormity of his misstep. Eddie Roman and Herb Cohen joined the Army as an alternative to six months in jail, while Floyd Layne and Norm Mager were released. But Ed Warner was slapped in jail for six months. "The judge considered Warner to be incorrigible and uncontrollable," a lawyer remembers. "Warner was too flamboyant and he also had a record as a juvenile delinquent. Streit believed in rehabilitation by deprivation."[9]

In a 63-page document Judge Streit distributed the blame for the CCNY scandal and other scandals evenly among the gamblers, corrupt players, college administrators, coaches, and alumni groups who participated in this "evil" (according to Streit) system of commercialism and overemphasis of athletics. Streit also held that coaches were given artificial academic titles and that in many instances their tenure depended on their producing winning teams.

"Intercollegiate football and basketball are no longer amateur sports," the judge said. "Scouting and recruiting violations are almost universal and scholastic standards are evaded."[10]

On November 19, 1954, the Board of Higher Education charged Holman, an assistant coach, and a professor with unbecoming conduct for tampering with the scholastic records, neglect of duty, and failure to cooperate fully with the 1951 basketball fix investigation. All three were suspended without pay, pending a thorough inquiry by the Board of Higher Education. Holman was fired, but the decision was eventually overturned. Once reinstated, Holman spent the next two years traveling, conducting basketball clinics in Mexico, Israel, Japan, Turkey, and Hawaii. He retired six years later in 1960, after coaching City College for 37 years. Nat Holman had 30 winning seasons and a win-loss record of 422–188.

The CCNY 7 were not the first nor the last players to be seduced by gamblers. Their scandal of 1951 coincided with the rise of big-time basketball. Collegiate basketball emerged from the cramped quarters of the campus gym to capacity crowds of professional arenas, and Madison Square Garden was the center of it all. From Stanford out West, to Bradley in the Midwest and Kentucky in the South, the Garden hosted matchups between teams from all over the country. These collegiate games established the Garden as the mecca. But with basketball's success came illegal gambling in and around the arena.

Holman's win-loss records, impressive as they are, are not the measure of his contributions to and influence on the sport. Nor is the double championship. His greatest value is in the way he helped move basketball toward a truly national game.

Today, Nat Holman's contribution and legacy is evident at the highest levels of the game. Los Angeles Lakers coach Phil Jackson credits 1970s New York Knicks coach Red Holzman as a primary influence in his coaching concepts. Holzman, in turn, credited his college basketball coach, Nat Holman, as a significant influence on his coaching philosophy.

"He was a great coach and a great teacher," said Holzman. "And when I see teams today that play smart, that play with a lot of movement, that play unselfishly, I see the legacy of Nat Holman."[11]

↓ CARTOON DEPICTING NAT HOLMAN with a basketball pump, suggesting he has added air to his players, illustration for an article titled "Basketball Coaches Are Nuts," by Tim Cohane in *LOOK Magazine*, 1948

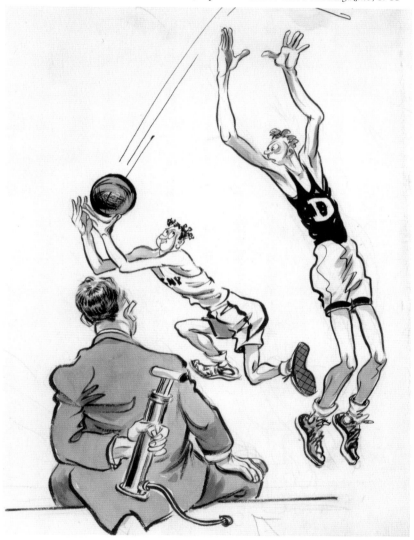

WILLIAM GIBBONS is an assistant professor and archivist at the City College of New York where he teaches courses in library and information science and urban studies with a particular emphasis on Harlem. He has published articles on sports, hip-hop, and civil rights in the *History Teacher*, *Encounter*, and *Collection Building* and is currently at work on a biography of Nat Holman and New York City basketball.

BOYS FROM THE CITY: NEW YORK'S JEWISH BASKETBALL STARS

JEFFREY S. GUROCK

I was seven years old when I attended my first Knicks "home" game at the 69th Regiment Armory. Back in the 1950s, NBA games were pushed out of Madison Square Garden to make way for the far more popular Ringling Brothers Circus. My dad, my brother, and I sat in front row seats in that half-empty arena not only to root for New York stars like Richie Guerin but to cheer on Dolph Schayes of the Syracuse Nationals, the greatest Jewish player to ever make it to the NBA. We were proud that one of ours performed so well on the hardwood. A year later we were in the balcony of MSG to shout encouragement to two opposing squads when Yeshiva University competed against the Israeli National team then on its inaugural trip to the United States. It was thrilling to see two teams wearing blue and white—Jewish colors—on their uniforms. At home and through school, my parents did their utmost to inculcate in their children an attachment to our faith and ethnicity. When I became a historian, I came to understand that there were decades when Jews were stars on New York City's college and professional teams. They didn't just win championships; these trailblazers helped Jewish immigrants win acceptance into American society.

The first Jewish college basketball stars emerged before World War II. Between 1929 and 1931, St. John's University "Wonder Five" basketball team won 68 of 72 games. Four of the five starters were Jews. These prime-time players followed in the footsteps of Jewish ballplayer Nat Holman. In the 1920s, he played for the Original (New York) Celtics alongside future St. John's basketball eminence Joe Lapchick. In 1936, when the Long Island University (LIU) Blackbirds went 25–0, three Jews were the most outstanding athletes.

Ten years later, when the Knicks played their first game within the fledgling Basketball Association of America, a forerunner of the NBA, four of the five starters were Jews. Two years later, All-American Dolph Schayes entered the league and would become the all-time leading scorer in the NBA until a rather large fellow named Wilt Chamberlain eclipsed his record. Schayes was NYU's greatest Jewish ballplayer, though there were many others.

Amid this era of prominence, Paul Gallico, sports editor for the *Daily News*, had a ready, if racist, explanation. "I suspect, that basketball's appeal to the Hebrew, with his Oriental background, is that the game places a premium on an alert, scheming mind, flashy trickiness, artful dodging and general smart-aleckness."

A more reasoned explanation for Jewish success is that these players were the standouts among the literally thousands of children of immigrants—Jews and Christians alike. They bought into the messages of Americanization through sports that New York schools and settlement houses preached. And although the sporting options were many, basketball skills could be honed most easily and cheaply both indoors and on the concrete courts of schoolyards. Perhaps as important, proficiency in sports, and especially basketball, served as a way to prove that Jews belonged in America.[1]

Page 30: **DOLPH SCHAYES** #4 of the Syracuse Nationals and Tommy Heinsohn #15 of the Boston Celtics fight for a rebound, November 2, 1957, photograph by Peter Carroll

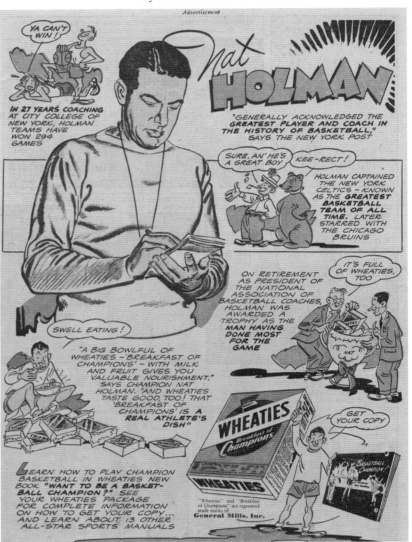

↑ **WHEATIES CEREAL ADVERTISEMENT** featuring Nat Holman, 1946

In 1936, as Hitler's Berlin Olympics approached, LIU's squad of Jews and Christians boycotted the games in protest against anti-Semitism. But over the long haul of decades, it was the City College of New York (CCNY)—with its predominantly Jewish basketball team and overwhelmingly Jewish student body—that made the most consistent statements that Jews belonged in America.

Looking further back, Jews helped establish CCNY's basketball program and legacy. In 1907, CCNY's basketball team was five years old and won eight of nine games. The majority of the 12-man squad were Jews.[2] A year later, the Beavers knocked off both Yale and Princeton to the delight of their ever-growing cadre of fans. These early successes were harbingers of decades of future victories.

From 1910 to 1950, the majority of CCNY's team and stars remained Jewish. They also suffered through three losing seasons, and confronted a schedule that included many of the top colleges from all over the country.[3]

Starting in 1919, Nat Holman coached his charges to appreciate student crowds. Besides his acumen as a tactician, the nattily dressed, well-spoken, professorial mentor projected a large measure of style and class onto CCNY's basketball program.[4]

As a "Jewish" school—to its critics and fans alike—there were additional elements in play when the CCNY team took the court. Second-generation New York Jews—players and fans alike—countered anti-Semitic canards of their day. They said, in athletic rebuttal to critics like the aforementioned Peter Gallicos, to take a look, as an enthusiastic fan put it, "at the dizzy weavings, at the City College gym, of five dark, gargoyle-esque figures triumphing over the blond and sunny frankness of their opponents." To those who would characterize Jews as interlopers, "our victories," wrote one alumnus of CCNY, "over famous colleges and universities...were important beyond the actuality of the score...we came out of the settlement houses, off the streets, into what seemed the mainstream of American life."[5]

This prideful feeling that through athletics the Jews of CCNY belonged in America peaked in 1950 when the college upset a series of top-notch, nationally ranked opponents and captured both the National Invitation Tournament and the National College Athletic Association championships. Among the college's legion of Jewish fans, it was a far more transcendent victory. The personal identification with the team was so profound that the sense on the streets around Convent Avenue was that the ballplayers "did not do it for us, it was us that did it." There was an aura of "reflected glory and a vindication of our way of life." There was also a satisfaction that it had been done side by side with outstanding African American athletes who belonged in this uniquely integrated campus. In no small measure, they had demonstrated what a successful multicultural America might become.

Indeed, along the way, as an important backstory to their on-the-court accomplishment, they had struck a blow against racism.

↑ **DOLPH SCHAYES** of NYU keeps the ball away from Joe Ossola of St. Louis University, 1948

↑ **DOLPH SCHAYES**, c. 1955, photographer unknown

The story was told and retold on the campus about how they had gone out and routed Adolph Rupp's Kentucky Wildcats after the southern hoopsters had refused to shake the hands of CCNY's black players before the opening tip-off. It was not lost on the school's loyalists that just five years after the fall of Nazism, Jews and blacks had defeated a man named Adolph. In the aftermath of the victories in the two tournaments, Nat Holman received national attention, including an appearance on the *Ed Sullivan Show*. More important to the Jewish students on St. Nicholas Heights, there was a palpable joy about their achieved status as equal to all others in the country, through an American pastime.[6]

The long-enduring bond between students and athletes ended in the early 1950s. A traumatic fissure took place in 1951 when seven star players—five Jews and two blacks—were arrested for "shaving points." It was the first of several basketball scandals that rocked the American sports world in that decade. *Newsweek* magazine characterized the nefarious goings-on as "the most sickening scandal in the history of American sports."

On campus, students were first stunned by their classmates' betrayal. They were soon outraged, as it was revealed that these athletes had made it to St. Nicholas Heights with the help of altered admission documents and had remained eligible to compete through corrupted transcripts. A *New York Times* editorial assessment early on in the investigation asserted that "somehow the home, the neighborhood, the campus, the college fostered a crooked, distorted sense of values and produced moral shipwreck," contributing to the gloom. At CCNY, the home, neighborhood, and school always had been closely connected as a source of community pride. For so many, "it was a moral breakdown, a humiliation for Jews," because CCNY "represented Jewish culture." Fortunately, the scandal did not morph into blatant anti-Semitism against this Jewish school and its students, even if Adolph Rupp did opine that New York gamblers—perhaps intimating Jewish gamblers in Gotham—"could not reach my boys with a ten foot pole." As it turned out, soon some of his own stars were brought to law courts for comparable chicanery on the hardwood. Still, it has been argued that "CCNY would never have the same place in the hearts of New York Jews as it did before February 1951" when the scandal broke.[7]

In its aftermath, ostensibly to keep gamblers away, the New York City Board of Higher Education decreed that the team would no longer play in Madison Square Garden. With a downgraded schedule and no chance to play in the mecca of basketball, CCNY would never again be successful in recruiting top-notch players. In the glory days, two years before the scandal, the team had traveled over an intersession to California for a three-game stint. They arrived on the West Coast via airplane at a time when few teams, college or professional, made such expensive transcontinental trips. In Los Angeles, excited CCNY alumni—including film star and former student Edward G.

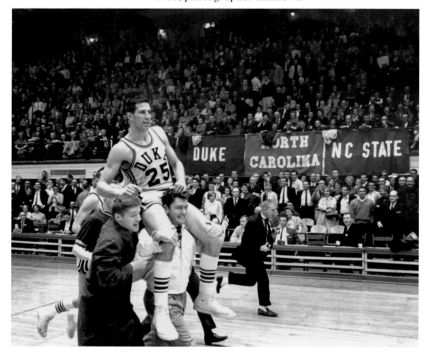

↓ **ART HEYMAN #25**, carried by his teammates at Duke, 1963, photographer unknown

THE BALLPLAYERS "DID NOT DO IT FOR US, IT WAS US THAT DID IT."

Robinson—feted them. And besides which, in the 1950s and 1960s, CCNY people neither needed nor wanted their ball club to speak for them.[8]

Meanwhile, Gotham's best Jewish basketball players—and there still was a considerable number—were recruited by schools all over the country. A more likely destination for those collegians who knew the city game best was south of the Mason-Dixon Line. In the mid-1950s, former St. John's University coach Frank McGuire moved to the University of North Carolina and created what was called his "underground railroad." He built the Tar Heel program with, in his own words, "Jewish players and Italian players...boys from the city," tough competitors who brought an aggressive, urban attitude to Tobacco Road. McGuire's prize passenger was Lennie Rosenbluth, who garnered first team All-American honors and was voted National Player of the Year in 1957.[9]

By the 1960s, Jews were no longer seen as predominant in basketball. It had become the African American sport. Need it be emphasized that to become preeminent, black players had to overcome far more onerous racist epithets than Jews had and segregationist policies that kept their numbers down. Indeed, as late as 1979 some prejudiced New Yorkers went so far as to dub their home professional team as the "N'bockers" when the Knicks fielded an all African American lineup. Meanwhile, while in 1963, Oceanside, Long Island–born Art Heyman of Duke University—following in the footsteps of Lennie Rosenbluth—was named the Associated Press's college hoopster of the year, in the half century that followed only two Jews would be elected members of NCAA Division I All-American teams. The one Jewish New Yorker chosen was Romanian immigrant Ernie Grunfeld, who starred at Forest Hills High School before teaming up out of town with fellow New Yorker, African American and Fort Hamilton High School's Bernard King at the University of Tennessee. Eventually, both men played for the Knicks.

At present, there are no identifiable Jewish youngsters playing either at a Jewish community center or within a high school loop or the AAU leagues who harbor NBA hoop dreams.[10]

↑ **LENNIE ROSENBLUTH #10** University of North Carolina, c. 1955, photographer unknown

JEFFREY S. GUROCK is the Libby M. Klaperman Professor of Jewish History at Yeshiva University.

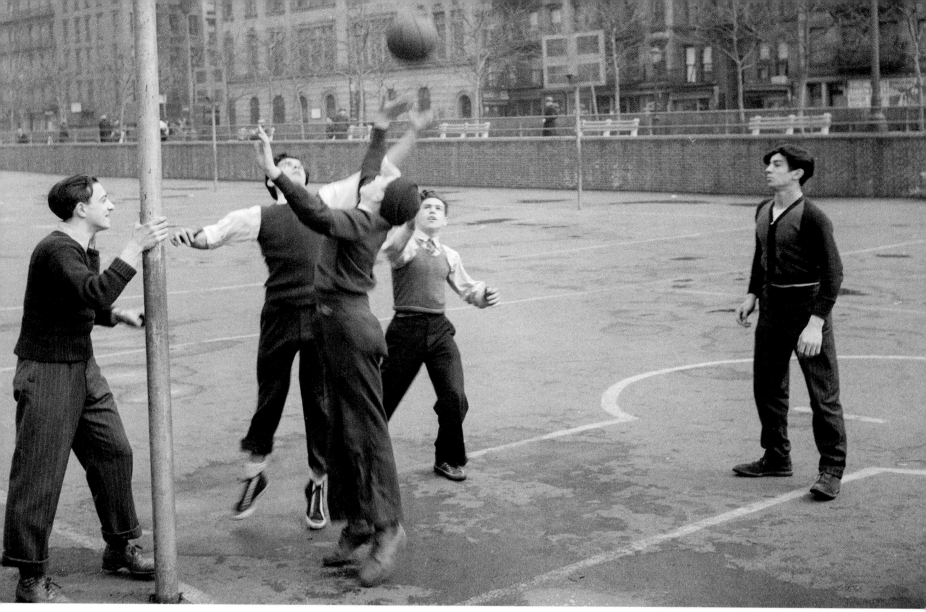

↑ **BASKETBALL**, 1904, photograph by Andrew Herman

THE CITY GAME IS BORN

In 1893 the *New York Times* hailed the arrival of "basket ball," a sport that "has within two years acquired a popularity which places it on a par with the oldest and best known indoor sports." James Naismith invented the game, an indoor, less injury-prone alternative to football, in 1891 at the YMCA in Springfield, Massachusetts. Instead of running with the ball and tackling opponents, players passed the ball to each other, aiming for a basket or box placed about 10 feet from the floor. After observing Naismith's new game, Dr. J. H. McCurdy, the physical director of New York City's 23rd Street YMCA, brought it to New York.

Basketball spread from New York's YMCA branches to colleges, school gymnasiums, armories, and dance halls throughout the five boroughs. Teams such as the Original Celtics and Harlem's New York Renaissance stimulated interest in basketball as a professional sport. At a time when New York received record numbers of immigrants, the game helped hold together an increasingly multiethnic city. Settlement houses, along with Catholic and Hebrew youth organizations, taught the city's kids to play, while outdoor playgrounds like the one in Seward Park (the first permanent, municipally built playground in the country) gave them an opportunity to play together. (LT)

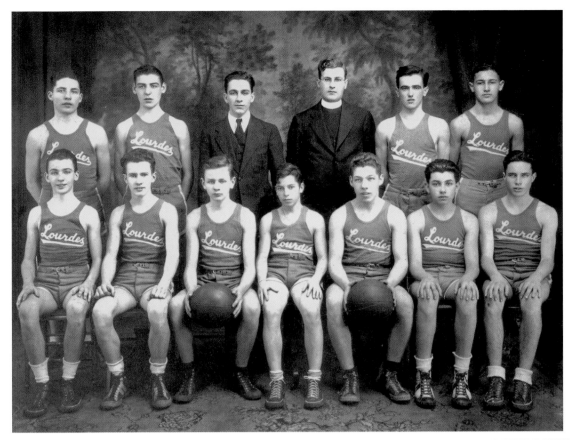

↑ OUR LADY OF LOURDES BASKETBALL TEAM, Brooklyn, 1936

↑ OUR LADY OF LOURDES BASKETBALL TEAM, Brooklyn, 1936

↓ WEST SIDE YMCA BASKETBALL TEAM, Manhattan, 1934–35

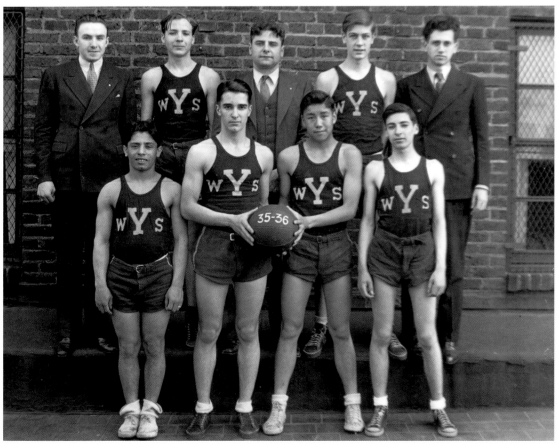

↑ LEATHER TRAINING BASKETBALL, 1910s

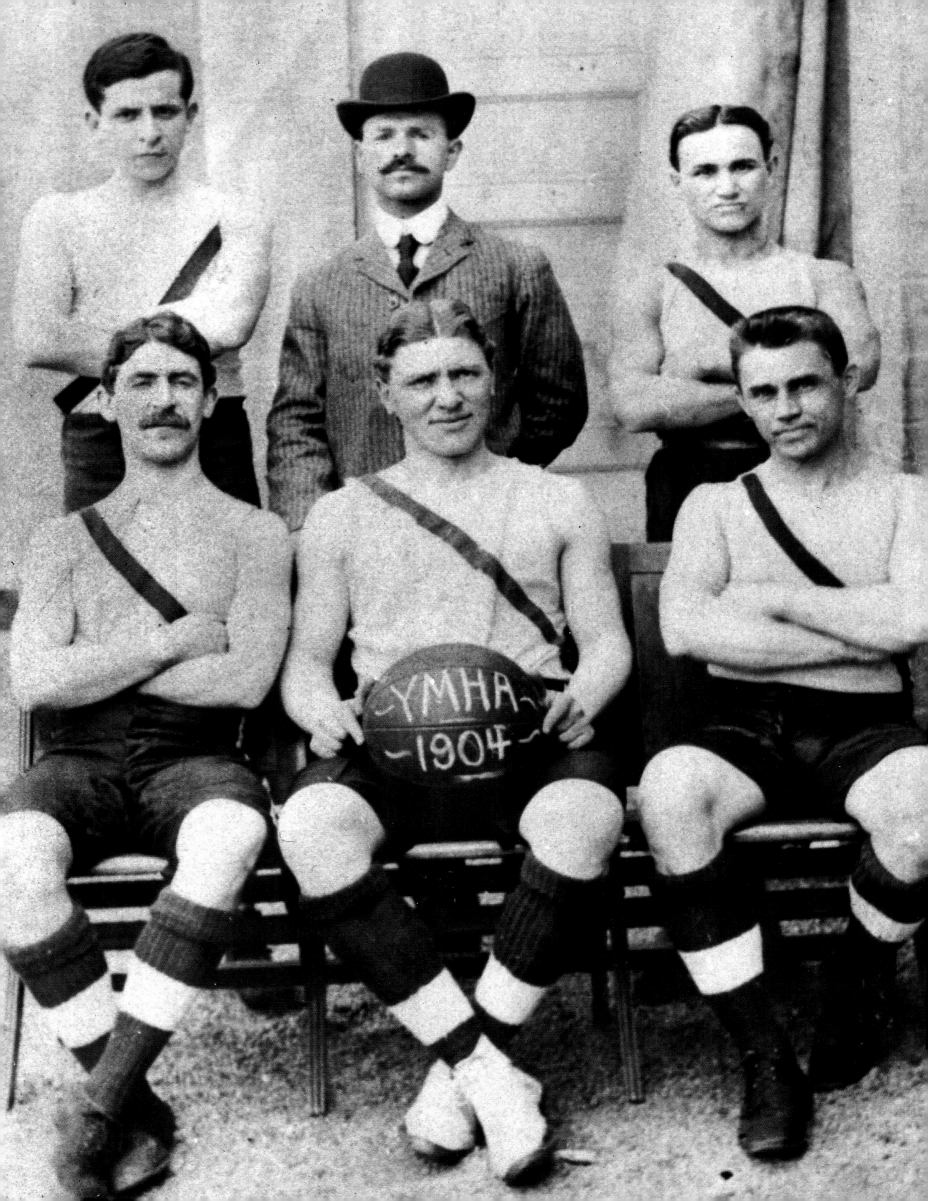

↑ HEBREW NATIONAL ORPHAN HOME BASKETBALL UNIFORM,
mid-20th century

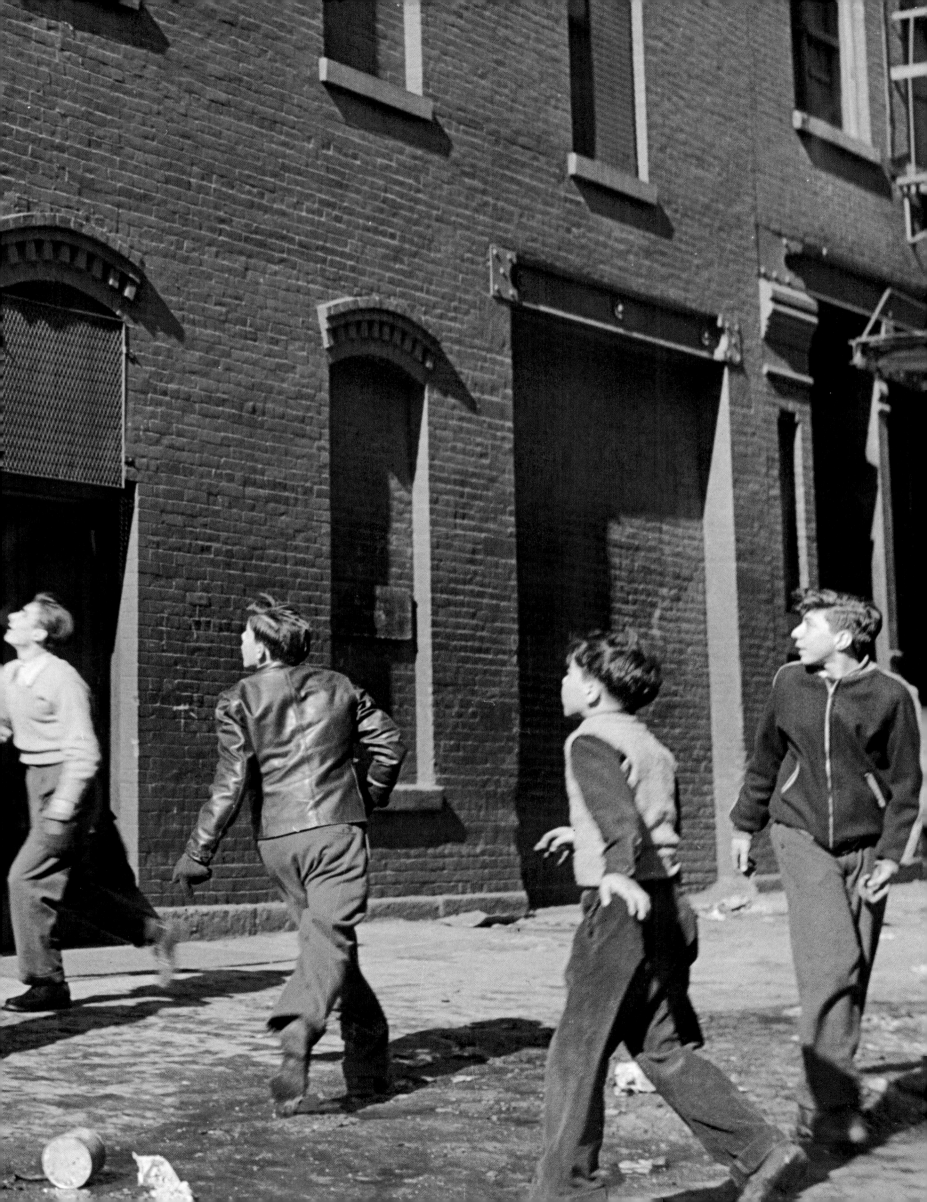

Pages 42–43: **BASKETBALL**, New York, c. 1950, photograph by Morris Huberland

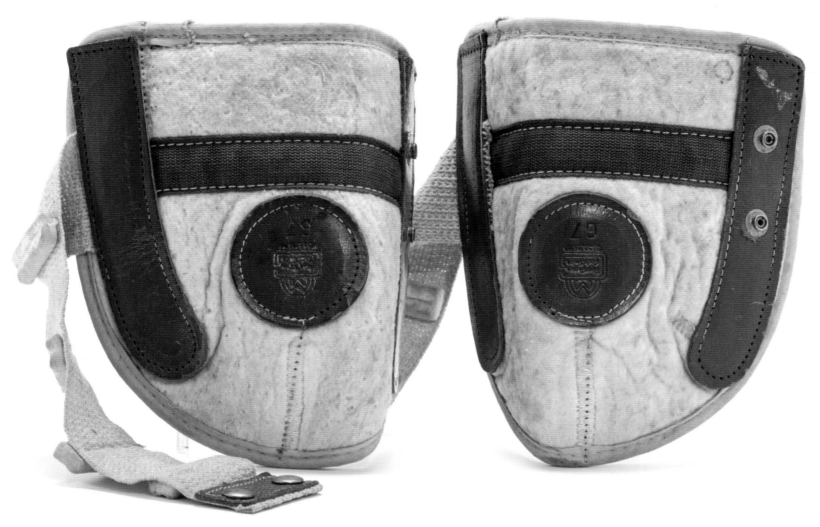

↑ **KNEEPADS**, 1920s

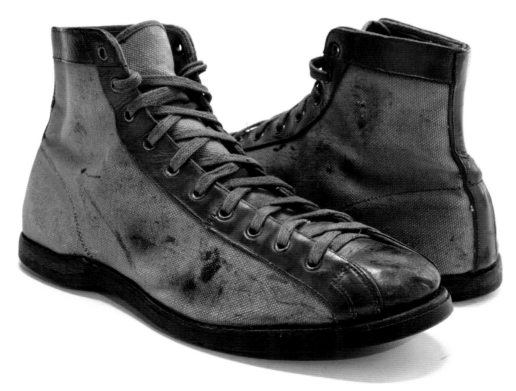

↑ **LEATHER AND CANVAS BASKETBALL SHOES**, 1905

CITY/GAME: BASKETBALL IN NEW YORK

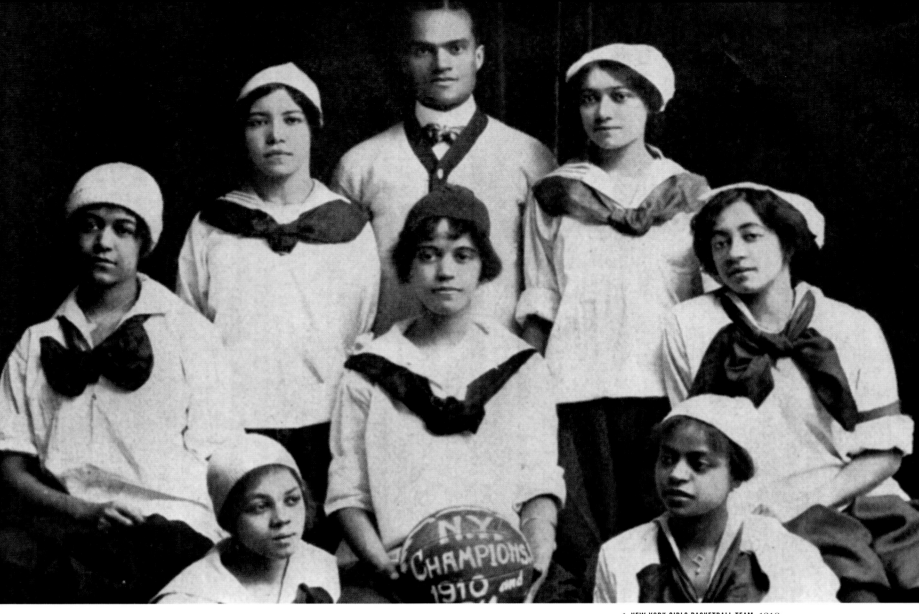

↑ NEW YORK GIRLS BASKETBALL TEAM, 1910

BLACK FIVES

Just after the game of basketball was invented in 1891, teams were called "fives" in reference to their five starting players. Since basketball was racially segregated, teams made up entirely of African American players were often known as "colored quints," "Negro cagers," or "black fives." The sport remained divided from 1904 until the racial integration of the National Basketball League in the 1940s and the National Basketball Association in 1950. The period in between became known as the Black Fives Era, when dozens of all-black teams emerged, flourished, and excelled.

The Smart Set Athletic Club won the inaugural Olympian Athletic League championship title in 1908, and were dubbed Colored Basketball World's Champions by journalist Lester Aglar Walton. In the decades that followed, all-black teams throughout the country came to represent not just organizations and owners but whole communities. One African American team, the Harlem-based New York Renaissance (a.k.a. the "Rens") stood apart as arguably the most successful basketball team of the century, irrespective of race or ethnicity. From 1923 to 1948, the Rens won 2,588 of 3,117 games, a staggering winning percentage of 83 percent sustained over a 25-year period. They ushered in the Harlem Renaissance period, smashed the color barrier in pro basketball, and helped pave the way for the civil rights movement. The men and women of the Black Fives Era were true basketball pioneers whose desire simply to play their best and innovate the game opened doors for generations of African American players. (CJ)

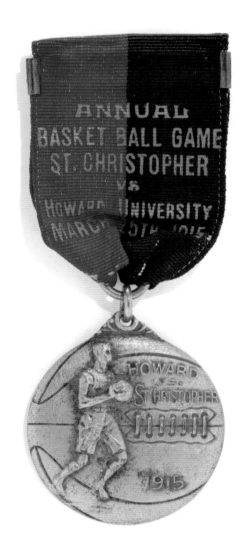

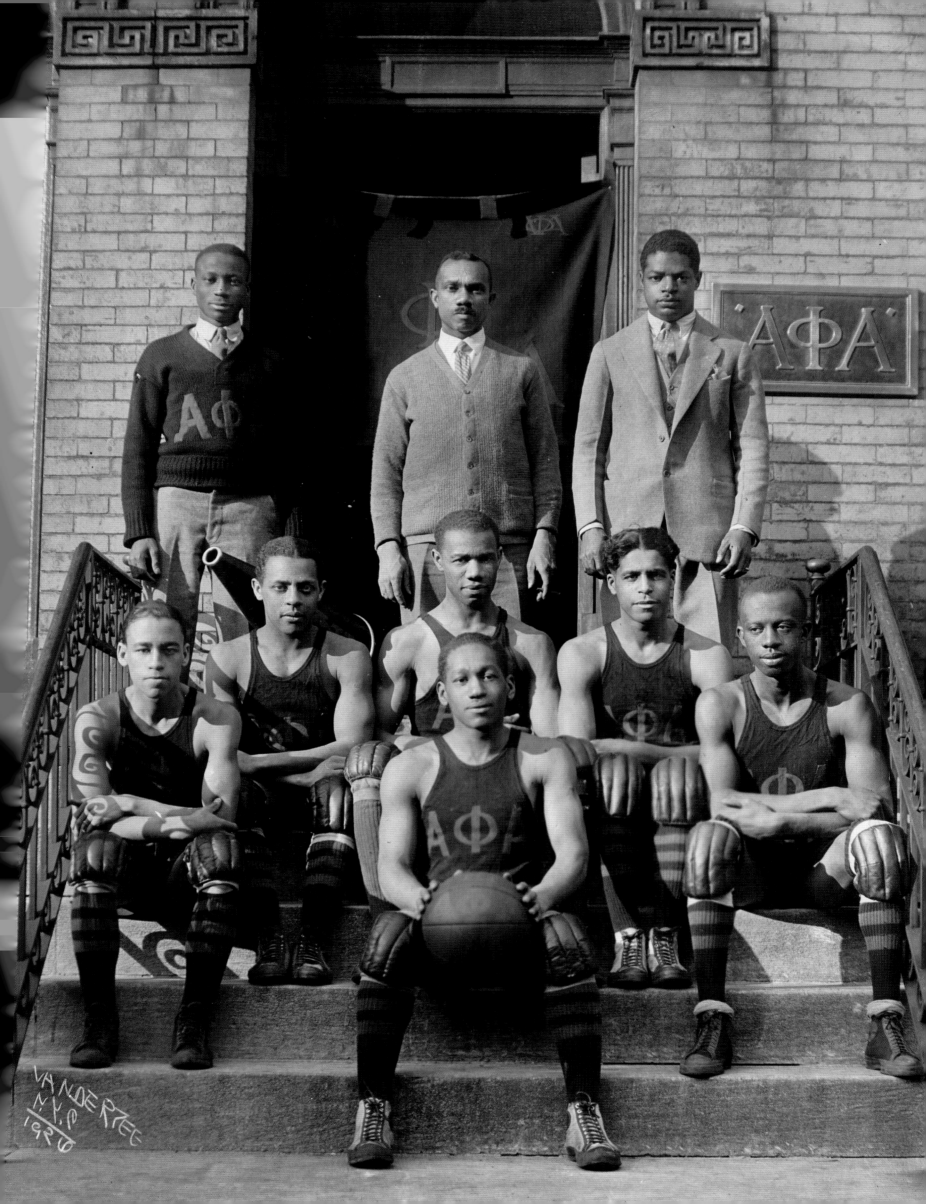

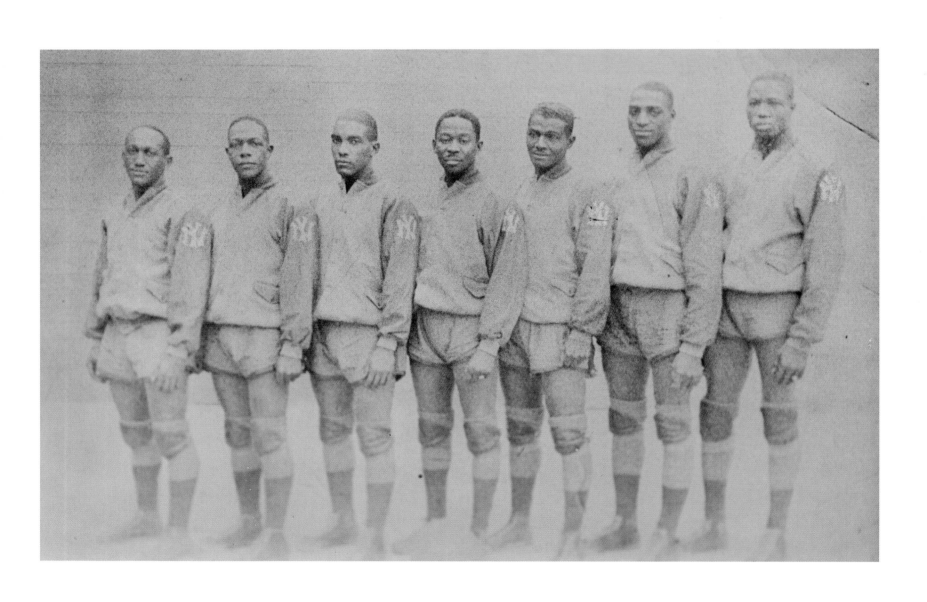

↑ NEW YORK RENAISSANCE HALL OF FAME TEAM (left to right)
"Fats" Jenkins, "Bill" Yancey, Johnnie Holt,
"Pappy" Ricks, Eyre Saitch, "Tarzan" Cooper, and
Willie Smith, 1933–34, photographer unknown

↑ HARLEM RENS WORLD CHAMPIONSHIP TEAM, 1939,
photograph by Morgan and Marvin Smith

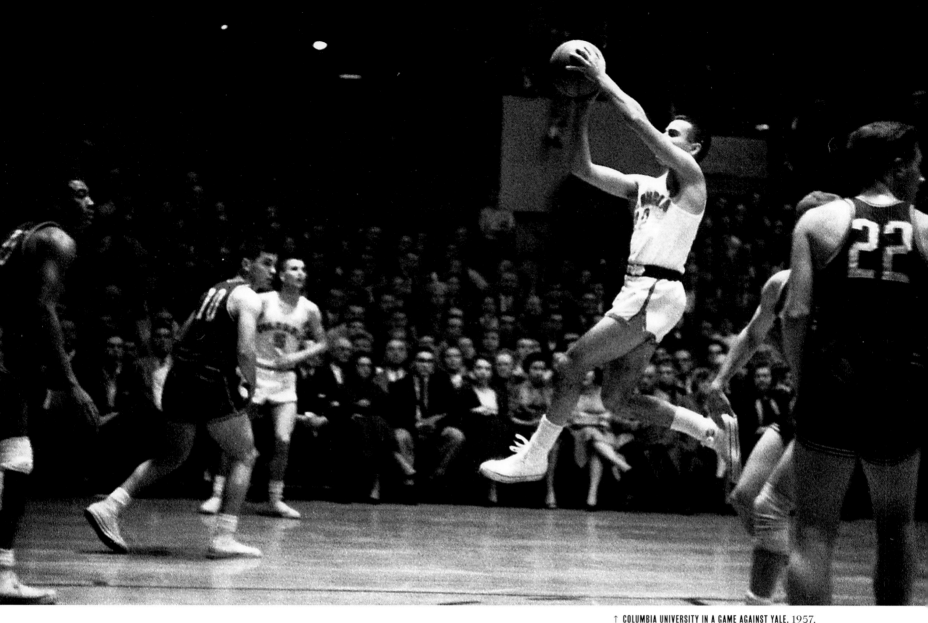

↑ COLUMBIA UNIVERSITY IN A GAME AGAINST YALE, 1957,
photograph by Marvin E. Newman

COLLEGE RIVALRIES

From the mid-1930s to the early 1950s the epicenter of college basketball in America was Madison Square Garden. The city's basketball powerhouses CCNY, NYU, St. John's, and LIU battled one another and guests such as Notre Dame, DePaul, and Stanford for supremacy. Doubleheaders, triple-headers, the Holiday Festival Tournament, the National Invitation Tournament (NIT), and the Metropolitan New York Conference championship were all fought at the Garden.

A seemingly endless stream of talented players rose up through the city's storied high schools into the city's colleges, where they were coached by the past generation's all-stars-turned-mentors passing on the wisdom of the New York game. The high point of the city's college era came in the 1950–51 season when Nat Holman's CCNY players were the upset winners of the NIT finals at the Garden and then, nine days later, won the NCAA tournament, again at the Garden. Yet, this high point was immediately followed by the game's low point, when players from CCNY, LIU, and several other colleges were charged in a gambler-enabled point-shaving plot, effectively ending the reign of New York college basketball in 1951. College ball would not return to the Garden until 1979, when the newly created Big East Conference began holding its finals there. (MA, AA)

↑ **PROGRAMS FOR DOUBLEHEADERS** at Madison Square Garden
featuring New York City colleges, 1946–51

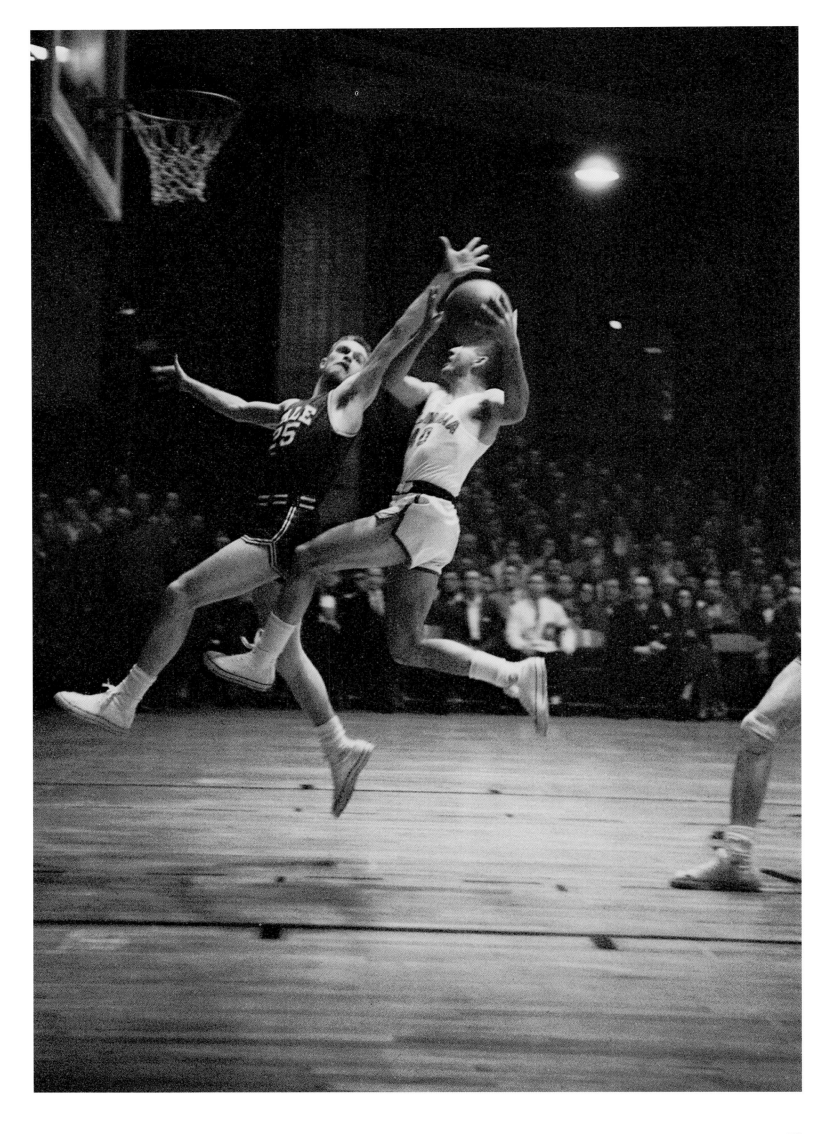

← COLUMBIA UNIVERSITY IN A GAME AGAINST YALE,
1957, photograph by Marvin E. Newman

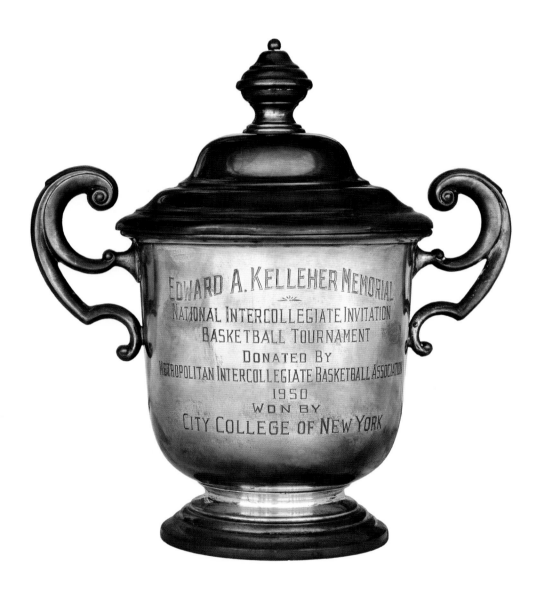

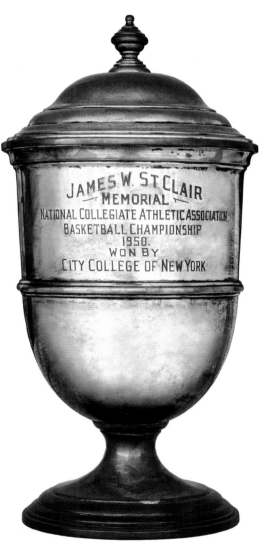

↑ **NIT TROPHY** won by City College
of New York (CCNY), 1950

↑ **NCAA TROPHY** won by City College
of New York (CCNY), 1950

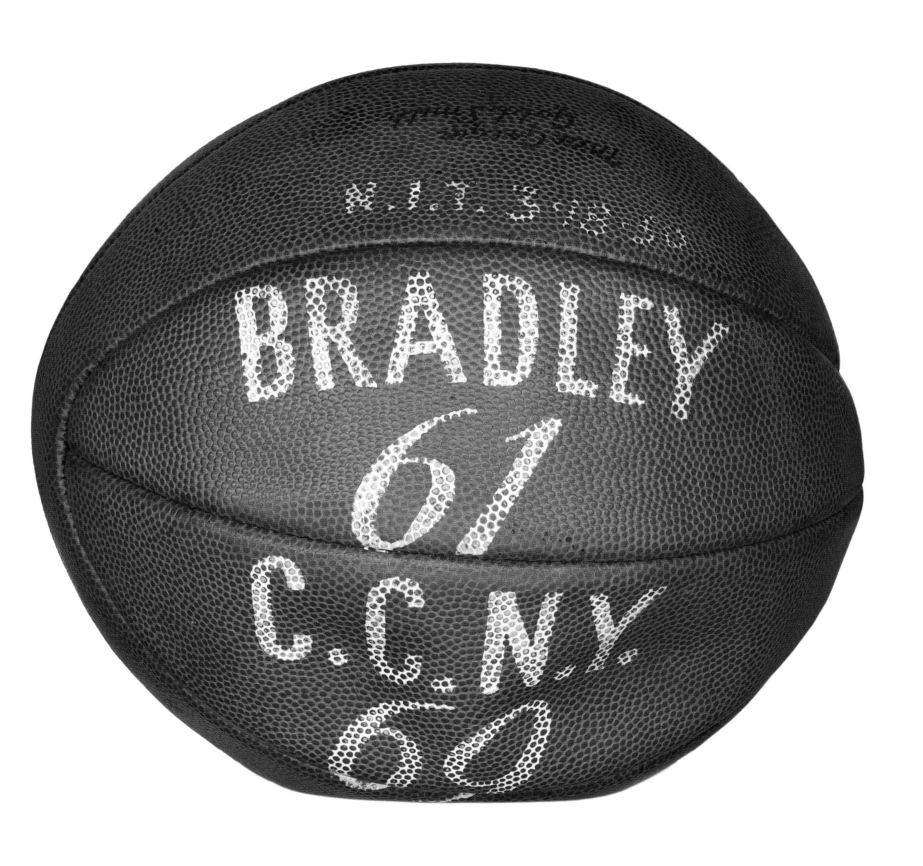

↑ CITY COLLEGE'S NIT GAME-WINNING BALL,
CCNY beat Bradley 69–61, 1950

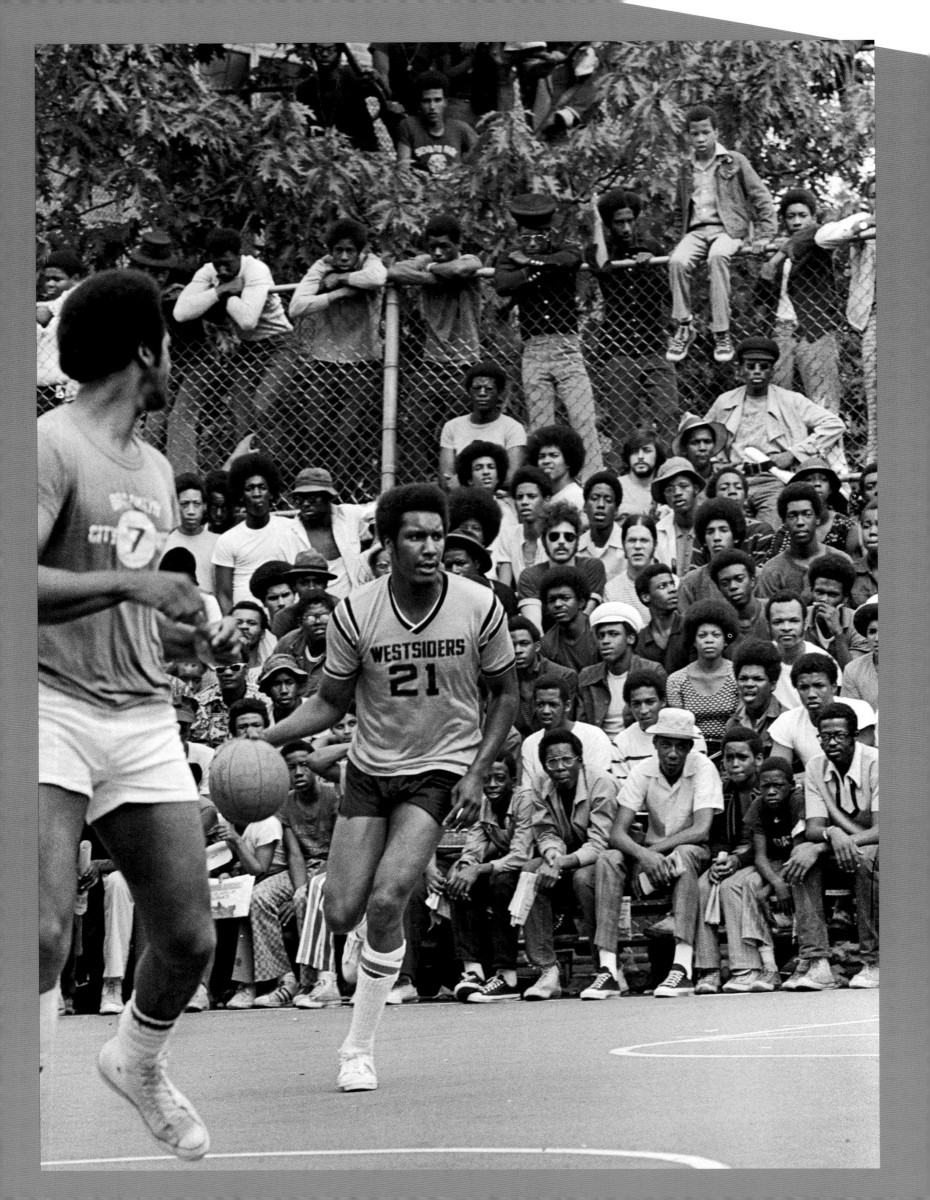

THE DESTROYER, THE HAWK & THE PEARL: RUCKER'S LEGENDS

VINCENT M. MALLOZZI

Growing up in East Harlem at a time when basketball was the national pastime and Joe Hammond was our Babe Ruth, I saw classic hoop battles at the La Guardia Memorial House on East 116th Street and at the outdoor courts in Jefferson Park on 114th Street. But nowhere could I find the kind of basketball that was being played at Rucker Park, and nowhere could I find another player with the basketball résumé of Joe Hammond, a 6'3.5" hoops prodigy who never played a minute of high school or college basketball. Yet, at age 19—with Rucker Park his primary stage—he was drafted by the defending champion Los Angeles Lakers in the NBA's 1971 Hardship Draft. At a time when the New York Knicks roster included world-class players like Walt "Clyde" Frazier and Willis Reed, my favorite player was Hammond, who was nicknamed The Destroyer for his ability to crush opposing defenses with a lethal outside shot. Hammond, whom I first saw play on a basketball court at the Wagner Projects across the street from the old tenement building where I lived on 119th Street, was as undisciplined a player off the court as he was unparalleled on it. He was the greatest player you never heard of, which is why I felt compelled to tell his story, and to share the spine-tingling tales of so many other Asphalt Gods who soared into basketball folklore, but whose exploits had rarely, if ever, been recorded in newspapers or on film.

Across the street from the site of the old Polo Grounds, where project buildings now cover the same earth that Willie Mays once did for the New York Giants, a historic piece of basketball real estate remains intact. Rucker Park, the legendary basketball stage on 155th Street and Eighth Avenue in Harlem, is the birthplace of an electrifying brand of run-and-gun, above-the-rim hoops played by men with nicknames as colorful as their high-flying games, who forever changed the way the game was played at the collegiate and professional levels.

"There would not be an NBA as we know it," said Richard "Pee Wee" Kirkland, "if it were not for Holcombe Rucker."

Kirkland was referring to the humble parks department employee who began staging basketball games in playgrounds around Harlem in 1946 as a way to keep neighborhood children off the troubled streets.

Some of those children, such as Thomas "Satch" Sanders and Nate "Tiny" Archibald, later made the leap to the NBA and took their flamboyant styles and innovative moves with them. They had perfected both in the Rucker Tournament, a stage upon which college and pro players did battle with their playground counterparts. As a result, the tiny, windswept patch of asphalt surrounded by stone bleachers and chain-link fence was transformed into the world's most famous outdoor arena.

"There is no place on earth as important to the evolution of the game of basketball as Rucker Park," said Ernie Morris, 77, a Holcombe Rucker disciple and the tournament's unofficial historian. "For all it has meant to New York and basketball around the world, it should be designated a city landmark."

Page 56: RUCKER LEAGUE BASKETBALL TOURNAMENT, 1972, photograph by Tyrone Dukes

↑ RUCKER LEAGUE BASKETBALL TOURNAMENT, 1966, photograph by Daniel McPartlin

Morris was there in the summer of 1957 when Wilt Chamberlain crushed a team of all-stars that included Cal Ramsey, a rugged rebounding machine from New York University who later played for the Knicks.

"Wilt just about tore the place down," said Morris. "It was a sight to behold."

The same could be said for the performances of Black Jesus, a.k.a. Earl "The Pearl" Monroe, an Asphalt God who entertained the masses by performing miracles on the blacktop. Jumpin' Jackie Jackson could leap high enough to win bets by snatching quarters placed atop backboards on courts across the city.

Then came Connie "The Hawk" Hawkins, who costarred in the greatest game never played at the old Rucker Park, on 130th Street and Seventh Avenue, on a day in 1960 when several thousand spectators gathered to watch the Hawk do battle with Roger Brown, his friend and Brooklyn high school rival.

Many considered the high-flying Hawkins, a star at Boys High School (now known as Boys & Girls High School), and Brown, a smooth 6'5" guard at Wingate, the country's best high school players.

"By game time, the place was packed, and the court was reduced to the size of a bowling lane," Morris said. "There were cops everywhere and cars triple-parked and people who couldn't get seats who were standing on top of their cars and hanging up in the trees. It was so insane, the game had to be cancelled."

During Rucker Park's heyday in the early 1970s, a time when weekend crowds exceeded 10,000, Joe Hammond and Julius Erving—both New Yorkers—were the tournament's two best players.

Hammond's dominating performance at Rucker Park led to his selection in the 1971 NBA Hardship Draft, an offer he turned down, he said, because he was making more money selling drugs on the Harlem streets that the $50,000 the Lakers had offered him to play as a rookie.

Erving, the high-flying, gravity-defying Dr. J, who was born and raised on Long Island, played college ball at UMass and became an instant superstar with the Virginia Squires of the American Basketball Association. He was the Michael Jordan of the bell-bottom generation.

Fathers still tell their sons about the Rucker League's most famous game in 1970, when Hammond's Milbank squad, a team of talented but undisciplined playground stars, squared off against Erving's Westsiders. The former was composed mostly of professional players that included Charlie Scott, Billy Paultz, Mike Riordan, and Brian Taylor.

On that day, thousands of fans streamed into Rucker Park for the highly anticipated showdown. Much like the turnout for the Hawkins–Brown game a decade before, those who couldn't get seats climbed the fences or perched themselves on trees limbs or rooftops to get a glimpse of the action.

"It was," Erving would say long after his Hall-of-Fame NBA career had ended, "a bone-chilling experience."

According to Kirkland, players, and fans, players from both teams warmed up before the game, but Hammond was nowhere to be found. Despite chants of "We Want Joe, We Want Joe" cascading from the rooftops to the tree limbs to the bleachers, the referees decided to start the game on time. Without Hammond, the Westsiders dominated, with Erving leading the charge.

Skinny as Six O'Clock and with a tall Afro hairstyle, Erving terrorized the local legends with extraordinary moves to the basket and a series of sky-scraping dunks on one helpless defender that prompted the public address announcer to say to the overflowing crowds: "The Doctor's surgery was a success—the patient died."

Just before the start of the second half, which Milbank trailed by double digits, a deafening roar ripped through the bleachers as Hammond could be seen across Eighth Avenue, getting out of a limousine.

With police holding back the crowd, he seemed more like a movie star heading into an Academy Awards ceremony than a basketball player 24 minutes late for a game.

On his first trip down the court, the ball quickly found Hammond's hands and *whap*, he hit a jumper. The Westsiders got the ball but Kirkland made a steal and shoveled the ball behind his back to Hammond, who broke away and *wham*, he dunked it so hard that people started dancing in the stands and spilling out onto the court.

When order was restored, Milbank eventually tied the score and the battle raged through two overtimes before the Westsiders prevailed. Hammond, who said he scored 50 points in the half to Erving's 39 (though Peter Vecsey, the former *New York Post* basketball columnist who coached the Westsiders said it was more like 40 points apiece), won the tournament's Most Valuable Player Award.

"It was mind-boggling, considering all of the great players that were on the court that day," Vecsey said. "It was a once-in-a-lifetime experience, like no one has ever seen before—or will ever see again."

VINCENT M. MALLOZZI, born and raised in East Harlem, has written four books on basketball, including *Asphalt Gods: An Oral History of the Rucker Tournament*. A member of the Pro Rucker Hall of Fame, he is now a reporter on the Style Desk of the *New York Times*.

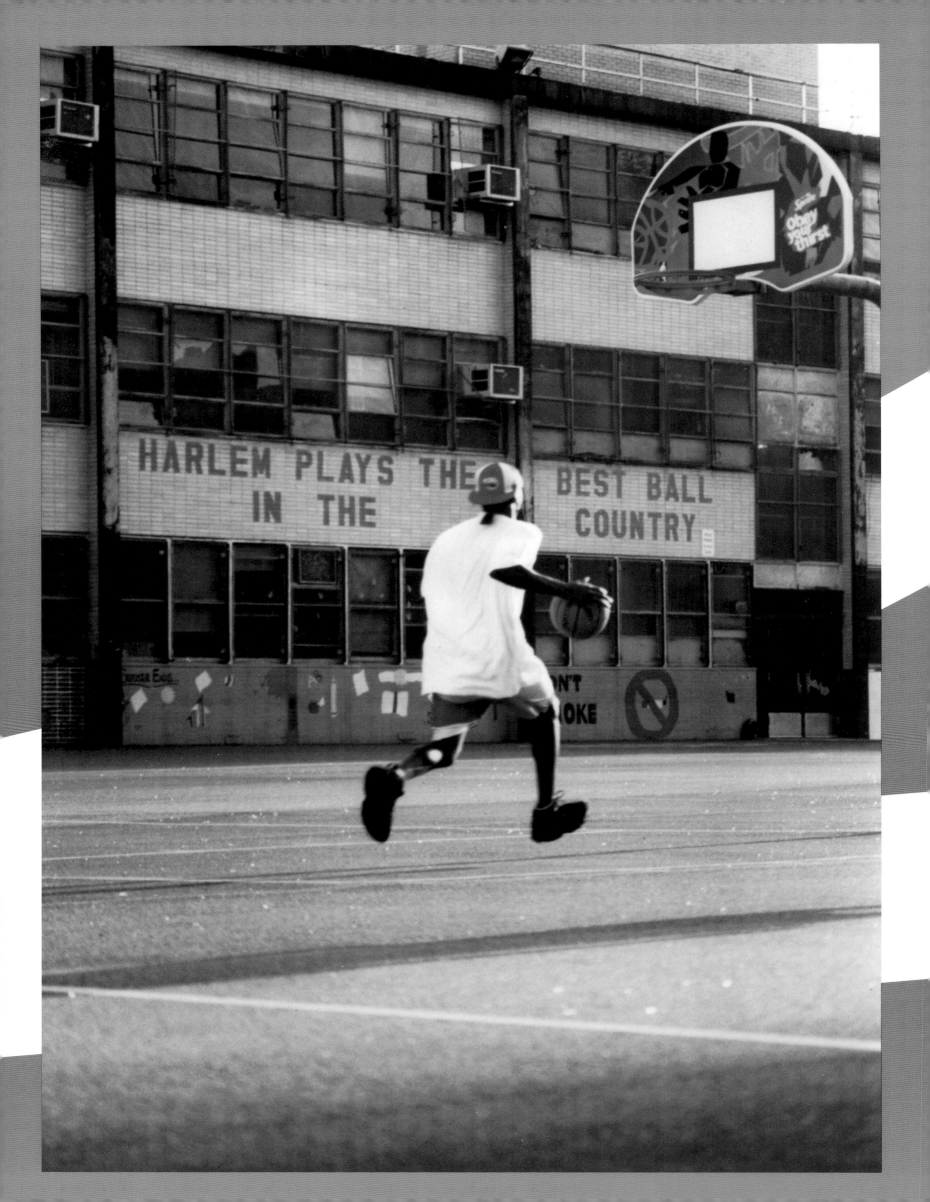

ROCK, RUBBER, 45S: B-BALL, KICKS & BEATS

CHAPTER 5

BOBBITO GARCÍA

New York City connected basketball, sneakers, and hip-hop years before the rest of the country.

I started to make the connection during the summer of 1981. I had just survived tryouts inside the Douglass Projects Community Center. The gym, or more appropriately toaster oven, was devoid of windows or ventilation. Coach Kelsey Stevens, star guard for the New York Gauchos, opened the fire exit door so we could catch a little breeze.[1] This was basically hot yoga 30 years before it became a *thing* in New York City.

The payoff was being down with my first summer ball squad ever—the Holcombe Rucker Memorial League. Before making the team, I'd play five-on-five, Booties Up, and 21 in schoolyard pickup and was a Catholic Youth Organization (CYO) participant as well.[2] All were fly, but when coach passed out our Holcombe Rucker Memorial tournament T-shirts, man…I was more jubilant than the day I graduated out of junior high school!

In 1946, educator Holcombe Rucker invented the idea of organized outdoor summer basketball for youth. Using his tournament as a draw, the Harlem-based leader organized after-school activities for hundreds of students. In the 1950s, Mr. Rucker—as he was affectionately called by many who revered him—added a college and pro division, which attracted the elite ballplayers of the world. These weekend battles drew thousands, which was unprecedented in the playground in any era—or any city. In the process, Rucker became canonized in uptown Manhattan as the progenitor of "summer ball."

Our Rucker tournament T-shirts were aubergine with white lettering. I wasn't a starter, so I didn't have first dibs on the fly numbers like Walter Berry's 21 or Dwayne "Pearl" Washington's 31. Berry and Washington were stars in the hood, All-American selections at St. John's University and Syracuse, respectively, and spent time in the NBA. I was given 11, which wasn't a bum number at all. Plus, graphically it had symmetry with the PONY logo above.

Grassroots marketing by sneaker brands was only a few years old in 1981. The trickle-down strategy of the established ones like Converse and Adidas had always been to focus on pro and college athletes. But in the late 1970s, upstarts Nike and PONY finally gave a direct line of communication to youth on the streets. My generation (Gen X) and community were on the precipice of creating a global shift in the basketball world, sneaker industry, and music scene with a burgeoning countercultural movement.

Coach gave us each a PONY discount card to be redeemed at Paragon, downtown's preeminent sporting goods store. If you were an athlete about your bizness, that's where you went! Kicks were relegated to one small wall, usually tucked away in the back.[3] Sneaker shops were still a nascent venture at this point. There wasn't a lot of space for variety.

Accordingly, brands back then would only release limited color choices to the public. Black on white was standard. Red or royal

↓ ADVERTISEMENT FOR PUMA "CLYDE" BASKETBALL SNEAKERS, 1970s

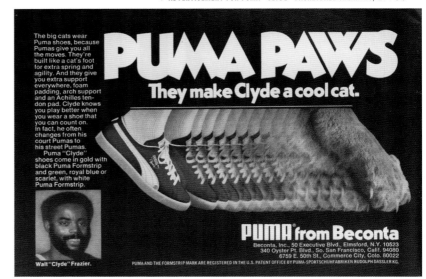

I HAD CREATED A ONE-OF-A-KIND THAT WAS SO *FUEGO*.

blue on white was occasional. Getting fruit flavor colors like orange, purple, gold, or money green was virtually impossible unless you played for an elite program like Power Memorial High School or Riverside Church. I wanted to dip up my feet with the aubergine tournament shirt, though![4] Matching black with purple was unchallenging. Red with purple was a straight no-no!

No one had purple on white PONYs. No one! The PONY Pro Model stripe on the side of the shoe was suede, which became my canvas. I took a deep purple permanent Magic Marker and colored each chevron (a type of stripe) on my sneakers carefully, so that the result would appear factory made. I had created a one-of-a-kind that was so *fuego.*[5]

Riding the subway back then was the equivalent to posting a photo on Instagram today. Walking through the eleven cars in between stations was like being a supermodel strutting down the runway during Fashion Week. The MTA was where you learned what was hot across the city: who was wearing what and how it was being worn. The underground was also where you could earn immediate gratification if you had on something eye catching. I had a 45-minute ride from uptown Manhattan to Brooklyn Tech High School.

You can imagine my disappointment when I debuted my purple and white PONYs, and no one even batted an eyelash. Wasn't until I got off at Nevins Street that I had realized the marker wasn't permanent—at all. The purple ink had rubbed on to the upper side of the opposite foot—both sides ruined. Arrrgh! The quick remedy was Griffin Shoe Polish, which was popular among nurses to keep their shoes white. The sponge applicator would leave the solution looking blotted and pasty, though. Ugh. I went from looking like NBA scoring leader Bob McAdoo to Nurse Ratched from the film *One Flew Over the Cuckoo's Nest* in the span of 24 hours!

Our first game was at Mount Morris, now known as Marcus Garvey Park, in Harlem. The court was hallowed ground. The late Cal Ramsey a.k.a. "The Hawk" played there in the 1950s, before he became an All-American at NYU. Joe "The Destroyer" Hammond perfected his "money-in-the-bank" jumper there. He unleashed the move in 1977 and set Rucker Park's single game scoring record with 73 points—a mark not matched even by NBA scoring leader Kevin Durant. Mount Morris was also where a young seven-foot center named Lew Alcindor made his debut in the Rucker Pro, which was his first time under the whistle against NBA athletes. Alcindor later changed his name to Kareem Abdul-Jabbar and still holds the league's title of all-time leading scorer.

Although history permeated the asphalt, there was little fanfare for our 9 a.m. Midgets division (15 and under) game. None of our parents were there to watch. Harlem was still asleep from the park jam the night before. The scorekeeper announced on the PA, "next two teams—get dressed." The ref walked over to our bench to command, "No shorts with pockets, fellas, and tuck your shirts in!"

↑ ADVERTISEMENT FOR PONY BASKETBALL SNEAKERS, 1980s

These rules were in place, I surmise, to prepare us for adulthood by making us conservatively presentable. We were the earliest generation of hip-hop culture, though, so while we proudly wore our Holcombe Rucker uniforms, none of us wanted to rock them "properly."

Half of us turned our shorts inside out. We all wore them baggy and low on the hip. Our tube socks were folded under so they rested around the ankle for extra support instead of stretching them up to the knee. Look at photos of popular NBA players like Julius "Dr. J" Erving and Earvin "Magic" Johnson in 1981. We appreciated their games, but we were trying to look polar opposite to anything we saw on TV. We took our cues from the hood, and then pushed that forward with creativity. "Big" John, a fellow Boricua and burly power forward, had his PRO-Ked Royal Flash high-tops. He called them "dope fiend jelly roll" PRO-Keds because they were wide like the feet of a drug addict we played five-on-five with from time to time, and they looked like jelly rolls. I had my purple stripe PONYs that no one else had. Our starting guard, "Skeeter," wore the Converse Pro Mesh. "Penny" Sean (he had slipped on a penny during a game) rocked Nike Blazers. The overarching mentality was to be unique. Not one of us had the same brand or even model.

This was New York. This was Uptown. This was playground basketball. This was us.

As we broke up into two lines, the scorekeeper pulled out a 12-inch record of the Treacherous Three's "Body Rock" single, and played it on the turntable's built-in speaker. Soon, we could all hear Special K rhyming, "See I'm not in the place by accident, cuz I've been sent to represent, the magnificent, intelligent, that's why I'm on the mic with this statement that the party's content is excitement..." Sent chills up my spine. Rap was a baby still wearing diapers at the time. Sugarhill Gang's "Rapper's Delight" was the movement's first number one hit because WKTU and KISS FM took a chance on hip-hop and programmed the record for daytime play. But "Body Rock" was strictly underground and only known by true hip-hop heads.

Being on that layup line at Mount Morris, listening to "Body Rock," wearing a Holcombe Rucker tournament shirt with purple customized sneakers—that's where the crossroads of rock, rubber, 45s came together for me. They crashed together inside my cerebellum as well as my spirit and I wasn't alone.

By the 1990s, basketball, sneakers, and hip-hop became pretty synonymous. The University of Michigan's "Fab Five," led by freshmen Chris Webber and Jalen Rose, wore their shorts baggy with black ankle socks en route to the NCAA Final. Their synchronized look garnered a ton of media attention in one of the most watched televised games in any sport that year. Major Division I programs were playing Redman's "Time 4 Sum Aksion" instead of cueing the student band. In 1996, rookie Allen Iverson caused a rumble at the NBA due to his brash street attitude and style. The league responded by trying to enforce a dress code.

For the 2018–19 season, the NBA lifted all restrictions on what sneakers players could wear, causing a complete frenzy with fans and the media. The result has been an array of original, exclusive, and customized models to be displayed on the hardwood.

No one would or should, remember my first Holcombe Rucker Memorial game in Harlem back in '81. What is memorable for me, though, is that I was a member of a small community of forward thinkers who created a pivotal shift in global culture that the rest of the world caught up to 10 to 15 years later.

↓ THE AUTHOR PLAYING IN THE RUCKER TOURNAMENT, 1982

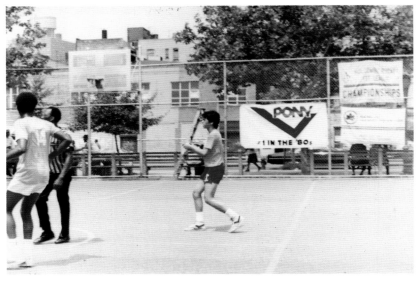

→ ADVERTISEMENT FOR PRO-KEDS BASKETBALL SNEAKERS
featuring New Yorkers Kareem Abdul-Jabbar and Nate "Tiny" Archibald, c. 1975

BOBBITO GARCÍA a.k.a. "Kool Bob Love" is an award-winning filmmaker, world renowned DJ, and author who has put an indelible footprint on multiple urban movements. The New York City native currently produces his b-ball tournament Full Court 21™ on four continents and is the director of the new series *SneakerCenter* on ESPN+.

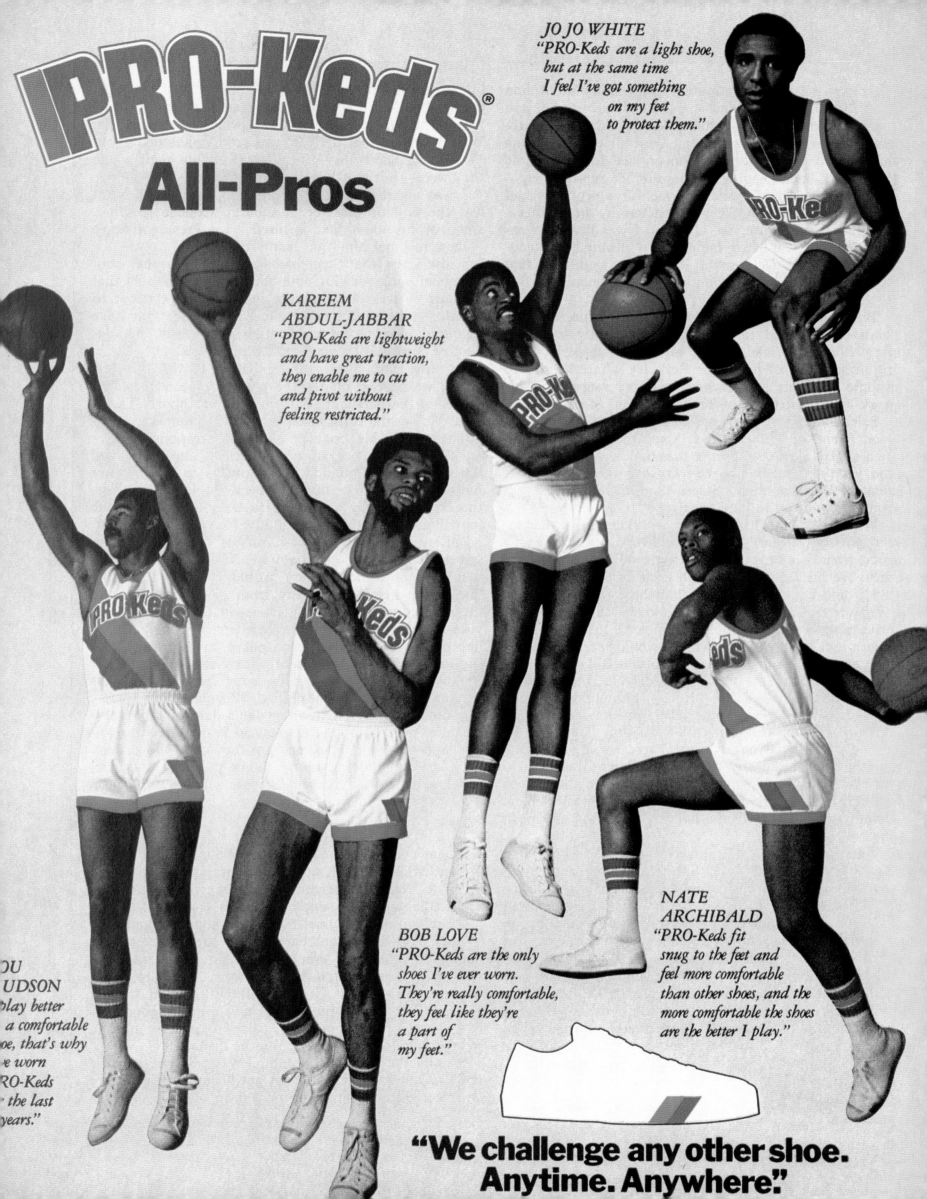

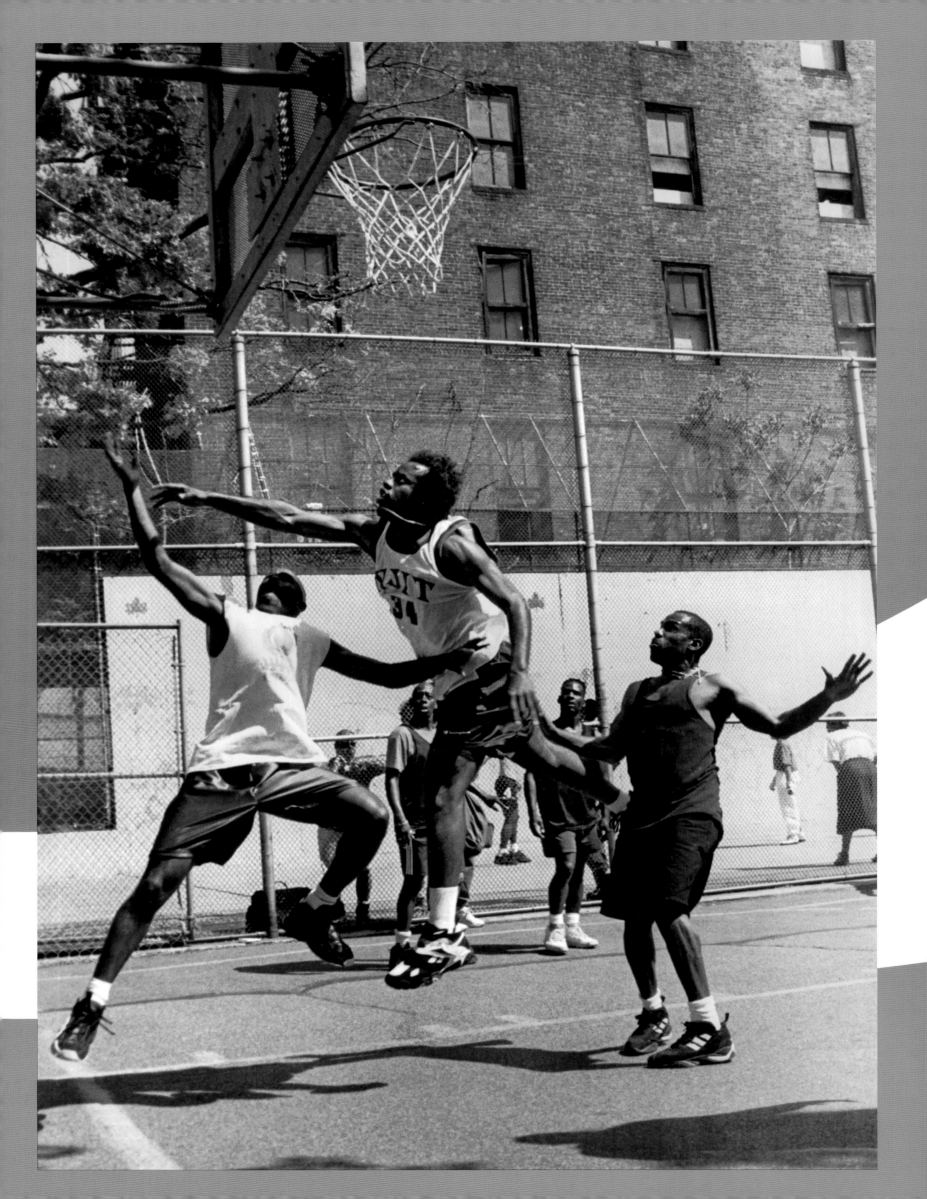

FIELDS OF ASPHALT: LOST IN THE CITY GAME

THOMAS BELLER

1. THE LANGUAGE OF PICKUP BASKETBALL

When my mother went into surgery, I left the hospital. The alternative was sitting in a waiting room staring at a giant screen waiting for her name to pop up. It wasn't a dire situation medically, but I didn't see the point of marinating in my own worry for 90 minutes. I biked north on York Avenue—past Sotheby's and the cul-de-sac where writer George Plimpton had his *Paris Review* office and threw his parties.

I kept going and then took a right and arrived at Carl Schurz Park—an anemic little slice of green along the East River that is hard to call a park in comparison with Riverside Park or Central Park. But it had a court.

I was surprised to find a slender Asian teenager in high-tops taking tentative shots.

"Can I shoot with you?" I asked.

He nodded. A moment later he was standing by the fence looking at his shoes or his phone as I dribbled and shot with his ball. Was this a matter of shyness or some cultural barrier that made him assume only one person could use the ball at a time? I felt like I had mugged him.

"Come shoot with me and I can get your rebounds and you can get mine," I said.

He was maybe 13 or 14 years old, impossibly slender, and tall for his age, I thought. Cargo shorts, Jordan high-tops, a black tank top and a black Nike baseball cap on his head. It was as though he had purchased an outfit for the explicit purpose of shooting hoops in a New York City park.

He came over and we shot around in silence. I wondered if he spoke English but it didn't really matter. The language in which we communicated was basketball. He had an awkward shot—he was a teenager in the midst of a growth spurt. As I got loose, I started doing little "shake and bake" moves with the dribble. These are point guard moves, city moves—head fakes, hesitations, spins, dribbling between the legs, letting the ball hang in the air beneath your hand for an extra moment before crossing it over. All in slow motion.

He responded with tiny movements of his own—a fake, a crossover. The city game combines the gestures of dance with those of a three-card monte dealer. I was sure he was playing out his own private basketball fantasy life. He seemed like a new inductee into the basketball cult who had not yet been briefed on playground etiquette.

I took it upon myself to explain. For example, when one person misses a shot, the rebounder throws him the ball and jogs to the perimeter while the person who missed goes in for a layup. Then they pass it out to the shooter, who will then shoot until he misses. I didn't explain this with words, I just threw a leading pass at him after he missed. Then, after I missed, I jogged toward the basket with my palms up and facing out—the universally understood sign language for "throw me the ball."

Page 66: **WEST 4TH STREET**, 1996, photograph by Doug Lynn

↑ **BANRI TAKENOUCHI**, a basketball organizer from Japan, meets local pickup player Dave Rucker at Goat Park, 2011, photograph by Bobbito García

↑ **BARTLETT PLAYGROUND**, Brooklyn, 2008, photograph by Jeff Mermelstein

I recently discovered that I was fluent in a language I never knew I possessed. Or maybe it's more accurate to say I found it so intuitive that I forgot other people did not understand. A college friend who once saw me play in a pickup game in Brooklyn Bridge Park in the summer of 2019 later remarked, "I could see people were following a code of behavior and a set of rules that everyone in the game understood, but I had no idea what they were."

If only this was the sort of thing one could put on a CV, "Languages: English and pickup basketball." My playground basketball life is metabolic, instinctive, and compulsive. To say that for a long time I never really thought about it is only half right; playing the game was what I did to avoid thought. Like a heavy drinker attuned to the moment in the afternoon when it is acceptable to make the first drink, my afternoons were—and are—always punctuated by a moment when I am suddenly aware that going to play basketball is an option. This is followed by a negotiation—with myself—about if and when I could do so. Soon I am rushing to the nearest court, or suppressing the urge.

Toward the end of that long ago midday session of shooting around at Carl Schurz Park, I was feeling good and attempted a dunk. As almost always happens, I missed. But the rim rattled, the backboard bobbed up and down, and this turbulence gave our little gathering at the church of hoops a kind of credibility. A moment later, he dribbled the ball out near the top of the key, and I stepped toward him as if to guard him.[1] There was no way I was going to even pretend to play one-on-one with this kid. I couldn't resist the gesture, though.

I love playing one-on-one and in situations like this—two people at a court in their own world, maybe each with their own ball. I played organized ball continually from seventh grade through four seasons in college, yet much of my basketball education took place on playground courts, and one-on-one is a foundational aspect of the playground game. I always play my best basketball when I am the best player on the team. When you play one-on-one, there is no ambiguity about who this is.

Also, playing one-on-one with a stranger is a bit weird if you are not used to it. I don't mean the physical intimacy of the contact, though there is that, but rather that there is some vulnerability in the very act of trying, making an effort, in a contest that pits you directly against someone else. You could lose and you have to deal with that. Conversely, you might win, feel good about it, but then have to try to hide that feeling. Expressing too much joy can be seen as a weakness, too. After all, there is no outside authority to make the game or enforce the rules, and this makes you both more vulnerable and more free. There is a kind of autonomy of the physical space of a playground. It's part of the city, in full view of it, yet fenced off and apart. In such a space, one can get lost in the game.

I didn't play one-on-one with this kid, but the basketball catharsis I had come for had been achieved. I had gotten lost in the world

of shooting. I hadn't thought once about my mother, who came out of her surgery just fine. I would have forgotten about the event entirely but for this basketball vacation, and maybe the fact that this was the same hospital in which, many years earlier, my father had passed away.

When I waved goodbye to the kid, he waved back at me with a passivity that seemed forlorn. I thought of a line in John Edgar Wideman's book *Hoop Roots* that I found curious and true, and return to often, even as I don't really understand it: "We play basketball to meet our fathers."

2. RICH

There is an anecdote in Jonathan Abrams's book *Boys Among Men: How the Prep-to-Pro Generation Redefined the NBA and Sparked a Basketball Revolution* that has always fascinated me.

In 1989, Kevin Garnett was 13 years of age. He would go to his local playground, sometimes arriving before dawn, and not leaving until he was shooed away by the police at night. During the day, there was a competitive game, and one player in particular, Bear, brutalized the young Garnett verbally and physically. He was over six feet tall and three hundred pounds, and singled out Garnett for abuse. Nevertheless, Garnett returned to this court with a compulsion that sounds almost like an addiction.

I can say from experience that to be humiliated on the basketball court is an expense that has compound interest—you can't entirely leave it behind, because people have seen it, and you will be tested again to see how you react to the abuse when you return to that court. But, in another sense, you can leave it behind because, after all, it happened in a world contained almost entirely within the playground and the park.

Today, a player of Garnett's height and talent would probably have been spotted long before he was 13. He would have been brought indoors, into the complex preprofessional ecosystem of basketball that points toward the NBA (though rarely leads there). Why did Garnett keep coming back? Maybe he played there until his potential swept him off the playground and into the gym.

The first time I bounced a ball without the supervision of a gym teacher at school was around 1977. That's when I started wandering down to my local playground court at 76th Street and Riverside Drive. By no means was it at the same level as the famous spots like Rucker Park or West 4th Street courts, but Riverside playground had a good basketball reputation at the time. It was usually crowded enough on weekdays that when you got on the court for a full or even a half-court game, you had to win or be consigned to waiting another hour. On weekends, it was packed. For me, street basketball was a place where I was beaten, humiliated, and insulted, explicitly or not. It wasn't personal but it was. It wasn't racial but it was, a little.

IF ONLY THIS WAS THE SORT OF THING ONE COULD PUT ON A CV, "LANGUAGES: ENGLISH AND PICKUP BASKETBALL."

It was about talent but also about physical grace and personal style. It was also about justice and injustice. I embodied the latter because so much height had been squandered on a person who had so little talent. But I kept coming back.

Was I driven by a love of the game? Yes, I suppose, but only if you expand the parameters of "the game" to include the basic act of survival in an inhospitable environment. Is an addict driven by a love of the drug?

I first arrived on this court when I was around 11, and for a while, I only peered at the players on the full court. Eventually I went over there and played—or tried to. Mostly I stayed on the half court, but even there it was hard to get picked for a team. I often had to call my own next, which I hated (and still hate) doing because it implicated you in the politics of choosing players.[2] Eventually you would probably have to get into it with someone else who claimed they had next. So I always tried to get onto a team.

There was one guy named Rich with whom I had an almost explicitly masochistic relationship. He was a very fat dude who played in immaculate white sneakers and socks that he changed into while sitting beside his gym bag.

"Do you have next?" I would ask.

He would stare out onto the court at whatever was happening there and, a picture of meditative tranquility, nod his head, yes.

"Can I run with you?" I would ask.

With the same serene expression he would shake his head, no.

On some occasions he would take the trouble to murmur, "I have my five," which was worse than "no," because it was not true. Or did it indicate that I was at least worth speaking to?

On the court, Rich was a pretty good player. His big move was to bounce you off his girth and then fade away on the baseline for a short jumper.

He was also a trash-talker and an early user of the mouth guard. He'd remove it when he talked, like so many players do today. When he talked, he usually talked trash. I always played extra hard against him, eternally bitter for those years of insults. If the goal was to earn his respect, it was a total failure.

This went on for at least six years. Then one day, I overheard some guys talking on the sideline.

"Did you see the picture?"

"I didn't even know it was Rich!"

It took a while before I realized they were referring to a gruesome image on the front pages of both New York tabloids that day—a heavy black man lying facedown on a subway platform, arms down at his sides, face turned sideways, a pool of blood collecting beside him. It turns out Rich was a token booth clerk. His afternoon appearances at the court were after his shift at a nearby station. Like all token booth clerks at the time, he would periodically leave the booth with a bucket to collect tokens from the turnstile.

Someone shot him for a bucket of subway tokens. He was the victim of a senseless robbery.

It wasn't that I had lost a friend. If anything, I'd lost a nemesis. I certainly have no right to eulogize the guy. But at the same time, he was part of my life in some strange but important way, part of the landscape of my basketball youth and then the chapter that comes right after, when you are at your full height and starting to fill out.

The chill I felt when I made the connection between Rich and the tragic image in the paper is with me still. I've relayed the anecdote numerous times. I wrote a "Talk of the Town" piece for the New Yorker that was in galleys in 1991, when he was shot. At the last minute, the magazine killed it. The Crown Heights riots—which heightened racial tensions between blacks and Orthodox Jews in the neighborhood—had just happened. The tone in the city had changed, I was told, and the piece no longer felt right.

I also used the anecdote in a piece about streetball that appeared in the debut issue of Vibe magazine in 1992. Nearly 10 years later, I included it in a long essay about pickup basketball that appeared in the Sunday New York Times.

A couple of weeks later the Times received a beautiful note from one of Rich's friends. Writing a decade after Rich's murder, he wrote about his local court on Lafayette Avenue in the Bronx, which had been Rich's home court, and the regular group that still played there on weekends. A square near the court was renamed Richard A. Daily in Rich's honor.[3]

Rich never liked me, but he was part of my basketball education. I think a lot of players have some version of this experience, some basketball demon and or shame they have to overcome.

The triumphs of streetball—the game winning shots and so forth—tend to fade from my memory while the defeats and humiliations stay with me like souvenirs.

For example, in my early twenties—the prime-time Rich era—I got punched in the face by a guy named Red. I don't recall the infraction, just some words back and forth and then I was on the ground. My response was to get back up and keep mouthing off, but not hit back. The game resumed. Later, just as I returned home, my friend Tom Cushman called. He had been on the basketball team with me in high school; he was a musician and a sardonic guy. I wasn't ready to talk to him or anyone else just then.

"Can I call you right back?" I said.

I slammed the phone down in its cradle before he could answer and, in the silence of my bedroom, burst into tears. I sobbed for what felt like a long time. Then I composed myself, wiped my face, and reached for the phone. Only then did I see that I had not put it cleanly back in the cradle; it was ajar. I picked it up. No dial tone.

"Hello?" I said.

"I heard all that," said Tom.

"Oh my God."

YOU HAVE TO EXPAND THE PARAMETERS OF "THE GAME" TO INCLUDE THE BASIC ACT OF SURVIVAL IN AN INHOSPITABLE ENVIRONMENT.

"So I guess I don't have to ask how you're doing?"

This event speaks to my lingering fascination with Wideman's remark and its mystery. Streetball as a place where you test yourself, as you would against a father. Streetball as a place where the triumphs and defeats are only partly about basketball.

3. BARCLAYS

In April 2008, I got a call from a photographer, Jeff Mermelstein, who was working on a project about basketball in Brooklyn. We would go around to different playgrounds and gyms, he said, and he would take pictures and I would take notes. The resulting project, for which I would get paid, would be displayed inside the fantastical future home of the Brooklyn Nets.[4] There was a catch, though. The project's patron was the ethically dubious real estate developer Bruce Ratner. He's the man who brought the Nets and the Barclays Center to Brooklyn via a massive real estate development for which basketball was a kind of Trojan horse.[5]

To involve myself with Ratner was to be a collaborator against the citizens of Brooklyn for whom this massive development was an attack on the scale and texture of their neighborhoods—Park Slope, Fort Greene, Cobble Hill, and Brooklyn Heights—where St. Ann's School, from which I graduated from high school, is located. The drama of Ratner's Brooklyn development has been unfolding since 2003, and, as of 2019, it's still not over. In fact, it's not even primarily Ratner's anymore.

My first thought, therefore, was: no way.

On the other hand, it would be a chance to roam the basketball courts of New York or at least Brooklyn. When I travel, I always make a point of playing in whatever city I am visiting.[6] In New York, however, I always imagine myself as some version of John Cheever's *The Swimmer*, going from court to court to court, but I never do it. Instead, the afternoon rolls around and I rush to the nearest court as though to the nearest bar. So I said yes.

We visited the courts on Tillary Street next to the Brooklyn Bridge, near where NBA stars Bernard and Albert King had grown up in the Fort Greene projects. Then we went to see a tournament in Bedford-Stuyvesant, where the two teams from neighboring housing projects were playing for a tournament championship. One team wore red jerseys, the other yellow. The court was bordered, at one end, by a high brick wall painted deep maroon. The star of one of the teams had once been a major talent, I was told, recruited by Division I colleges. He may have attended one, briefly. But the streets got him. The story came to me in fragments from someone standing next to me on the sidelines.

The player I watched was a high volume shooter who raged and demanded the ball. Some players develop basketball skills within the structure of superior athleticism, and some players are possessed with an intuitive knack for the game—referred to as court vision, or

↑ **BROWER PARK**, Brooklyn, 2009, photograph by Jeff Mermelstein

basketball IQ, or feel for the game—around which they train their way toward athleticism. At the highest levels you need both.

This guy had lost his hops, but his basketball skills had not developed to make up for it—you could see he was used to overpowering opponents, but the rise was no longer there. He was already, in his mid-twenties, a lion in winter. When Jeff sent me images from that day, one of them featured this guy on the ground, on his back, sweating, with no one else in the frame. My sense of him that day was that he had been running, jumping, yelling, raging the whole time, surrounded by a lively crowd pushing in on the sidelines, but the photograph told a different story—the frame is entirely empty except for this guy on his back, the look on his face like that of a soldier who had just been shot. The picture captured a sense of his isolation and even grief that in the rush of real time you could only sense. Sometimes these games mean nothing to the people playing them and at other times you feel like epic stories of identity and loss are being played out on the court.

It was a promising start for the project, but the Ratner money ran out and it was discarded along with the Frank Gehry designs.

For the past few years, I have gone out to the Barclays Center every June to witness the NBA Draft. There is so much ecstatic pageantry, it's like a high school prom, but with the promise of huge sums in the immediate future. There is also an undertow of grief, some of it stemming from the memory of what was overcome. In the 2019 draft, each of the first three picks spoke emotionally of the people who helped them get to this point. Zion Williamson, with tears streaming down his face, spoke of the sacrifice his mother had made to get him to this level. Ja Morant, the number two pick, said of his father, "He made me who I am today," and wept. R. J. Barrett rested his head on his father's shoulder in such a way that his face was hidden from the camera while his father calmly praised his hard work. It almost seemed like a joke until Barrett's body began visibly shaking with sobs, a thunderstorm that had passed when he lifted his head a few moments later.

As with a prom, some of the night's tension, beyond who is picked when, is the knowledge that while this is the end of something, it is also another beginning with no assurance of what is to come. Most players drafted in the first round make real money for several years, but many don't last in the league for much longer than that.

I tend to spend just a few minutes out on the floor of the arena, where the big stage is and the players wait with their families for their name to be called. Most of my night is spent backstage, where the draftees are shuttled down long corridors from room to room for a series of interviews, photo shoots, and press conferences. There are party spaces for receptions that also serve as photo shoots. There's a lot to see and overhear like in 2018, when Michael Porter Jr.'s tiny little sister said, "I can't believe you are in the NBA," to her brother. But he towered so far above her in his white suit, and was so thronged with people, that he didn't seem to hear.

This year, at the end of a long hallway, I came upon a small plaque dedicated to Bruce Ratner. It was dated 2012, the year the arena was completed.

4. MOSES AND THE CITY GAME

Here is an unprovable fact that, nevertheless, holds up under commonsense scrutiny: New York City has more public basketball courts than any other city in America—more than Los Angeles, more than Chicago. New York City has, I would venture to say, more actual hoops attached to backboards than any other city in the world, and the person most responsible for this fact is Robert Moses.[7]

The legacy of Moses was defined by Robert Caro's magisterial book, *The Power Broker: Robert Moses and the Fall of New York City*, which continues to send ripples through a general population who, were it not for this book, would almost certainly have never heard of a man named Robert Moses. The effect of the book on me, when I read it, was galvanic. It is both the *War and Peace* of New York history, and a Mephistophelean portrait of a man for whom power was a driving force. It is also an X-ray of the many economic and political forces that shaped New York City, most of which operate out of the public's view, or at least mine. Caro's prose has a meticulous, granular specificity, and also an incantatory style. It's thrilling when Moses is able to envision, in a single burst of inspiration, entire parks, beaches, highways, and other public works that have had an indelible effect on city life. And it's distressing to see the contempt with which Moses treated the people and neighborhoods that his plans destroyed. When, by the end of the book, Moses finally comes toppling down, it feels a bit like you are witnessing the demise of a tyrant.

As a kid, we take a lot of our built environment for granted, a condition that can last well into adulthood. Caro's book was, for me, the beginning of my consciousness that the city in which I grew up and, until fairly recently, lived, was built, planned, and composed of choices. Among many of these choices—the decision to build all these basketball courts.

According to Alexander Garvin, a professor of urban planning at Yale University and author of *The Planning Game: Lessons from Great Cities*, 25 percent of New York City's territory is devoted to public parks. This is the largest percentage of any American city. A huge portion of these parks were created by Robert Moses.

Garvin's book is devoted to the realpolitik of planning as it has played out in a number of different American cities. It is implicitly a field guide to getting things done at the municipal level. Unsurprisingly, he takes a very bright view of Moses, who during his long tenure as chairman of the New York City parks department, oversaw the creation of 658 playgrounds.

I have tried to understand how it was decided that a New York City playground should have, among its amenities, a basketball court. Most of these decisions were made not long after Moses took

over the New York City parks department in 1934, a time when the game was not nearly as prominent in the culture as it is now.[8]

I wondered if there was one unsung individual who, in a parks department planning meeting of that era, advocated for basketball courts while another individual wanted shuffleboard. Poking around the parks department archives from this period, I found nothing that would answer this question. But there was a memo about all the tournaments the parks department sponsored in its playgrounds. "All kinds of tournaments and contests are held," it begins and proceeds to list the activities: "Baseball, basketball, volleyball, handball, marble shooting, paddle tennis, checkers and jacks."

Had things played out differently, we might be making movies called, *Jacks Dreams*, or talking about March Madness in terms of marbles.

Playgrounds and public basketball courts almost always sit side by side and the similarities are instructive. Both are a bit haunted and even scary when empty, and noisy when full. Both appear to be chaotic scenes of innocent recreation when seen from outside the fence. Inside the fence it is more complicated. In the case of the basketball court, profanity and insults are part of the game. There are always currents of violence in a basketball game, and sometimes street basketball feels as much about the very act of asserting oneself as it is about the game of basketball. My sense is that pickup basketball players in New York are much more decorous and respectful of each other these days than they were in the 1970s to 1990s.

"You can be loud without being disrespectful," was an actual phrase I heard uttered on a court in the summer of 2019, and more than the sentiment expressed, the very sentience of the thought would have been unusual when I was younger. The world and the country and the city and the neighborhood—they all change, and so do the courts in their midst.

And yet: the basketball courts of New York are like old-growth forests. Standing on one, it can feel like the city grew up around them. They're just there. But forests are dense, vertical spaces; the basketball courts of New York have the reverse optical and emotional effect. In a dense, vertical town they are like asphalt meadows—a dull gray flatness, sometimes painted parks department green, that are like Etch A Sketches on which complex arrangements are traced every day, and then erased every night to begin again the next morning.

It was in Caro's book that I learned, with amazement and pride, that Robert Moses dreamed up the entirety of his vision for Riverside Park in one burst of inspiration while standing on a promontory at 76th Street and Riverside Drive. In this very spot, a set of stairs now descend to the court where I grew up playing. On which I still play.

5. BACKBOARDS & DINOSAURS

I went down to the basketball courts in Riverside Park on a recent Saturday and found a bunch of obstinate old basketball dinosaurs warming up. Dinosaurs not because of age, though a bunch of us

↓ **BARTLETT PLAYGROUND**, Brooklyn, 2008, photograph by Jeff Mermelstein

are up there in years, but because we have refused to accept that this once-fertile, well-regarded oasis of basketball has more or less dried up. It used to be a minor basketball mecca. Obviously, it was not a world-famous spot like the West 4th Street courts or Rucker Park, but it was a place where quality players showed up, along with a wide assortment of others. It was crowded in the afternoons and packed on weekends.

We took shots in that pregame ritual in which other people are acknowledged in the most indirect ways (like giving the ball back after a made shot). There were even a few college-age players with some skill who had not gotten the memo that pickup basketball should be sought out elsewhere—at downtown courts near Battery Park City, uptown in Harlem, or out in Brooklyn and the other boroughs.

I wrote a long piece in 2015 pondering why street basketball in New York seems to be so much less vital and so underpopulated with serious players, compared to earlier eras. I came up with many possible culprits—gentrification prominent among them. But the one that seems most conspicuous is the simple fact that many areas of life that once fell under the category of "play," have become professionalized. There are afternoons when these courts are almost empty except for a couple of athletic young men, usually black, coaching considerably less athletic young boys, usually white, for an hour's rate that can reach $100.[9]

I thought about this as teams were divided up and the game commenced. I guarded a wiry guy with a jump shot. This meant I had to work on defense, stepping out to guard his shot. My big move, when I have to guard shooters, is to force them left, though I never pay attention to whether they might actually be a lefty or not. On offense, I'm thrown into the conundrum of my basketball life. At 6'5.5", I was much taller than the wiry guy and it was presumed that I should "go down low."[10] But I never want to. I played small-time college basketball in the 1980s, and regarded the post as a prison. On offense, it is a place of violence but also a kind of passivity, a contradiction captured in the basketball phrase, "feed the post." It's as though the "big man" is an animal who must have the ball meted out to him a bare minimum of times lest he become unhappy, lethargic, or unmotivated to do his work on the defensive end, which is to rebound the ball and immediately hand it over to the guards.[11] Now I handle the ball, shoot from the outside, drive facing the basket, at least until it all goes wrong and I miss a few shots in a row, at which point I retreat to the old ways.

After the game a longtimer named Joe pointed up to the backboard and said, "I've been trying to get the parks department to change this backboard for years."

"Why?" I said, instinctively alarmed by all change. "It looks fine."

He pointed to the wooden frame to which the fenestrated old metal backboard was affixed. It had rotted a bit. The rim itself was sagging, and must have been two or three inches too short, though none of the old-timers seemed to mind this. Then he pointed to a faint oval high up on the backboard above the rim.

"Used to be a sticker. Some little girl climbed up there and put it there in 1978," he said.

"I've been coming here since 1977," I said. "And I don't remember a sticker."

"It lost its color years ago."

"What color did it used to be?"

"I think yellow," he said, and we both stared at it.

I suppose I will be grateful when they replace the rim and backboard with one that is of a true height, and that doesn't make such a huge clanking sound when the ball goes off the backboard. But I will be a bit sad to know the remnant of that sticker will be gone. I've lived in a happy oblivious presence for 40-plus years and just now found out about it. Now I want to hold onto it. I am tempted to say I learned that from playground basketball, too, which is to say I learned the instinct to hold onto things. But the opposite may be true. Pickup basketball in the park is like a river in the sense of Heracleitus' ancient aphorism: you can't step into the same river twice. The river changes, as does the person. But in another sense the playground of New York may as well have been formed by the glaciers that cut the route of the Hudson River, visible from the court in Riverside Park. It feels sometimes like they were there since the beginning of time.

THOMAS BELLER is the author of several books including *J. D. Salinger: The Escape Artist* (2014), which won the New York City Book Award for biography/memoir. He is an associate professor and director of creative writing at Tulane University and a longtime contributor to the *New Yorker*.

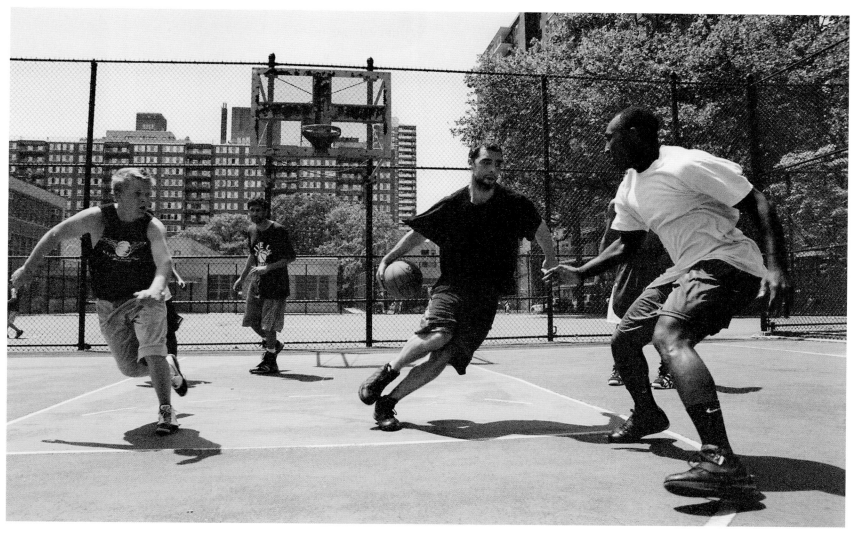

↑ **TYSON HARTNETT** (center, with ball), Goat Park, Manhattan, 2011, photograph by Bobbito García

YOU CAN BE LOUD WITHOUT BEING DISRESPECTFUL.

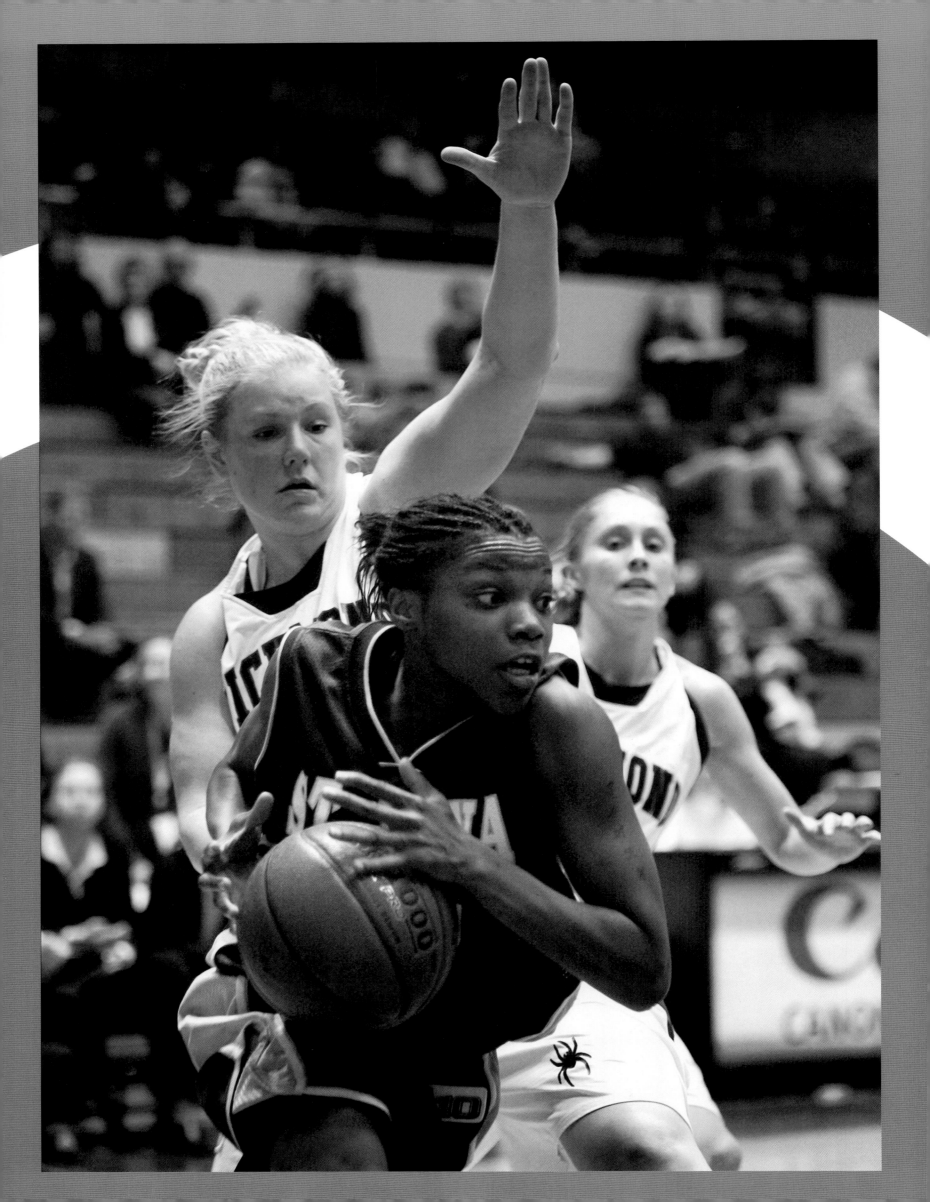

I GOT NEXT: GIRLS & STREETBALL

PRISCILLA EDWARDS

New York City is known to many as "the mecca" of basketball. I grew up navigating some of the most iconic courts of the world. My time on those courts shaped me into the player and eventually the woman I am today. Those legendary courts inspired me to mentor young girls to be the best versions of themselves. As far back as I can remember "the mecca" and those iconic courts were the center of my life. But for most of it growing up, there was one thing missing—women.

Going to Rucker Park or Dyckman you never knew who would show up. Lamar Odom, Stephon Marbury, Larry "The Bone Collector" Williams, Kobe Bryant all came through. You name it—they played, unless you were looking for top WNBA or women's college ballplayers. Female basketball stars were largely absent from the streetball scene in New York City.

I admired players like Becky Hammon, Teresa Weatherspoon, Sheryl Swoopes, and others. But it didn't dawn on me until years later that those superstars never played under the bright lights and packed crowds in Harlem. Eventually, I considered it the norm for female players to be overlooked, underappreciated, and invisible when it came to the basketball scene.

The WNBA's inaugural season began April 24, 1996. This meant young girls would finally have a chance to play professionally in the United States. Before then, the only professional play open to women was overseas or in obscure semipro leagues. Though I wanted a shot at playing on a big stage in the pro leagues, I also found the big stages existed right in my backyard in New York City.

There is absolutely nothing like it. The street game taught me lessons a classroom never could. My game was tailor made by it—gritty but smooth, unassuming but confident. I learned from the local drug dealers, whose hoop dreams were cut short. They taught me how to not back down, how to fall and get back up, and most importantly, how to command respect. Believe it or not, I always appreciated their guidance and protection. I never had any brothers, so they provided their best rendition of that roll. The rest of my game, I picked up from letting my imagination run wild.

There was inspiration in everything around me. The timing of my crossover was in sync with dance moves coming out of Harlem. To me, the "Tone wap"[1] and a hesi[2] had the same cadence. If you had rhythm and could dance off the court, you could two-step on anybody on the court.

I played like I had something to prove. Most times, as the only girl on the court, I did. The phrase, "I got next" is synonymous with streetball culture. It's a rallying cry to say "I'm ready for war." When you shout it out, all eyes are on you. Make that call as a 15-year-old girl on a male-dominated court, the guys scan you up and down to see if you're worthy of the right. Next, they scoff, "Is this girl serious? Next? Yeah, OK."

I never really paid attention to the fact I was one of the few girls playing among boys and men. The regulars I ran with knew and respected me. But this didn't mean they took it easy on me. For every busted lip or eye I endured as a result of an "overaggressive guy with an ego," a stamp of respect was also earned. For every crossover or bucket I delivered, their perception of a "girl player" was changed. Each scar is a reminder that I fought to be here and would continue the fight as long as it took.

Another way to earn respect is to get a nickname. You haven't really arrived on the streetball scene until basketball royalty—like an emcee, coach, or legend—blesses you with a nickname. It's one of many unwritten rules in New York City hoop culture. My nickname came in the eighth grade, playing for the CAS Douglass Panthers and legendary Coach Marvin "Hammer" Stevens. Anyone who knows Hammer knows he is *not* good with names. I went from "Baby" to "Boobie" until one day he said, "I'm going to start calling you Snake."

I was confused and hated it at first. He explained: "Because you're skinny and you slither through the lane, just like a snake."

From that day, Snake became my name on the court. As a female ballplayer, I can't tell you just how official that was. There is nothing like walking onto a court and someone from the other side shouts "Yo, we got Snake." It was empowering. Everytime I hit the court, people wanted to know why they called me "Snake," and it became my job to show them.

That year, the Panthers were composed of future Division I players and pros: Shannon Bobbitt, Mercedes Dukes, Renee Taylor, Jennifer Brown, Crystal McFadden, Kisha Stokes. And many others. An all-girl team with serious hoopers was a dream come true. By the end of my first summer with Douglass, my living room was packed with trophies. Playing with this crew changed my perspective on girls basketball. We were winners, we were confident (some would even say cocky), and we backed it up together. That confidence propelled my game and my self-esteem to another level. In fact, I carried it with me to college, where I met more talented players and encountered a subtler kind of sexism.

I was always taught life isn't supposed to be fair, but the disparities I witnessed between men's and women's sports bothered me. The locker rooms for women weren't as nice. People didn't support us, even though we were just as talented and competed just as hard as the men's basketball team. Eventually, my disappointment at these inequalities turned into a new source of motivation. My goal was to "dead" the perception that women athletes are inferior.

Today, as a college coach, I still have to address disparities and sexist attitudes, but now it's to my players. As a player, I fought this by playing hard and defeating doubters. As a coach, I'm fighting by mentoring young girls.

I'll be completing my tenth season as a Division I coach, third as associate head coach of Providence College. My summers are filled with evaluating the next generation of young talent in packed convention centers. Because of this I haven't played in a summer tourna-

IS THIS GIRL SERIOUS? NEXT? YEAH, OK.

ment or any organized ball in years. The days of throwing my ball in my bag and walking to "Crack Is Wack" Playground on Second Avenue are over. I miss it a lot and find myself walking to empty parks in my neighborhood, reminiscing about the games played there. I remember how it felt to hear the "oohs" and "ahhs" after laying a sick crossover.[3] I remember seeing the pure rage when I scored on a boy or grown man and made him look silly in the process. I remember the little girls watching on the other side of the fence, waiting their turn to call "Next."

Page 76: **ST. BONAVENTURE'S PRISCILLA EDWARDS** drives past Richmond to the basket, March 4, 2005, photograph by Haraz Ghanbari

↓ **BASKETBALL COURT BETWEEN 12TH AND 13TH STREETS, AND AVENUES B AND C, LOWER EAST SIDE**, 1978, photograph by Geoffrey Biddle

PRISCILLA EDWARDS is an associate head coach at the Division I level. She's also the founder of PE Basketball and PE Wellness—which works to help holistically develop and mentor aspiring athletes on and off the court.

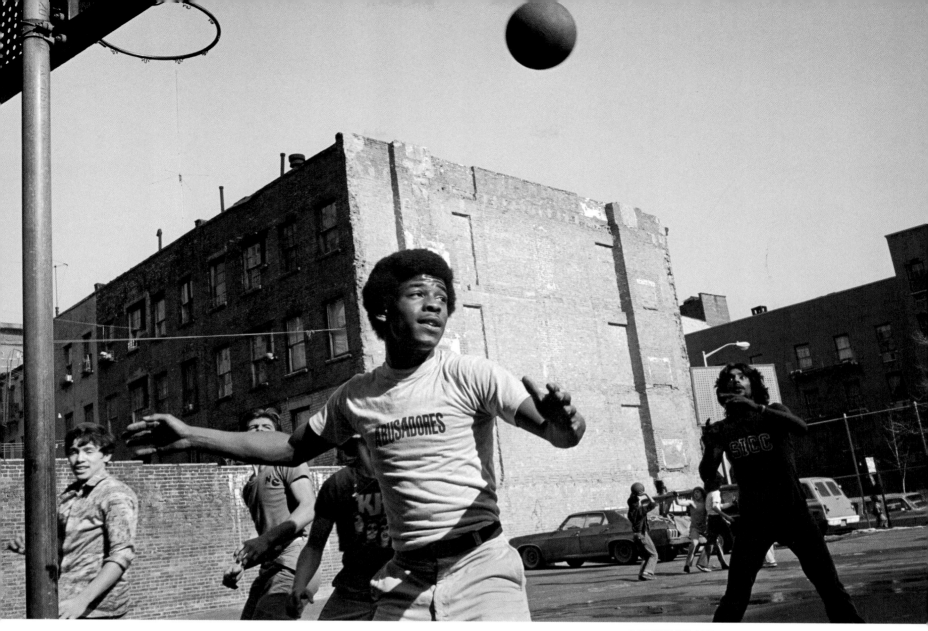

↑ **ALPHABET CITY**, 1977, photograph by Geoffrey Biddle

1,800 COURTS, FIVE BOROUGHS, ONE CITY

The official website of the New York City Department of Parks & Recreation proudly highlights that in this "basketball capital of the world" a basketball game is within walking distance of just about any location across the five boroughs. Due in part to the large-scale efforts of master builder Robert Moses who claimed to have built 660 playgrounds across the five boroughs, the official number of outdoor courts maintained by the parks department is a whopping 1,800, which does not include the city's indoor recreation centers or the courts maintained by the New York City Housing Authority. In short: basketball is thoroughly embedded into the landscape of New York.

From informal pickup games and youth leagues, to high-profile tournaments with sponsors and celebrity sightings, playgrounds and schoolyards across the city provide a stage for a range of matchups. The legendary cast of characters, which includes Julius "Dr. J" Erving, Joe "The Destroyer" Hammond, and Nate "Tiny" Archibald stretches back to the era of a young Nat Holman, the son of Russian Jewish immigrants, who found the game at Seward Park and the Henry Street Settlement. Today the drama carries on at Rucker Park, Goat Park, LeFrak City courts, Gersh Park, West 4th, and many, many others where New York–style ball handling and spectacular dunks keep spectators enthralled and the next legend waits to be crowned. (LT)

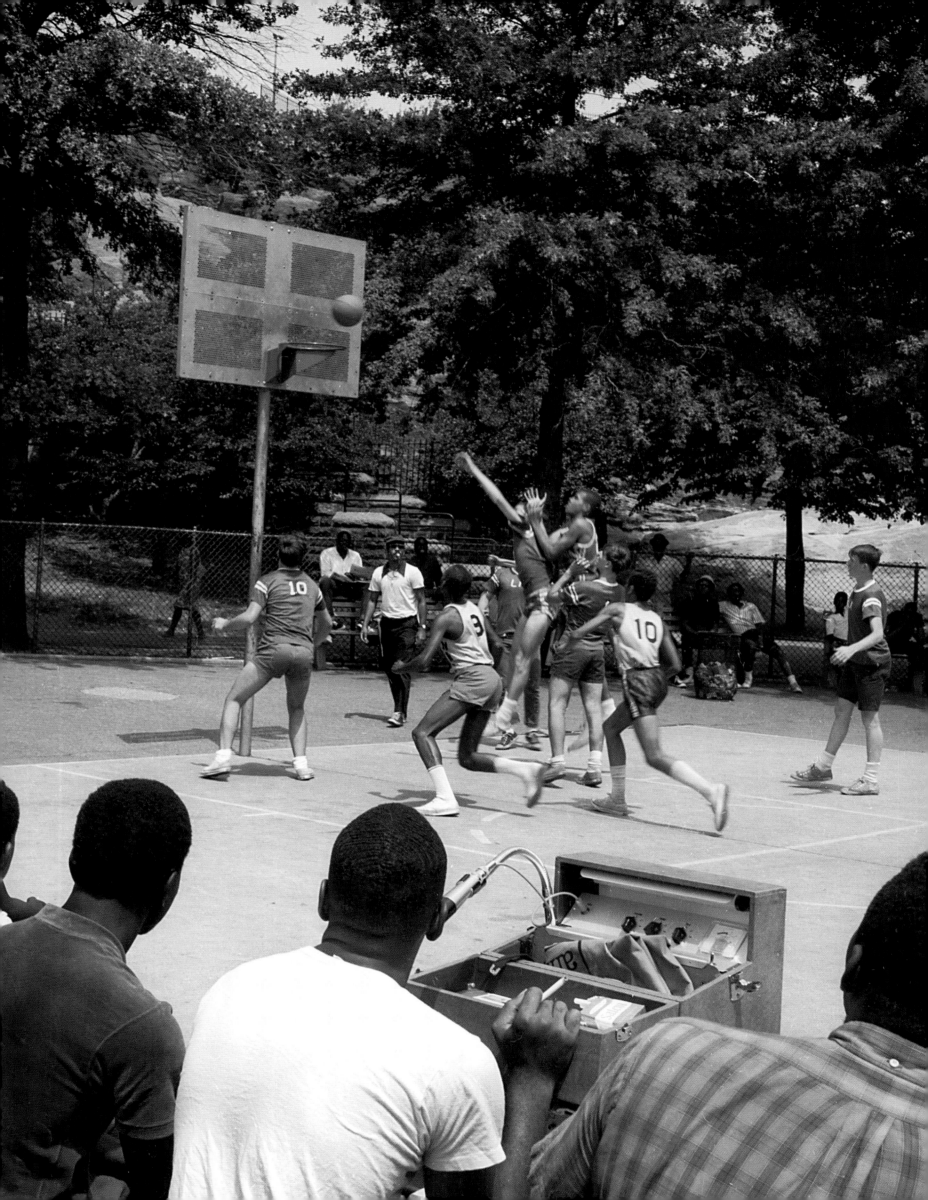

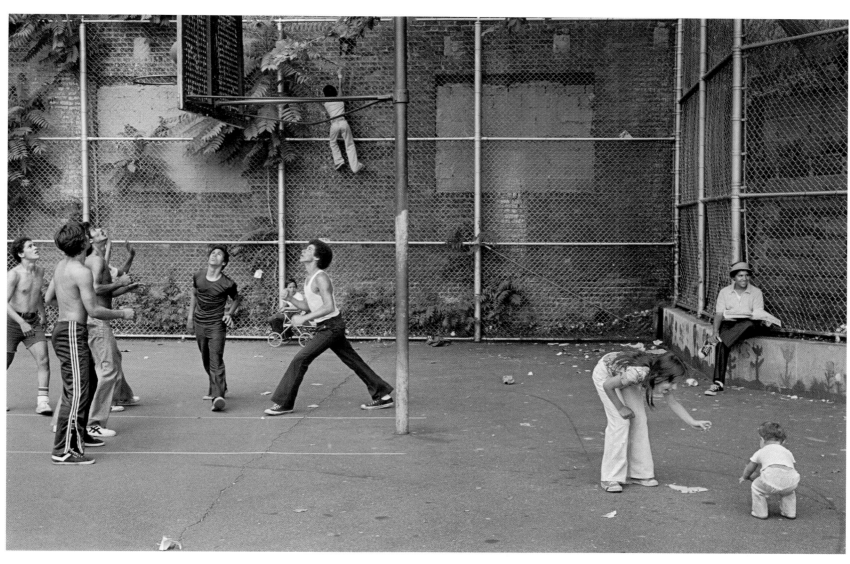

↑ CORNER OF 11TH STREET AND AVENUE A, 1977, photograph by
Geoffrey Biddle

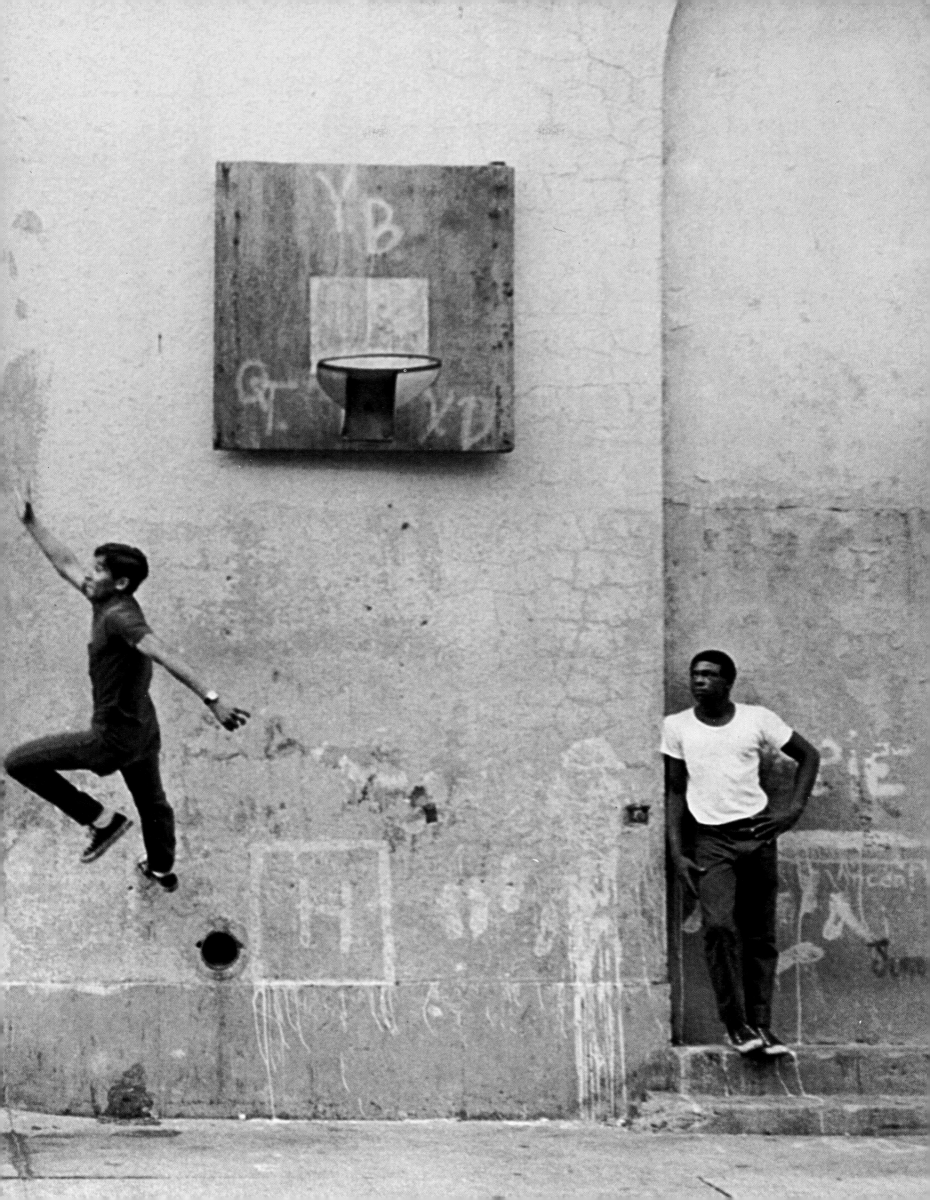

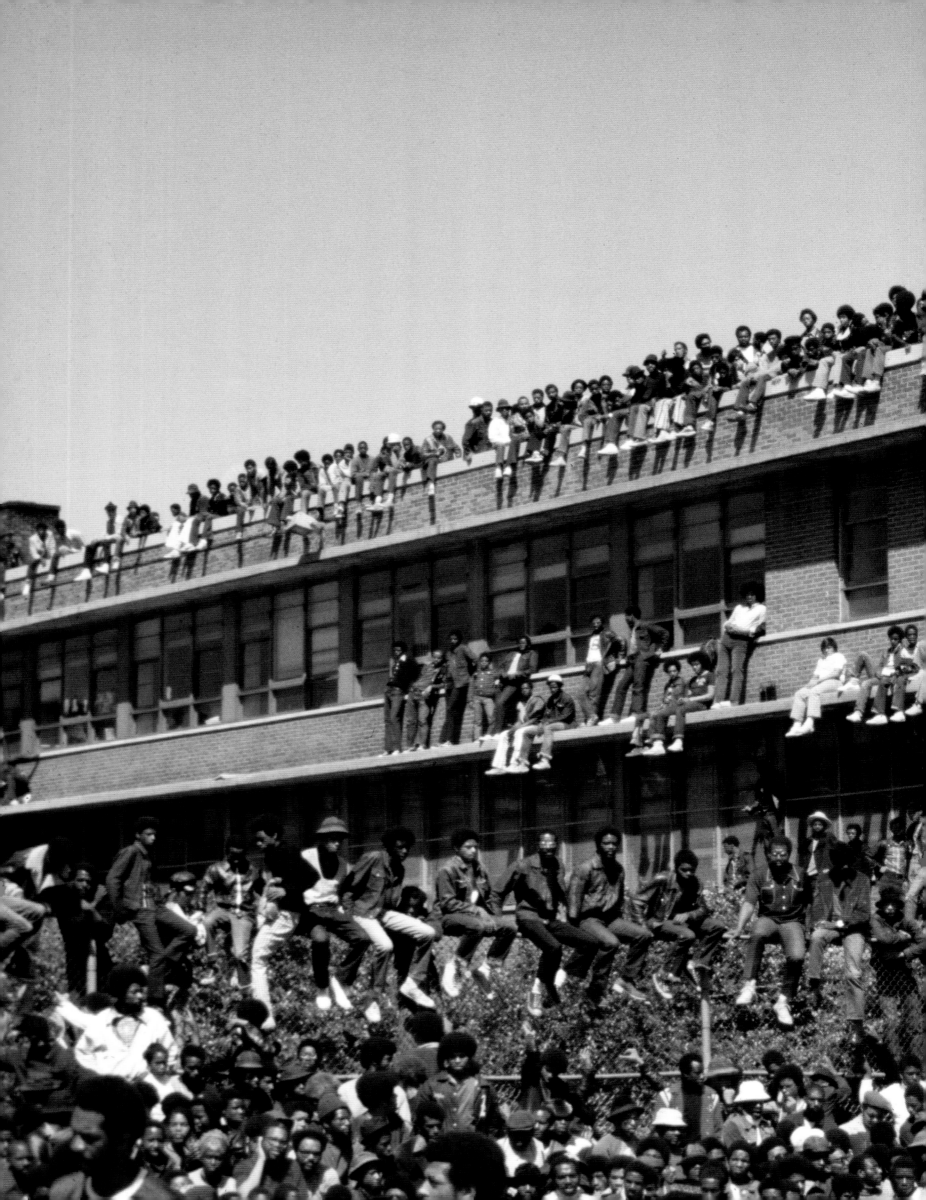

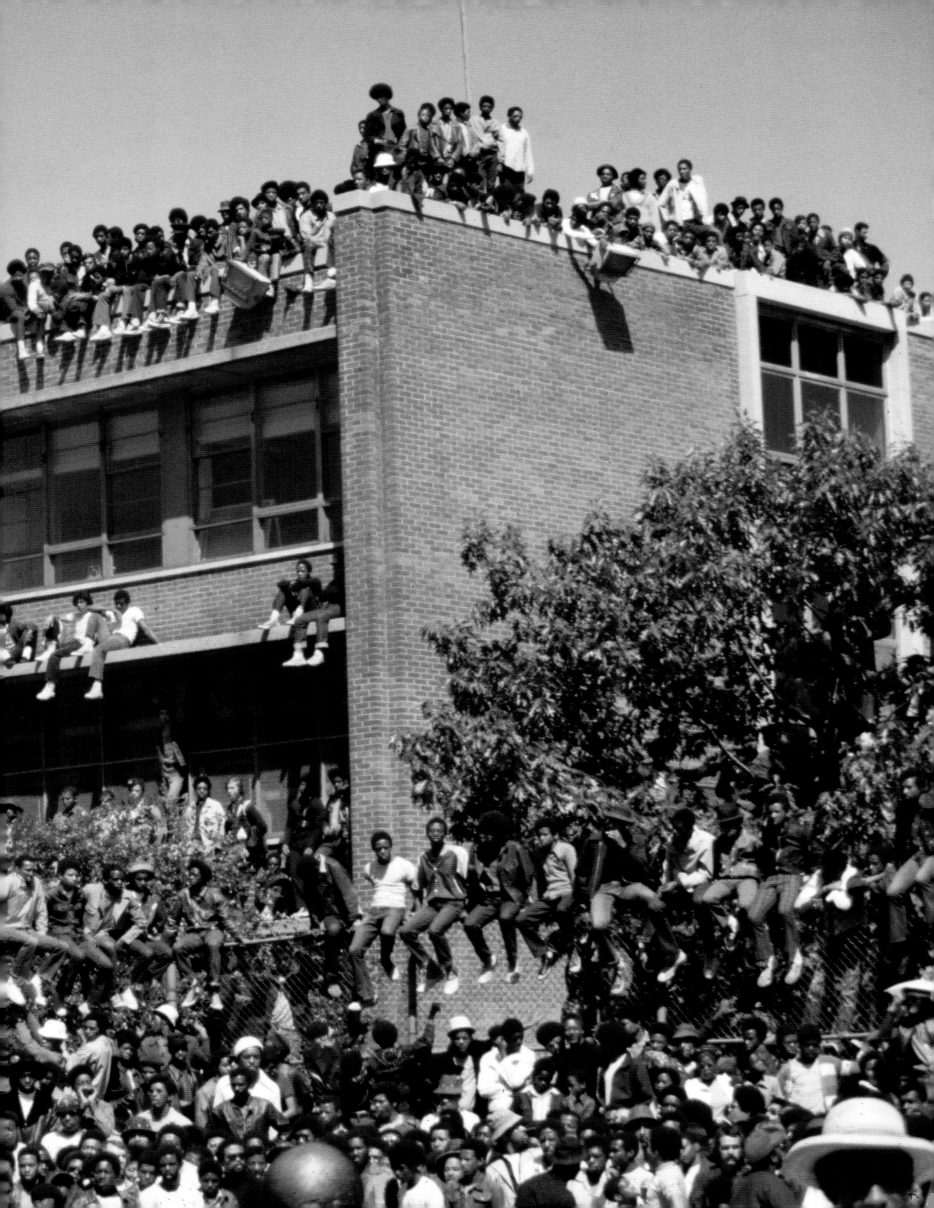

Pages 84–85: 109TH STREET, BETWEEN FIFTH AND MADISON AVENUES, August 1968, photograph by Katrina Thomas

Pages 86–87: RUCKER LEAGUE BASKETBALL TOURNAMENT, 1972, photographer unknown

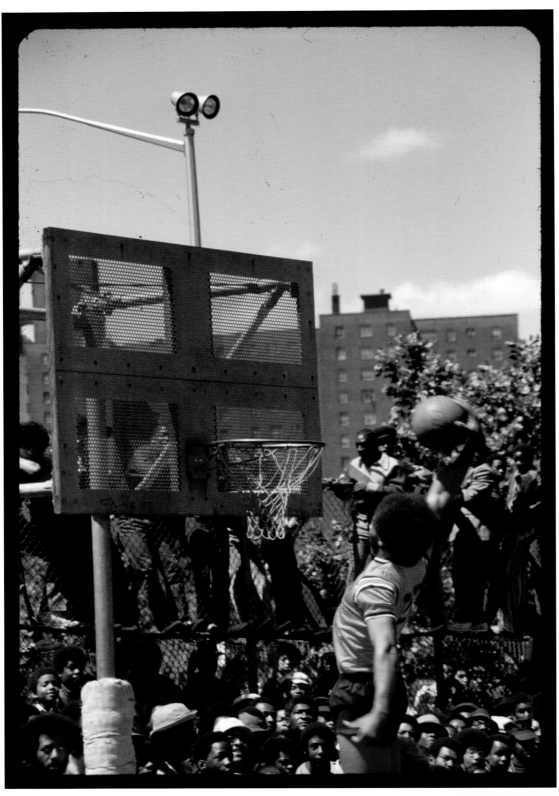

↑ RUCKER LEAGUE BASKETBALL TOURNAMENT, 1972, photographer unknown

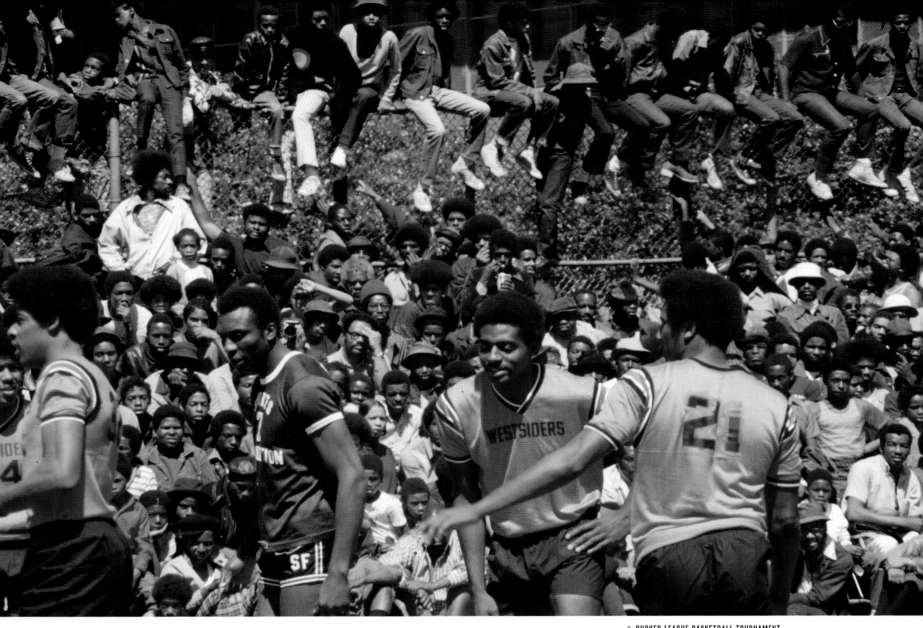

↑ RUCKER LEAGUE BASKETBALL TOURNAMENT,
Julius Erving #32 (at left) 1972,
photographer unknown

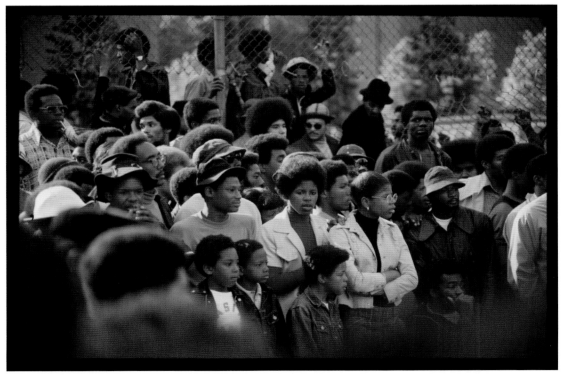

↑ RUCKER LEAGUE BASKETBALL TOURNAMENT, 1972,
photographer unknown

Pages 90–91: **JACK RYAN**, right, Full Court 21 Tournament, Booker T. Washington Playground, 2015, photograph by Kevin Couliau

→ **BIANCA BROWN #4 AND MONIQUE COKER #34** play a tournament at West 4th Street, 2003, photograph by Bobbito García

↑ **BUSHWICK**, Brooklyn, 2018, photograph by Andre D. Wagner

↑ **MAMADOU—BUSHWICK**, Brooklyn, 2016, photograph by Andre D. Wagner

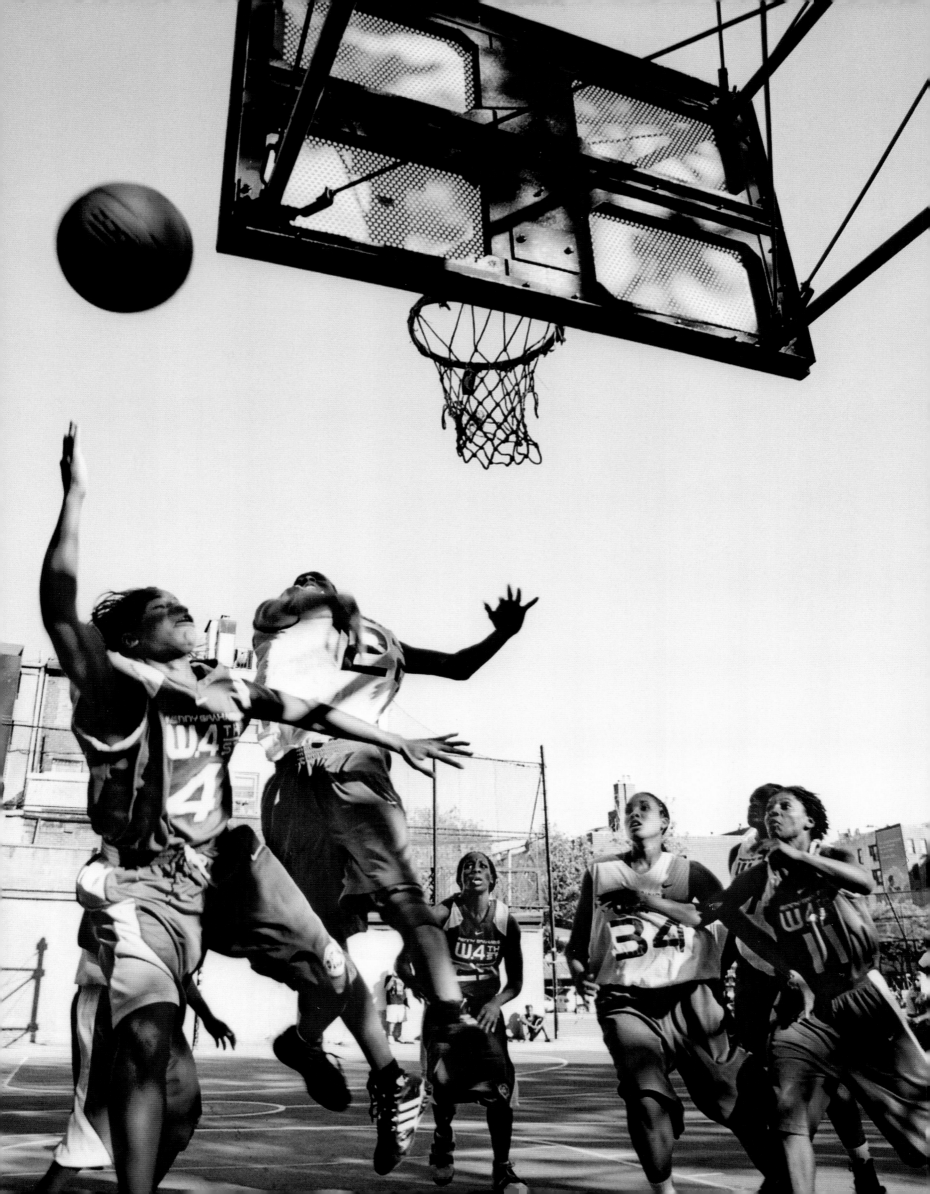

↑ TOURNAMENT AT WEST 4TH STREET, 2003,
photograph by Bobbito García

→ WHITTNEY "POSTMASTER" BARNES (LEFT) AND JANEESE "BORN READY"
GOODRIDGE, Ladies Who Hoop Classic Summer
Tournament, Sol Bloom Playground, 2017,
photograph by Dershiuan Ivy Lin

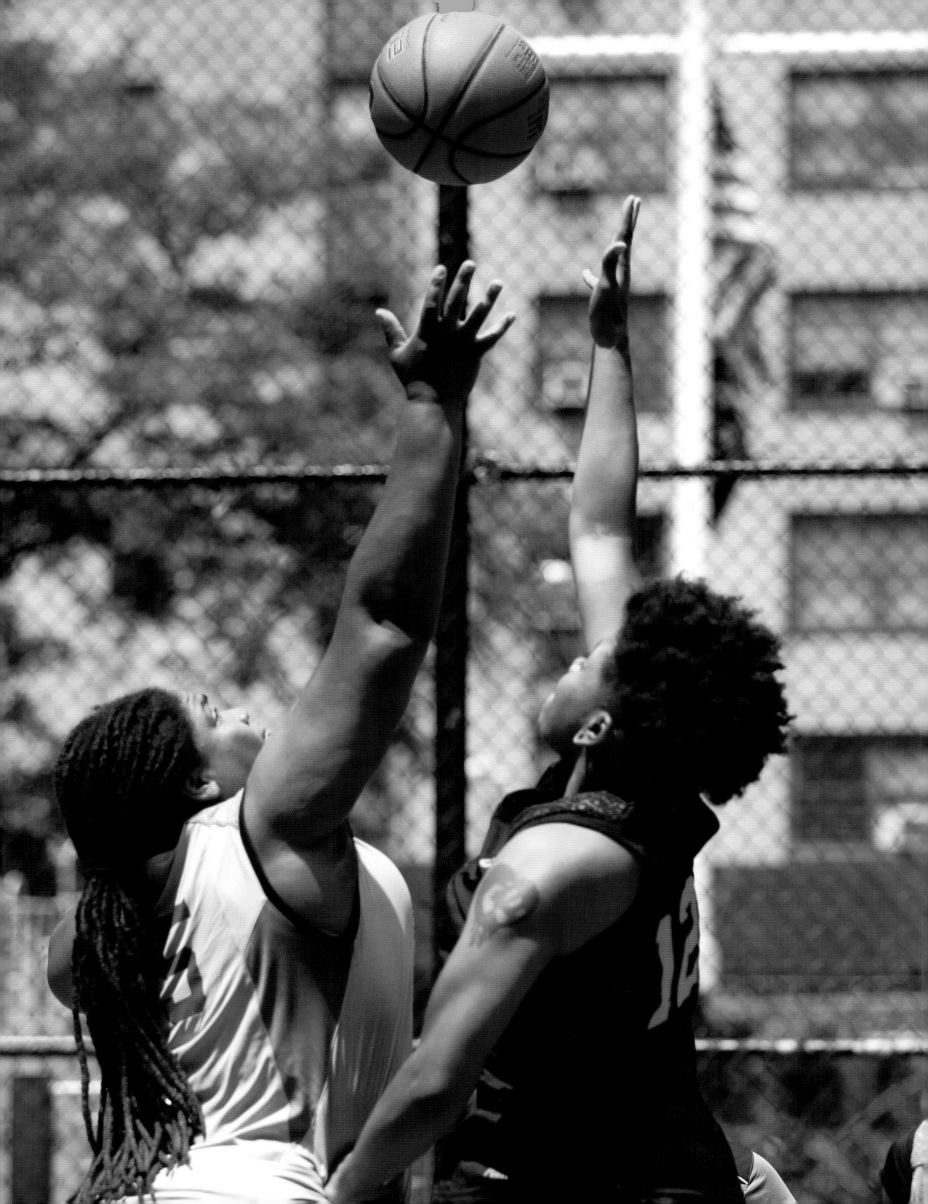

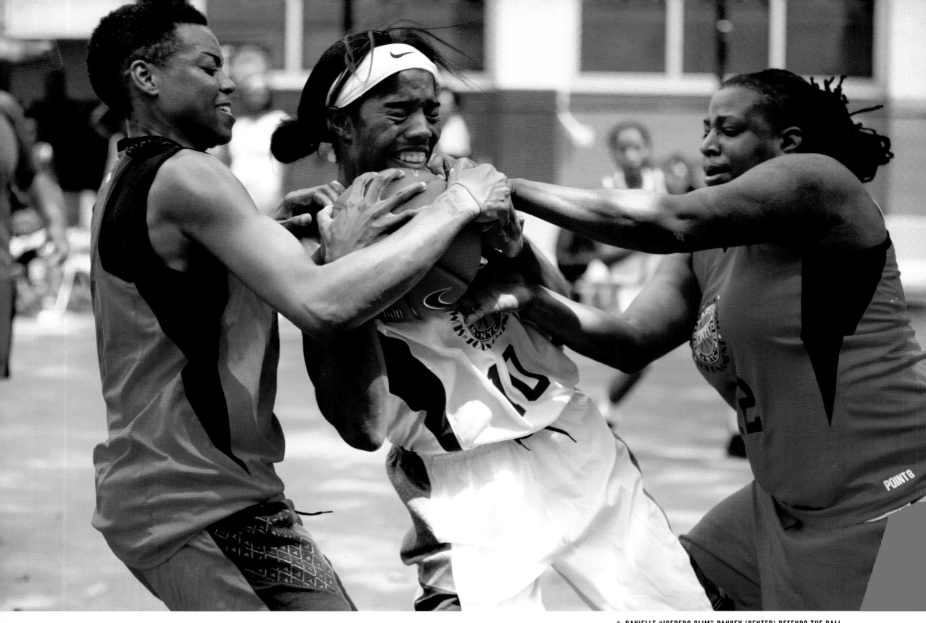

↑ DANIELLE "ICEBERG SLIM" PANKEY (CENTER) DEFENDS THE BALL
FROM NICOLE "THE CREATOR" RHEM (LEFT) AND TIARA "BLIZZ WHAT IT IZ"
BLIZZARD, Ladies Who Hoop Classic Summer
Tournament, Sol Bloom Playground, 2017,
photograph by Dershiuan Ivy Lin

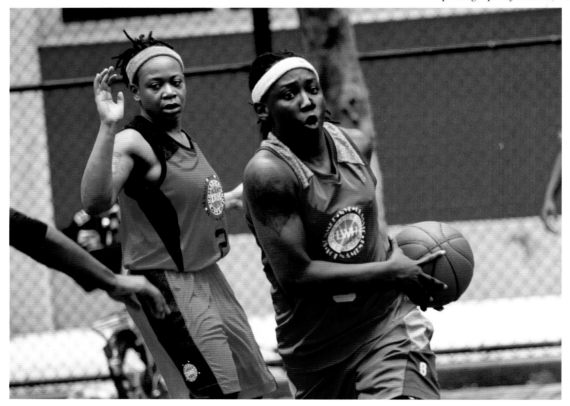

↑ CHRISTINE "DICE" PINNOCK (LEFT) AND DENISHA "QUIET STORM" DAVIS,
Ladies Who Hoop Classic Summer Tournament,
Sol Bloom Playground, 2017, photograph
by Dershiuan Ivy Lin

TRASH TALK

New Yorkers have famously been mouthing off to each other since long before the city's basketball culture evolved, but the creative, frenetic style of play that grew here has inspired a trash talk phenomenon that means players have to be just as quick with their words as they are with their feet if they want to become true streetball icons. Hoopers like Joe "The Destroyer" Hammond built their legend nearly as much on words as talent with the ball, and legendary rivalries between great players live through verbal battles both on and off the court. The sneaker company AND1 did a lot to bring trash talk to the mainstream, popularizing many of the zingers in this section to promote its brand. Quick-witted ballers beware, however—if you talk a big game, but can't back it up on the court, it'll be much worse than if you'd lost with quiet dignity. (EH)

HIT THE GYM, YOUR GAME IS WEAK.

HIT THE SHOWER, YOUR GAME STINKS.

YOU REACH, I TEACH.

HAVE YOU GOTTEN INTO COMPUTERS LATELY? MAN, YOU ARE HACKING.

I'M JUST LOOKING AROUND TO SEE WHO'S GONNA FINISH SECOND.

FLOATER LIKE A BUTTERFLY,
I STING LIKE A BEE,
YOUR HANDS CAN'T STEAL WHAT
YOUR EYES CAN'T SEE.

YO DID YOU CALL
THE POLICE. CAUSE
THE SWAT TEAM JUST ARRIVED.

STOP, DROP, AND ROLL...
I'M ON FIRE.

GOD RESTED ON THE SEVENTH,
BECAUSE I PLAYED HIM ON THE SIXTH!

I PASS BY YOU
SO MUCH I THINK
I SHOULD PAY YOU A TOLL.

HERE'S A QUARTER.
I ALWAYS GIVE TO
THE GAMELESS.

RESPECT THE GAME,
LEAVE THE COURT.

COOKIES!!!

GIVE 'N' GO! GIVE UP THE GAME
AND GO HOME!

WHAT'S WRONG? MOMMA FORGET TO
PACK YOUR GAME?

EVERYBODY'S GOOD
AT SOMETHING.
KEEP LOOKING.

I'M THE BUS DRIVER.
I TAKE EVERYONE TO SCHOOL.

I'M THE MAYOR.
I DO WORK FROM DOWNTOWN.

YOU'VE GOT SOMETHING
IN YOUR EYE...MY JUMPER!

CALL ME THE SURGEON.
I JUST TOOK YOUR HEART.

IF YOU HAD MY GAME,
YOU'D STILL HAVE YOUR GIRL.

DO YOU HAVE A SUITCASE
FOR ALL THAT TRAVELING?

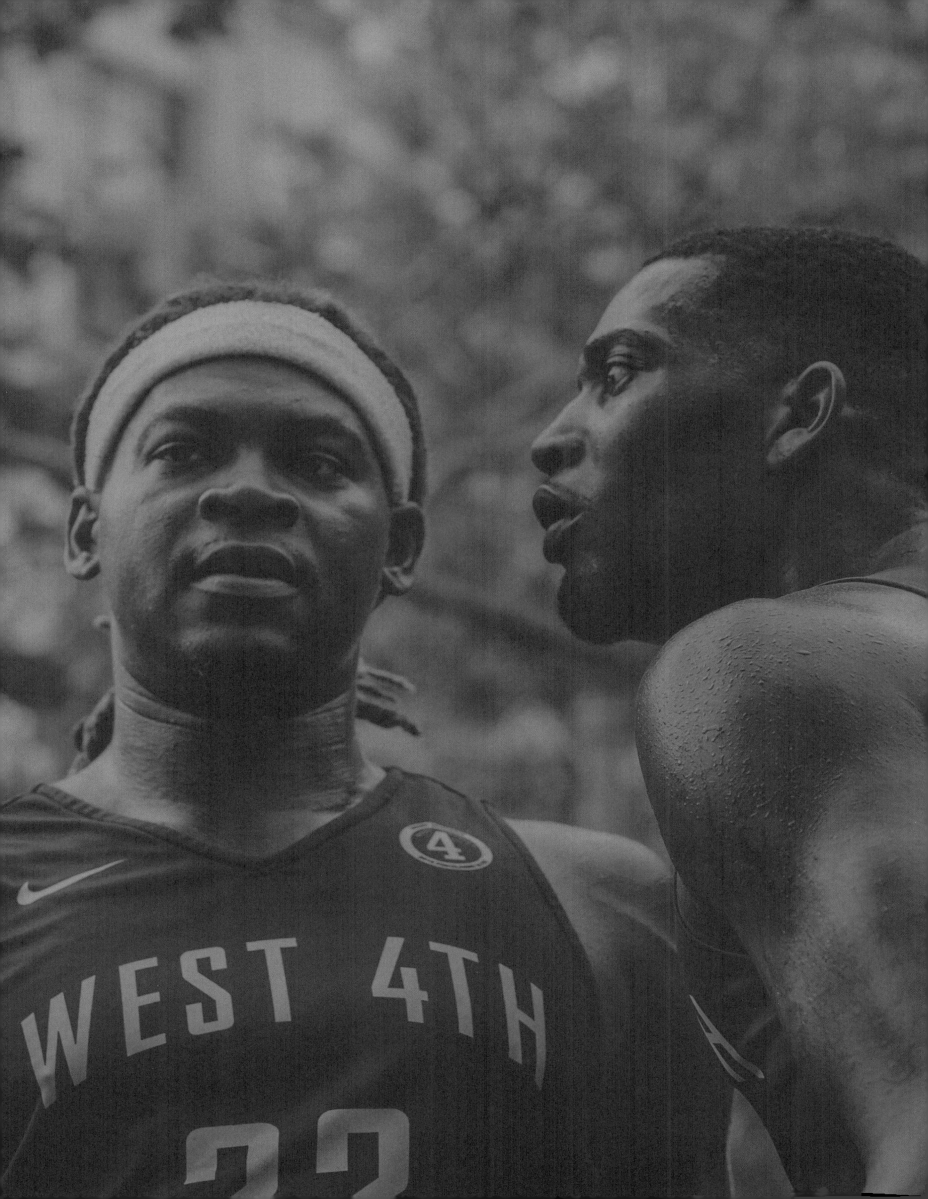

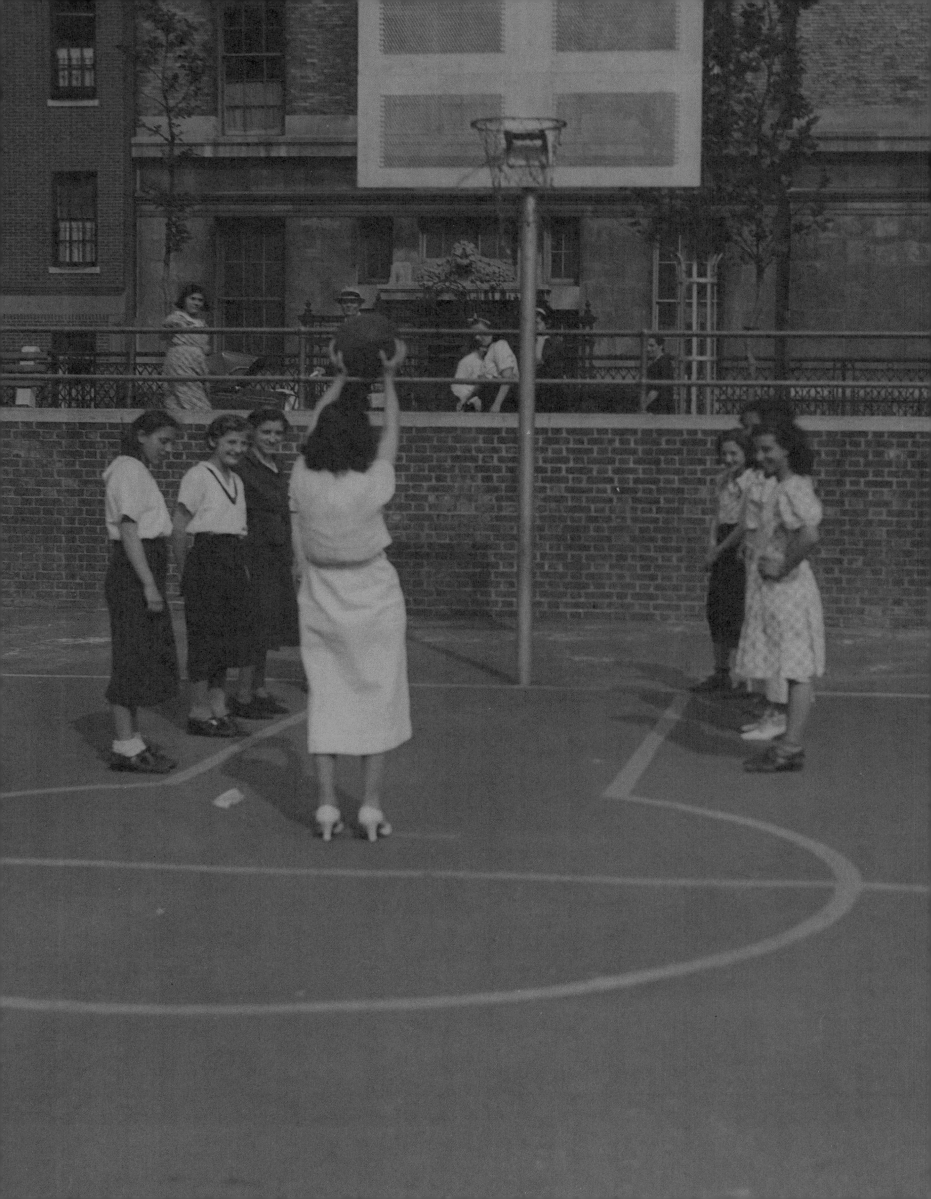

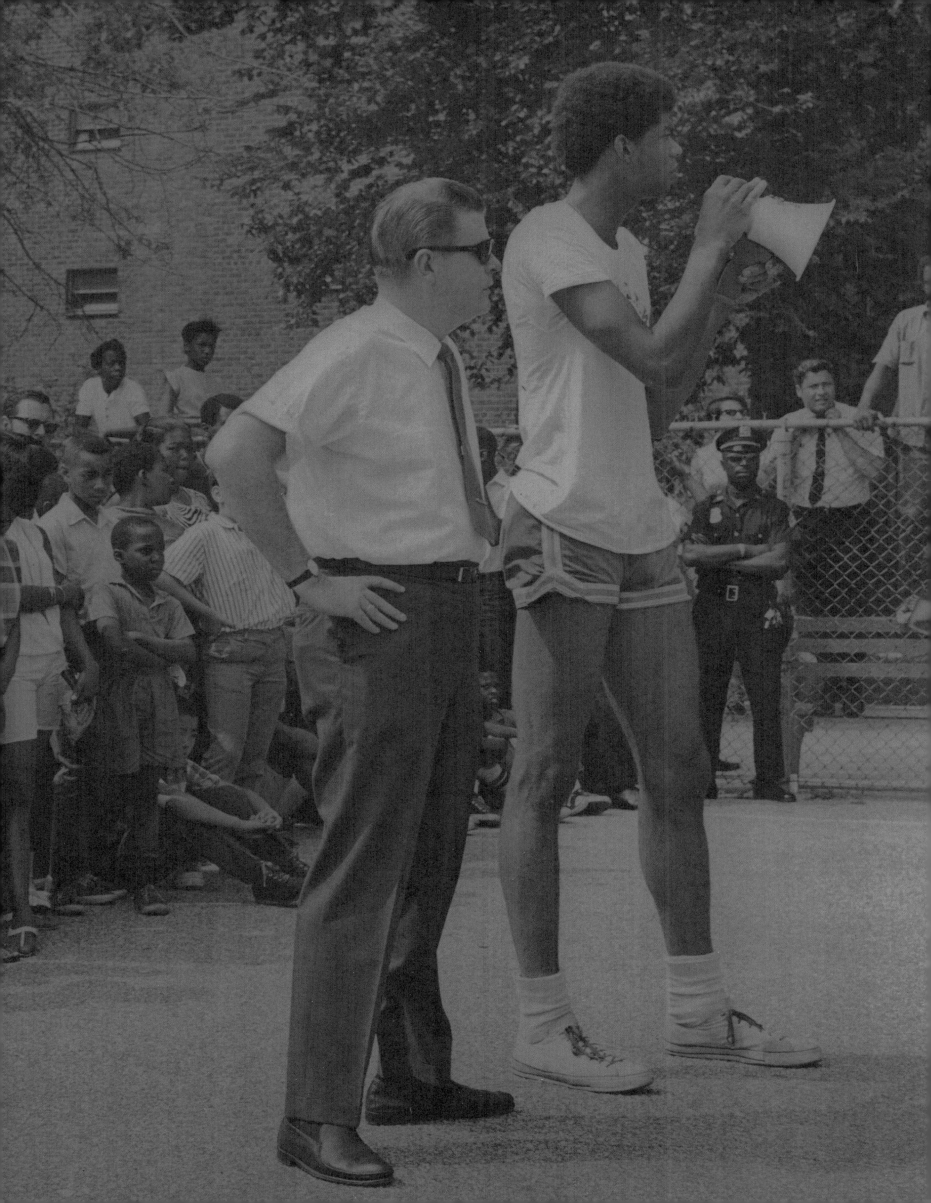

NEW YORK CITY'S LEGENDARY STREETBALL COURTS

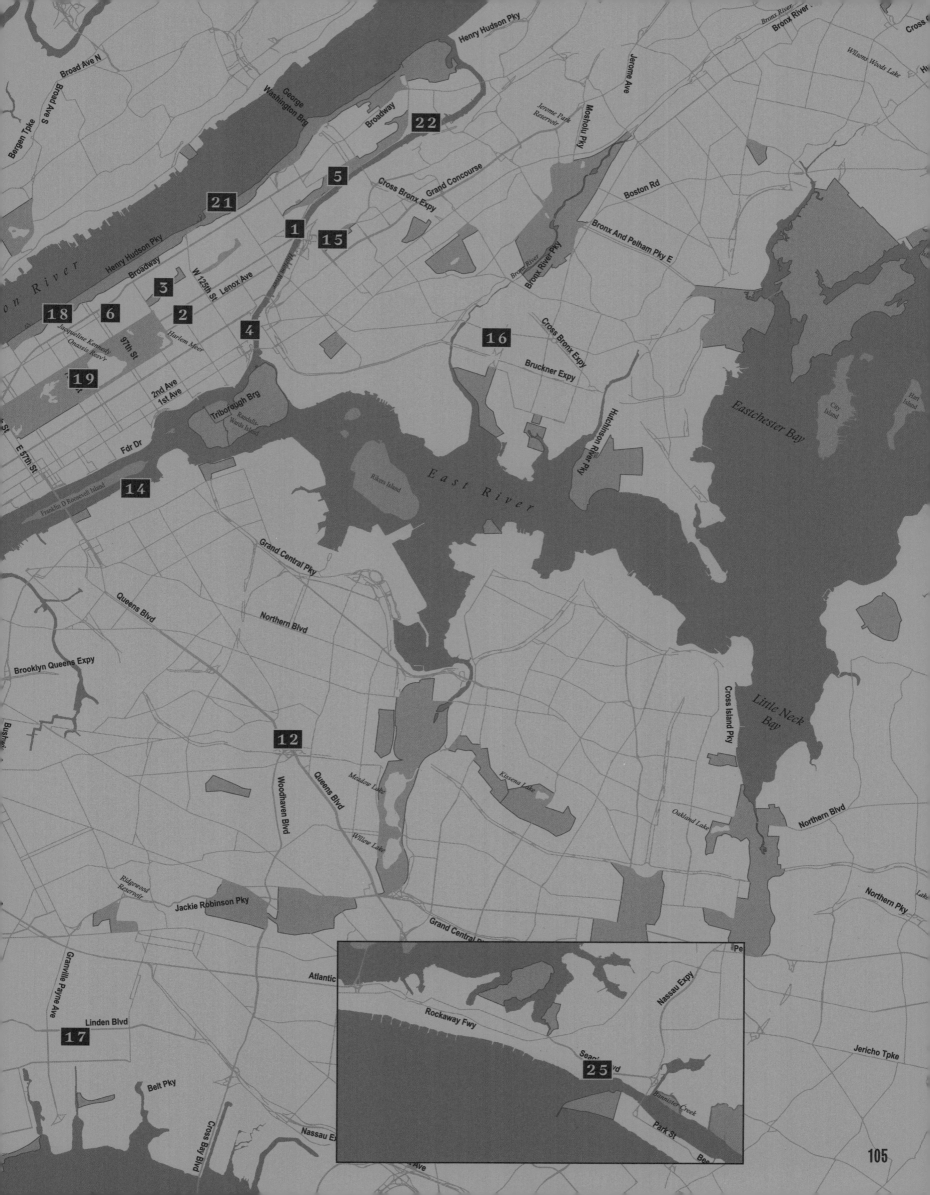

1 RUCKER PARK

Holcombe Rucker Park, at 155th Street and Eighth Avenue, is probably the most iconic streetball court in the world. Built in 1956, it was renamed in 1974 after Holcombe Rucker, the tireless playground director for New York City parks who first started holding summer basketball events here. Its history is deep and complex, and many of the greatest ballers in history (Wilt Chamberlain, Kareem Abdul-Jabbar, Joe "The Destroyer" Hammond, Dr. J, Kemba Walker, Tiny Archibald, and countless more) scuffed their shoes on its concrete before they (or the place) were ever famous. Rafer "Skip to My Lou" Alston even got his nickname here, making the trek all the way from Jamaica, Queens.

2 KINGDOME

Located at the center of the New York City Housing Authority's Reverend Dr. Martin Luther King, Jr. Towers, this single, full-size court is surrounded by seating and, from spring through fall, foliage and sunshine. The "Kingdome," only a few blocks from the Harlem Meer at 115th Street between Fifth and Malcolm X Avenues, is home for hoopers from near and far in Harlem and beyond, and its spectator-friendly design and central location in the housing development make for high-stakes, entertaining basketball.

3 MORNINGSIDE PARK

A welcome green space in West Harlem, close to the Columbia University campus and hosting a weekly market, Morningside Park is also home to a number of basketball courts. While they might not boast the legend of Rucker or the drama of the Kingdome, the Morningside courts are still popular spots for pickup. The park stretches from 110th to 123rd Streets, and is close to a number of Harlem landmarks, namely the Apollo Theater, the Lafayette and Washington Monument, and the Cathedral Church of St. John the Divine.

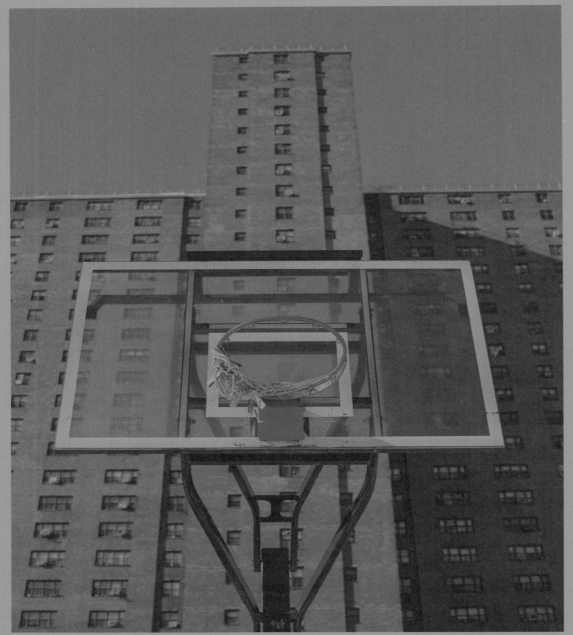

HOLCOMBE RUCKER PARK, 2014, photograph by Kevin Couliau

4 CRACK IS WACK PLAYGROUND

Keith Haring painted his historic *Crack Is Wack* mural on a handball wall in the shadow of Harlem River Drive in 1986 (and it was restored in 1995, five years after his death), but people have been playing handball and basketball there since 1957. Despite (or maybe because of) the highway overhead, the space now known as Crack Is Wack Playground is a picturesque, popular spot for basketball to this day, right by a world-famous piece of visual art.

5 THE PIT

The Sunken Playground, so called because one side is sunken under a wall separating the playground from the rest of Washington Heights, is a pickup spot not far from McKenna Square and the Harlem River. At the corner of West 167th Street and Edgecombe Avenue, the "Pit" is located in Highbridge Park, which spans from Inwood to North Harlem, Dyckman Street to Rucker Park.

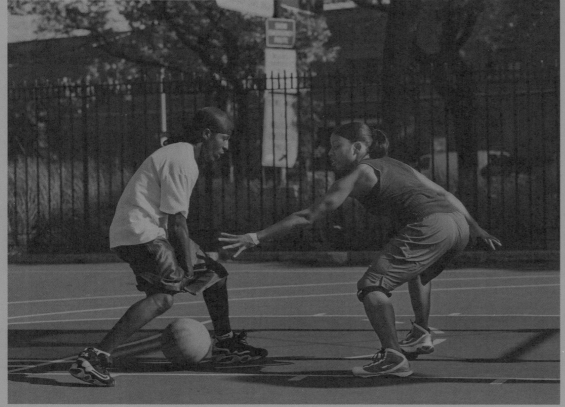

CRACK IS WACK PLAYGROUND, 2010, photograph by Kevin Couliau

6 GOAT PARK

The Happy Warrior Playground, on Amsterdam Avenue from 97th to 100th, is better known to streetballers as Goat Park, for court legend Earl "The Goat" Manigault. The Upper West Side courts here are two blocks from Central Park and three from Riverside, and Goat Park is one of the biggest destinations for hoops in Manhattan. Kids and adults are both welcome in streetball in general, but especially in Goat Park, which serves a predominantly residential neighborhood home to lots of young families. Kareem Abdul-Jabbar and Wilt Chamberlain played here, too, as did Connie Hawkins, an NBA Hall of Famer and Harlem Globetrotters great.

7 THE CAGE

For high-level pickup in lower Manhattan, ballers can't go wrong with the West 4th Street courts, nicknamed the "Cage" for the high metal fencing that keeps stray balls from flying out and colliding with cars, passersby, and patrons of nearby restaurants, bars, and art house theaters. In the heart of Greenwich Village, right by Washington Square Park, the Cage also boasts a yearly tournament and is known for its nonregulation size.

8 WASHINGTON MARKET

Washington Market Park, wedged between Stuyvesant High School and Tribeca and only a few blocks from One World Trade Center, is a destination for pickup in the Financial District. There are both a half and a full court for the public to use, and instead of handball, the "other court" here is for tennis.

9 STANTON STREET

Sara D. Roosevelt Park was built by Robert Moses in 1934 and both divides and bridges SoHo, the East Village, and Chinatown. The Stanton Street courts between Chrystie and Forsyth Streets were part of the park's original plan and are still home to pickup today, in what is now a vibrant arts neighborhood full of museums and performance spaces.

10 NAVY WALK

Serving the New York City Housing Department's Ingersoll Houses and the nearby neighborhood of Vinegar Hill, the Navy Walk courts are not far from Fort Greene Park and LIU Brooklyn. They are situated in a shady spot among the trees in the projects, on a path that winds between the developments. This is as classic of a projects ball spot as can be found in Brooklyn.

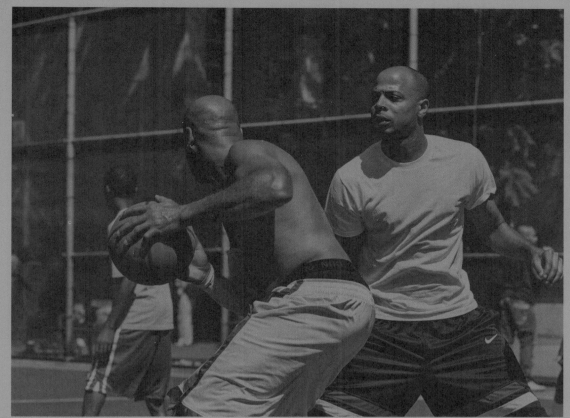

"THE CAGE," WEST 4TH STREET, 2010, photograph by Kevin Couliau

WASHINGTON MARKET PARK, 2017, photograph by Kevin Couliau

11 PIER 2

Players who pick the Pier 2 courts in Brooklyn Bridge Park can admire the skyline right across the river (and, increasingly, the one growing on Brooklyn's own side). Ellis Island and the Statue of Liberty can also be seen on a clear day, but players would be advised to keep their eyes on the ball. The Pier 2 courts opened in 2014 as part of a redevelopment of the formerly industrial Brooklyn waterfront.

12 LEFRAK CITY

At the south end of Corona, Queens, the LeFrak City Apartments comprise an enormous housing development really best understood as a small neighborhood entirely on its own. Of course, a place like this needs streetball, and there are courts between the towers themselves, along with a nearby running track. Not too glamorous, sure, but an important place for ball nonetheless. Kenny Anderson grew up here.

13 CLOVE LAKES PARK

Clove Lakes Park, near the Sunnyside neighborhood of Staten Island, is a bustling public space that provides the people of the "fifth borough" with a place to play ball. Near Wagner College and Silver Lake, the courts at Clove Lake are a quiet, peaceful place to play, relative to the high-energy streetball of the other boroughs and especially Manhattan.

PIER 2, BROOKLYN BRIDGE PARK, 2015, photograph by Kevin Couliau

14 RAINEY PARK

Rainey Park, built on land the city acquired in 1904 on the East River in Astoria, has views of Roosevelt Island and the Upper East Side. Next to Socrates Sculpture Park, it's also home to basketball. It is just one court, without much spectator seating of its own.

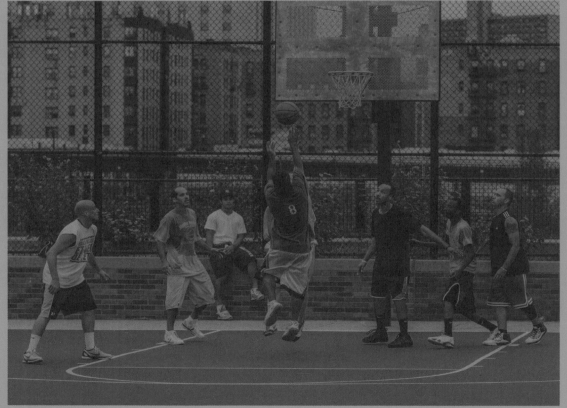

15 MACOMBS DAM PARK

Directly across the river from Rucker Park and in the shadow of the new Yankee Stadium in the South Bronx, Macombs Dam Park is built over the remains of the old one that stood from 1923 to 2009. Especially in the summer, it is an extremely active area for recreation, and in New York, recreation is often synonymous with basketball. There's baseball here, too, along with a track and field, a playground, and a sculpture garden.

MACOMBS DAM PARK, 2011, photograph by Kevin Couliau

16 PARQUE DE LOS NIÑOS

Along the Bronx River Parkway, at the corner of Watson and Morrison Avenues, the Parque de los Niños is a spot for streetball in Soundview. The park is next to the Clason's Point public library, and its name is a great example of the fact that New York is not a monolingual city, and that streetball is not a monolingual sport.

17 LINDEN PARK

Known as Gershwin or "the Gersh" for the adjoining George Gershwin Junior High, Linden Park, near Jamaica Bay, is a popular spot for pickup that also offers handball, tennis, and a playground. Well-used both during the school year and in the summer months, the Gersh provides quality basketball in a relaxed, somewhat suburban part of Brooklyn.

18 RIVERSIDE PARK

This iconic park runs from 72nd to 158th along the Hudson River, and among its many playgrounds, recreation areas, and sports fields are a number of basketball courts. Beloved by ballers all across the Upper West Side, anyone from the neighborhood can tell stories about watching basketball here, if not playing it. Skate parks, handball courts, and plenty of other basketball-adjacent activities are available here, too.

19 GREAT LAWN COURTS

At the north end of the Great Lawn, just south of the gate house at the reservoir and a little bit into the park from the Metropolitan Museum of Art, the Great Lawn courts are the premier location for ball in Central Park, a daily destination for tourists and New Yorkers alike. Weather permitting, basketball happens here nearly every day, and there are more than enough hoops to go around.

20 ST. JOHN'S REC. COURTS

For a fee, from 8 a.m. to 9 p.m. on weekdays and on weekend mornings, New Yorkers can gain access to the St. John's Recreation Center, with a gym, swimming pool, and, of course, both indoor and outdoor basketball courts. While it is not exactly streetball, the indoor games here can be intense, and they aren't stopped by bad weather.

THE GERSH PARK LEAGUE, LINDEN PARK, 2015, photograph by Kevin Couliau

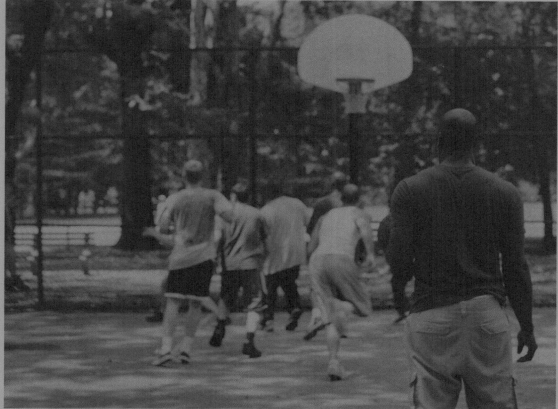

GREAT LAWN BASKETBALL COURTS, 2009, photograph by Kevin Couliau

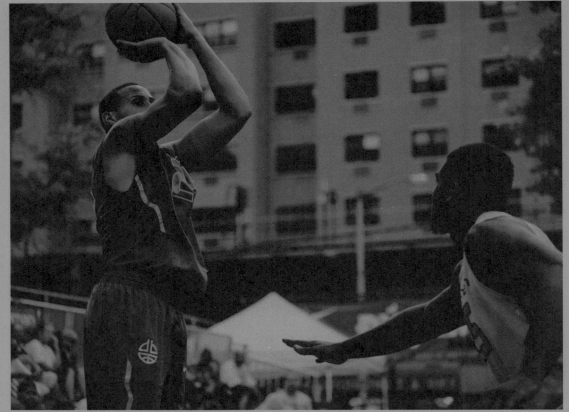

DYCKMAN TOURNAMENT, MONSIGNOR KETT PLAYGROUND, 2010, photograph by Kevin Couliau

21 RIVERBANK STATE PARK

Riverbank State Park, at the north end of Riverside Park, is an enormous public center that offers not just basketball but also tennis, a skating rink, an outdoor pool, baseball, art installations, and even an amphitheater. A pedestrian footbridge links it to Riverside Drive over the Henry Hudson, and it is an important, well-equipped destination for hoops.

22 MONSIGNOR KETT PLAYGROUND
(DYCKMAN)

On 500 West 204th in Washington Heights, Monsignor Kett playground is a streetball haven and the home of the Dyckman Basketball Tournaments, which run every single day from June to August and feature everyone from peewees to pros. Beside Fort Tryon Park, the Harlem River Park, and Inwood Hill Park, "Dyckman" is surrounded by other public spaces and is a peaceful, dedicated, and top-class place for hoops uptown.

23 RAYMOND BUSH PLAYGROUND

Amid the tree-lined streets of Bed-Stuy is Raymond Bush Playground, a beloved streetball destination for people from Brooklyn and beyond. Right alongside Marcus Garvey Elementary School, "the Hole" is open to kids and grown-ups alike, and if players are not careful they might find themselves being crossed up by someone a lot like one of the teenagers from the basketball documentary *Soul in the Hole* (1997).

24 PAERDEGAT PARK
(FOSTER PARK)

James "Fly" Williams's home court was Paerdegat Park, locally called Foster Park. In Flatbush, Brooklyn, adjacent to P.S. 198, Foster is a local attraction for Brooklyn residents and a site for regularly held tournaments, too. The land became a park and first featured basketball in 1941, but the modern, full-size court was introduced with renovations in 1999, and rebuilt totally in 2015.

25 ROCKAWAY BEACH

Knicks immortal Dick McGuire got his start at Rockaway Beach, playing countless hours of streetball in his youth with neighborhood friends and developing their own signature streetball style. Courts first went up here in 1939, and have been full of play ever since, right by the iconic boardwalk and near the only legal surfing beach in the city.
(EH)

Page 112: BASKETBALL CLINIC FOR NYCHA RESIDENTS, July 1970, photographer unknown

Page 113: 101ST STREET AT FIRST AVENUE, 1975, photograph by Paul Hosefros

→ SPECTATORS AT WEST 4TH STREET, 2016, photograph by Kevin Couliau

"THE HOLE," VAN DYKE PLAYGROUND, 2010, photograph by Kevin Couliau

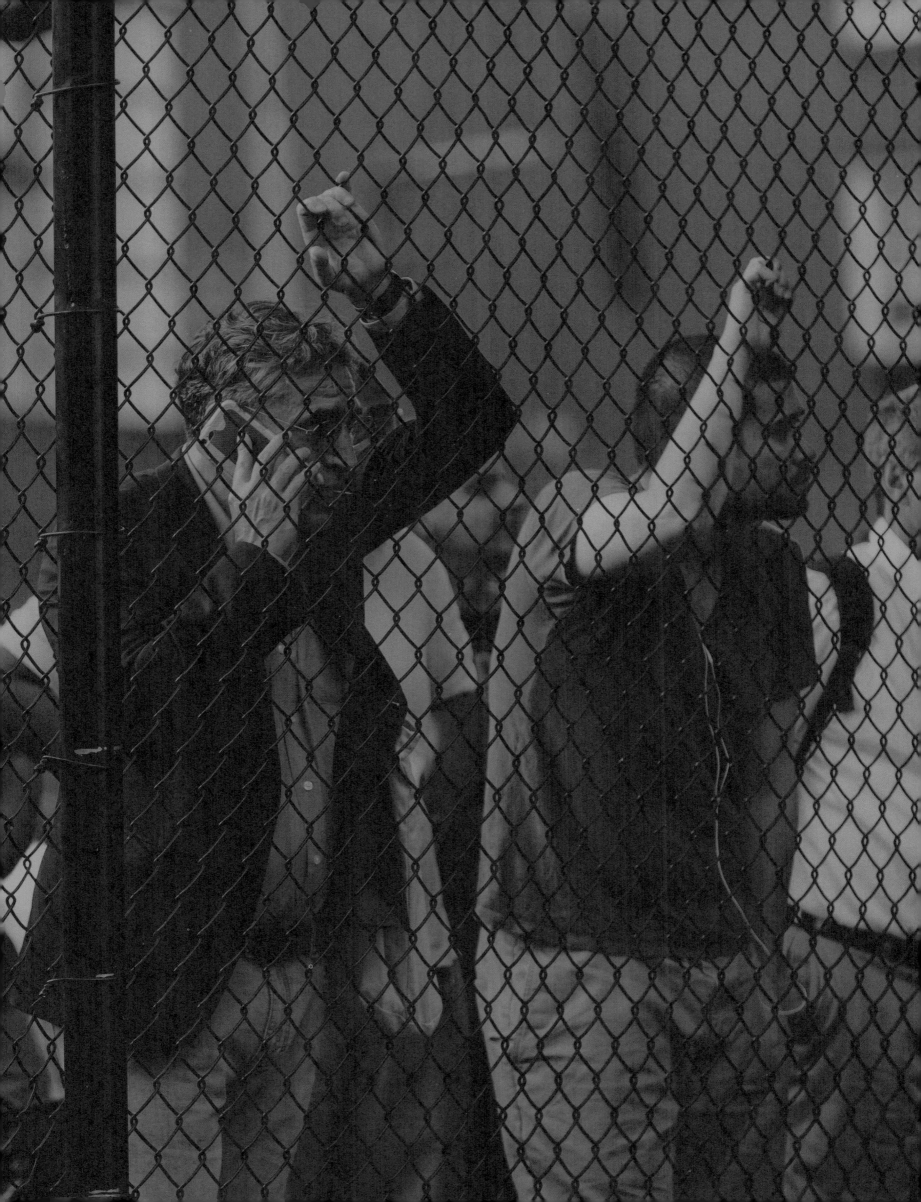

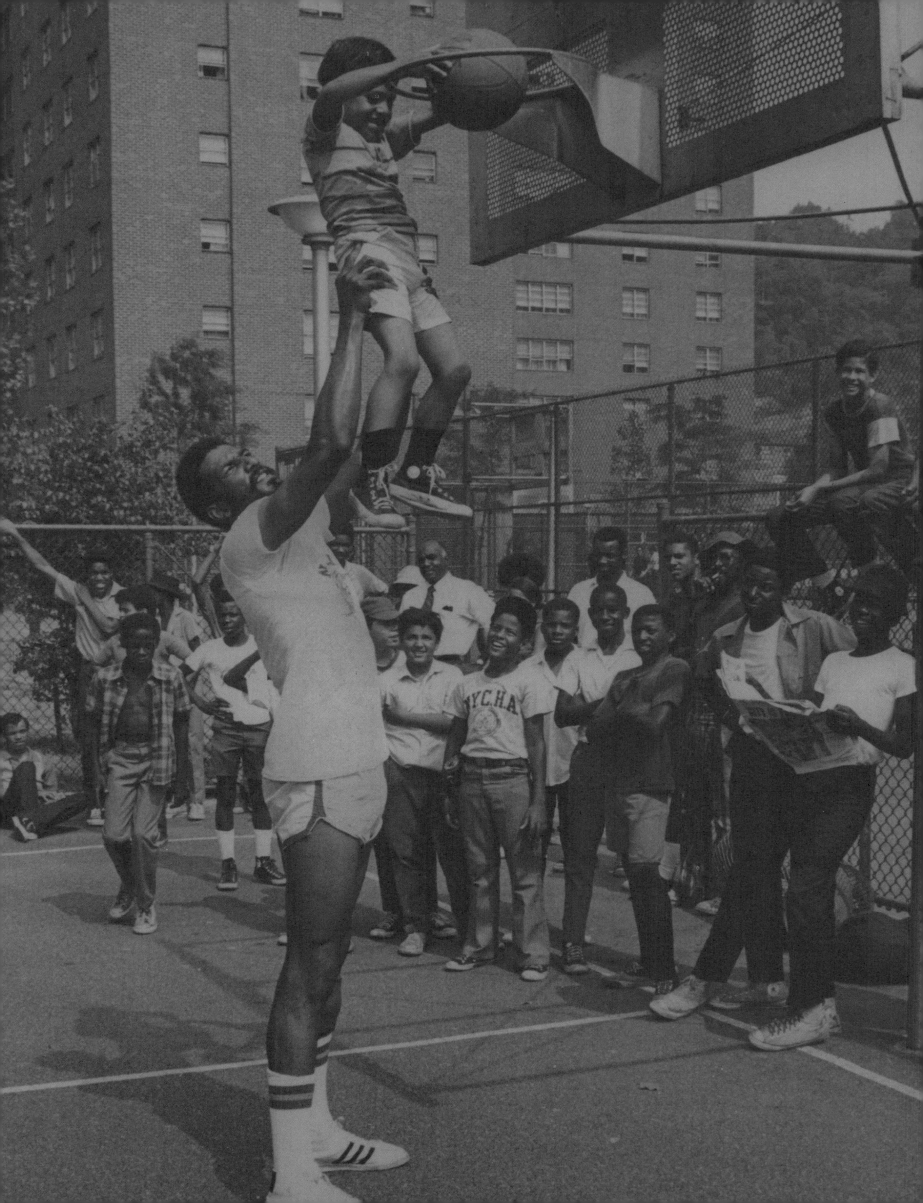

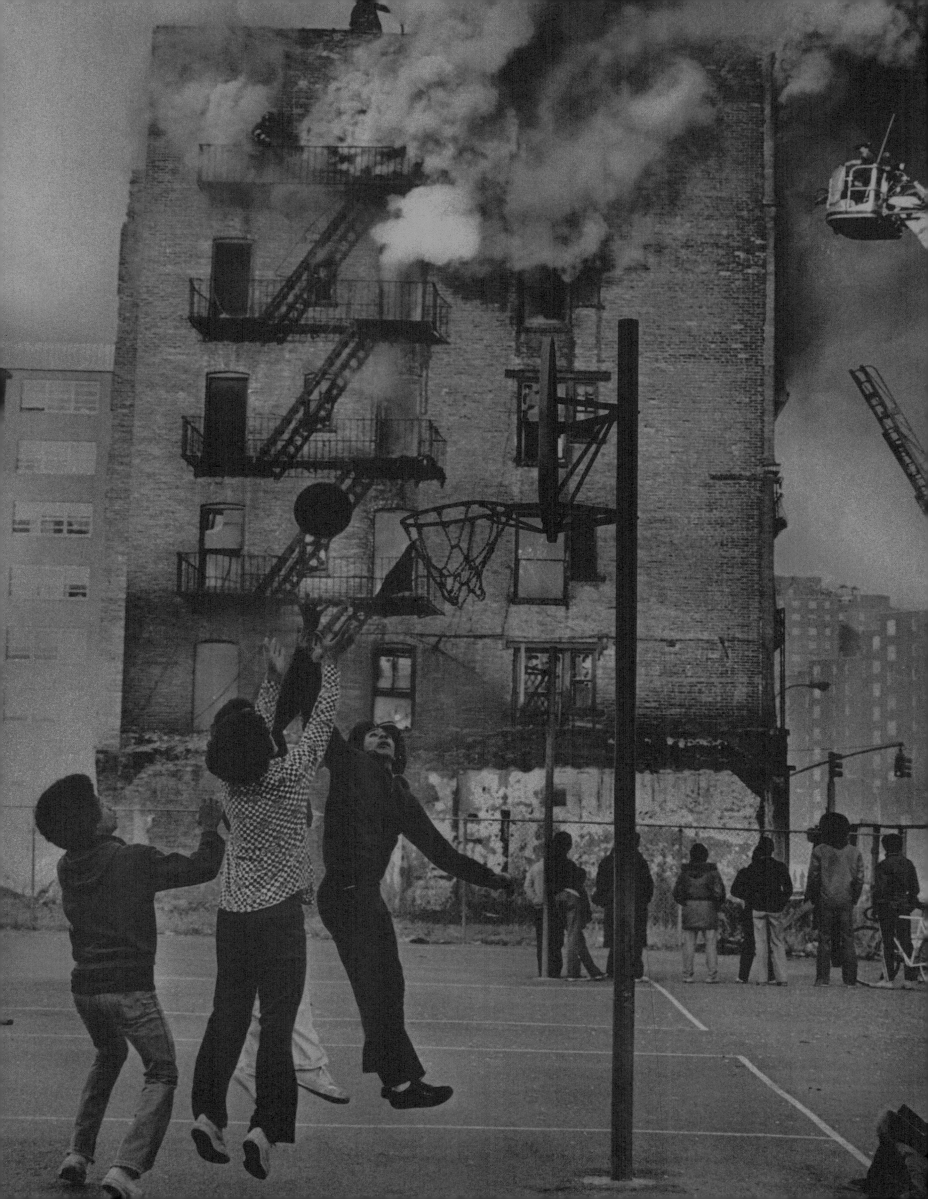

KENNY SMITH

Queens native Kenny Smith grew up in LeFrak City, was coached by the legendary Jack Curran at Archbishop Molloy High School, and played college ball with the North Carolina Tar Heels. During his 10-year NBA career, he won two NBA Championships with the Houston Rockets. Today he is an Emmy-winning basketball commentator and analyst.

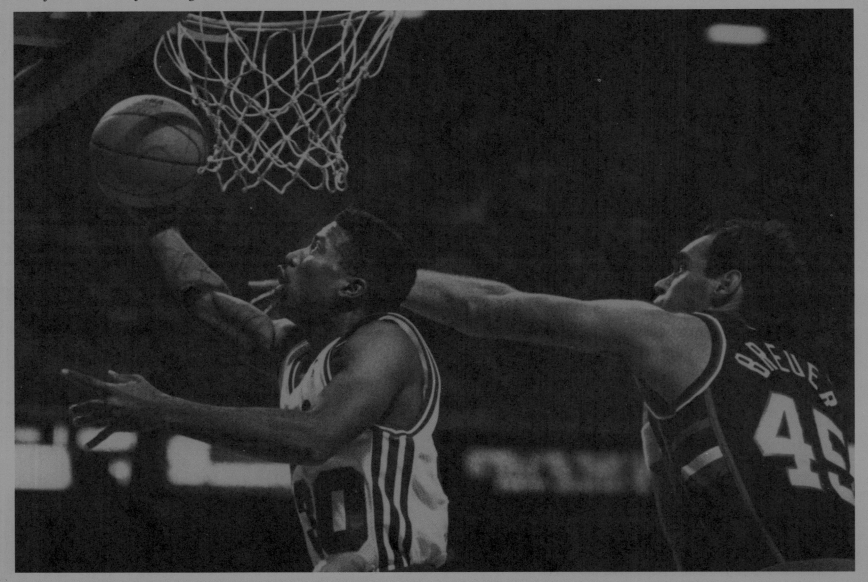

WILLIAM C. RHODEN: IS NEW YORK STILL THE MECCA OF BASKETBALL?

KENNY SMITH: For one thing, the proximity of all the basketball courts: there are so many basketball courts in the city. If you're on Park Avenue you can walk five blocks and find a basketball court in New York City. And the average, casual New Yorker loves the game. You see a guy on Wall Street take a lunch break and go shoot hoops with the guy who doesn't have a job. There's a verbal appreciation for each other, unwritten, so for everyone basketball became the city game.

What makes us the mecca, what makes us the city game is the casual person's appreciation for basketball. The casual fan in LA doesn't appreciate the guy who, everyday gets off the bus, goes to the gym, doesn't lift weights, but goes and hoops. They don't appreciate that guy in LA, they probably don't appreciate that guy in Chicago.

WR: WHEN YOU LEFT HIGH SCHOOL FOR THE UNIVERSITY OF NORTH CAROLINA, DID YOUR NEW YORK PEDIGREE MAKE YOU STAND OUT?

KS: When I went to North Carolina, people were like "we've got a New York City point guard." They didn't say we got Kenny Smith. They said, "We got a New York City point guard and his name is Kenny Smith." When guys from other cities came in, they didn't say, "We got a Philadelphia forward." They said, "We got a New York City point guard." What other place and what other position do they say that about?

WR: THERE ARE GREAT PLAYERS IN EVERY CITY. EVERY CITY HAS TURNED OUT GREAT PLAYERS. WHAT MAKES NEW YORK DIFFERENT?

KS: What we always had are the guys who shouldn't make it, make it. The guy who shouldn't play varsity basketball, but because he had an intuition about the game he made his varsity team. The guy who shouldn't go to St. John's gets a scholarship to St. John's; the guy who's at St. John's who should not make the NBA, but gets a 20-year: Mark Jackson. We have those guys. Mark Jackson should not have been in the NBA based on his attributes. Can he shoot? Not really. Is he fast? Nah. Can he jump? Nope. But he played 20 years in the NBA. Those are our guys. It's not Jordan, Kobe, LeBron. It's Mark Jackson. That's us, all around the country.

WR: DOES NEW YORK CITY HAVE MORE PLAYERS WHO PLAY THE GAME FOR THE SAKE OF PLAYING?

KS: Yes. You've got great players coming out of Chicago, great players coming out of LA. But in those cities, only the ones who want to be great play. In New York, the guys who play don't want to be great. They just want to play. Back in the day, and even now, everyone who's playing AAU, everyone who's playing streetball, everyone who's playing travel ball, everyone playing in high school in those cities, had delusions of grandeur to be in the NBA. Everyone in New York, they just want to play. They don't think they're going to be in the NBA. So you have everyone playing. We had a guy in our neighborhood, Fat Ike. I had Fat Ike on my team because he knew how to set a helluva pick. He ain't trying to make the NBA. He ain't thinking about it. Those guys don't exist in other cities.

WR: WHY DOES NEW YORK GET THE REPUTATION OF BEING OVERHYPED?

KS: Because we are. But we make it because we really shouldn't make it. We get the guy who can't run, can't jump, can't shoot, but will tell you, "Hey, this is how I can play well." So you get that in your rolodex. Then you got the guy who can jump out the gym, you get them transferred to "Oak" in the rolodex. You get everything in the rolodex because so many people play the game.

WR: CHARLES BARKLEY SAYS NEW YORK IS OVERRATED.

KS: I tell him that New York can't be overrated if you're the only one who comes out of Leeds, Alabama. In my neighborhood, in my apartment building in LeFrak City, there are more guys who played Division I basketball than in Leeds, Alabama.

WR: ON THE SURFACE, NEW YORK IS NOT TURNING OUT AS MANY GREAT PLAYERS. WHY?

KS: New York is still the mecca, but what has happened is that prep schools have changed basketball. Parents hold their kid back for a year, giving him a better opportunity to get a Division I scholarship at a higher level, so they go to a prep school. New York has Cole Anthony, the number one player in the country who is going to be drafted by the NBA. He went to Archbishop Molloy for three years, then transferred to Oak Hill Academy. When he goes to North Carolina, they'll say he comes from Oak Hill Academy. It's going to look like no players are coming out of New York. They're coming out, but a lot of players are leaving the city to go to prep schools. It gets watered down because of all the movement.

WR: WHY IS THE RUCKER IN HARLEM STILL CONSIDERED THE MOST HALLOWED SPACE IN THE PLAYGROUND BASKETBALL UNIVERSE?

KS: Kobe Bryant didn't go to the LA Summer League, he played at the Rucker. Kevin Durant didn't go to the Chicago Summer League, he went to the Rucker. When Bill Clinton was president, he didn't go to the LA Summer League, he went to the Rucker. They know.

WR: YOU PLAYED FOR THE RIVERSIDE HAWKS. ONCE UPON A TIME RIVERSIDE AND THE GAUCHOS HAD THE FIERCEST RIVALRY IN THE COUNTRY. WHAT MADE THE ORGANIZATIONS DIFFERENT?

KS: Riverside and the Gauchos were like the Yankees and Mets.

WR: WHO WAS WHO?

KS: You have to ask that question? Riverside is the Yankees. The Mets may have some good team, but the Yankees are a way of life. Riverside was a way of life.

WR: WHY ARE NEW YORK FANS SPECIAL?

KS: There's no such thing as a casual fan in New York. Other fans don't care like we do. Fans in other cities date the game; we're married to the game.

WR: WHO ARE THE FIVE PLAYERS WHO EPITOMIZE NEW YORK CITY BASKETBALL?

KS: Tiny Archibald and Kareem Abdul-Jabbar. Those are our go-to guys. Everybody else can put their hats in the ring.

WR: WHAT ABOUT WALT "CLYDE" FRAZIER?

KS: I was going to say Clyde. He's not from New York but he embodies New York. When Clyde got here he embodied the flamboyance of New York. He's our peacock. We like to be peacocks.

WR: IS NEW YORK THE MECCA BECAUSE OF ALL THE GREAT PLAYERS THE CITY PRODUCED?

KS: We don't have the best players. We don't have Michael Jordan—although he was born in Brooklyn. We don't have Kobe, we don't have LeBron. But we've got Mark Jackson. We got a million Mark Jacksons—y'all don't have a million Mark Jacksons. You don't have guys who shouldn't have made anything, who stay in the NBA for 15 years. You don't have God Shammgod and Rafer Alston. A lot of guys out of Chicago were better than God Shammgod, but he got a sneaker deal. He's the fabric of New York basketball culture: 6'1", can't shoot. That's us: we ain't the best, we're just the mecca.

← KENNY SMITH #30 of the Sacramento Kings makes a basket against Randy Breuer #45 of the Milwaukee Bucks, 1989, photographer unknown

TOM KONCHALSKI

Tom Konchalski, whom sportswriter John Feinstein once called "the last honest man in the gym," became a full-time basketball scout in 1979, and purchased the scouting newsletter *HSBI Report* from Howard Garkinkel, his former employer, in 1984. Konchalski's report rates thousands of high school players each year, and is available to college coaches by subscription only.

WILLIAM C. RHODEN: TELL ME ABOUT YOUR BASKETBALL ROOTS.

TOM KONCHALSKI: I was born in Washington Heights, and when I was two, my family moved to Queens. I grew up in a golden age of New York City basketball, where you couldn't help but fall in love. I grew up watching Jackie Jackson, unequivocally the greatest jumper who ever lived, watching Roger Brown and Tony Jackson. This is a decade before the installation of the three-point arc. They would shoot and drain intergalactic threes. I went to Archbishop Molloy for high school. I saw Jack Curran develop into one of the greatest coaches in the history of the game. I watched a tall skinny kid from St. Jude in upper Manhattan by the name of Ferdinand Lewis Alcindor grow into Kareem Abdul-Jabbar and become a true force of nature.

That was my growing up, and that was a golden age. It would have been hard not to fall in love with the game.

WR: YOU ARE AN INSTITUTION. HOW DID YOU BECOME A SCOUT OF HIGH SCHOOL TALENT?

TK: I always was a junkie, and I'd be around the game, and I'd coached summer league teams and CYO teams and went to coaching clinics. I'd work summer camps and over the course of a long time, I met a lot of people, and that's how it gradually evolved.

When I was in high school, I was in Mike Tynberg's camp. Mike Tynberg had been Howie Garfinkel's camp counselor in Enfield, New Hampshire, and they were very close. He got Howie Garfinkel involved in basketball and they were very close until they had a big falling-out and became tremendous and feverish rivals much more than the Gaucho-Riverside rivalry. It was the Gems and the Nationals. The Gems was Mike Tynberg's team, the New York Nationals was Howie Garfinkel's team.

Since I was in the Mike Tynberg camp when I was in high school, I was friendly with him. And if Howie would see me at the Garden he'd give me the evil eye. Then later on Howie and I gradually became good friends and I ended up working with him.

WR: WHY IS GARFINKEL IMPORTANT TO NEW YORK CITY BASKETBALL?

TK: He really brought recruiting into the modern age where people from other parts of the country knew more about eastern players. Not only New York City players, but eastern players. And then certainly with the Five Star camp he started, that did a great deal to grow the game. The camp produced more than 500 players who went on to the NBA.

WR: NAME YOUR ALL-NEW YORK CITY TEAMS?

TK: My all-New York City team—and this is based on players I actually saw play—would be: Lew Alcindor, center; my two forwards would be PSAL guys, Connie Hawkins, Boys High, 1960, and Roger Brown, Wingate, 1960; my two guards would be Kenny Anderson and Kevin Joyce.

My all-New York City team, and this is based on how their careers turned out, not what they did in high school: Kareem Abdul-Jabbar, center; Connie Hawkins and Bernard King. My guards would be Bob Cousy and "Tiny" Archibald.

My all-time New York public league team would be Connie Hawkins and Roger Brown; "Pearl" Washington, and Stephon Marbury.

WR: WHO IS THE MOST IMPORTANT HIGH SCHOOL PLAYER TO COME OUT OF NEW YORK CITY?

TK: Kareem. Not even close. I mean, I never saw Wilt in high school. I saw Wilt many times later on, even before he went into the NBA. But Kareem was the best high school player. Not even close.

WR: WHO WAS YOUR FIRST BASKETBALL HERO?

TK: Connie Hawkins was my first hero, and I'd follow him around from park to park. He'd palm, not cup, but palm rebounds out of the air.

WR: WHAT'S YOUR FONDEST MEMORY OF YOUR EARLY DAYS AS A NEW YORK CITY BASKETBALL JUNKIE?

TK: The first high school all-American All-Star Game was played June 29, 1960, in Jersey City. They played outdoors. I had just graduated from the eighth grade and the only graduation present I wanted was to go to that game and see Connie Hawkins be voted the MVP. The players who were in that game were incredible. John Thompson, George Leftwich, Roger Brown, Connie Hawkins, Jumpin' Joe Caldwell, Paul Silas, Jeff Mullen. Connie Hawkins had graduated from Boys High that day. He didn't even think he was gonna make that game. He didn't show up at the beginning of the game. I was heartbroken. Toward the end of the first quarter, he comes running out of the dug-out, because they had a portable court on the inside of the baseball stadium, and comes running on and actually took over the game. That was a great moment for me.

WR: WHY IS THE RUCKER SO IMPORTANT TO THE LEGACY OF NEW YORK CITY BASKETBALL?

TK: That was terrific basketball and it was really competitive basketball. They played to win. One of my favorite Rucker memories was, every year they had the New York Philly All Star Game, the Baker League would come up and play. With Philly, Earl Monroe would come up, Wali Jones would come up, guys like that. I remember, and this could've been like '72 and Earl Monroe's playing for Philly and New York had Connie Hawkins, Julius Erving, and "Tiny" Archibald. I mean, they played to win. It wasn't to put on a show and they didn't go through the motions. They played to win. Kevin Durant, maybe about four or five years ago, came up and played three straight nights. The first night at Rucker and he had 66 points. He just wanted the experience. You're not going to see that any more. There's too much money involved. I remember there was a tournament at City College, Chicago was in it. The New York team had "Tiny" and Julius Erving and Larry Keenan and guys like that. Chicago was in with Bob Love and Detroit was in with George Gervin. Think of that. Those are guys who were Hall of Famers. And that's the kind of basketball that you're not going to see again.

WR: HOW DID NEW YORK CITY BECOME THE URBAN EPICENTER OF BASKETBALL?

TK: As America became urbanized and industrialized, the pace of life quickened, and baseball was seen as too slow of a game. America yearned for a more electric game. Today the rhythm of the game of basketball is the heartbeat of our urban culture. Round ball truly is the city game.

New York City became the mecca because there's no more urban city in the United States than New York. Just look at the density of the population. We didn't have large areas where you could have baseball fields or football fields. But in a tenement area you wouldn't even have to have a full court, you might just have a basket that was put up on the side of the building. So you could play the game. And that's why New York became the mecca, because with limited recreational space, New York certainly had enough space for a hoop.

And basketball was a cheap game. It doesn't require a lot of equipment. You know, kids would play it with things other than even basketballs. Kids would use a rolled up sock when they started playing, they'd use a rubber ball. That's why New York became the mecca, though I don't think it is any longer.

WR: YOU FEEL THAT NEW YORK LOST ITS BASKETBALL "SWAG" HOW?

TK: Now that the game has spread, kids have lost their sense of pride in playing in New York City basketball. They'll always say that New York City is the mecca, and that the Garden is the biggest stage onto which you can step. But they don't really believe that. If they did, they wouldn't leave quality high school programs in the city and go

to the New England prep schools. They wouldn't cross the Hudson River and go to New Jersey. They wouldn't do that. I don't think they're proud to play New York City basketball and I think that's really the root of the decline of New York City basketball.

WR: HOW DID THE KNICKS OF THE 1970S BECOME SO BELOVED?
TK: The reason they stole the heart of New York was because they played the kind of basketball that those people grew up with. Team basketball, excellent ball movement, player movement, and they just played a New York City style of play, the way the old City College teams would play, the way the old LIU teams under Clair Bee would play, same thing with NYU and St. John's. They played a different style of basketball.

WR: IF THE KNICKS REGAIN CHAMPIONSHIP FORM, COULD THAT RAISE THE LEVEL OF NEW YORK CITY BASKETBALL?
TK: I think there's a trickle-down effect. If they become a contender, this might reestablish some pride in New York City basketball. It might trickle down to college programs.

As the Knicks declined and college basketball declined, high school basketball has declined. Everyone looks to the highest level.

WR: CAN NEW YORK ONCE AGAIN BECOME THE MECCA?
TK: It's not going to happen overnight. Let's say if the Nets really get going, become a major contender in the NBA, some of the local college programs whether it's St. John's or Iona are going again, then maybe it's going to trickle down to the high school level.

Then kids are going to stay in New York and then kids are going to be proud once again.

Page 116: TOM KONCHALSKI scouting high school players at Rose Hill Gym on Fordham University campus, 2003, photograph by David Bergman

→ CONNIE HAWKINS #23 of Boys High School blocks Columbus in the Public School Athletic League (PSAL) Final, Madison Square Garden, 1960, photograph by Dan Farrell

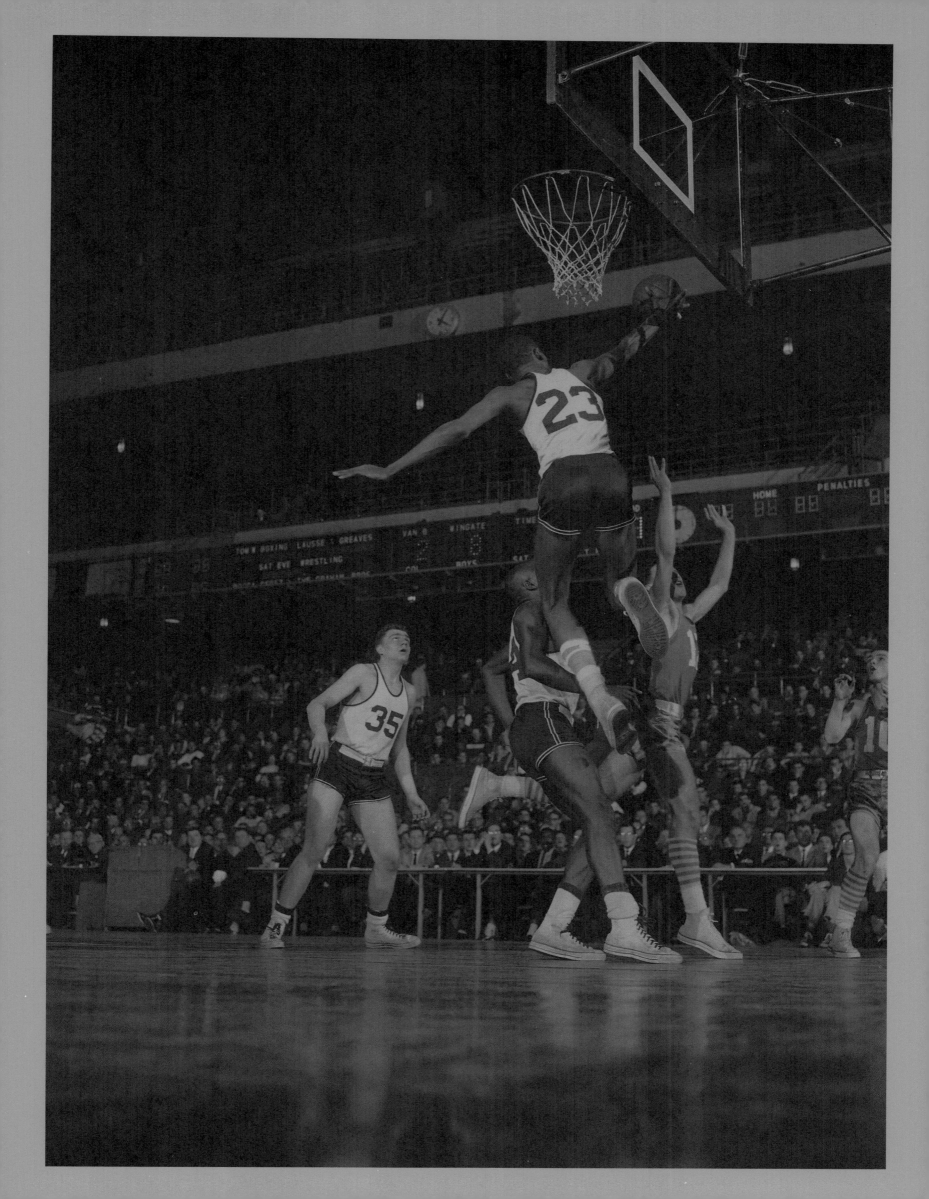

CHAMIQUE HOLDSCLAW

Queens-born Chamique Holdsclaw led Christ the King High School's women's basketball team to four straight New York State Championships and at the University of Tennessee she won three consecutive Women's Basketball Championships. She was WNBA Rookie of the Year in 1999 and is an Olympic gold medalist.

WILLIAM C. RHODEN: YOU GREW UP IN QUEENS. WHEN DID YOU BEGIN GOING TO THE PLAYGROUND?

CHAMIQUE HOLDSCLAW: I was 11 years old when I started going to the park. I was nervous because there weren't that many girls out there. It was dominated by men. I had to get out there, I couldn't cry about being fouled. When I crossed those lines I wanted to be an equal. Being out there, getting knocked down and getting back up helped build who I am today.

WR: WHERE WAS YOUR FIRST PARK?

CH: The Astoria Housing Projects, we had the courts in the center of the housing projects, so we had all these tournaments. Where I lived you had three housing projects lined up within four miles. You had Astoria at one end and you had Queensbridge housing project at the other end. In the middle was Ravenswood, so Ravenswood was the mutual meet up for everybody. The DS—Department of Sanitation—Park, that's where the *big* tournaments were going on. We also had the Boys and Girls Club on 21st Street, which was also a neutral place. You can imagine back then different projects would get into a beef. But it was cool.

WR: WHAT WAS AN AVERAGE SATURDAY LIKE?

CH: We'd wake up early, I'm talking about 7 a.m., go out, get our squad. We'd start shooting around where we lived. Then we'd go to Ravenswood, see who was there. Ultimately our goal back then was to get to Queensbridge and be ready, because they had all the ballers there.

WR: WAS BEING A GIRL A BARRIER?

CH: I got to play on a lot of courts. At first it was like, "We don't know if we want her to play because she's a girl." But I earned my respect, and that felt good.

WR: IS IT ANY DIFFERENT FOR YOUNG GIRLS STARTING OUT?

CH: It's definitely different now. There are more AAU teams. Parents are asking me what AAU teams I played on, what camps I went to. It's different now, even playing, maybe it's a safety thing but a lot of people don't necessarily want their kids outside, they want to be more structured inside because that's considered "safe." Back in the day, we could be outside but it was like a community taking care of you. When I went out, everybody was reporting back to my grandmother. It's different now: it's more organized and costs more money.

WR: DID COMING FROM NEW YORK GIVE YOU AN EDGE?

CH: People knew I was tough and they were a little intimidated when they heard New York City, even though I was a big softy, but it gave me that edge. Also, we were known for being creative players, being able to create our own shots. So, automatically, I got that respect: she's tough, she can get to the rack.

WR: DID COMING FROM THE NEW YORK PLAYGROUND SCENE GIVE YOU A COURT MATURITY? A SENSE OF COOL?

CH: Yes, that's what it gave to me because when you're out there on the playground it's so intense and competitive, I felt like I knew how to always hold my composure and motivate my teammates. That came from being on those New York courts. Can you imagine being knocked down, and I'm getting elbowed in the chest by guys? I couldn't do anything because I wanted to fit in. From that type of stuff, you just earn respect.

WR: YOU STILL SING THE PRAISES OF NEW YORK CITY—AND CHRIST THE KING.

CH: I always let kids know that the WNBA had three number one draft picks from Christ the King: me, Tina Charles, and Sue Bird. I have to let the kids know, this is New York: this is what we do. We're always representing.

WR: HOW HAS GENTRIFICATION AFFECTED THE CITY GAME?

CH: If you look at our city, New York City is very gentrified now. I remember my family in Brooklyn lived on Fort Greene, I remember going over there; I was scared to go on the courts in Brooklyn. They've got ballers, they've got hoopers. Now I go visit my family and it has changed. You see a lot more diversity on the courts. It's just different. There's been a shift, just as New York has changed.

WR: DID YOU EVER PLAY IN THE RUCKER OR THE ENTERTAINERS LEAGUE AS IT'S NOW CALLED?

CH: Back then it wasn't a popular thing for young ladies to play. I would just go there to pick up some moves. That's where I learned that I had to speed up my crossover dribble. Then you go home and you're practicing: I got to get tight; I got to get tight. But I was just there watching, taking it in.

WR: IS NEW YORK STILL THE MECCA OF BASKETBALL?

CH: New York will always be the mecca of basketball, just because of the history. But in recent years it's fallen off, I don't know what it is. We're used to having all these all-Americans from the McDonald's game on the men's and women's side and it really hasn't been like that in that last 10 years. It's just different. Back then everybody went to school in the city, so if I didn't have a game, I'd try to get up to Rice to go watch Felipe Lopez play. There was more of a sense of community—you wanted to be in those gyms. I don't know if we have that any more. Everybody's going to prep school. You're representing New York as a whole, but that feeling of being in these gyms is missing. It bothers me that the kids aren't staying in New York, they're being shipped away because they're good players. Yes, they represent New York City, but it's nothing like hearing those stories back in the day about how we stayed home. That made the connections deeper, rooted.

WR: HAS THERE BEEN A LOSS OF PRIDE IN PLAYING IN NEW YORK CITY?

CH: There's no loyalty. It's what can you do for me? What can I get out of this? Now parents understand that my kid can get a scholarship. I want my kid with the best trainer and this school is saying it can help. I want to get my kid out of New York to go to Maine, to go to California, to go to IMG Academy. We're going to send them there because this where they get to play with the best.

WR: WHEN DID YOU REALIZE THAT BASKETBALL COULD TAKE YOU PLACES?

CH: When I would go to the playgrounds. You had so many guys who you could touch who attracted coaches, I saw Bobby Cremins, coach K—I would see them watching pickup games. This is what I grew up seeing: the coaches helping guys make it out of the playground and go on to college. As a young athlete, that's what I aspired to accomplish—to use the game to help me get a college education. I realized that if I could dribble this rock, be one of the best, and have good grades, I could get this opportunity.

WR: WHAT DID PLAYING BASKETBALL IN NEW YORK DO FOR YOU?

CH: It changed my life. It gave me a sense of confidence. It gave me a level of acceptance, it gave me opportunities. Without New York City, without that air, I probably never would have really understood what that meant. Despite the circumstances around you, to know that "Hey, we're good at something, we have a skill that these other people want." You carry that through life. Just to understand that you belong. You're special. You've got something to offer.

← CHAMIQUE HOLDSCLAW #1 of the Washington Mystics defended by Crystal Robinson #3 of the Liberty, Game 2 of the Eastern Conference Finals, Madison Square Garden, August 24, 2002, photograph by Jesse D. Garrabrant

MARK JACKSON

Brooklyn-born Mark Jackson was coached by Patrick Quigley at Brooklyn's Bishop Loughlin Memorial High School and played ball with Chris Mullin at St. John's. He was drafted by the Knicks in 1987 and teamed with Patrick Ewing and Charles Oakley to turn the Knicks into playoff contenders. He coached the Golden State Warriors from 2011 to 2014 and today is a game analyst for ESPN.

WILLIAM C. RHODEN: WHAT ARE YOUR EARLIEST MEMORIES OF PLAYING BASKETBALL IN NEW YORK CITY?

MARK JACKSON: I was born in Brooklyn, the first seven, eight years of my life, and then moved to Queens. I remember going to the park after school, going to the park on the weekends, competing, watching my older brother and the people on the court compete, and battle, and scratch, and claw, and argue, and debate, asking who's got next and waiting for the next run, and all those things. Those are my fondest memories, just waiting for an opportunity to one day be selected.

WR: YOU TALKED ABOUT THE DISAPPOINTMENT OF NOT BEING CHOSEN.

MJ: I can remember my brother shooting to see who picked teams and he'd be one of the captains and I just knew, "OK, I know I'm going to be on my brother's team." He'd say, "I got you," but four guys later he's got a team and I wasn't selected. I would have to wait until our run had died down and they needed an extra guy, and nobody was out there pretty much, and I would play. Up until that point, there was no chance I was going to be on the team. Truthfully, looking back, my brother made the right decision, but you couldn't tell me that at 11 years old.

It was a lesson to be learned. You know, in New York City you earn your position and then there's a pecking order from day one. You have to earn the right to move up that list. When you do, those are great times, but it's a grind and it's competitive from the jump. That's the one thing that is instilled in New York players throughout history.

WR: SOME PEOPLE SAY NEW YORK BASKETBALL IS OVERRATED.

MJ: I disagree totally that New York is overrated. We don't have the exclusive rights to competitive basketball and great playground basketball. But basketball was birthed in New York and it was duplicated all around the country. It's just the competitive nature of the city: the best players around the world would come to New York to play in the summer leagues, in the park leagues. Kevin Durant scored 66 points at the Rucker. That wasn't the first time he scored 60 in a playground, when he cooked those dudes at the Rucker. It was the platform that the mecca gives you, and elevates you to part of the history and the story that ultimately is told.

BR: WERE YOU A RIVERSIDE HAWK OR A GAUCHO?

MJ: I played with people from the neighborhood. I played one tournament with both of those teams. I played once with Riverside and once with the Gauchos, but mainly I played with guys from the neighborhood. We just put a team together and wanted to compete rather than be on one of those teams. They both claim me, but I played with them once.

WR: WHEN YOUR BROTHER DIDN'T PICK YOU WAS THERE TENSION AT HOME?

MJ: None at all. You know, I mean, I'm sitting there thinking, you're tripping and you didn't pick me, but he's my older brother. I understood in a weird way the competitive gene—that he wanted to put the best five guys on the floor. That really sparked something in me. Nothing was given to me. I had to earn it, so it birthed a desire, or hunger, a competitive spirit.

WR: HOW OLD WERE YOU WHEN YOU STARTED BEING CHOSEN CONSISTENTLY ON THE PLAYGROUND?

MJ: We moved to Queens when I was about seven, eight years old. I was foolish enough to believe I could play with those guys. I probably got good when I was 11, when I felt like I could be on the court.

WR: SOMEONE SUGGESTED THAT NEW YORK CITY MAY NOT HAVE HAD THE GREATEST PLAYERS BUT IT HAD AN ABUNDANCE OF MARK JACKSONS, PLAYERS WHO MAY NOT HAVE BEEN THE FASTEST, QUICKEST BUT WOUND UP HAVING GREAT NBA CAREERS.

MJ: I agree and I disagree. I do believe we have some of the greatest players that's ever played the game. Kareem Abdul-Jabbar is a New York City dude. Dr. J is a New York guy, Tiny Archibald, Lenny Wilkens, Bernard King, Bob Cousy. We have incredible, all-time great players. But we also have some people who carved a niche and found a way to impact the game because of their knowledge, because of their competitive spirit, because of their willingness to sacrifice, because of the grind mentality.

WR: WHAT IS THE GREATEST GIFT THAT NEW YORK BESTOWS ON BASKETBALL PLAYERS IT PRODUCES?

MJ: I would say the New York "swag," the New York confidence, the New York grind, the New York competitive spirit in every playground, in every tournament, in every league. In addition, New York turns out great point guards. In my opinion, I was part of the greatest point guard class in the history of, not just New York, the country: Kenny Smith, Pearl Washington, and Kenny Hutchinson. Then a year later, you got to me. Talk about competition. If I wanted to eat, I had to compete and have an edge. A year after me, you had Rod Strickland and Boo Harvey. I mean, we were loaded at the point guard position. It was just an incredible time to be playing.

WR: WHAT GAVE YOU YOUR EDGE?

MJ: I would say that playing with old people who did not make it in the league, did not make it in college, but knew how to play ball. I was playing against those people in the park every single day. What I did not have in athleticism, what I didn't have in quickness, what I didn't have in certain areas, I was able to become a guy who knew the game inside out mentally. I could outsmart you. It's a credit to playing with those guys, against those guys, watching the Magic Johnsons.

WR: WHO DID YOU WANT TO BE WHEN YOU WERE YOUNG?

MJ: I wanted to be Earl Monroe as a kid growing up. Not the Earl Monroe that played in Baltimore, I'm talking about the Earl who came and sacrificed with the New York Knicks. I learned a whole different side just watching that. All of those things helped develop and nurture me into the player that I became.

WR: A LOT OF GREAT NEW YORK CITY HIGH SCHOOL PLAYERS HAVE LEFT THE CITY FOR PREP SCHOOLS. HAS THAT HURT THE CITY'S REPUTATION?

MJ: First of all, I wouldn't have left the city. I'd have taken the same route, even if I was playing today. I just think it's a different time and guys are taking avenues. But that doesn't take it away from New York producing great players. It has hurt the rivalries we used to have: Christ the King playing Bishop Loughlin; Xaverian playing Alexander Hamilton with Jerry "Ice" Reynolds. That was epic. You don't get that anymore.

WR: YOU WENT TO ST. JOHN'S INSTEAD OF LEAVING THE CITY. DID THAT MAKE A DIFFERENCE IN YOU BEING SEEN AS MORE OF A NEW YORK CITY PLAYER?

MJ: I think it made a difference, but not as big of a difference as winning did. I didn't just go to St. John's, I went there and was part of a historic run, you know, winning, going to the Final Four, being on the number one team in the country, winning the Big East tournament championship in Madison Square Garden. Winning on the biggest stage makes a difference.

← MARK JACKSON #13 of the Knicks dribbles past Isiah Thomas #11 of the Detroit Pistons, Madison Square Garden, 1991, photograph by Nathaniel S. Butler

WR: DID BEING DRAFTED BY YOUR HOMETOWN TEAM, THE KNICKS, SOLIDIFY YOUR REPUTATION AS A QUINTESSENTIAL NEW YORKER?

MJ: Again, it's winning. When I got there, they hadn't been a playoff team. I go there and we become a playoff team. We experienced success. The Garden was bouncing. We have success in the playoffs. We ultimately get to the Eastern Conference finals and we're playing the Bulls. Ultimately what made the difference was that I went there, and we won.

WR: IS THAT WHY WALT FRAZIER IS STILL REVERED? BECAUSE HE WON TITLES WITH THE KNICKS?

MJ: He's definitely New York. Here's a guy who won championships in New York City and became a household name worldwide. He had a "swag" about him that had New York City written all over it. He's definitely New York City and it shows you what can happen when you do it—when you win in New York City. Walt Frazier will forever be embraced, loved, respected, and appreciated anywhere he goes in New York City. He can still be stopped anywhere in the streets of New York and asked for pictures and autographs, and all of that. He's respected and appreciated, and he's an absolute legend.

WR: YOU SPENT MORE THAN A DECADE IN THE NBA AS A PLAYER; YOU WERE AN NBA HEAD COACH, NOW YOU ARE A BROADCASTER. ARE NEW YORK CITY PLAYERS DIFFERENT? CAN YOU TELL THE DIFFERENCE?

MJ: You can always see it. Whether you're playing against them in high school, or playing against them in college, or playing against them in the pros. Certain guys you can identify with where they come from the more you hang around, the more you realize it, whether it's a toughness or softness, great competitors are guys that'll be the first to tap out. You can get an idea of where they're from.

WR: DID YOU PLAY AT THE RUCKER?

MJ: A couple times. It was a lot of fun playing against guys that you heard about, and some that you didn't that had flat-out game, you know? You don't realize until you're in the middle of the game and a dude that you never heard of is going at you, and experiencing a certain level of success while trying to go at you. Again, it breeds something because now you swell up and you want to prove a point. The crowd is always going to go for the underdog, trying to hype up the guy who's supposed to win the match.

WR: WHY IS THAT SUCH AN ICONIC EXPERIENCE?

MJ: It's just like Madison Square Garden; what makes it distinctive is the history, all the people who have stepped on that floor prior to you stepping on it. You hear the stories your whole life growing up about the Rucker, the legends who made it, and the legends that didn't make it. You want to be part of that story when it's told.

WR: EVEN AFTER A SUCCESSFUL ROOKIE NBA SEASON, YOU WERE BACK IN QUEENS, PLAYING ON THE PLAYGROUND.

MJ: I was fortunate enough to win Rookie of the Year and went back and played in the Rucker. I'm back at my playground in Queens, waiting for everybody to come after school for the run. It's what you want. People are saying, "Oh you played for the Knicks and you in the park?" Yeah. This is the grind. It puts you in position to want to be great, to want to prove a point whether it's Rucker Park or City College. I remember going to City College and I got to, you know, play against Rod Strickland and it's standing room only. There's no, "I'm just going to go through the motions today," because everybody's going to be talking about it afterward. You can get 40, 50, 60 points, but somebody got 10, but made a heck of a move. That story's going to be told totally different.

WR: DOES THAT FEROCITY STILL EXIST?

MJ: It's changed. I won't blame it on anything specific. I guess it's different times. There's certain things that today's players do better than yesterday's players. Today's players are absolutely better businessmen, they're better athletes, but they are not better competitors.

There's no way in the world I'm going to go to the gym and Kenny Smith is in the gym, or Rod Strickland is in the gym, and we're going to sit down, and not play against each other. That ain't happening. I'm coming after you and you're coming after me. If we're in the gym, it's on. We respect it and we appreciate it, but it's a different time right now. You know, it's just the way it is. I can't imagine "Load Management." What do you mean, load manage? You know what load management to me would be? Coach, give me a day off from practice. OK?

WR: IS NEW YORK STILL THE MECCA OF BASKETBALL?

MJ: I think it still is. I don't think it's going to change. Have we poured out the same level of talent that we once did? No. That's not the point. You remain the mecca because of the history. The history of New York City ballplayers is unmatched. It's the platform of Madison Square Garden, the platform of Rucker Park, the platform of the playgrounds of New York City, West 4th Street, Citywide, Elm Corps, all those things are part of it. You can't tell the history of basketball without talking about New York City. That's what makes New York the mecca. It's not false bravado. It's a real part of the story of what James Naismith created.

→ ST. JOHN'S UNIVERSITY'S MARK JACKSON #13 tries to hang onto the ball against Montana State, 1986, photographer unknown

KENNY ATKINSON

Long Island–born Kenny Atkinson is the head coach of the Brooklyn Nets. He played professionally for 14 years, and was assistant coach of the Knicks from 2008 to 2012, helping the team reach the postseason in 2011 and 2012.

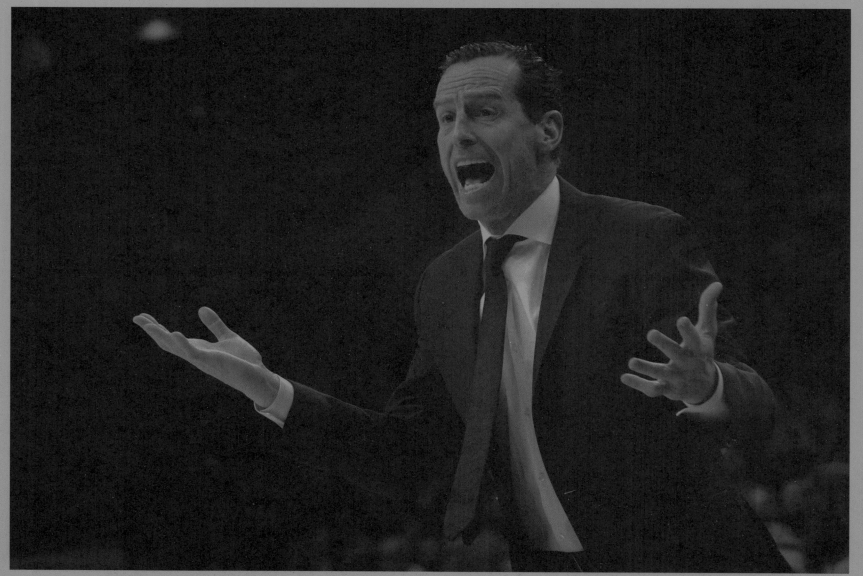

WILLIAM C. RHODEN: YOU WERE BORN AND RAISED ON LONG ISLAND—HUNTINGTON. WHAT WAS THE PERCEPTION OF NEW YORK CITY BASKETBALL?

KENNY ATKINSON: There was an aura. I thought it was the best basketball in the country, the best in the world. That's where it was, where basketball was made. You had your other places—Chicago—but being from the island, it was all about New York City ball. We were—intimidated is the wrong word—but there was a mystique. When you played against a city guy it was like, oh, man, he's a New York City player. You'd better be ready.

WR: WHEN DID YOU FIRST COME IN CONTACT WITH THE NEW YORK CITY GAME?

KA: I went to Five Star basketball camp in the ninth, tenth grade. I started seeing those guys then. That was the real first taste I had. Most of it was reading about them in the *Daily News*—the legends, the legendary stories that trickled down to us even though I wasn't physically there. At Five Star I started seeing the bodies behind the names.

WR: WHAT WAS THE HEYDAY OF NEW YORK CITY BASKETBALL?

KA: When I was in junior high, elementary school that was when New York basketball was cooking.

WR: WHO WAS THE FIRST GREAT NEW YORK CITY PLAYER YOU ENCOUNTERED, FIRSTHAND?

KA: Pearl Washington. Pearl Washington was the epitome for guys my age of the New York City ballplayer. The Newsday Classic game—New York City versus Long Island—that was the first time I saw Pearl. I went back home and practiced Pearl's moves in the driveway. On Long Island and Upstate New York, we kind of had basic games. The city players and the city game had so much more flair. There was a personality to it. It was just different.

WR: WHAT MADE THE CITY GAME SO DISTINCTIVE?

KA: Kenny Anderson is a good example of that. I remember playing against Kenny when he was at Georgia Tech and I was at Richmond. There was almost a sixth instinct; my dad used to call it the city instinct. You're driving and all of a sudden, here comes Kenny Anderson from behind making the strip. There's awareness. It's tough to explain, but whether it was passing the ball or stealing the ball or there was just another level of instinct that probably came from thousands of hours in the playground, which is different from how a lot of us grew up, playing more in gyms and being coached. They just had a flair, great instincts and great character. I haven't seen another player like Pearl, with that type of flair, that smile. There's just been something different.

WR: WHAT WAS YOUR SUMMER BASKETBALL ROUTINE AS A YOUNG PLAYER ON LONG ISLAND?

KA: I used to hop around Long Island. Before I got my driver's license I had these two friends and we just used to park hop. You put a banana and a bottle of water in your backpack and you were off. I would hop around Huntington, South Huntington, I'd go into Nassau County all the time, just trying to find the best run. You wanted to make your mark at the park. There's nothing like trying to gain respect on the playground. When I was in college at the University of Richmond, I'd venture into Brooklyn. When I was in DC I'd find the best park there.

WR: IS NEW YORK CITY STILL THE CAPITAL OF BASKETBALL?

KA: When we were growing there was word of mouth and reading the newspapers and everybody kind of stayed put. There were two guys that transferred schools, but it was much more...I think it's lost its luster; I don't have the breakdown of who's big time in the city and who's not. It's just not the same. The buzz is not the same, and I'm not sure why.

WR: YOU GREW UP WATCHING THE KNICKS, NOW YOU COACH THE BROOKLYN NETS. CAN THE NETS REVITALIZE NEW YORK CITY BASKETBALL? CAN THE NETS BRING BACK THE BUZZ?

KA: I'd really like to think it could come back to where it was; we obviously have the population. I think it's going to take a push from our college programs getting good, and then the Nets and the Knicks being really good. It'd be great to have that rivalry. But it's hard to fathom that New York City basketball could get back to the level where it was, when you're talking all those legendary players, starting with Kareem. I think it's a tough task. I know for Kyrie Irving that's a big reason he came to Brooklyn. I think the mystique of New York and even New Jersey basketball is a big deal for him and obviously, KD (Kevin Durant) with the Rucker, scoring 66 points, that was incredible. I know former Net D'Angelo Russell went over and played in the Rucker. It's be great to get that going again. It'd really be great for the young guys growing up playing the game to be able to look at us and say, "Hey, basketball's back in New York."

WR: FROM FINDING A PARKING SPOT TO GETTING A SUBWAY SEAT, NEW YORK IS COMPETITIVE. WINNING IS ALMOST THE ONLY WAY TO DISTINGUISH YOURSELF. CAN THE NETS BREAK THROUGH?

KA: I feel a change. I live in Brooklyn, so I can feel the excitement from the fans. I feel like there's a change. With KD and Kyrie coming, I think that's going to be another push and there's going to be more interest now. The way you really get attention from New Yorkers is winning: you've got to win big. You're talking about the Giants and the great Knicks teams. You've got to win because this market is so competitive, with the sheer number of people trying to make it here; it's not just basketball, it's everything. For us, it's not enough just being a playoff team, you've got to win big.

WR: FINAL THOUGHTS ON NEW YORK CITY BASKETBALL, PAST, PRESENT, AND FUTURE.

KA: Reverence and respect. It was intimidating; those were the best guys, and you knew all their names and their reputations. It was the city game. That was it.

← BROOKLYN NETS HEAD COACH KENNY ATKINSON reacts to a call on the court, 2018, photograph by Matt Slocum

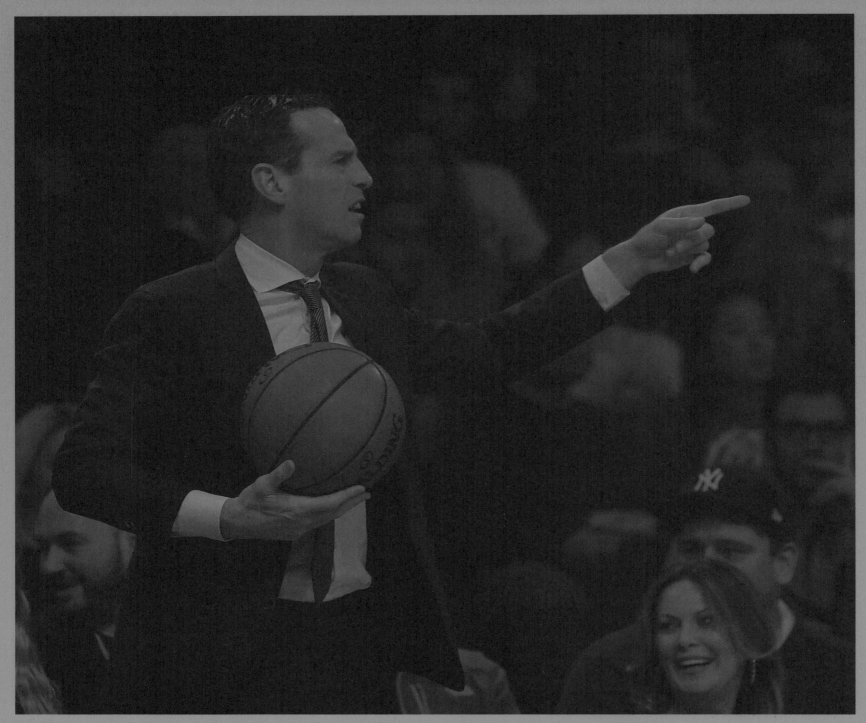

↑ **KENNY ATKINSON**, 2018, photograph by Jim McIsaac

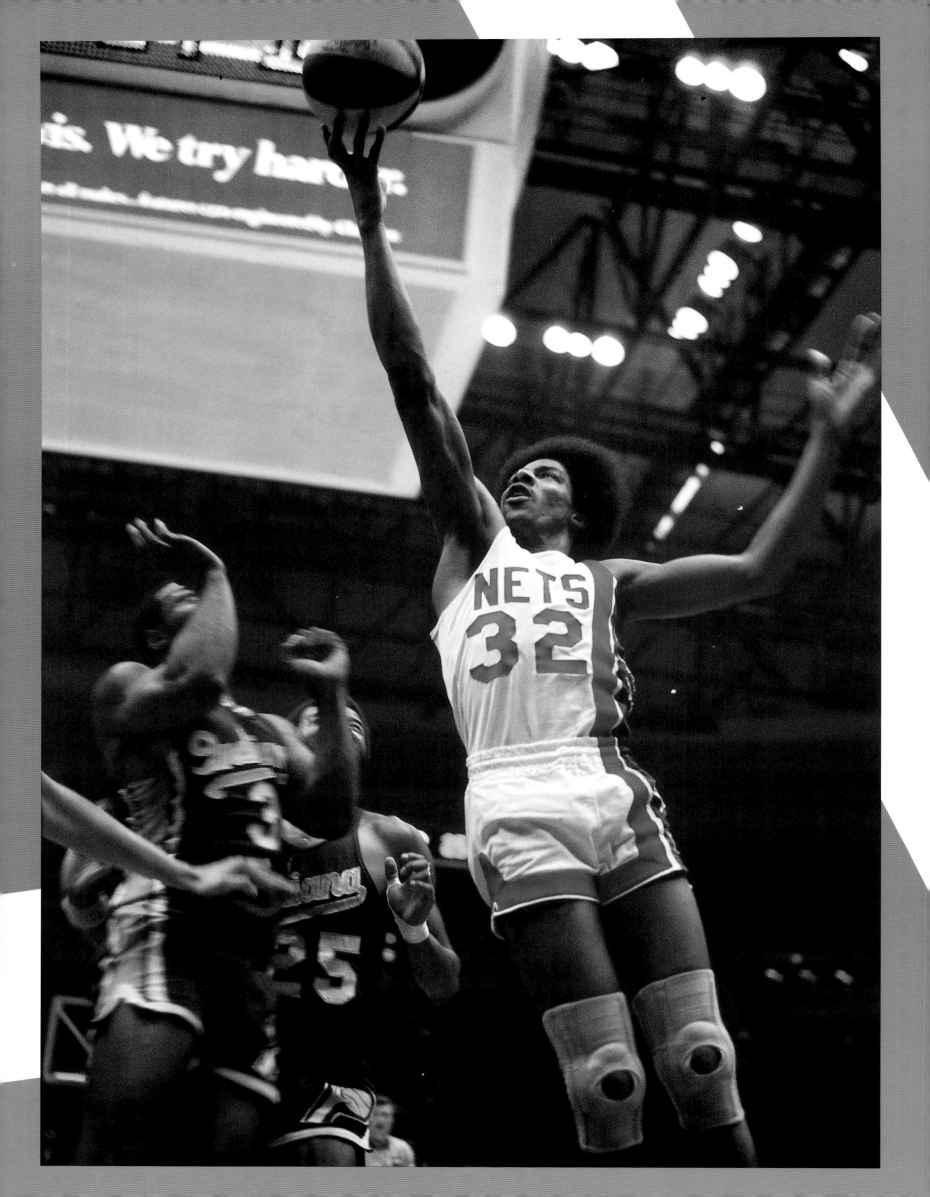

TOO BIG FOR JUST ONE: KNICKS, NETS & LIBERTY

JAMAL MURPHY

Basketball has been an indelible part of New York City culture for longer than I have been alive. I was born in Brooklyn in the mid-1970s, a few years after their last championship. Little did I know that two more professional basketball teams—the Nets and the Liberty—would not only find a home but come to be a definitive part of the city.

The seeds of New York City's basketball culture began to grow in 1946—when the Knickerbockers were born as one of the founding members of the Basketball Association of America (BAA). Knicker-bockers or "knickers," of course, was a style of pants worn by the original Dutch settlers of the city that rolled up just below the knee. Eventually the name became synonymous with settlers and later, with New Yorkers in general. The Knicks, as the team was later called, would eventually reside in Madison Square Garden—oft described as the "World's Most Famous Arena" and the "Mecca of Basketball."

Basketball is a fast-paced sport (even when the score is low) and requires its participants to think and make quick decisions under pressure, similar to what New York City demands of its residents. The city loves and understands the game. The game loves and understands the city.

The Knicks' championships in 1970 and 1973 put the city where it has always thought it rightfully belonged—on top of the world. It is no secret that New Yorkers think highly of their city and themselves as an extension. The dominance and charisma of those two teams matched the personality of the city. Walt "Clyde" Frazier's slick play-making, cool under pressure demeanor, and flamboyant style off the court was New York. Willis Reed's toughness and dominance was New York. Bill Bradley's scholarship, statesmanship, and dead-eye jump shot was New York. The team's overall understanding of the game and win-at-all-costs mentality was New York.

Around this time, a second professional basketball team moved into the area. But it had an on-again, off-again relationship as a New York City team. The New Jersey Americans were formed in 1967. A year later, the team moved to Long Island and became the New York Nets and began shaping New York's basketball culture as well. Julius "Dr. J" Erving was treating the American Basketball Association (ABA) like Rucker Park—displaying style and athleticism never seen before in the professional ranks. The New York native led the Nets to two ABA championships in 1974 and 1976, and won three league MVPs. His style was so New York—innovative and too cool for school. But all of his MVP awards and never before seen moves on the court were not enough to keep the team from returning to the Garden State. It moved back in 1977 and would remain there for the next 35 years, as the New Jersey Nets.

The Knicks, however, stayed put. By the 1990s, a gruff, if less tal-ented group was under the helm of Pat Riley. The slick-haired Hall of Fame coach was a star made for New York. He came to the team after leading the Showtime Los Angeles Lakers to four champion-ships. Patrick Ewing, the team's star player, represented dominance

Page 130: JULIUS "DR. J" ERVING #32 of the New York Nets in a game against the Indiana Pacers, 1974, photograph by Ron Koch

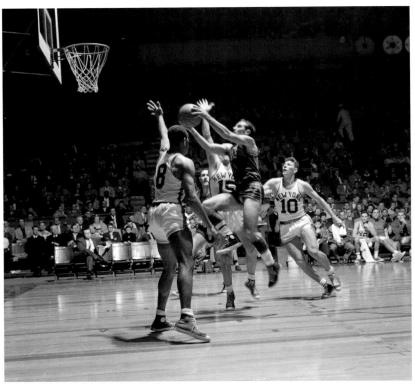

↑ KNICKS IN A GAME AGAINST THE FORT WAYNE PISTONS, 1953, photograph by Arthur Rothstein and Frank Bauman

IT JUST WASN'T BIG ENOUGH.

and intimidation. The heart and soul of the Knicks was Charles Oakley, whose physical and mental fortitude became a source of pride for New Yorkers. The spark plug of the team was John Starks, who famously packed groceries in Oklahoma a few years before dunking on Michael Jordan in the playoffs in the World's Most Famous Arena. All of these Knicks were born somewhere other than New York, but they became New Yorkers, much like the makeup of the city itself.

My father, Clyde (named by his parents well before Walt "Clyde" Frazier came on the scene), used to tell me that he (not me who was born in Brooklyn) was a true New Yorker because he made the conscious decision to move to New York City from Opa-Locka, Florida. I apparently just got lucky. By this standard, the 1990s Knicks were New Yorkers in the truest sense—transplants who worked together to create something big.

It just wasn't big enough.

The Knickerbockers could never get by the aforementioned MJ. And even when he retired abruptly, the dream was shattered by an all-time great named Hakeem Olajuwon. In 1994, the Knicks lost to the Houston Rockets in the NBA Finals, thanks in large part to the Finals MVP and 1993–94 League MVP. Those failures and future ones are also a part of New York City culture. True New Yorkers carry a healthy dose of pessimism with them, especially when it comes to their sports teams.

While Knicks fans were licking their wounds, New York City gained another professional basketball team, one that represents a major segment of the city's citizenry. The Women's National Basketball Association (WNBA) was founded in 1996, as a counterpart to the male-dominated NBA. One year later, the New York Liberty was formed and was one of eight original franchises of the league.

Women's basketball is also a huge, though overlooked and underestimated, part of the fabric of New York City culture. On any blacktop in the city you're likely to find girls hooping with the boys, crossing them up and clappin' 'boards.[1] One of the greatest women ever to play in college and the WNBA, Chamique Holdsclaw, hails from Queens, New York.

The Liberty have represented the city well, bringing in stars such as Hall of Famer Teresa Weatherspoon, Becky Hammon, Tina Charles and Swin Cash, to name a few. The team made four WNBA Finals appearances between 1997 and 2002, showing off a smart, tough, defensive-minded playing style reminiscent of their early 1990s male counterparts. Nevertheless, they have not been able to win a championship title.

New York City always felt too big—physically and emotionally—for just one NBA team. Manhattan had the Knicks, but something was missing to represent the truest of New Yorkers who walk the streets of the other four boroughs.

In 2012, the Nets returned to New York, this time to Brooklyn and the newly erected Barclays Center on Atlantic and Flatbush Avenues.

↑ SPENCER DINWIDDIE #8 of the Brooklyn Nets, 2016, photograph by Ron Turenne

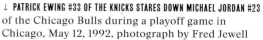

↓ PATRICK EWING #33 OF THE KNICKS STARES DOWN MICHAEL JORDAN #23 of the Chicago Bulls during a playoff game in Chicago, May 12, 1992, photograph by Fred Jewell

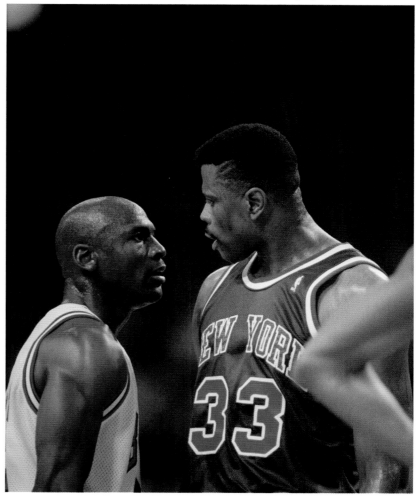

After mostly hard times in New Jersey, other than two Jason Kidd–led NBA Finals appearances in 2002 and 2003, the move to the city's largest borough marked a brand-new beginning for the franchise.

For the first time, the Nets officially became a city team. While on Long Island and then New Jersey, the Nets were looked at as slight outsiders, almost basketball suburbanites to New Yorkers. Yes, they were family and we kept in touch with them, but they were always the "other" team. The move to Brooklyn instantly challenged that notion.

The current Brooklyn Nets reflect the Brooklyn story. While the native Knicks have struggled in recent years, it is the Nets who have become the hardworking group that started from the bottom, but made the playoffs this past season. While New Yorkers and tourists alike rush to Madison Square Garden like a Broadway play, Barclays Center, like Brooklyn, is starting to boom and become the cool place to be. Many of the Nets players also live in Brooklyn, making them that much more of a city team.

All three of these basketball teams influence New York City and are heavily influenced by it, creating a kind of urban ecosystem. The Knicks have the deepest connection with the city because they have been here the longest. Their summits have been euphoric for the city (or so my father told me). But more often, their deficiencies have made their fans and the city harder and disabused them of blind optimism—a key component of the New York state of mind. So, in a weird way, Knicks losses have contributed to the city's culture.

Despite the Knicks' lack of recent success, Madison Square Garden is firmly entrenched as the ultimate venue and atmosphere for professional basketball, kind of like the Rucker Park of the NBA. The Garden is as big or bigger for visiting players as it is for the home team. Up-and-coming stars are gauged by how well they play on 32nd Street and Seventh Avenue, as sort of a rite of passage to superstardom. Individual moves are judged by the oohs and ahhs they generate inside the Garden.

Thus, the Knicks are always relevant because they are synonymous with the city. Even when being ridiculed, the Knickerbockers remain in the conversation. God help the rest of the country if they ever regain prominence.

The Liberty and the Nets are intrinsically New York as well, but are more influenced by the city than vice versa. They are recent arrivals. Both franchises are expected to represent the city in style, grit, and results. The Nets, in particular, represent the new New York City attitude shaped by Brooklyn legends Jay-Z and the late Notorious B.I.G. The Brooklyn Nets are a younger team, so their Brooklyn fans are younger and grew up more on hip-hop and pop culture. You can see this in the arena, where Biggie and Jay-Z are displayed and played prominently and the team's special uniforms were inspired by Biggie.

Like Jay and Biggie, the Liberty and Nets are the outer borough New Yorkers who were overlooked, but kept grinding. Eventually,

they gained the love and respect of the entire city. Their style of play and heart were sculpted by and testaments to the city that helped raise them into winners.

Basketball wasn't invented in New York, but New York surely invented its own form of the game. The Knicks, Nets, and Liberty have all contributed to that form to different degrees and for different periods of time. Don't expect any of the grit, toughness, smarts, or flamboyance to change, New York City won't allow it.

↓ **LISA LESLIE #9** of the Los Angeles Sparks goes up for the opening tip-off against the Liberty in the inaugural WNBA season opener, June 21, 1997, photograph by Andy Hayt

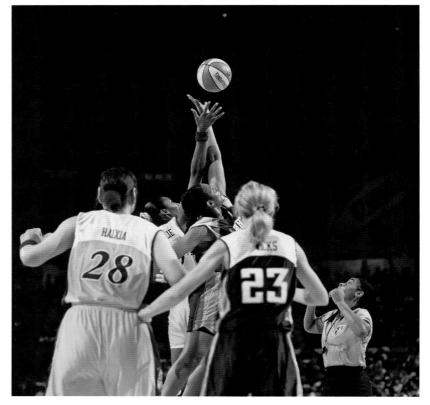

JAMAL MURPHY is a sports writer, attorney, and executive producer and cohost of the Bill Rhoden *On Sports* podcast. Murphy has covered and written about the NBA, NFL, MLB, NHL, college basketball, men's and women's tennis, and boxing. This Brooklyn native is a Nets, Knicks, and Liberty fan.

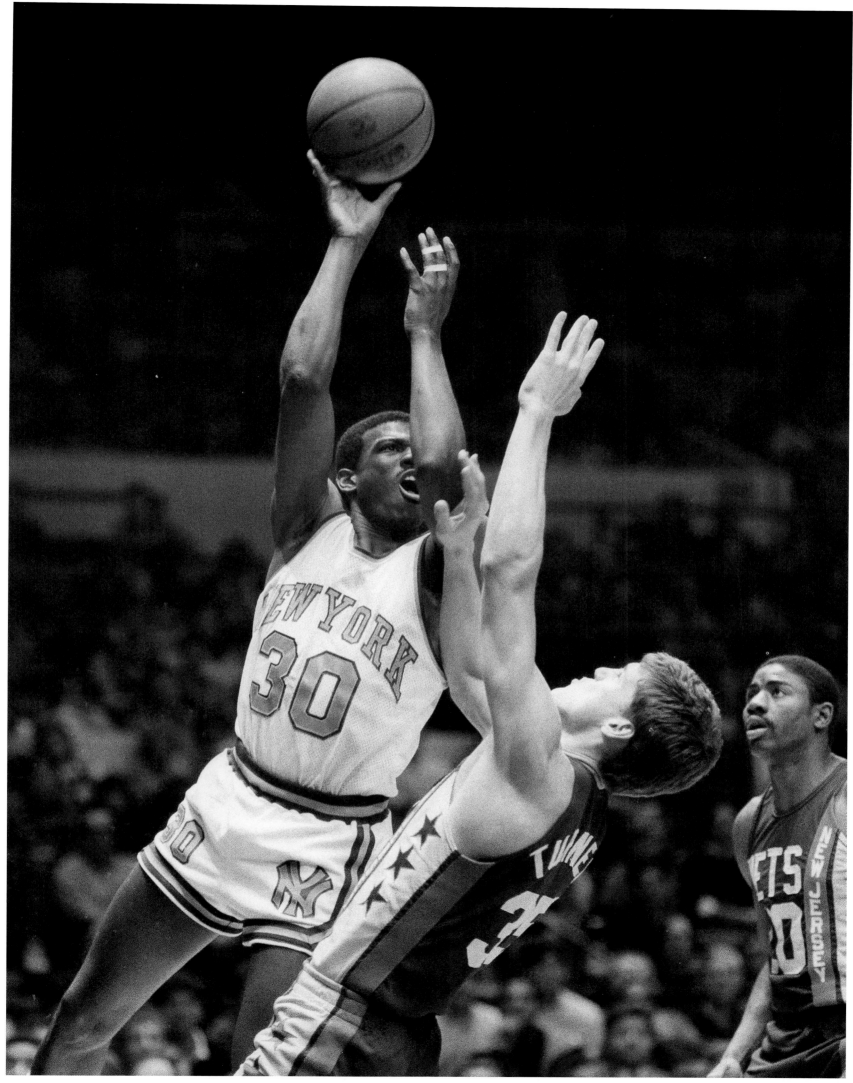

↑ **BERNARD KING #30** of the Knicks tries to get past the
Nets' Jeff Turner #35 and Michael Richardson #20,
December 25, 1984, photograph by Bill Kostroun

CLYDE COOL

THERESA RUNSTEDTLER

"New standards for excellence on the basketball court and style and class off the court have been set by Walt Frazier."—Phil Pepe, *Black Sports*, 1973[1]

Coming of age in Ontario, Canada, in the 1980s and early 1990s, it seemed as if all of the best of Black culture and basketball emanated from New York City. Though the Knicks of my youth had mixed success, I still cheered for them as if they were my home team, hoping that some of their flair would rub off on me. Toronto eventually got its own franchise in 1995 and I worked as a Raptors dancer during my college years. Whenever the Knicks came into town, they brought that New York attitude with them.

Now a sports historian working on a book about how Black players reshaped professional hoops in the 1970s, I came across Walt "Clyde" Frazier, and his story has given me a greater appreciation for the place of New York City in the evolution of Black basketball cool. New York was not only where he played ball—it was his playground, the exciting backdrop for his experimentations with Black style. As the media, fashion, and finance capital of the United States, New York helped make Clyde a Black icon with widespread influence.

Since the 1970s, Walt Frazier has managed to retain his relevance and appeal among new generations of hoops fans. On March 29, 2017, a spirited Frazier, decked out in a giraffe-print suit, was on hand at Madison Square Garden to unveil his new pony-hair, cow-print sneaker. Puma and Packer Shoes teamed up to honor Frazier's 72nd birthday with the "Clyde." The updated namesake sneaker was an homage to Frazier's flashy 1970s style.[2] Although shoe endorsements are now the norm in the NBA, Frazier became the first basketball player to have his name on a Puma sneaker in 1973.

In June 2018, he signed a lifetime deal with Puma to promote the brand in the basketball space.[3] Beyond endorsements, he is a Knicks commentator on MSG Networks. In 2010, he rereleased his 1974 autobiography and self-help book, *Rockin' Steady: A Guide to Basketball & Cool*.[4] What explains his unique staying power in the professional basketball scene? Looking back can help us find the answer.

Frazier was the embodiment of Black New York cool in the 1970s. On the court, the 6'4", 200-pound guard exemplified controlled improvisation with his nimble-fingered steals and swift passes. Defying popular stereotypes of the emotional and impulsive Black player, he was cool under pressure. He rarely showed anger or lashed out at referees. He hardly perspired, furthering his air of unflappability.[5] Off the court, he was a style icon with an unabashed enjoyment of the finer things in life—from flamboyant fashion, to luxury cars, penthouse apartments, and beautiful women. He was a crossover sex symbol at a time when it was still uncommon for mainstream American society to embrace Black men as objects of desire. Men wanted to be him and women wanted to date him. Frazier was also one of the first NBA players to consciously develop a personal brand

that landed him numerous endorsements and made him a celebrity beyond basketball. He was an athletic entrepreneur who moved confidently in the business world. This suave professional man who paid homage to the distinctiveness of Black style was able to retain his broad-based appeal because he largely steered clear of controversy. His enthusiastic embrace of entrepreneurialism meshed well with contemporary ideas about Black enterprise as the key to Black progress. He also remained "neutral" when it came to racial politics, preferring to be an aspirational role model rather than an outspoken activist.[6] In many respects, he set the mold for nonactivist, Black professional athletes like Michael Jordan and O.J. Simpson.

Picked fifth overall by the New York Knicks in the first round of the 1967 NBA draft, Frazier was a bit of a dark horse when he entered the league. Born in 1945, he came of age in the Black section of Atlanta, when Jim Crow still ruled the South. He was not dirt poor, but neither did he grow up privileged. He lived in a duplex apartment with his grandmother and eight younger siblings and learned to play basketball on an uneven dirt playground in the 1950s.

Frazier started as an all-around athlete. At David T. Howard High School, an all-Black institution, he was the star quarterback of the football team and catcher for the baseball team. During basketball season, he played varsity hoops. His coach first shaped Frazier's signature defensive style by teaching him the twin mantras of "defense before offense" and "pass before taking a wild shot."

Although Frazier received many college scholarships to play football, the dearth of Black quarterbacks in the NFL convinced him to play basketball instead. Though he went on to play for the somewhat obscure Salukis of Southern Illinois University, his decision to ball was rewarded. He was named a Division II All-American two years in a row, and led his team to the NCAA Championship finals in 1965. Despite these accolades, when the Knicks drafted him, he started out with a fairly modest contract.[7] But it would not be long before Frazier emerged as an NBA superstar in the 1970s.

He played for the Knicks 10 years before being traded to the Cleveland Cavaliers in 1977. Two years later, he retired with a secured place in NBA history. With the Knicks, he averaged 19.3 points per game, won two NBA championships (1970, 1973), played in seven NBA All-Star Games, and was named to four All-NBA First Teams and seven NBA All-Defensive Teams. In 1987, Frazier was voted into the Naismith Memorial Basketball Hall of Fame.[8]

The stories of how he got the nickname "Clyde" help shed light on Frazier's evolving philosophy and aesthetic of Black cool. During his rookie season, he spent thousands of dollars buying clothes in every city he visited. When in Baltimore for a game against the Bullets, he purchased a wide-brim hat made of brown velour for $40 (about $300 in 2019). When he wore it around, his teammates and other NBA players laughed at him. "At the time, nobody was wearing wide-brim hats like that," Frazier recounted in *Rockin' Steady*. "They made

HIS TWIN MANTRAS WERE "DEFENSE BEFORE OFFENSE" AND "PASS BEFORE TAKING A WILD SHOT."

me feel so stupid that I almost stopped wearing those hats. But I just decided to wear what I want to wear." Shortly thereafter *Bonnie and Clyde* hit theaters. The film about Bonnie Parker and Clyde Barrow's spree of armed robberies in the 1930s made flashy wide-brim hats all the rage. Danny Whelan, the Knicks trainer, was the first to call Frazier "Clyde" and it caught on. Not only was Frazier a flamboyant dresser off the court, but he was also a master at stealing the ball on the court.[9] And, he did both with a calm sense of confidence, unafraid to set, rather than merely follow, trends.

Frazier connected his own brand of Black masculine cool to the broader Black experience in the United States, both past and present. "Cool is a quality admired in the black neighborhoods," he explained in *Rockin' Steady*. "Cool is a matter of self-preservation, of survival. It must go back to the slave days, when oftentimes all a black man had to defend himself was his poise. If you'd show fear or anger, you'd suffer the consequences."

The ongoing consequences of racial segregation and economic divestment in Black inner-city areas continued to shape expressions of Black masculine cool in the 1970s. "Today, the guy respected in the ghetto is the guy who resists the urge to go off—who can handle himself in a crisis, who can talk his way out of a fight," Frazier contended. He added that Black cool transcended the individual.

"Cool also provides a kind of community defense in the ghetto," he said. "It's used when we're faced with group adversity. Sometimes it's used against the cops, who have often been suspect by blacks."[10] Among young Black men especially, being cool was a shared tactic of survival in a violent, racist society.

Frazier was, in some ways, the epitome of Black American manhood. He was an underdog, an improbable star. He was not a particularly fast runner, high jumper, or high scorer, but he said he made up for these shortcomings "by playing it cool."[11] At a time when fans cheered for crushing dunks and aerial acrobatics above the rim, he and the Knicks somehow managed to make defense exciting. "Defense is not something passive. Defense is a weapon," Frazier maintained. "You've got to take gambles in order to put pressure on the other team." When he was on the court, the crowd sat up in anticipation, "looking for the flashy ballstealing" that made him "the most spectacular defensive man in the league." He would wait until his opponent put the ball on the floor and then flick it away into the hands of one of his teammates. It was all part of Frazier's subtle game of mental intimidation. "It's not only that Clyde steals the ball, but that he makes them think he's about to steal it, and that he can steal it any time he wants to," Frazier's backcourt partner Bill Bradley noted.[12]

Frazier also played a game of deception, finesse, and improvisation. He was a trickster on the court, conjuring the clever, yet unlikely heroes of Black southern folklore. "I don't believe in contact defense," he told *Sport* magazine in 1971. "I stay back from them, not up close. My philosophy is, I like to keep them guessing

↑ **WALT "CLYDE" FRAZIER** signs autographs in a New York City playground, 1970, photograph by Walter Iooss

where I am...It's like I'm playing possum, I'm there but I didn't look like I'm there."[13]

He enjoyed experimenting on offense. On the attack, he could change up his tempo in an instant. "He comes down lollygagging around and before you know it he zips to the basket or puts up a jumper," fellow NBA guard Don Chaney said.[14] Adding to his reputation, Frazier and his teammates crafted and spread apocryphal stories of his extraordinary reflexes and laserlike precision.

"He can take the sugar out of a cake...without disturbing a crumb of the cake," Knick center Willis Reed told *Black Sports* in 1973.[15] "Clyde is the only man who can strip a car while it's going forty miles an hour," Bill Hosket, another teammate, once claimed.

Frazier himself bragged about his hand speed in *Rockin' Steady*, recalling how he caught a cocktail glass in midair without spilling a drop while at a bar one night. He even provided two pages of diagrams detailing how to catch a fly with your bare hands.[16] Bringing together the southern trickster tradition with the swagger of urban streetball, Frazier fashioned himself as a Black 1970s folk hero.

Yet Frazier's expression of Black basketball cool struck a fine balance between being free to experiment and maintaining focus and control. He put function before style on the court. "I use fancy stuff only when I have to, when it's necessary," he told young players in his treatise on cool. If tricks had no purpose, then they were just "wasted motion." Playing good basketball was about "being under control" and above all, "making the play."[17]

Indeed, it was off the court that Frazier's flamboyance found its purest expression—especially in his carefully curated fashion choices and other forms of conspicuous consumption. He came by his fastidious sense of style early on in life. As a tween, he washed his sneakers with soap and a brush every night so they would be clean and white for school the next day. "I remember being very exact how I laced them up when I went to play basketball in the dirt schoolyard in Atlanta," Frazier reminisced. "This was when my sneakers were the hottest item in my wardrobe."[18] As an NBA player, he took his style to another level. It became the cornerstone of his personal brand of Black cool. His Black fans embraced his flair as an expression of Black pride. And, as long as his on-court performance was up to par and he remained silent on Black politics, white fans eagerly consumed his "exotic" form of Black masculinity.

During his years with the Knicks, his fashionable lifestyle was the subject of many magazine articles. In June 1970, *Sport* magazine featured him in a four-page fashion spread.[19] The pictorial showed Frazier enjoying a life of leisure, wearing the latest colorful styles next to a beautiful Black woman. Sportswriters detailed his vast and expensive wardrobe of vibrant, tailor-made suits, wide-brim hats, fur coats, and lizard and alligator shoes. They described his penthouse apartment on Manhattan's east side—a space he had difficulty getting co-op board approval to move into—as a residence of grandeur.[20]

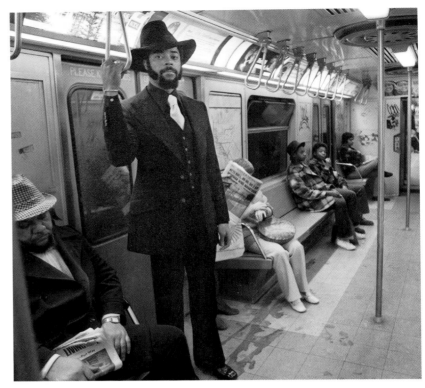

↑ **WALT "CLYDE" FRAZIER** rides the subway to work, 1974, photograph by Richard Drew

NEW YORK IS MASS MEDIA. IT'S WHERE IT ALL HAPPENS.

His living room had a red plush carpet, a black baby grand piano, curved, armless sofas, and two coordinating chairs in black and red. His bedroom had wall-to-wall shag carpet, a round bed with mink bedspread, purple walls, and round mirrors on the ceiling.[21] Frazier also owned a 1965 Rolls-Royce with red leather seats and a two-tone body, though on game days he preferred to take the subway to Madison Square Garden to avoid the hassle of driving. Beyond the sporting press, *Esquire* magazine's fashion panel voted him the "Best Dressed Jock," while *Pageant* magazine named him one of the "10 Sexiest Athletes."[22] Frazier recognized the central role of New York City, America's fashion and finance capital, in the making of his Black cool persona. "In any other city I might not be Clyde," Frazier noted. "New York is mass media. It's where it all happens."[23]

As Clyde, Frazier became a Black icon against the complicated economic backdrop of the 1970s. As the first decade after the civil rights victories of the 1960s, it was a moment of great promise and stagnation for Black Americans. The Black professional classes began to find more acceptance and success in mainstream society. Yet the urban crisis caused by white flight and deindustrialization also deepened. With the loss of industry and tax dollars, Black inner-city neighborhoods became sites of concentrated and persistent poverty, decaying housing and infrastructure, concentrated crime and violence, and a host of related social problems. The energy crisis and economic recession further complicated conditions. By 1973, just as the recession hit, Frazier was earning around a quarter of a million dollars a year from the Knicks. He became a beacon of hope amid desperation for some and a model of Black upward mobility amid new opportunities for others.

Frazier was one of the most visible examples of an urbane Black professional man. After *Black Sports* published a feature on him in 1973, Shirley Ann Collier, a reader from Chicago, requested more stories like it. "I hope you will continue to publish those articles on our *Beautiful* men," she wrote to the magazine. "After all, the white press is forever coming up with a bad image of our people."[24] One cannot help but see Frazier's influence in the pages of *Black Sports*, the first major sports magazine dedicated to covering Black athletes and targeting Black fans in the 1970s.[25] Alongside travel, car, and business features, *Black Sports* began publishing a style series called "Peacock Alley" in 1973. "To the Brother, fashion is a feeling, an expression of pride," *Black Sports* explained. "It's just as much a style of manner as it is a style of dress. It's knowing he's right down to the subtleties like shirt buttons and shoe texture."[26] Rather than following the trends, the fashionable Black man was his own authority. He led and never followed. A subsequent style pictorial noted that even as the Black professional man began to "infiltrate the primarily non-minority bastion of big business," he still retained "that unmistakable flair indicative of and vital to his very being."[27] This was Clyde in a nutshell—an archetype of Black cool to be emulated.

↑ **WALT "CLYDE" FRAZIER** in his bedroom, 1971, photograph by Walter Iooss

His mystique continued to grow. Frazier was recognized wherever he went, as he hobnobbed with New York's "beautiful people." His name appeared in gossip columns, as they speculated about his romantic life. He did not seem to mind the attention. "I enjoy being recognized," Frazier told *Black Sports*. "I can remember when I wasn't recognized." He was happy to stop for autographs. Living in New York City had not made him cold, but it had taught him two important lessons: "Never trust anybody and save your money."[28]

How he saved and made money became another hallmark of Frazier's embodiment of the rising Black businessman of the 1970s. Instead of paying for his wardrobe, he saved money by parlaying his personal style into endorsement deals with various fashion brands. While out on the town, he wore furs by Ben Kahn, suits by George Elliott, and shoes by The Blacksmith.[29] Ripley Clothes of Brooklyn made him their "fashion development coordinator" and "walking trademark."[30] Frazier eventually turned this personal branding strategy into a moneymaker as he sold everything from Puma shoes to Pioneer stereo systems to Colgate toothpaste. Although shut out of the more lucrative endorsement deals held by his white teammates Dave DeBusschere and Jerry Lucas, what Frazier managed to accomplish was unprecedented for a Black basketball player.[31]

As an athletic entrepreneur, Frazier created a personal business empire that supplemented his Knicks salary with diversified streams of income. He published two autobiographical books, *Clyde* (1970) and *Rockin' Steady* (1974). He had an interest in several businesses, including a hair salon, a liquor store, and a boys' basketball camp.[32] He was also the president of Walt Frazier Enterprises (WFE), a full-service athlete management company that he formed in partnership with Irwin Weiner.[33] WFE represented athletes in contract negotiations, helped them with financial investments, offered them legal services, and arranged their promotions, endorsements, and personal appearances. Frazier had started the business to help other players like him to be more financially secure. "I feel there's a need to help the Black athlete," Frazier contended. "Most of us haven't had any financial background at all and I've been successful. And a lot of guys desperately need the service. You'd be surprised at how some of them get burned—even some of the old pros."[34] For Frazier, the ultimate of Black cool was to live a good life without always having to worry about money.

Despite these accomplishments, Frazier's popularity in New York City, especially among white fans, remained dependent on how well the Knicks were playing. As the team began to fall in the standings in the mid-1970s, so too did Frazier's appeal. His seeming nonchalance on the court was praised when the Knicks were winning championships. But this same behavior garnered sharp criticism when they began to lose. His lucrative contract (by the late 1970s he was earning around $400,000 a year) and conspicuous consumption became liabilities as the Knicks fell in standing. Moreover, both his on-court and off-court expressions of Black cool ran in the face of the "traditional" American values of hard work, restraint, and thrift, particularly in the context of 1970s stagflation and deindustrialization, and the emergence of the "silent majority." By the 1976–77 season, Knicks fans had taken to booing and heckling him at games, while New York sportswriters regularly blasted him in the press.[35] A convenient scapegoat for the Knicks' fall, Frazier was unceremoniously traded to the Cleveland Cavaliers in 1977.

His talents diminished by foot injuries, he played out his final years in Cleveland. In retirement, Frazier continued to live with a sense of flair, while wearing many business hats. He was a player agent, part owner of a franchise in the now-defunct United States Basketball League, and later a charter-boat captain in the US Virgin Islands. After Hurricane Hugo destroyed his home and boat in 1989, he moved back to New York City, where he became a commentator on Knicks' broadcasts.[36] Now, over four decades since his playing days, any criticism of him has been replaced with nostalgia for his athletic feats with the championship-winning Knicks team of the early 1970s. Frazier's trademark expression of Black New York cool, unmatched during his heyday, also remains a striking part of his mythology. Not only does he continue to make money off of it, but it has paved the way for subsequent Black basketball stars' embrace of coolness and confidence, extravagance and exuberance, both on and especially off the court.

↓ WALT "CLYDE" FRAZIER with his new book,
Rockin' Steady, 1974, photograph by Dave Pickoff

THERESA RUNSTEDTLER is associate professor in the Department of History and the Critical Race, Gender, and Culture Studies Collaborative at American University. A scholar of African American history, her research explores the intersection of race and sport. She is the author of *Jack Johnson, Rebel Sojourner: Boxing in the Shadow of the Global Color Line*.

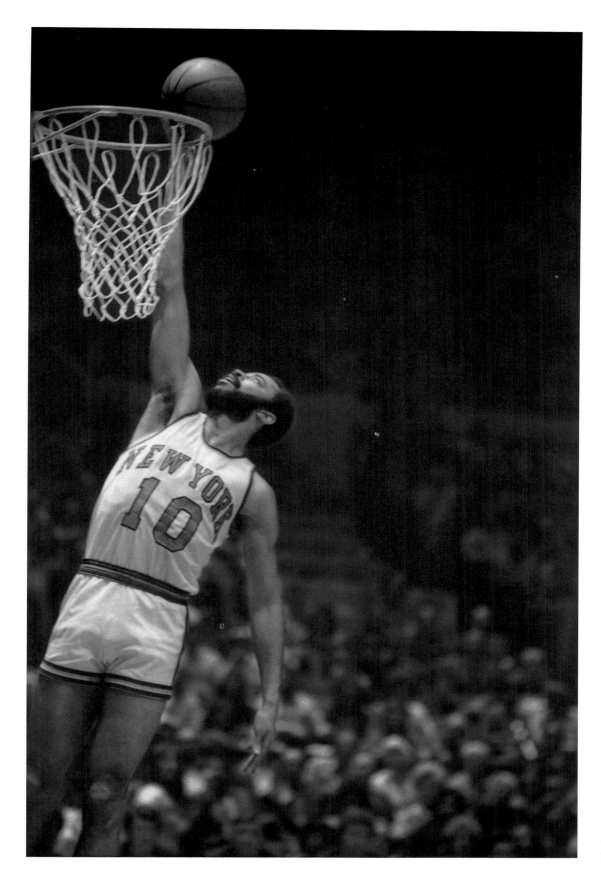

← **WALT "CLYDE" FRAZIER #10** of the Knicks, 1973, photograph by George Kalinsky

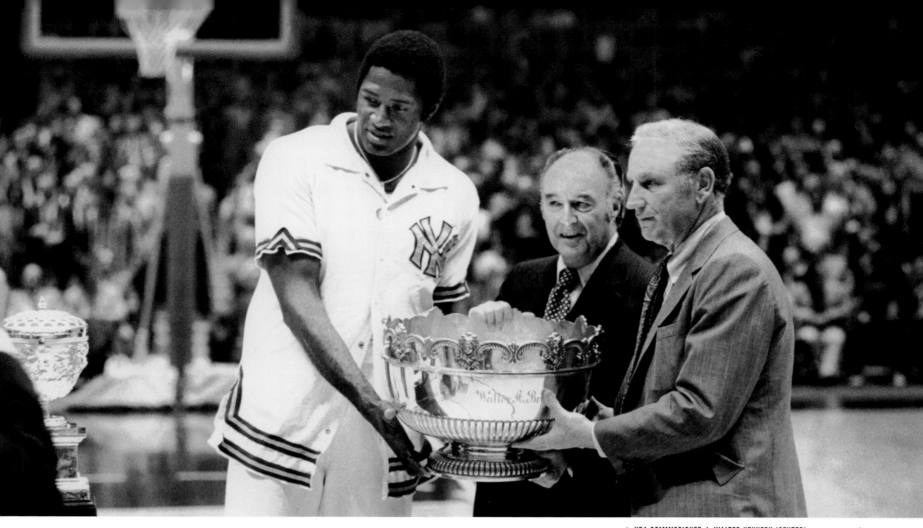

↑ **NBA COMMISSIONER J. WALTER KENNEDY (CENTER)** presents the Walter Brown Memorial Trophy to Willis Reed and Red Holzman, 1970, photograph by George Kalinsky

KNICKS WIN THE CHAMPIONSHIP 1970 & 1973

On January 12, 1969, Joe Namath's Jets took Superbowl III; in October, the Miracle Mets took the World Series; and in April 1970, the Knicks faced the Lakers in the NBA Finals. Throughout the season the Knicks had been winning games and wowing crowds with defense-first, team-oriented play featuring Walt Frazier, Mike Riordan, Cazzie Russell, Bill Bradley, Dave DeBusschere, and, at center, Willis Reed. The Lakers were headed by Wilt Chamberlain at center, Elgin Baylor at small forward, and Jerry West at guard.

The Knicks won the first game at home, lost the second, took the third in overtime, only to be matched by the Lakers winning Game 4 in double overtime. Game 5 was a disaster: the Knicks won putting them a game from the championship but lost Willis Reed to a devastating muscle tear in his right thigh. Without Reed to match muscle against straining muscle with the impossibly strong Chamberlain, the Knicks lost Game 6 by 22 points.

Game 7—the Championship Game—was in the Garden. But how could they win without Reed? As Reed hobbled out of the locker room, his right leg dragged behind, stiff as a board. At the center jump, he didn't leave his feet, standing still as Chamberlain soared.

Yet the Knicks' first basket came on a Reed jump shot, and the next one as well. On defense, he formed a wall with his body, forcing Chamberlain just that few inches further from the basket to make him miss. And as Chamberlain gathered each pass, there were Frazier's probing hands, stealing the ball away. With Chamberlain stymied, Frazier took over the game, scoring 36 points, giving out 19 assists, and pulling down seven rebounds. The Knicks led by 27 at the half and the game was over.

In the 1972-73 season, the path to the championship ran through Boston, as the Celtics owned the best record in the league. In a tough Eastern Championship series that seemed to produce as many fouls and injuries as points, the Knicks took a three games to one lead, but the Celtics roared back to win Game 5 at home and Game 6 in New York. Once again a Game 7 would decide the series but this time the final game would be played in the Boston Garden, and in their entire history the Celtics had never lost a Game 7 at home.

Earl Monroe was matched against Jo Jo White, a key scorer, and was not doing well. After one quarter coach Red Holzman benched him for his roommate Dean Meminger, whose tight defense and speed turned the game around. The Knicks won 94-78. Meminger's play—and the balanced team in which all five starters averaged over 15 points a game for the series—were the essence of the great Knicks. Team play in which who scored did not matter carried the Knicks past the Celtics, and they went on to defeat the Lakers once again in five games. (SA, AA)

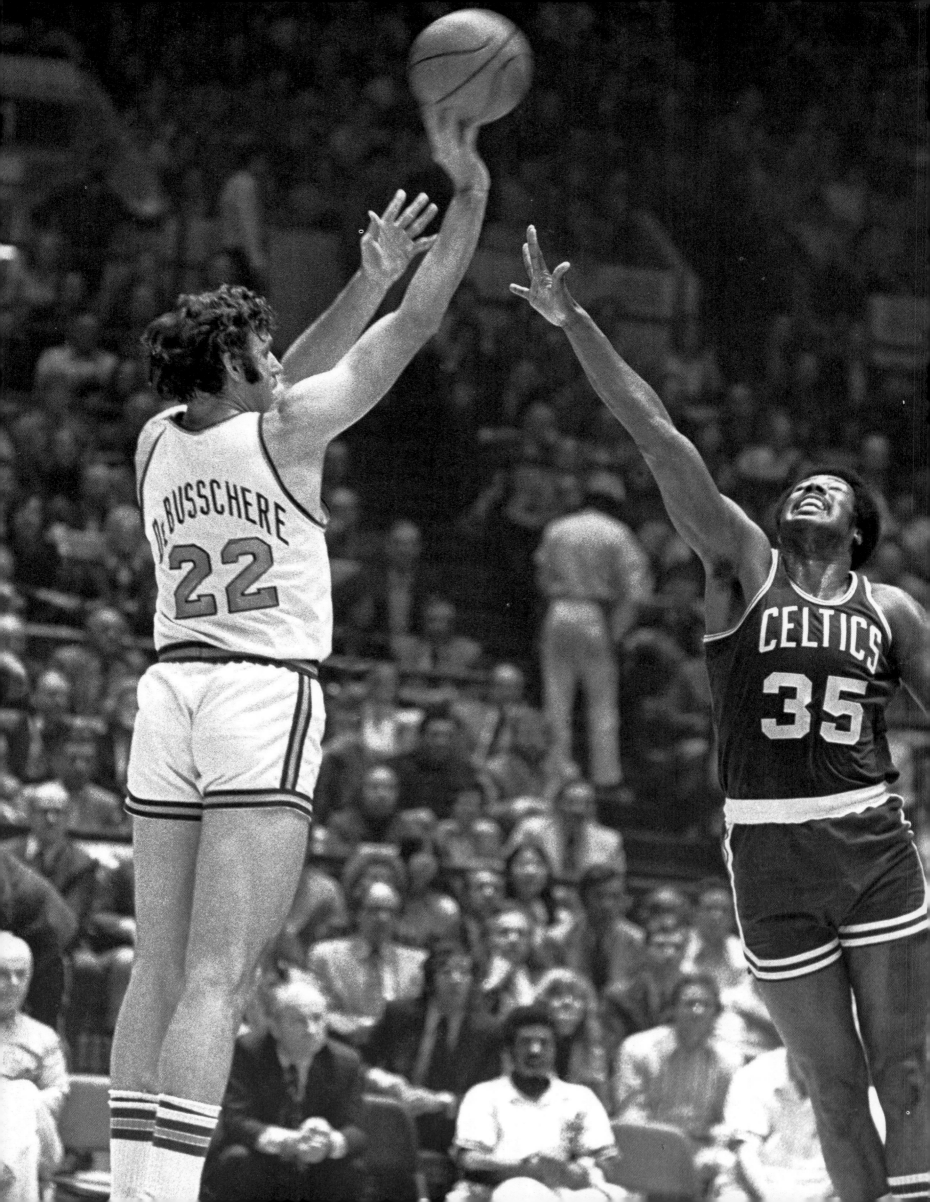

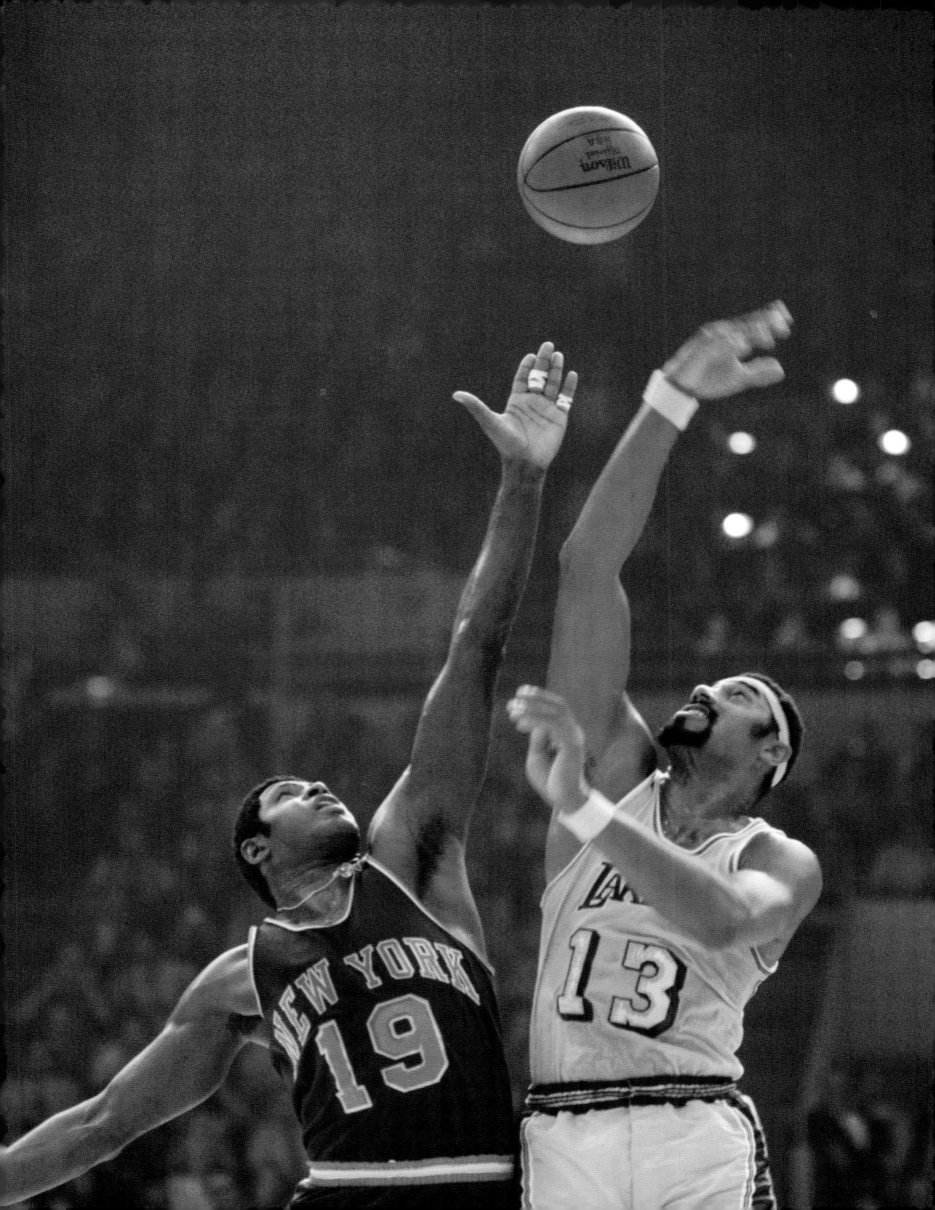

Page 146: **DAVE DEBUSSCHERE #22 OF THE KNICKS EVADES BOSTON'S PAUL SILAS #35** to take a shot, April 1973, photograph by George Kalinsky

Page 147: **NEW YORK'S WILLIS REED #19 AND LA'S WILT CHAMBERLAIN #13** fight for a tip-off in the NBA Finals, 1970, photograph by George Kalinsky

↑ **WILLIS REED'S** game-worn sneaker, 1970

↑ **WALT "CLYDE" FRAZIER'S** game-worn sneaker, 1972–73

↑ **DICK BARNETT'S** game-worn warm-up jacket, 1973

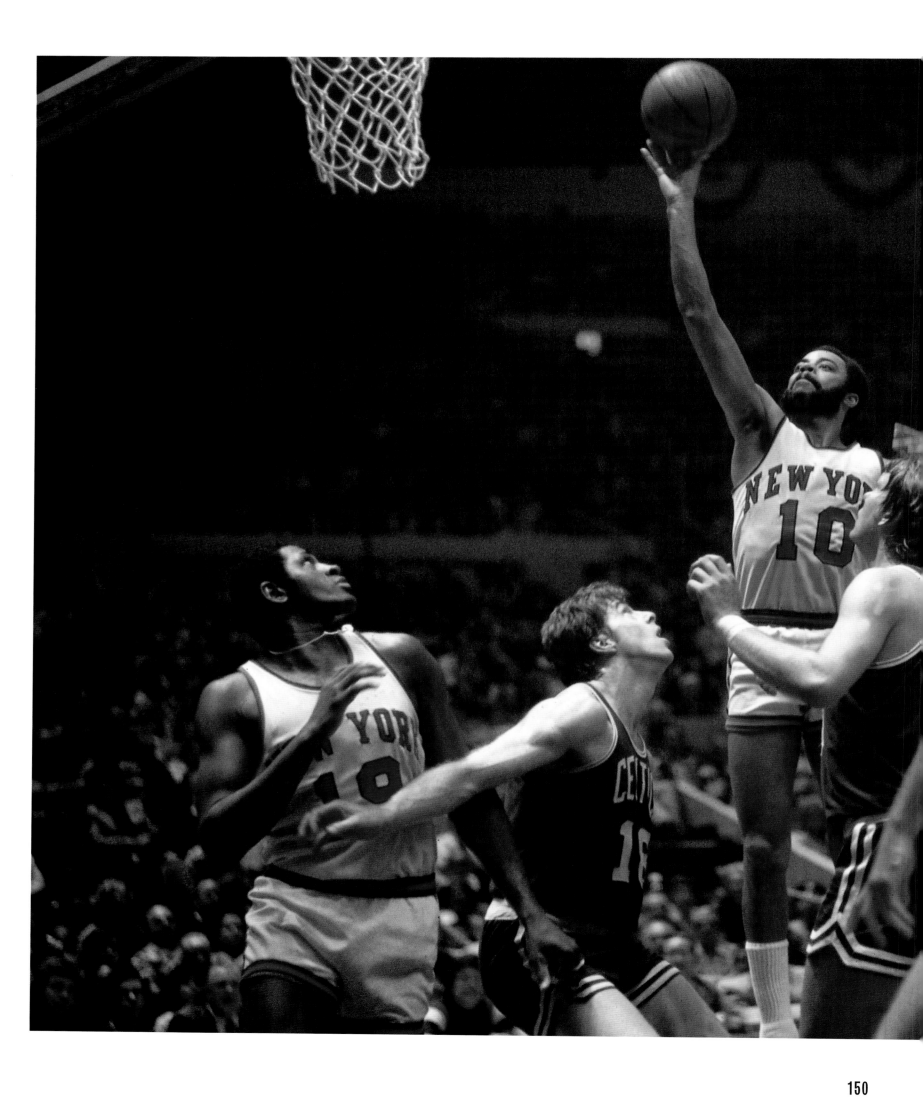

← **WALT "CLYDE" FRAZIER #10** of the Knicks shoots a layup against the Boston Celtics during the Eastern Conference Finals, Madison Square Garden, 1973, photograph by Dick Raphael

↑ TICKET TO PLAYOFF GAME 5, Madison Square Garden, 1973

↑ NEW YORK KNICKS CHAMPIONSHIP RING, 1970

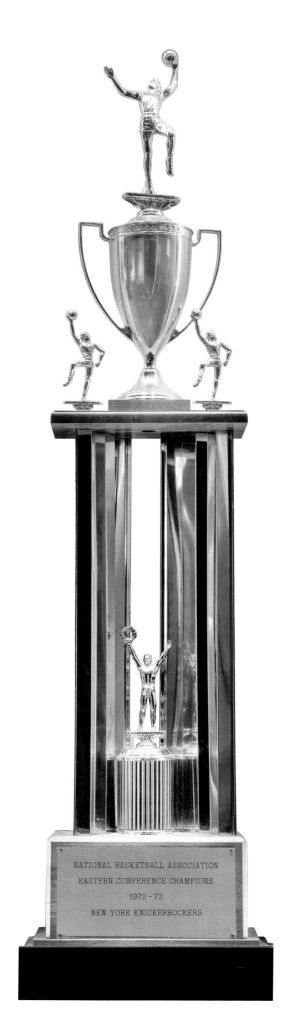

↑ NEW YORK KNICKS EASTERN CONFERENCE
CHAMPIONSHIP TROPHY, 1972–73

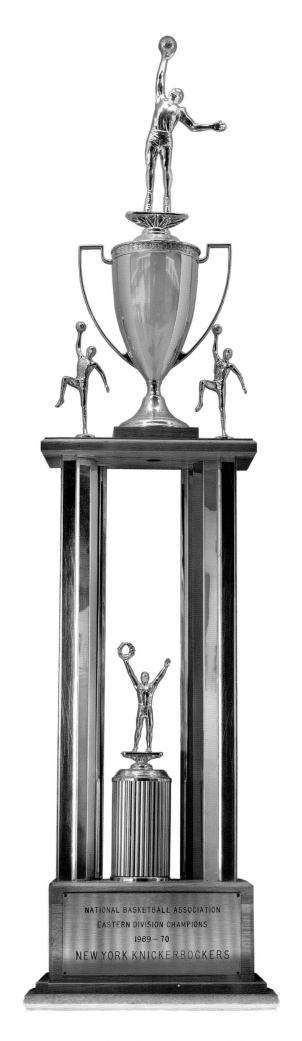

↑ NEW YORK KNICKS EASTERN CONFERENCE
CHAMPIONSHIP TROPHY, 1969–70

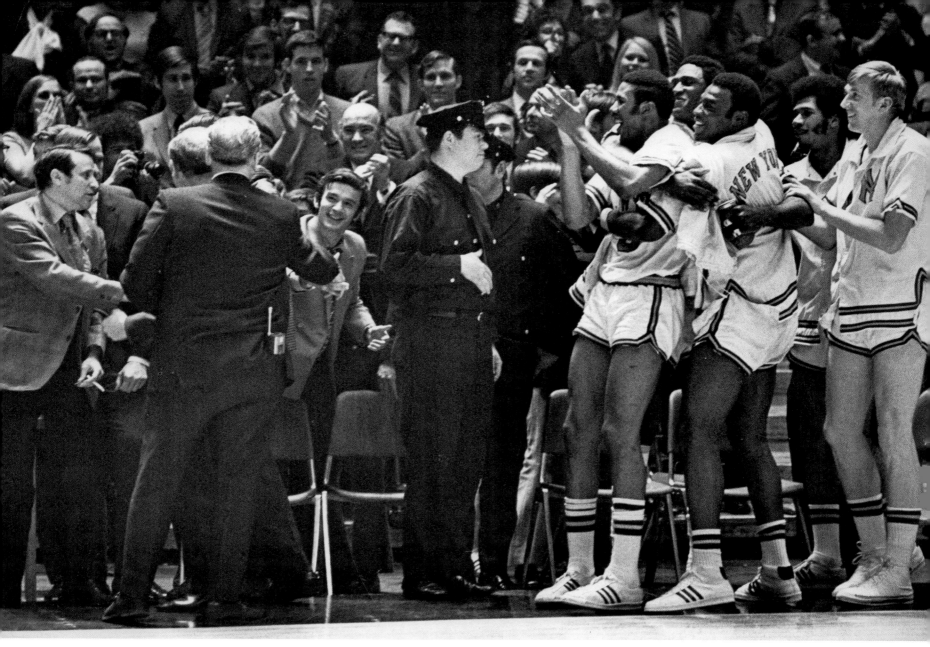

↑ KNICKS CELEBRATE WINNING THE NBA CHAMPIONSHIP,
1970, photograph by George Kalinsky

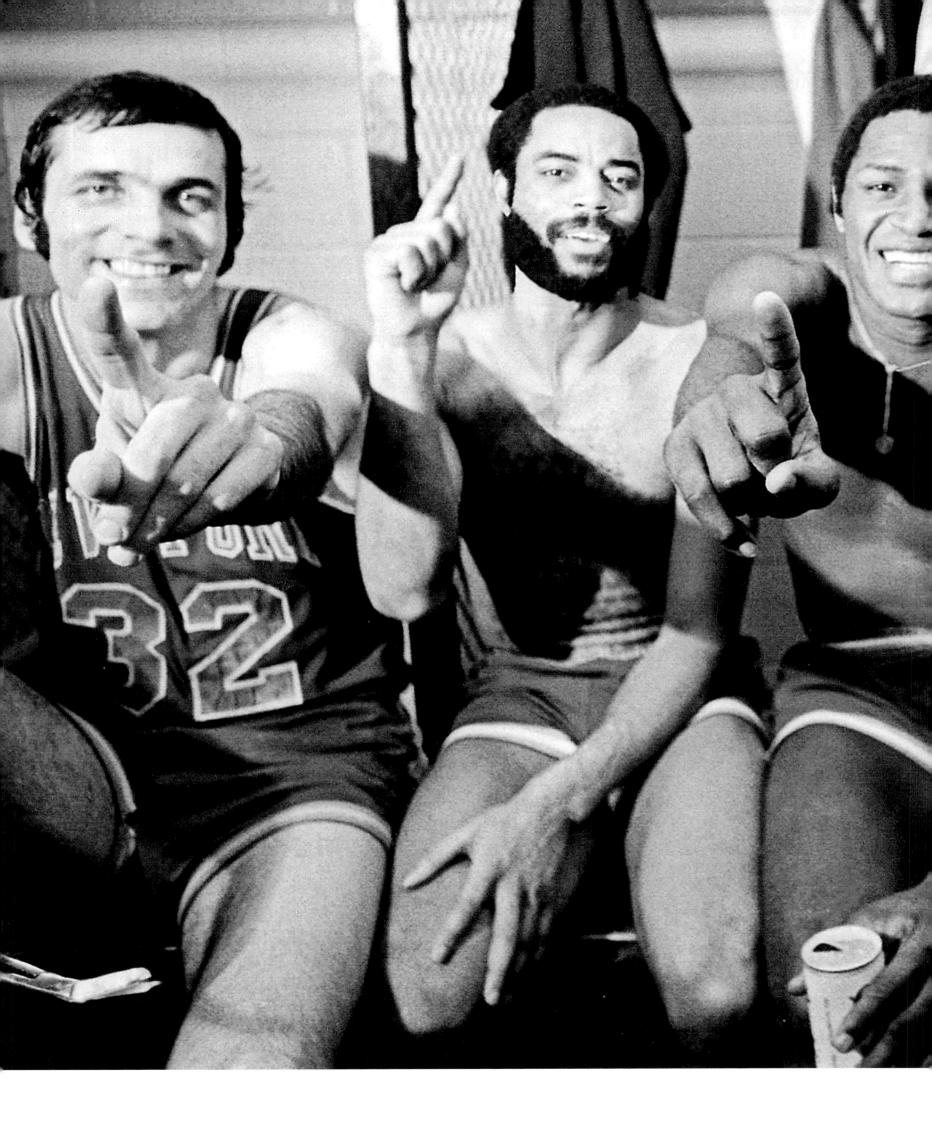

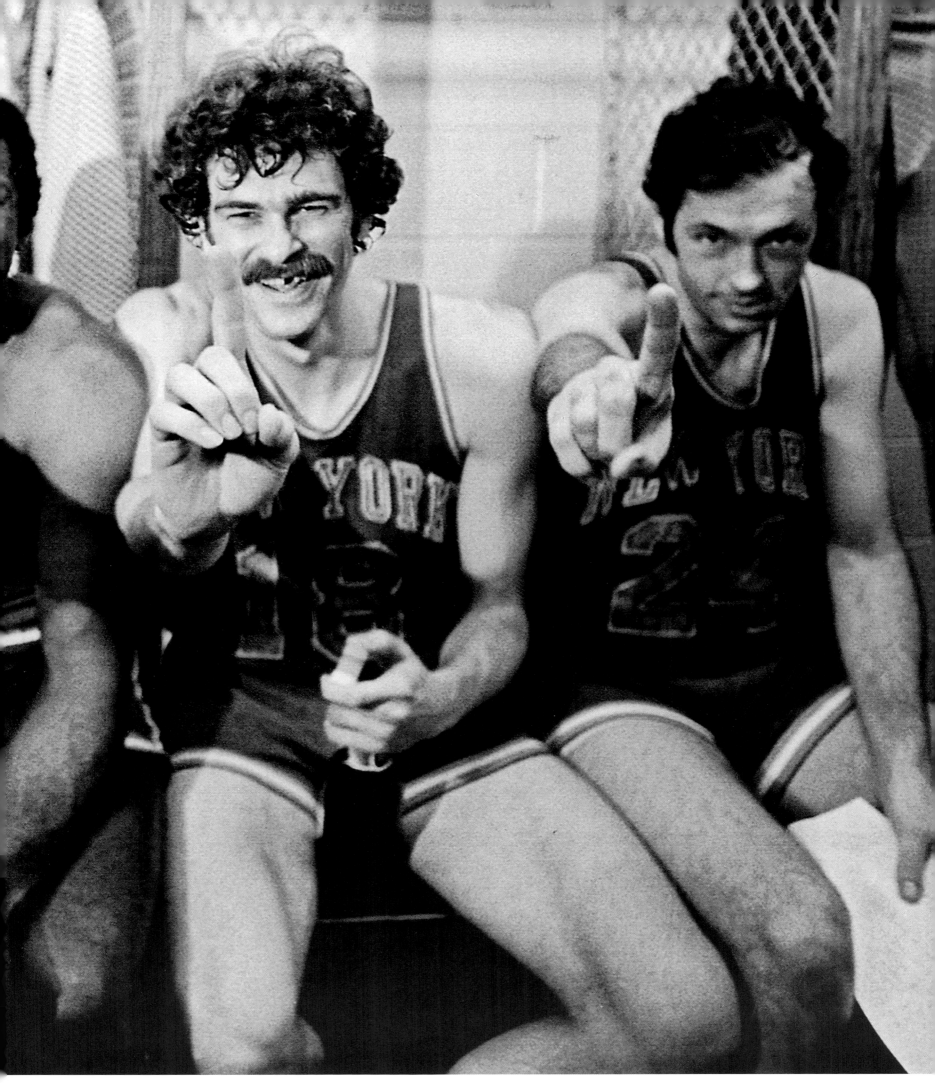

↑ JERRY LUCAS, WALT FRAZIER, WILLIS REED, PHIL JACKSON, AND BILL BRADLEY celebrate after defeating the Lakers for the NBA Championship, May 10, 1973, photograph by George Kalinsky

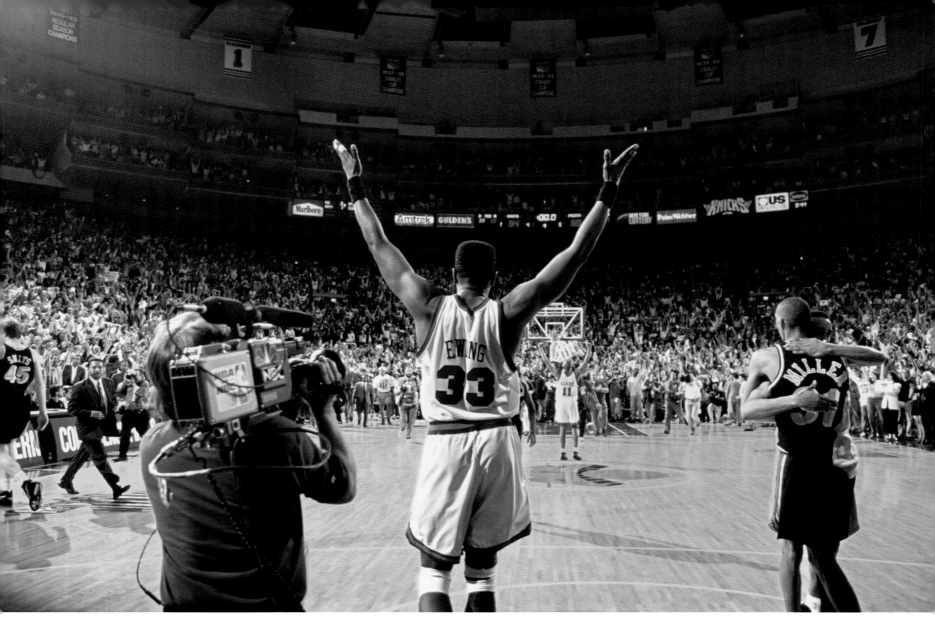

↑ **PATRICK EWING #33**, Game 7 of the NBA Eastern Conference Finals, Madison Square Garden, June 5, 1994, photograph by George Kalinsky

→ **PATRICK EWING #33**, NBA Playoffs, 1993–94, photograph by George Kalinsky

KNICKS, NETS & LIBERTY

New York's three home teams have seen their fair share of heartbreak and triumph, star players and disappointing finishes. Yet the fact that the Knicks have not reclaimed the NBA title since 1973 has not dimmed the enthusiasm of the city's die-hard fans, and the team still plays to raucous sell-out crowds at the Garden. With the arrival of Brooklyn's Barclays Center, which hosts games for both the Nets and the Liberty, New York fans now have two prominent venues for spectacular pro-basketball matchups. Today, the Knicks, Nets, and Liberty keep New York fans on the edge of their seats and maintain New York's role as a city with hoops in its heart. (LT)

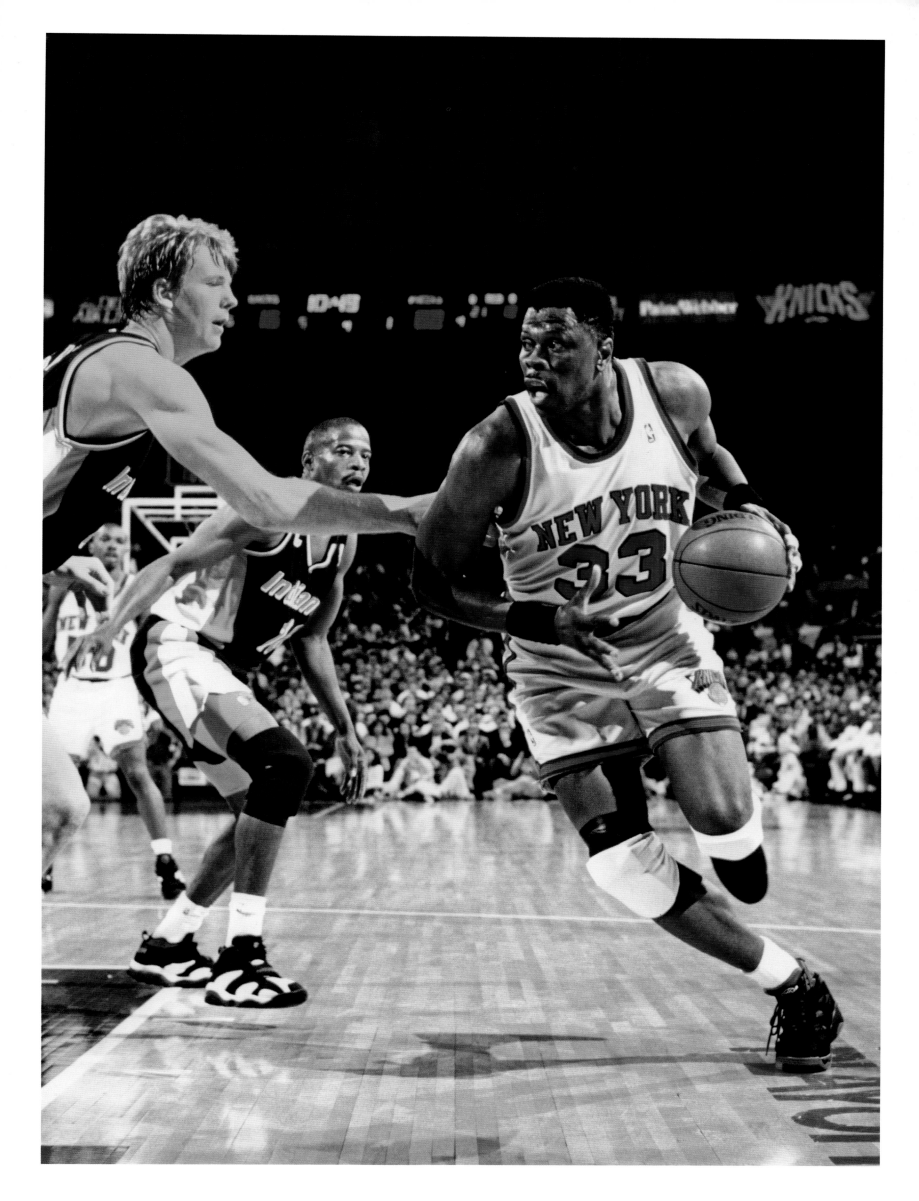

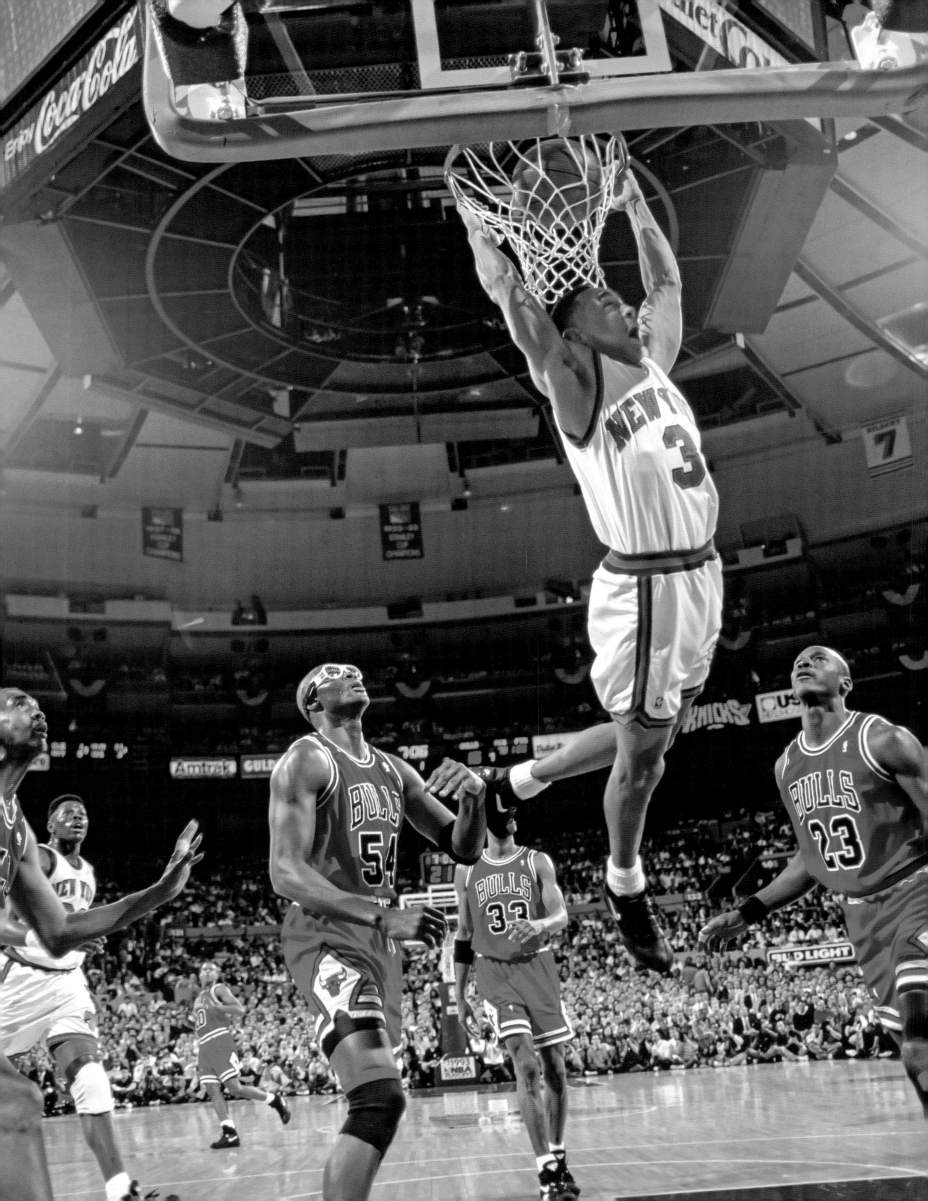

← JOHN STARKS #3 of the Knicks dunks against the
Chicago Bulls, NBA Playoffs, 1990s, photograph by
George Kalinsky

↑ KNICKS HEAD COACH PAT RILEY talks to his team during
Game 1 of the NBA Finals, 1994,
photograph by Andrew D. Bernstein

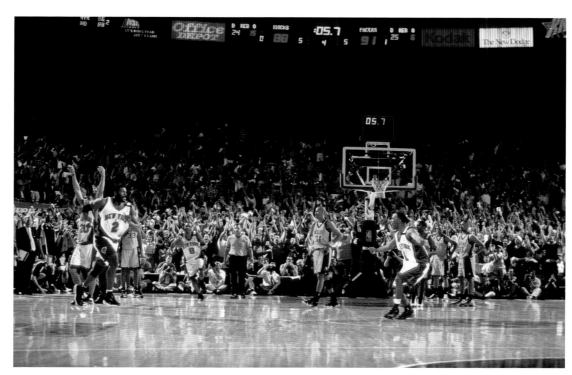

↑ IN A MOMENT KNOWN AS THE "LARRY JOHNSON 4-POINT PLAY,"
Johnson #2 is fouled as he sinks a 3-point shot,
and when he subsequently makes the foul shot he
gives the Knicks a 92–91 win over the Indiana Pacers
in Game 3 of the Easter Conference Finals, June 5,
1999, photograph by George Kalinsky

↓ **CARMELO ANTHONY'S** #7 career-high 62 points scored during this game against the Charlotte Bobcats broke Bernard King's 1984 60-point franchise record as well as Kobe Bryant's 2009 61-point Madison Square Garden record, January 24, 2014, photograph by Jeff Zelevansky

→ *FLOW STATE (DENNIS)*, 2019, photograph by Elena Parasco for the New York Knicks. Dennis Smith, Jr. was traded to the Knicks in January 2019.

← **JOHN STARKS #3** of the Knicks dunks against the Chicago Bulls, NBA Playoffs, 1990s, photograph by George Kalinsky

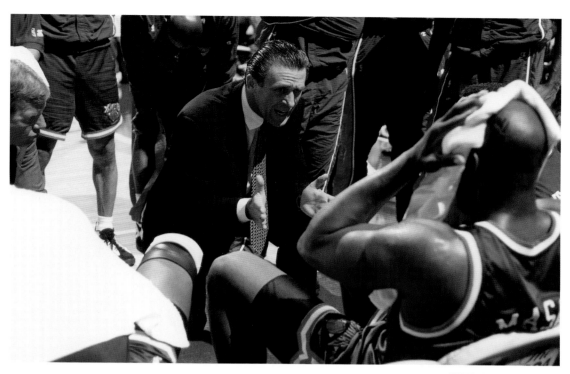

↑ **KNICKS HEAD COACH PAT RILEY** talks to his team during Game 1 of the NBA Finals, 1994, photograph by Andrew D. Bernstein

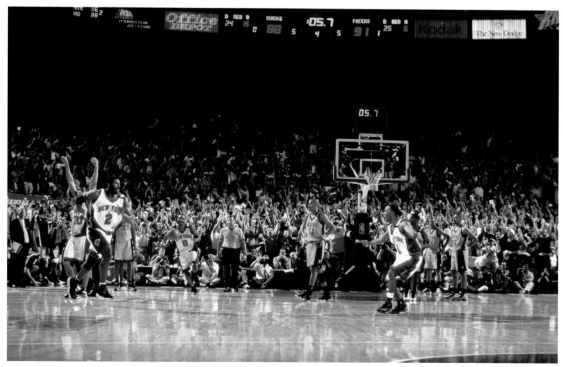

↑ **IN A MOMENT KNOWN AS THE "LARRY JOHNSON 4-POINT PLAY,"** Johnson #2 is fouled as he sinks a 3-point shot, and when he subsequently makes the foul shot he gives the Knicks a 92–91 win over the Indiana Pacers in Game 3 of the Easter Conference Finals, June 5, 1999, photograph by George Kalinsky

↓ **CARMELO ANTHONY'S #7** career-high 62 points scored during this game against the Charlotte Bobcats broke Bernard King's 1984 60-point franchise record as well as Kobe Bryant's 2009 61-point Madison Square Garden record, January 24, 2014, photograph by Jeff Zelevansky

→ *FLOW STATE (DENNIS)*, 2019, photograph by Elena Parasco for the New York Knicks. Dennis Smith, Jr. was traded to the Knicks in January 2019.

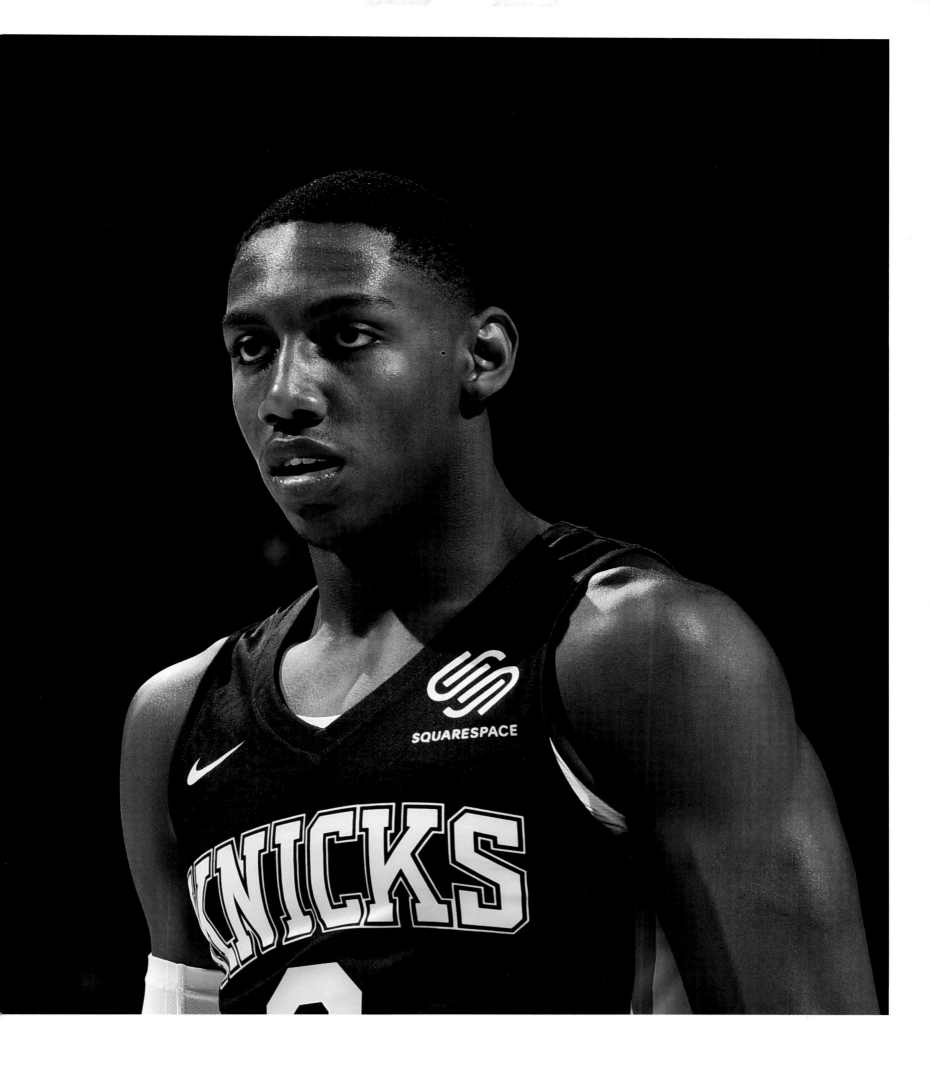

↑ R. J. BARRETT #9 of the Knicks, 2019,
photograph by Garrett Ellwood

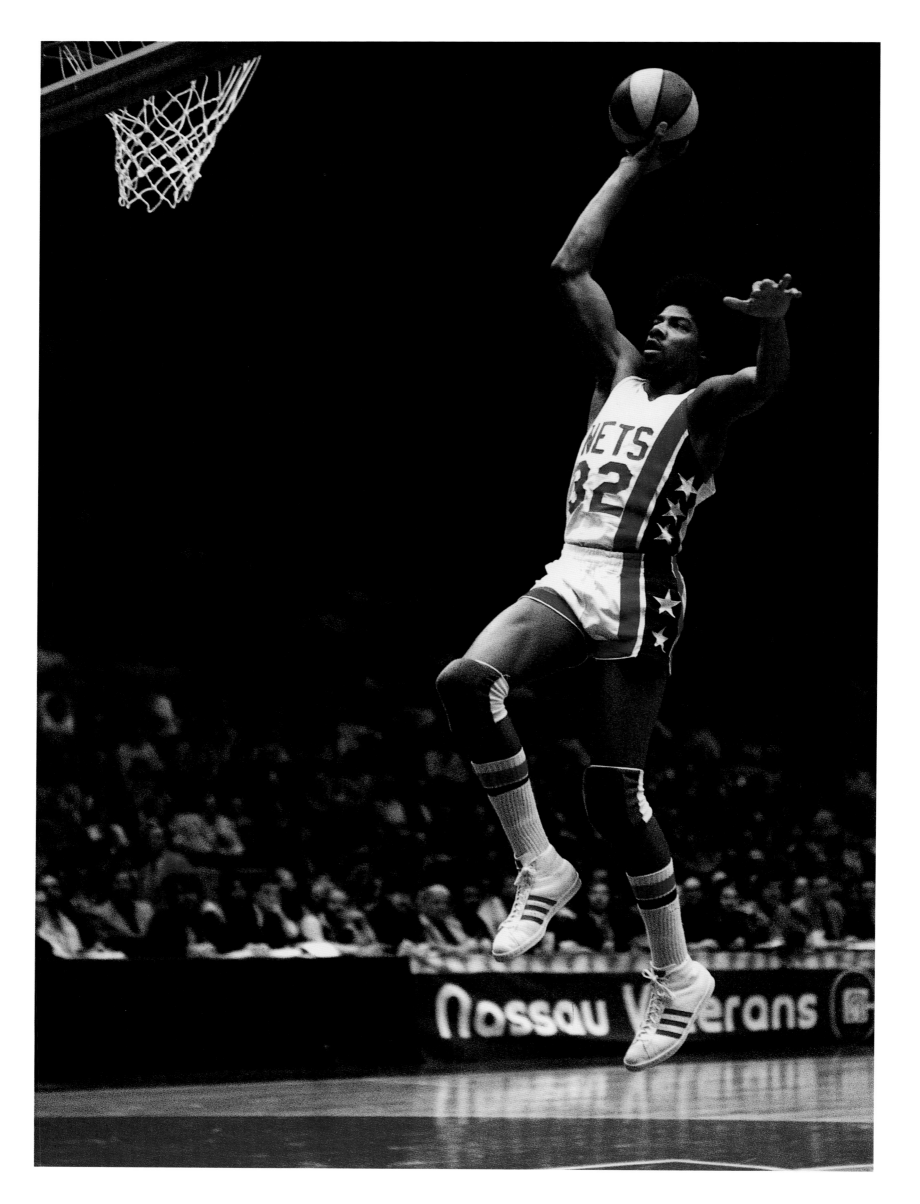

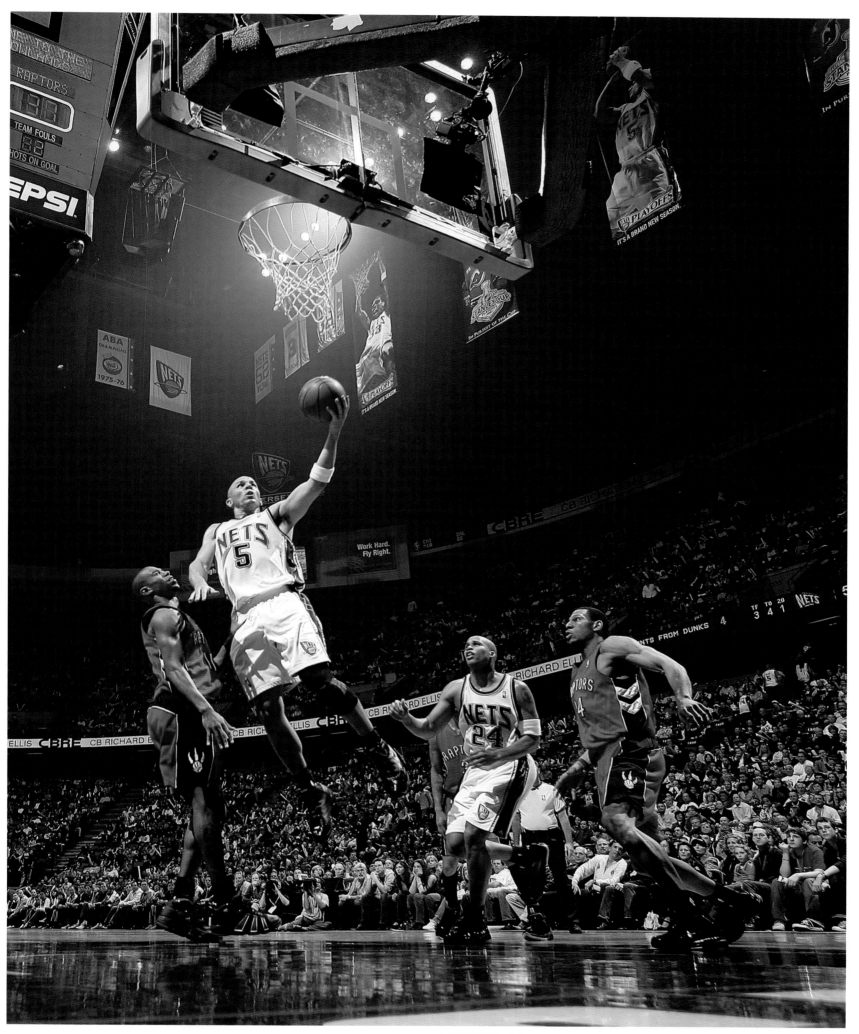

↑ JASON KIDD #5 of the New Jersey Nets shoots against T. J. Ford #11 of the Toronto Raptors, Game 3, Eastern Conference Quarterfinals, 2007, photograph by Jesse D. Garrabrant

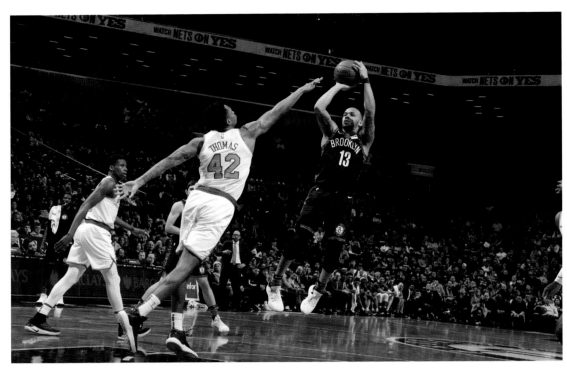

↑ **SHABAZZ NAPIER #13** of the Brooklyn Nets shoots against Lance Thomas #42 of the Knicks at the Barclays Center, 2019, photograph by Nathaniel S. Butler

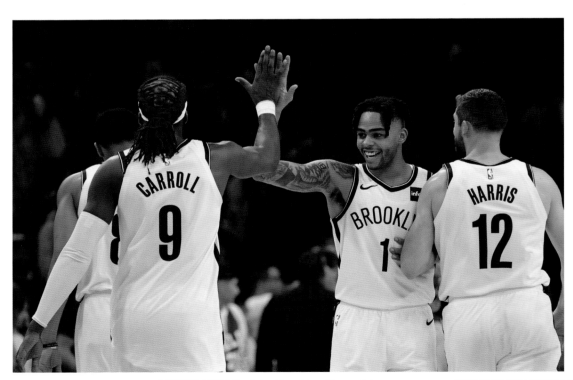

↑ **D'ANGELO RUSSELL #1** of the Brooklyn Nets celebrates with teammates DeMarre Carroll #9 and Joe Harris #12 after beating the Philadelphia 76ers 111–102 during Game 1 of the first round of the playoffs, 2019, photograph by Drew Hallowell

→ **KEVIN DURANT (LEFT) AND KYRIE IRVING,** NBA All-Star practice, 2019, photograph by Andrew D. Bernstein. In July 2019 the two players signed with the Brooklyn Nets, bringing a wave of excitement to New York fans.

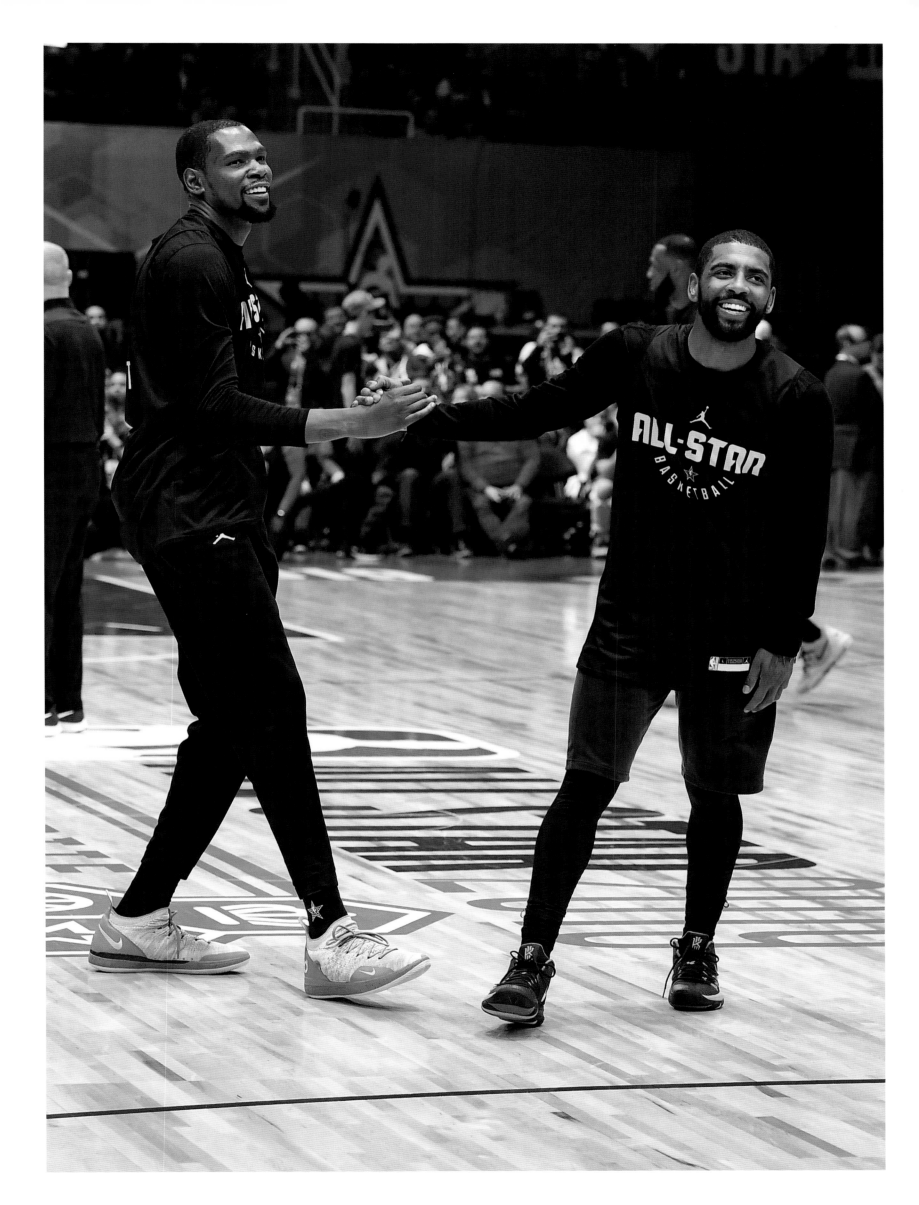

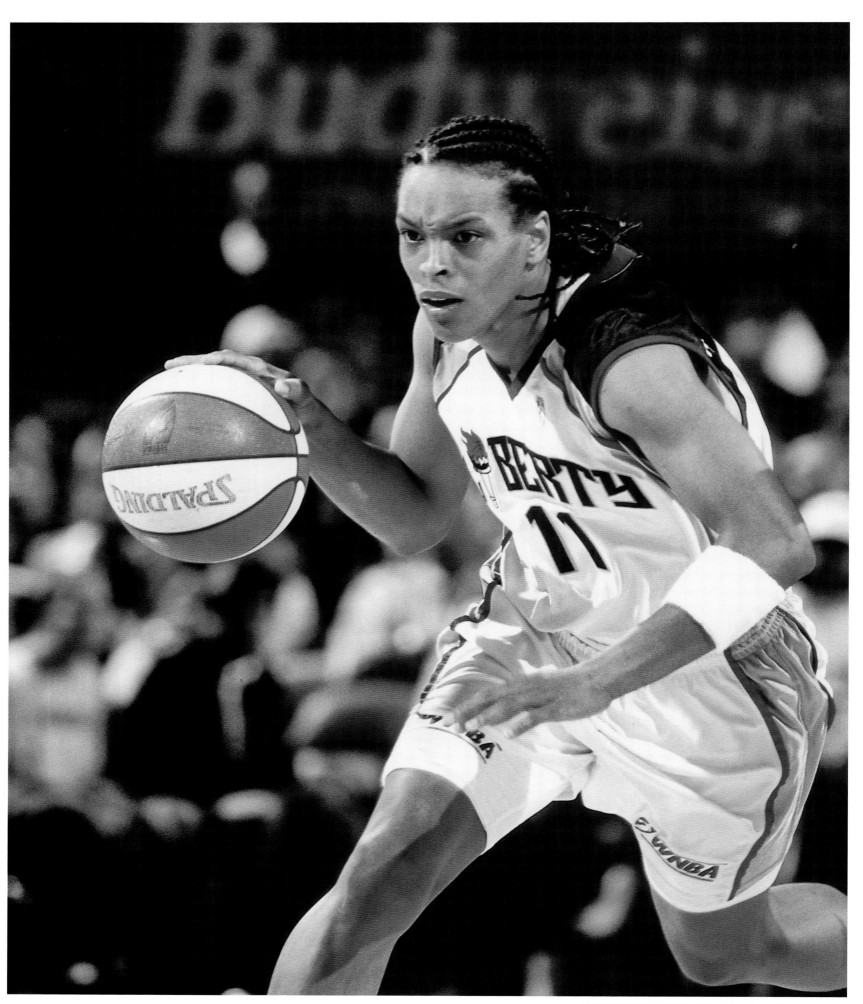

↑ TERESA WEATHERSPOON #11 of the New York Liberty,
Madison Square Garden, 1997,
photograph by Nathaniel S. Butler

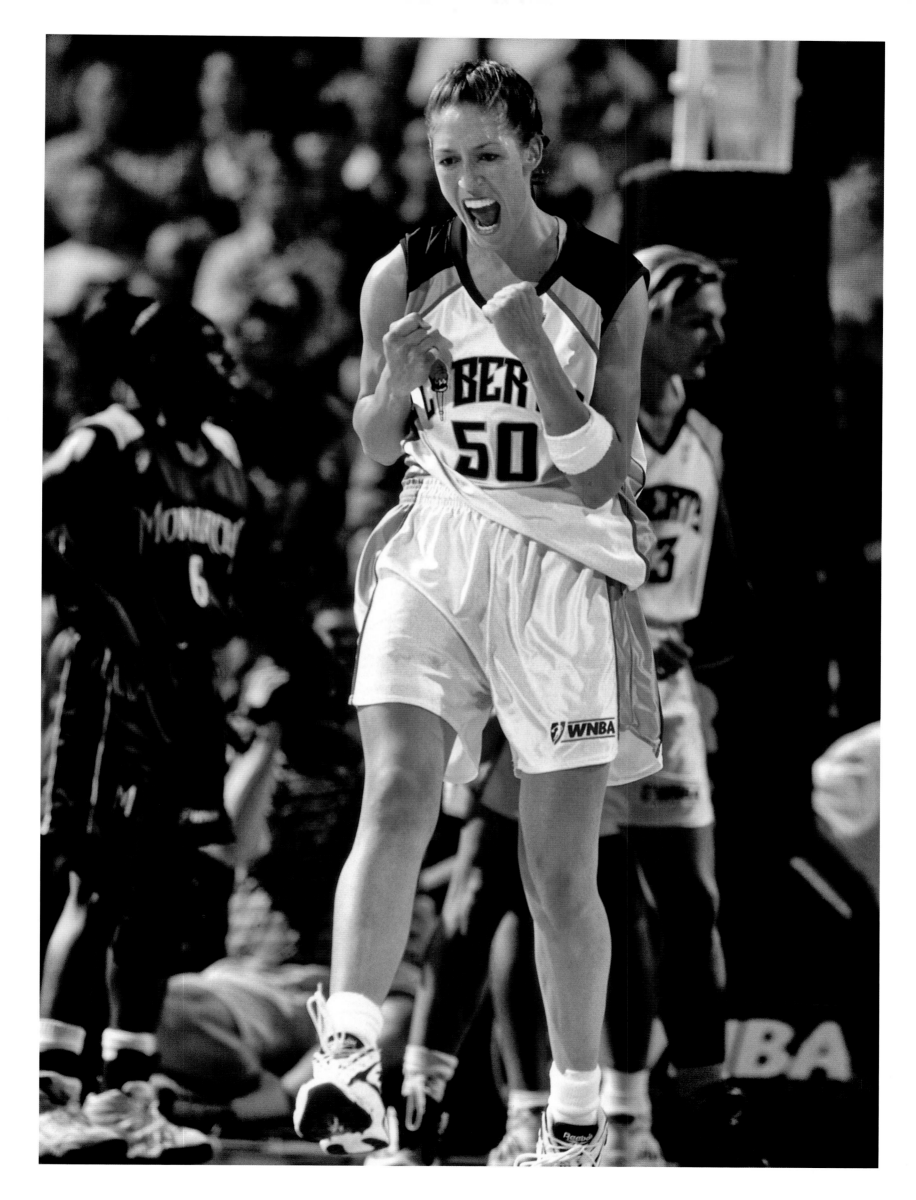

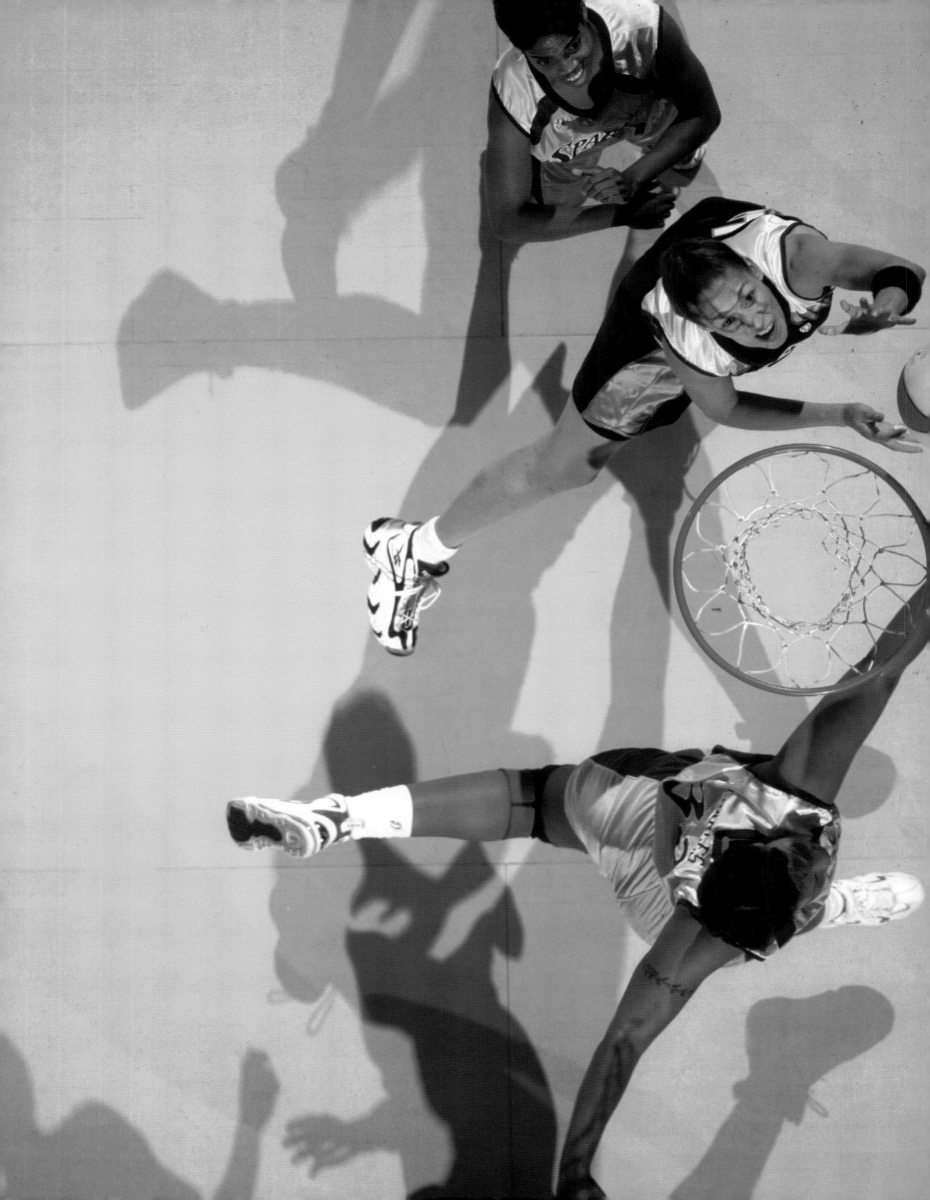

← REBECCA LOBO #50 of the Liberty shoots
a layup during the inaugural WNBA game against
the Los Angeles Sparks, June 21, 1997,
photograph by Andrew D. Bernstein

↑ WNBA BASKETBALL signed by the inaugural New York
Liberty team, 1997

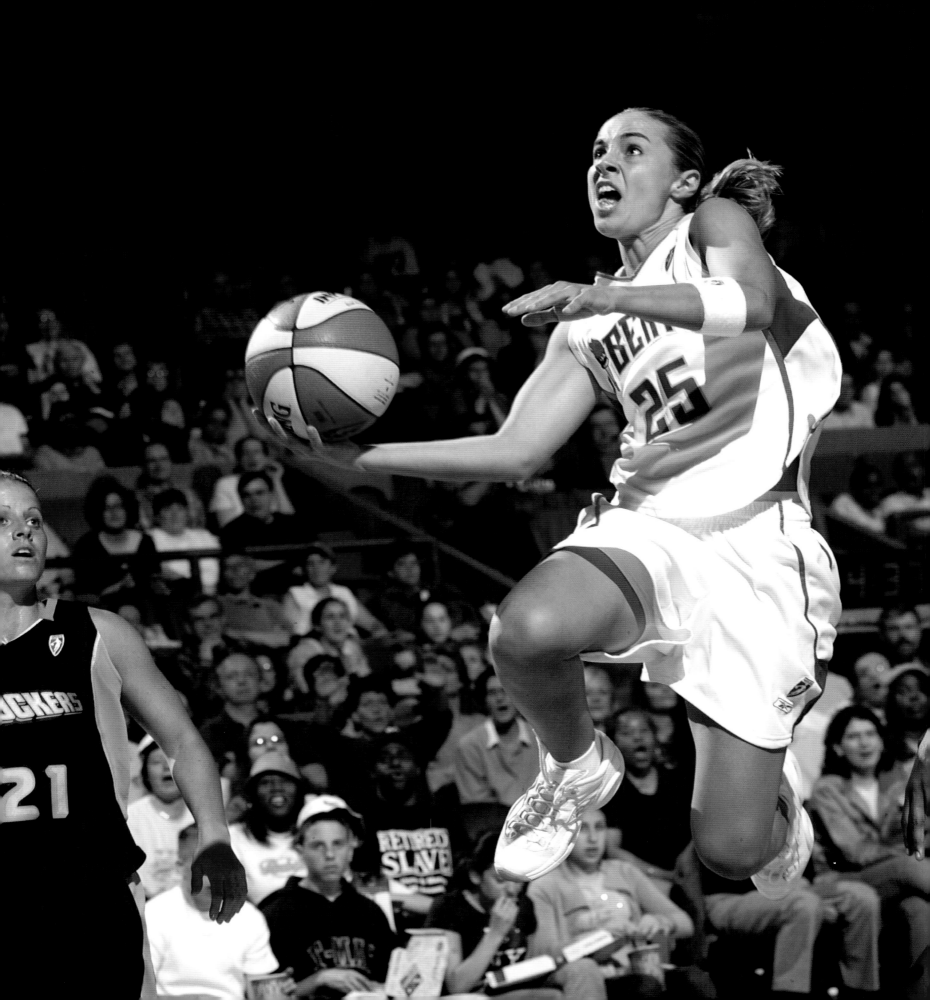

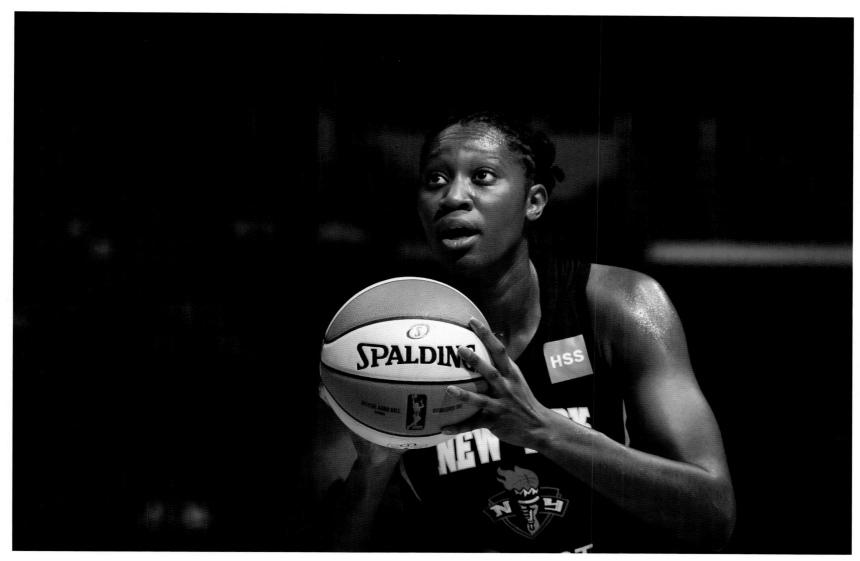

↑ **TINA CHARLES #31** of the Liberty, 2019, photograph by Juan Ocampo. While at Christ the King High School in Queens, Charles was the leading scorer on a team that won 57 consecutive games.

← **BECKY HAMMON #25** of the Liberty, Madison Square Garden, 2003, photograph by Jesse D. Garrabrant. A former Liberty point guard and cocaptain, Hammon was the second woman to serve as a coach for the NBA.

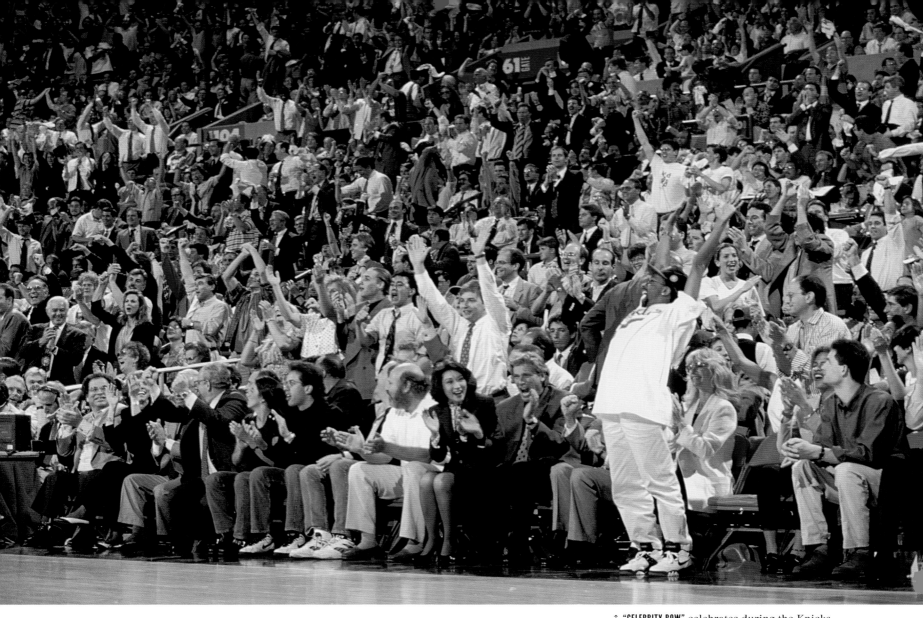

↑ **"CELEBRITY ROW"** celebrates during the Knicks playoff run at Madison Square Garden, 1994, photograph by George Kalinsky

CELEBRITY ROW

"What's the use in seeing something amazing if you can't turn to somebody you like, respect, care about, and say 'Did you see that? Do you believe it?'"—Spike Lee

What do Paul Simon, Spike Lee, Rihanna, and Jerry Seinfeld have in common? They've all sat courtside at one of New York's famous arenas. Showing up courtside to cheer for the Knicks, the Nets, or the Liberty, whether in one of the six prime seats the Garden calls "Celebrity Row" or in season tickets held for years, famous fans help make New York City a mecca of basketball. As Knicks fan and rapper Fat Joe (Joseph Cartagena) said, "We are true basketball fans. No matter what—rain, sleet, or snow, or even if we don't make it to the playoffs for 10 years—the Garden stands are still full." (LT)

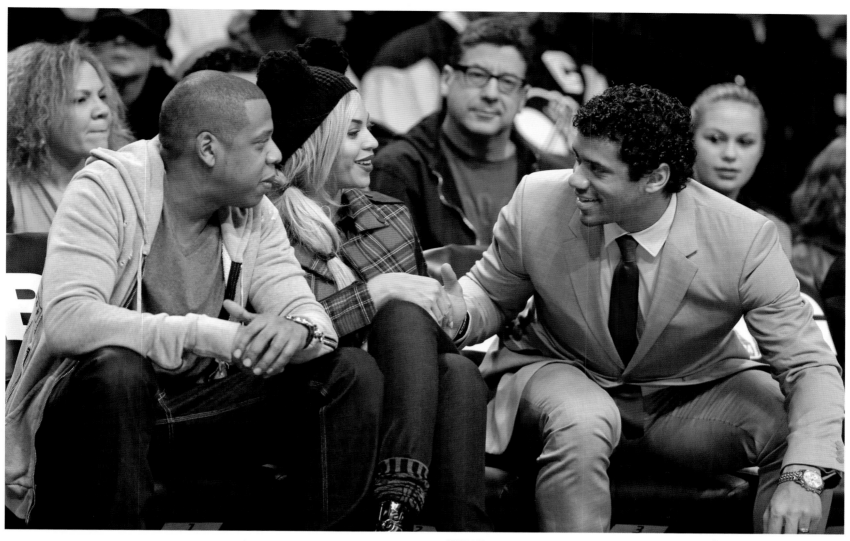

↑ **SEATTLE SEAHAWKS QUARTERBACK RUSSELL WILSON WITH JAY-Z AND BEYONCÉ** at Barclays Center for a Brooklyn Nets game, February 3, 2014, photograph by Kathy Willens

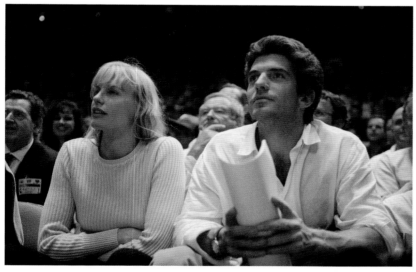

↑ **DARYL HANNAH AND JOHN F. KENNEDY JR.** sitting courtside at the Garden, June 12, 1994, photograph by Amy Sancetta

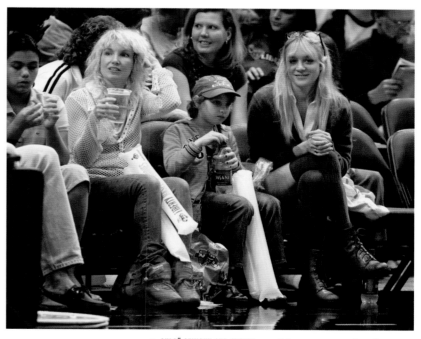

↑ **CHLOË SEVIGNY AND GUESTS** at a Liberty versus Sparks game at Madison Square Garden, June 3, 2006, photograph by James Devaney

TIME LINE

1891

Basketball invented by Canadian James Naismith at a Springfield, Massachusetts, YMCA. Dr. J. H. McCurdy, of New York's 23rd Street YMCA, brings the game to New York.

EARLY 1900S

Basketball comes to New York City through organizations, schools, and colleges that reflect the city's ethnic diversity. In 1902, the Henry Street Settlement, which will become a central site for outdoor play on the Jewish Lower East Side, includes a gym and playground. The following year, Flushing wins the city's first Public School Athletic League (PSAL) basketball championship at Madison Square Garden on 28th Street. By 1906, New York University forms a club and the Smart Set Athletic Club in Brooklyn launches the first formally organized and independently run all-black amateur basketball team, joined by a sister team, the Spartan Girls, four years later.

1907

St. John's University plays its first basketball game, losing to NYU.

1920

Nat Holman, who had played for the Roosevelt Big 5, a Jewish team from the Lower East Side, and the NY Knickerbockers Big Five, becomes basketball coach at City College of New York (CCNY).

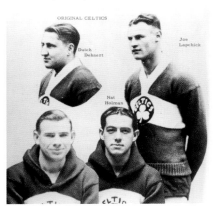

1921

Holman, already the coach at CCNY, joins the Original Celtics, along with Joe Lapchick, Johnny Beckman, Pete Barry, and Dutch Dehnert; for the next seven years, the team, whose passing and cutting style Holman learned at Seward Park, dominates professional basketball. Holman and Lapchick will continue to play key roles as college coaches in the city.

1921

The Spartan Braves, an early Harlem-based amateur team, win the Eastern Championship (for amateur African American teams).

1923

Caribbean immigrant Bob Douglas forms the professional New York Renaissance (a.k.a. the Harlem Rens), who play at the Renaissance Ballroom. Tickets include both a game and a formal dance. The team is the first all-black, fully professional African American–owned basketball team, including Clarence "Fats" Jenkins, James "Pappy" Ricks, Frank "Strangler" Forbes, and Leon Monde.

1920S

The Rens and Celtics compete in "race games," which attract large crowds. At first, the Celtics generally win; later on, the Rens incorporate the Celtics' fast-paced passing game, along with influences from ballroom dance in Harlem, to even the score. In 1924, the Rens win the first "Colored Basketball World Championship," and the following year, they defeat the world-champion Celtics.

1925

Madison Square Garden opens on Eighth Avenue, between 49th and 50th Streets.

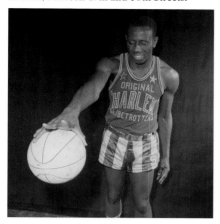

1928

Harlem Globetrotters formed in Chicago. Although the team had no direct connection to New York, the name "Harlem" signaled that it was a black team, since Harlem was known as the "Negro Capital of America."

1930S

Under Commissioner Robert Moses, New York City Department of Parks & Recreation builds nearly 700 outdoor basketball courts, in part to provide recreation for urban youth.

1930–31

George Gregory Jr. integrates the Columbia University basketball team, leading them to the Ivy League title and becoming the first African American All-American college basketball player.

1933–37

Red Auerbach, who will transform basketball as the coach of the Boston Celtics and a key force in the integration of the NBA, plays at Eastern District High School in Williamsburg, Brooklyn.

1934

Promoter Ned Irish makes the Garden the center of college basketball for the country. His initiatives include the annual Holiday Festival Tournament and the idea of single-admission triple-headers. Frank McGuire, who had starred at Xavier High School, plays for St. John's in Irish's events.

1935

Hank Luisetti, a player for Stanford, features the one-handed jump shot in a win over Long Island University coached by Clair Bee at Madison Square Garden, ending their 43-game winning streak. New York press gives visibility and legitimacy to a shot that coaches had previously disdained.

1936

The Catholic Youth Organization (CYO), which will become a central site for developing young talent in New York, is founded.

1936

Joe Lapchick becomes coach at St. John's.

1938

The National Invitation Tournament (NIT) is created as a year-end college basketball contest to be held at the Garden. Integrated teams are allowed, which is not true in all NCAA college leagues at the time.

1939

The Harlem Rens win the inaugural World Professional Basketball Championship, defeating Oshkosh. The team includes William "Pop" Gates, Clarence "Puggy" Bell, John "Boy Wonder" Isaacs, Charles "Tarzan" Cooper, William "Wee Willie" Smith, Eyre "Bruiser" Saitch, Zach Clayton, and manager player Clarence "Fat" Jenkins. John Wooden watches and admires the speedy pass-first team play.

1938–39

Head coach Clair Bee leads Long Island University to its second undefeated season and its first NIT championship. Commonly regarded as the best defensive coach of his time, Bee will never allow a losing record during his 18 seasons at LIU.

1939

IND Subway line links Brooklyn, lower Manhattan, and Harlem with a stop at West 4th Street in Greenwich Village, making the courts at that stop readily accessible from distant neighborhoods.

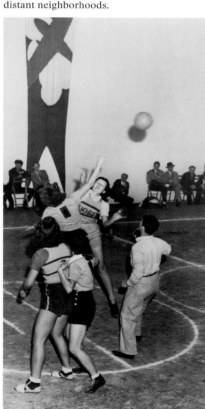

1939

New York hosts the World's Fair in Queens, and women's basketball is displayed there. Outdoor parks are built in Rockaway between 108th and 110th Streets as part of the cleanup after the fair closes. Dick McGuire, later a Hall of Fame point guard for the Knicks, learns to play there.

1940

College doubleheader at MSG broadcast on TV on CBS. The first televised college games ever are between Fordham and U. Pitt, and NYU and Georgetown.

1944

Dick McGuire—formerly nicknamed "Tricky Dick" for his flashy play—leads a St. John's team coached by Joe Lapchick to victory at the NIT at the Garden for the second year in a row.

MID-1940S

Future Hall of Famer Dolph Schayes, formerly the leader of borough champion DeWitt Clinton High School, enrolls at NYU at the age of 16 in 1944. Future Hall of Famer Bob Cousy plays for Andrew Jackson High School in Queens in the PSAL tournament in 1946.

1946

William "Pop" Gates and William "Dolly" King of the Harlem Rens integrate the National Basketball League.

1946

Promoter Ned Irish establishes the New York Knickerbockers—or Knicks—as one of the founding members of the Basketball Association of America. Joe Lapchick leaves St. John's to serve as the team's first head coach.

1946

Basketball Association of America, or BAA, the key precursor to the NBA, is founded in New York City as a league that will play in larger venues in major metropolitan areas. The first official BAA game is a matchup between the New York Knicks and the Toronto Huskies; in what the NBA now considers its first official game, Ossie Schectman of the Knicks makes the first basket.

1947

Holcombe Rucker, a playground director for the New York City Department of Parks & Recreation, begins creating tournaments in Harlem as a positive social outlet, encouraging playing basketball outdoors and in summer. This promotes a shift of basketball from indoors to outdoors, winter to summer,

and from supervised tournaments to more freewheeling streetball.

1947

Frank McGuire, graduate of Xavier High School and former St. John's player, becomes head coach of St. John's.

1947

The Knicks draft Japanese-American player Wataru Misaka, the first non-Caucasian, and first Asian American to play in the professional league that would become the NBA.

1949–50

The NBA is born out of a merger between the BAA and NBL.

1950

Under Nat Holman, CCNY fields a team notably including African Americans and Jews to defeat all-white Kentucky on the way to winning the NIT at MSG. That year CCNY also wins the NCAA, the only team to win both in a single year.

1950

Nat "Sweetwater" Clifton, former member of the Harlem Rens and Globetrotters, becomes the first African American player signed by the NBA, and plays for the Knicks.

1951

A point-shaving scandal rocks CCNY when four players are convicted of taking money from gamblers to fix how much they scored in a game. CCNY is permanently demoted to Division III. Notable players implicated

include Floyd Layne of Benjamin Franklin High School and Ed Warner of DeWitt Clinton High School. The scandal implicates three other New York City schools: NYU, Manhattan College, and LIU. Clair Bee resigns from the LIU coaching staff in disgrace after a number of his students are found to have been involved, and the university's entire athletic program is shut down until 1957.

1952

Frank McGuire leads St. John's to the Final Four, then leaves to coach North Carolina. North Carolina and Duke begin to become perennial powers in the Atlantic Coast Conference (ACC) and the NCAA, their teams fed by Jewish and Catholic players from New York City high schools.

1956

P.S. 156 Playground opens. It will become home of the iconic Rucker Tournament in the late 1960s.

1957

Lou Carnesecca becomes head coach at St. Ann's Academy, his alma mater. The following year he departs for St. John's, where he coaches until 1992.

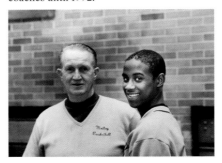

1958

Jack Curran begins coaching at the newly renamed Archbishop Molloy High School (formerly St. Ann's Academy). Curran will serve as head coach for more than 50 years, sending numerous players to NCAA and NBA greatness.

1961

Jack Molinas is arrested for paying 476 players at 27 schools over four years to adjust their play to suit gamblers. Connie Hawkins, graduate of Boys High, and Roger Brown, from Wingate High School, are associated with Molinas. Though Hawkins never shaved points, he is banned from college ball and the NBA.

1962

At the Rucker Tournament, the Brooklyn All Stars, with Connie Hawkins, play a memorable game against Big Wilt Chamberlain's Small's Paradise. Chamberlain takes over with a famous power dunk.

1963

Power Memorial the high school "team of the century" during Lew Alcindor's years, wins 71 games in a row, and ends up 95–6. Alcin-

dor develops the sky-hook, chooses John Wooden's UCLA over St. John's, and later changes his name to Kareem Abdul-Jabbar.

1964

Future Knicks Cazzie Russell and Bill Bradley meet up in the Holiday Festival at the Garden in a dramatic game won by Michigan after Bradley, who scores 41 points for Princeton, fouls out.

1967

In the last NIT tournament played at the old MSG, Walt Frazier leads Southern Illinois University to win the championship. He is drafted by the Knicks that year, develops the nickname "Clyde," and goes on to become one of the most legendary Knicks players of all time.

1967

The New Jersey Americans of the American Basketball Association are founded, playing home games in Teaneck, New Jersey.

1968

Madison Square Garden opens at its fourth and current location between Seventh and Eighth Avenues and 31st and 33rd streets. It is built atop the site of the former Pennsylvania Station.

1968

The New Jersey Americans become the New York Nets, and move their home games to Long Island.

1970

Julius Erving, a 6'6" Nassau County native known as "Dr. J" for his elegant, precise style of play and famous as one of the most proficient dunkers in basketball, leads the Westsiders to victory over Milbank in the Rucker championship. Milbank's star, the dominant Joe "The Destroyer" Hammond, only arrives in time to play the second half, but allegedly scores 50 points and certainly wins MVP.

1970

The Knicks, a perennial playoff team, win the NBA crown coached by Red Holzman. The team stars Walt "Clyde" Frazier, Bill Bradley, Cazzie Russell, Willis Reed, Dick Barnett, Dave DeBusschere, and Phil Jackson. Jerry Lucas and Earl "The Pearl" Monroe join the team the following year.

1971

Joe Hammond is drafted by the Los Angeles Lakers, but declines to sign with the team. Though described by some analysts

as the greatest streetballer that ever played, Hammond will never play in the NBA or the ABA.

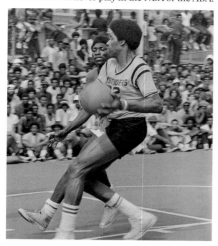

1972

Julius Erving breaks his Rucker scoring record with 56 points in a single game. His Westsiders are defeated by Tiny Archibald's Celtics, 140–132, but Dr. J will go to the Nets from the Virginia Squires in 1973, and eventually win an NBA championship with the Philadelphia 76ers in 1983.

1973

Knicks win a second NBA title.

1973

While playing for the Cincinnati Royals, Nate "Tiny" Archibald, a graduate of DeWitt Clinton High School, becomes the first player to lead the NBA in scoring and assists in the same season, a feat that has not been repeated since.

1973

Brooklyn's James "Fly" Williams leads all NCAA Division I scorers as a freshman at Austin Peay University. He later returns home and becomes a legend at the Rucker and West 4th Street.

1974

Led by Julius Erving, "Dr. J," former star of Rucker Park, the Nets win the ABA championship.

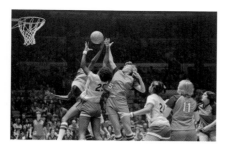

1975

Immaculata defeats Queens College 65–61 in the first women's college basketball game at the Garden.

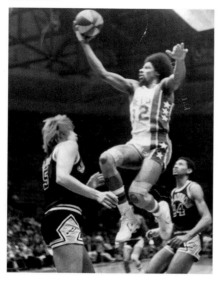

1976

Julius Erving wins the last ABA championship ever for the New York Nets. The same year, he takes the crown at the first slam-dunk contest.

1976

Nancy Lieberman, from Far Rockaway High School, and a regular at Rucker Park, wins silver as a member of the first ever US Olympic Women's Basketball team. Having just turned 18, she is also the youngest person ever to win an Olympic medal in basketball. She will go on to play in the WBL, WNBA, and serve as an NBA coach.

1977

Puerto Rican–born De Witt Clinton alum Butch Lee becomes MVP of the NCAA Final, leading Marquette, coached by New Yorker Al McGuire, to the championship. The first Latino player in the NBA, Lee goes on to win 1980 NBA Final with the Lakers.

1976–77

The Nets and three other ABA teams join the NBA. The Nets are forced to trade Julius Erving to the 76ers for cash to pay off a fine levied by the Knicks for sharing the New York

territory in the same league. Before the 1977–78 NBA season, the Nets will relocate back to New Jersey, after playing one year as the New York Nets of the NBA.

1977

Kenny Graham founds the West 4th Street Tournament, which attracts NYC's top players for decades, including those who would wind up in the NBA like Lloyd "Sweet Pea" Daniels, Mario Elie, Anthony Mason, and Smush Parker—plus playground legends like "Fly" Williams and Jack "Black Jack" Ryan.

1979

Big East Conference created. St. John's now has televised games against archrivals Georgetown and Syracuse. Starting in 1983, Big East finals are always played at the Garden.

1980S

Kenneth Stevens, Omar Booth, and Michael Jenkins create the Dyckman Tournament at Monsignor Kett Playground in Inwood, a park once used by Holcombe Rucker in an effort to revive the neighborhood.

1982

Rapper Greg Marius organizes the "Entertainer's Basketball Classic," to revive the old Rucker tournament. EBC, as it is known, will feature teams sponsored by hip-hop stars Jay-Z, Fat Joe, and Diddy, and fancy ballhandlers Rob "Master Rob" Hockett, Mike "Boogie" Thornton, Lamont "Tip Dog" Thornton, James "Speedy" Williams, Andre Blackett, and Malloy "The Future" Nesmith expand and elevate creative dribbling.

1982

St. John's, featuring sophomore star Chris Mullin, defeats North Carolina, the national champions led by Michael Jordan, in an overtime upset at the annual Tipoff classic in Springfield, Massachusetts. Later that season, Mullin will lead St. John's to victory at the Garden against Georgetown and will be named MVP of the Big East tournament when St. John's defeats Boston College.

1984

Syracuse All-American Dwayne "Pearl" Washington from Brooklyn dominates the Big East Championship against the Number One ranked defense of the Georgetown Hoyas, using tricky ball handling taken from the playground to score at will. He inspires future NBA All-Stars Tim Hardaway, Allen Iverson, and many others to implement crafty dribbling, particularly popularizing the crossover move.

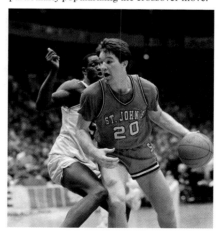

1985

St. John's, with Chris Mullin and Mark Jackson, reaches the NCAA Final Four against Patrick Ewing's Georgetown. Ewing is drafted with

the number one pick by the Knicks while Mullin is drafted with the seventh pick by the Golden State Warriors. Jackson will coach several pro teams and rank among the top five of all time in assists.

1984–88

Archbishop Molloy legend and LeFrak City native Kenny Anderson surpasses Lew Alcindor's record by becoming a four-time *Parade* All-American and an "All-City" player.

1988

Brooklyn-born St. John's alum Mark Jackson becomes the NBA Rookie of the Year for the New York Knicks.

1993

John Starks makes "The Dunk" against Jordan's Bulls in the final minute of Game 2 of the 1993 Eastern Conference Finals, knocking off Horace Grant's goggles and securing an iconic victory that will live on in T-shirts and posters for decades afterward. The Bulls, however, rally and defeat the Knicks 4–2 to take the series.

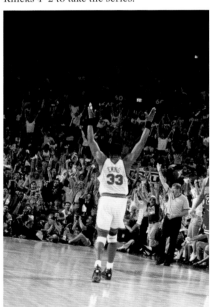

1994

With less than 30 seconds left to play, Patrick Ewing saves Game 7 of the Eastern Conference Finals with a dunk and carries the Knicks to the NBA Finals, where they fall just short of the Houston Rockets in another seven-game series.

1994

Dominican-born Felipe Lopez from Rice High School in Harlem becomes the consensus National High School Player of the Year, making him one of most high-profile, highly touted high school basketball recruits in history.

1995

"Thanks a Lot Spike!" reads the *Daily News* headline after Spike Lee's courtside trash talk inspires a miracle performance in Game 1 of the conference semifinals from Reggie Miller of the Indiana Pacers. The Knicks hold on for seven games but lose the series.

1995

Chamique Holdsclaw is named WCBA High School All-American after leading Christ the King to four consecutive New York State Championships. Holdsclaw will go on to play under Pat Summit at Tennessee, win three consecutive NCAA titles there, and be a first round draft pick into the WNBA.

1997

Harlem's God Shammgod reveals his signature dribble move—developed on the playground—during a nationally televised NCAA game. The "Shammgod" is still recognized globally and used by NBA All-Star guards like Chris Paul and Russell Westbrook.

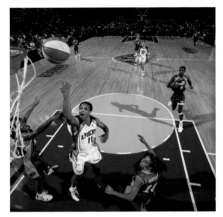

1997

New York Liberty, led by Teresa Weatherspoon, play in the inaugural WNBA game against the Los Angeles Sparks, and play their first home game in the Garden a week later. The first-ever WNBA All-Star Game is also held at MSG with four Liberty players attending: Weatherspoon, Rebecca Lobo, Kym Hampton, and Vickie Johnson. The Liberty reach the WNBA finals before losing to the Houston Comets.

1998

The AND1 Mixtape Tour is a touring basketball tournament presented through highlight videos of Rafer "Skip to My Lou" Alston and other streetball stars playing in the EBC Tournament at Rucker throughout the 1990s. It is sold on DVDs and aired live on ESPN2, spreading streetball flair nationwide.

1998

In this lockout-shortened season, an exciting, controversial, but nonetheless fun Knicks team under coach Jeff van Gundy and led by Latrell Sprewell and an aging Patrick Ewing make the finals. The Spurs best them in five games.

1998

Streetball legend Earl "The Goat" Manigualt, who had starred and created a tournament at Happy Warrior Playground on West 99th Street, and also played at Rucker, tragically passes away at 53 from heart problems. The courts on West 99th are renamed "Goat Park" in his honor.

1999

In Game 3 of the Eastern Conference Finals, Larry Johnson takes a foul and makes a game-winning three-and-one to earn the last

four of his 26 points with under 10 seconds left. Without an injured Patrick Ewing, the Knicks take the series, but lose in the finals against the Spurs.

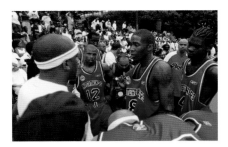

EARLY 2000S

NBA Champion Kobe "Lord of the Rings" Bryant plays in the EBC Tournament at the Rucker and electrifies the Harlem crowd. Former president Bill Clinton and NBA commissioner David Stern make appearances. Platinum hip-hop artists Fat Joe and Jay-Z have intense rivalry between their teams, which feature multiple NBA All-Stars including Allen Iverson, Stephon Marbury, and Jermaine O'Neal.

1999–2000

The Liberty reach the WNBA finals two years in a row, but lose both times to the Cynthia Cooper–led Houston Comets.

2001–03

The New Jersey Nets reach their first NBA finals in 2002, but are swept by the Lakers. They make the finals again in 2003, losing to the Spurs, 4–2.

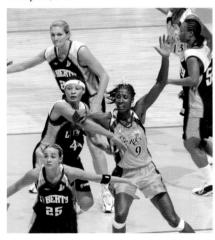

2002

Liberty reach their most recent WNBA final, defeated in two straight games by the Los Angeles Sparks. LA's Nikki Teasley makes a championship-winning three with fewer than five seconds remaining in the second game.

2004

Brooklyn's Sebastian Telfair breaks Kenny Anderson's all-time New York State scoring record, and also becomes the first player under 6′ to make the jump from high school to the pros after graduating from Lincoln High School. Shortly thereafter, the league disallows drafting of men under the age of 19.

2005

Christ the King, led by Tina Charles and Carrem Gay, finishes the year as the highest ranked high school team in the country.

2006

The Liberty are the first WNBA team to have their entire season nationally televised.

2006

Epiphanny Prince scores a record-breaking 113 points in a single game, playing for Murry Bergtraum High School. She later will play at Rutgers and become a two-time WNBA all-star.

2008

In front of nearly 20,000 fans, the Liberty play the first regular season professional basketball game ever held outdoors. They face the Indiana Fever in the Arthur Ashe Stadium in the Billie Jean King National Tennis Center in Queens, home of the US Open grand slam tennis tournament.

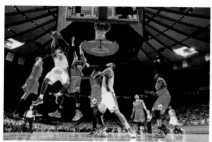

2012

Derrick Rose's Chicago Bulls come to the Garden for an intense regular season game, but are thwarted in overtime by a go-ahead three with less than 20 seconds remaining by Carmelo Anthony. He scores 43 points of the Knicks' 100, cementing himself as a modern Knicks staple.

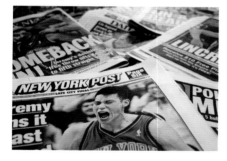

2012

Jeremy Lin, an undrafted player who had attended Harvard and played briefly for Golden State, becomes a star on the Knicks, sparking "Linsanity" and connecting with a growing presence of Asian Americans in New York City and the city game.

2012

NBA scoring champion Kevin Durant drops 66 points in the EBC Tournament at the Rucker. Although international news, it however does not break the single game park records held by Rucker Pro legend Joe "The Destroyer" Hammond (73 points).

2012

The New Jersey Nets move to the new Barclays Center in Brooklyn, becoming the Brooklyn Nets and New York's second men's professional team.

2016

Teenage social media sensation and Harlem resident Isaiah Washington brings international attention to his smooth signature move, "the jelly," with the #jellyfam phenomenon. A point guard for St. Raymond's in the Bronx, Washington states: "The New York City point guard is flashy, plays with a lot of heart, and I represent that with pride."

2015

The NBA All-Star game this year is held at the Barclays Center and hosted by both New York teams.

2015

Seven-foot-three Latvian power forward Kristaps Porziņģis is drafted fourth overall by the Knicks. He will go on to become their star, help pave the way for future foreign-born and European NBA players like Greece's Giannis Antetokounmpo to shine, and will controversially be traded away in 2019.

2018

Video game NBA Live 19 gives players their first chance to play virtual games on famous New York City streetball courts.

2019

Kevin Durant, Kyrie Irving, and DeAndre Jordan, three of the most dynamic, desirable free agents in the NBA, join the Nets, which inspires a lot of buzz around a New York team that looks a lot like a genuine contender.

PAGE 178

THOMPSON SQUARE PLAYGROUND, 1904, photograph by Byron Company

FIVE MEMBERS OF THE ORIGINAL CELTICS, including Nat Holman and Joe Lapchick, undated

CHARLES "TARZAN" COOPER of the Harlem Rens, 1920s

PAGE 179

HARLEM GLOBETROTTER GOOSE TATUM, 1951, photograph by Frank Bauman

OPENING DAY CEREMONY, Dr. Gertrude D. Kelly Playground, August 8, 1934

WOMEN PLAYING BASKETBALL at the New York World's Fair, 1939–40

DICK MCGUIRE, 1953, photograph by Arthur Rothstein and Frank Bauman

JOE LAPCHICK, Knicks training camp, 1948, photograph by Kenneth Eide

PAGE 180

LEFT TO RIGHT: IKE DUFFEY, LEO FERRIS, MAURICE PODOLOFF, NED IRISH, AND WALTER BROWN at the formation of the NBA, August 3, 1949, photograph by John Lent

NAT "SWEETWATER" CLIFTON #8 of the Knicks, October 17, 1951, photograph by Robert Kradin

CITY COLLEGE STUDENTS RALLY in support of Nat Holman during the point-shaving scandal, 1951

ARCHBISHOP MOLLOY Coach Jack Curran with Kenny Anderson, 1986, photograph by Vic DeLucia

BOYS HIGH SCHOOL'S LEW ALCINDOR, February 17, 1965

"HOW THE GARDEN GREW" from *Popular Mechanics*, November 1967

SNEAKERS worn by Walt "Clyde" Frazier during the 1970 NBA Playoff

PAGE 181

JULIUS "DR. J" ERVING #32, Rucker Tournament, 1972, photograph by Tyrone Dukes

RECORD commemorating the Knicks 1972–73 championship season

DEAN MEMINGER #7 of the Knicks dribbles past Tiny Archibald #10 of the Cincinnati Royals, 1973, photograph by George Kalinsky

IMMACULATA COLLEGE beat Queens College at the first women's college basketball game at Madison Square Garden, 1975, photograph by Joyce Dopkeen

JULIUS "DR. J" ERVING, ABA Semifinals, 1976, photograph by Larry Morris

OLD DOMINION'S NANCY LIEBERMAN breaks away from Louisiana Tech's Angela Turner, March 25, 1979, photograph by Michael O'Brien

CHRIS MULLIN #20 takes the ball up the court for St. John's, past Villanova's Ed Pinckney, 1985, photograph by Peter Morgan

PAGE 182

JOHN STARK'S GAME-WORN WARM-UP JACKET, 1993

PATRICK EWING #33 of the Knicks scores a three-pointer in a victory over the Chicago Bulls in Game 7 of the Eastern Conference Semifinals, ending the Bulls' three-year streak as NBA champions, May 22, 1994, photograph by George Kalinsky

TERESA WEATHERSPOON #11 of the Liberty in a game against the Los Angeles Sparks at Madison Square Garden during their inaugural season, 1997, photograph by Nathaniel S. Butler

NBA PLAYERS SEBASTIAN TELFAIR #12, JAMAL CRAWFORD #8, AND SMUSH PARKER #4 of Jay-Z's S. Carter team during the Entertainer's Basketball Classic at Rucker Park, August 12, 2003, photograph by Frank Franklin II

NEW YORK LIBERTY VS. LOS ANGELES SPARKS, Game 2 of the WNBA Finals, August 31, 2002, photograph by Scott Quintard

PAGE 183

CARMELO ANTHONY #7 of the Knicks goes to the basket against the Chicago Bulls, Madison Square Garden, April 8, 2012, photograph by Nathaniel S. Butler

"LINSANITY" newspaper covers, 2012

PROGRAM for the first Brooklyn Nets game at Barclays Center, November 3, 2012

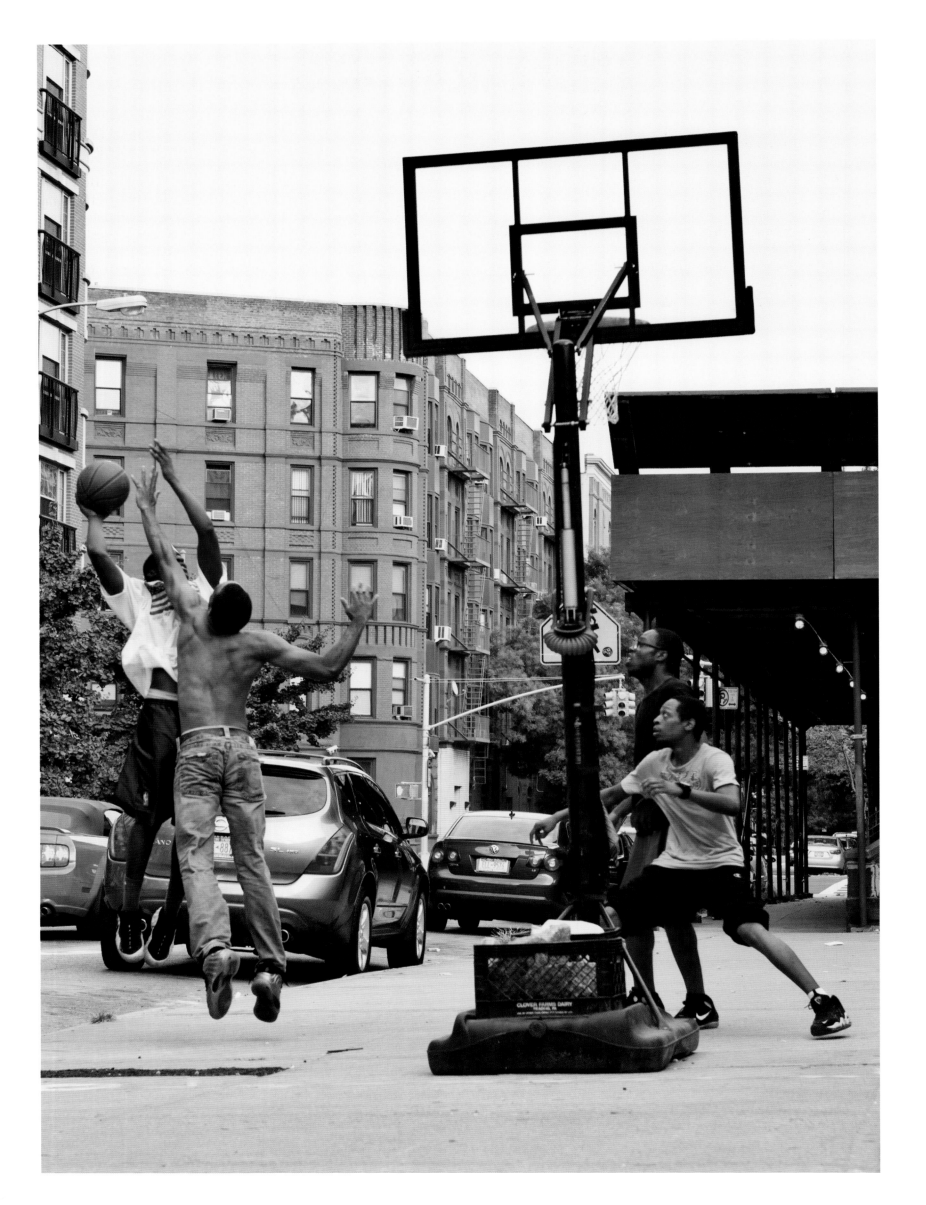

URBAN HEARTBEAT

CONCLUSION BY WILLIAM C. RHODEN

During the first board of advisers meeting for the *City/Game* project, a spirited debate broke out over an issue that struck at the essence of the exhibition: New York as the mecca of basketball.

How did New York get to be the capital of basketball and does it still hold that distinction?

We argued about everything, from who invented which game to which city turned out the most players.

Truth is, every city plays great basketball and produces great basketball players.

Bill Russell was from Oakland, California, by way of Louisiana. Wilt Chamberlain and Earl Monroe hailed from Philadelphia. LeBron James is from Akron, Ohio, and Kobe Bryant from a Philadelphia suburb.

Every city, every hamlet, every town has produced players. NBA rosters are dotted with players from around the world.

Even the legendary Bobbito García agreed that New York does not have the exclusive rights to competitive basketball and great playground basketball.

Yet New York remains a magnet. The *City/Game* exhibition and this accompanying book explore the source of that magnetism by examining where New York basketball has been, where it is, and where it is going.

During that initial session, some of us argued that the game, like the city, has become gentrified and that gentrification has drained the blood—the soul—out of the city and the city game.

Dr. William Gibbons, a professor at CCNY born and raised in Detroit, argued that his city produced a large number of big-time players. As a native Chicagoan, I argued that Chicago might have produced more NBA players than any city, including New York.

We all agreed that basketball has replaced baseball as a city game. The rhythm of the game of basketball is the heartbeat of our urban culture. New York, with its dense, diverse population, is emblematic of that urban heartbeat. New York didn't have large areas capable of accommodating baseball and football fields. In many areas there wasn't space enough to have a full court, so makeshift baskets were put up on the side of the building. Without spaces to perfect outside shooting, a premium was placed on finding creative ways to drive to the basket and to hit teammates with uncanny passes.

In many places the square rung at the bottom of a fire escape was used as a basket. Basketball was cheap, it didn't require a lot of equipment. On any given day you could watch young people playing basketball with a rolled up sock or a small rubber ball.

Basketball created opportunity. When Chamique Holdsclaw saw college coaches come to the basketball courts near her housing project in Queens to watch talented high school players, a light went off: if she could sharpen her skills, do well in school—play for the *right* high school—she could go to college on scholarship.

Holdsclaw played for Christ the King and earned a scholarship to the University of Tennessee, where she became an All-American and played professionally in the WNBA.

The more complicated question is whether New York remains the mecca of basketball.

The game is global; every country on nearly every continent is turning out basketball players. The best high school players now leave for prep school and academies outside the city, in many cases outside the state.

Yet the unique quality that makes the New York player distinguishable as a city player was implanted at age eight or nine on city playgrounds and makeshift courts: the competitive spirit.

The sense of competition is a constant; the competitive nature of New York City gives the New York City player what Nets Head Coach Kenny Atkinson calls an extra sense—a "city sense."

Just as millions come to New York each year to see if they have what it takes to make it, the best basketball players—pro and college—made the pilgrimage to Harlem at least once in their careers in an appearance at Rucker Park.

You can take New York players out of the city but you cannot take the city out of New York City players. What I learned during the course of this journey is that what gives New York the edge, what makes New York the capital—of everything, including basketball—is the people. The fans.

To live here, to compete here, to flourish here, requires passion.

That passion is expressed enthusiastically in a love of basketball.

"There's no such thing as a casual fan in New York," Kenny Smith said in an interview for this book during the NBA Finals. "Other fans don't care like we do," he said. "Fans in other cities date the game. New Yorkers are married to the game."

WILLIAM C. RHODEN is an award-winning sports journalist and author of *Forty Million Dollar Slaves: The Rise, Fall, and Redemption of the Black Athlete*. He was a columnist for the *New York Times* from 1983 to 2016, and today is writer-at-large for *The Undefeated*.

← 118TH STREET AND ST. NICHOLAS AVENUE, 2011, photograph by Kevin Couliau

NOTES

CHAPTER 1
MANHATTAN TAKES BROOKLYN:
NYC'S FIRST BLACK FIVES MATCHUP
Claude Johnson

1 Legend has it that the area's "Tenderloin" nickname was coined in the 1870s by an overworked, underpaid NYPD captain who, when reassigned to that precinct, was so pleased by the "perks" that he likened the post to a filet cut of beef. "I've had nothing but chuck steak for a long time, and now I'm going to get a little of the tenderloin," he was allegedly quoted as saying at the time.

2 African Americans, who represented about two percent of Brooklyn's total population at the time, were settled primarily in Crown Heights, Fort Greene, Bedford, Stuyvesant Heights, and Brownsville.

3 "Wealthy Negro Citizens: Several Residing in This City and Brooklyn," *New York Times*, July 14, 1895, 17.

4 "New Buildings," *Brooklyn Daily Eagle*, 10 January 1900, 15. [Refers to game venue description of gravel roof, etc.] "On The Hand Ball Courts: Lively Interest Taken in the Old Irish Game," *Brooklyn Daily Eagle*, 29 January 1900, 14. [Refers to "finely polished floor" and "three large skylights" quotes.]

5 "Basketball" was normally spelled as two words—"basket ball"—until the late 1910s.

6 J. L. Brewster, "Some Rules For Scientific Basket Ball," *Rochester Evening Times*, reprinted in *Spalding's Official Basket Ball Guide for 1905–06* (Indianapolis: American Sports Publishing Company, 1905), 57-63.

7 Ibid.

8 Amateur Athletic Union Rule II, Sec. 15. In 1908, the Collegiate Basketball Rules Committee dropped this rule, and the dribbler was once again allowed to shoot for the basket. However, the stubborn AAU kept the rule in place until 1915, when it conceded, and the dribble rule at last became uniform for both college and amateur play.

9 Amateur Athletic Union Rule II, Sec. 3.

10 "Official Rules—Season 1905–06," in *Spalding's Official Basket Ball Guide for 1906–07* (Indianapolis: American Sports Publishing Company, 1905), pg. 92. Rule II, Sec. 3 states that the "Official No. M Basket Ball" manufactured by A.G. Spalding & Bros. "shall be the official ball." Rule II, Sec. 4, states, "The official ball must be used in all match games. The "Official No. M" was made of leather and had laces on one side that protruded like those on a football. There was no needle hole. Inflating the sphere meant undoing the laces, unfolding a hose attached to its interior rubber bladder, blowing air into the hose with lungpower until the proper pressure was reached, folding the hose back down, and then re-lacing it. If the ball's pressure was not quite right after bounce testing, then these steps had to be repeated. The company's New York City offices were located at 124–128 Nassau Street downtown and at 29–33 West 42nd Street in Midtown.

11 "St. Christopher Wins," *New York Age*, November 21, 1907, 6.

12 "Gillen and Murphy Beaten," *Brooklyn Daily Eagle*, July 9, 1900, 13.

13 "With The Hand Ball Players: Grand Opening of the Knickerbocker Court on July 10," *Brooklyn Daily Eagle*, July 9, 1900, 4.

14 "Colored Basketball Teams in Big Contest," *Indianapolis Freeman*, November 30, 1907, 6.

CHAPTER 2
MR. BASKETBALL:
NAT HOLMAN INVENTS THE CITY GAME
William Gibbons

1 Producers and engineers created delays and echo effects using analog tape machines. In the late 1970s and early 1980s, CBS television chose to broadcast several NBA playoffs and NBA Finals games on a tape delay two to three hours after the local news had aired, at 11:30 p.m. eastern time, when the league's popularity and ratings were down, as the network did not want to preempt prime-time shows.

2 Dr. J's signature finger roll was an underhand basketball layup shot, in which the ball rolled off the tips of his fingers as he leapt above the rim with a slight twist of the hand. At the very zenith of his jump, the ball careened off his fingers and into the basket.

3 "Barnstorming" is a term used to describe sports teams or individual athletes who travel to various locations, typically small towns, to stage exhibition games. The barnstorming era lasted until the 1940s.

4 The mobile big man is a tall, substantial player who can move quickly. The organized fast break entails pushing the ball to score quickly.

5 Sam Goldaper, "Nat Holman is dead at 98," *New York Times*, February 13, 1995, B7.

6 Nat Holman, "Nat Holman," in *From Eminently Disadvantaged to Eminence*, ed. Harold Geist (St. Louis: Warren H. Green, 1973), 51.

7 After World War I, Frank McCormick lost control of the New York Celtics, but stubbornly refused to relinquish the team's name. So when Jim Furey took over, he changed the name to Original Celtics, whereupon he completely reorganized and incorporated the team player personnel, which was primarily made up of players with professional league backgrounds.

8 Rosen, Charles. *Scandals of '51: How the Gamblers Almost Killed College Basketball* (New York: Holt, Rinehart & Winston, 1978), 117.

9 Ibid., 194.

10 Ibid., 196.

11 Berkow, Ira. "The Lives They Lived: Nat Holman; No Passing Fancy." *New York Times Magazine*, December 31, 1995.

CHAPTER 3
BOYS FROM THE CITY: NEW YORK'S JEWISH BASKETBALL STARS
Jeffrey S. Gurock

1 See Stanley Frank, *The Jew in Sport* (New York: Miles Publishing Co, 1936), 49–50, noted in Levine, *From Ellis Island to Ebbets Field*, (New York: Oxford University Press, 1992), 27.
2 Team rosters do not identify the religious background of players. I am relying on Jewish-sounding names as an indicator of ethnicity. Still, many of the stars on the team have been identified as Jews in encyclopedias of Jewish athletes. Accordingly, it may be noted that year-by-year between 1925 and 1940, the percentage of Jewish players who were awarded a varsity letter was never less than two-thirds of those recognized. These tentative statistics were derived from the names that appeared yearly in the college yearbook, *Microcosm* (1925–40).
3 The statistics on the won—loss records of CCNY teams are derived from the files of the school's athletic department that are maintained at the CCNY Archives. Particularly in the early years of the 20th century, the game-by-game scores were not always available in the school's yearbooks or newspaper.
4 Sam Goldaper, "Nat Holman Is Dead at 98, Led C.C.N.Y. Champions," *New York Times*, February 13, 1995, on-line edition. On the criticism of CCNY fans by their own student newspaper, see Arieh Sclar, "A Sport at Which Jews Excel: Jewish Basketball in American Society" (Unpublished diss., Stony Brook University, 2008), 68. On the importance of these games to students, see Meyer Liben, "CCNY: A Memoir," in *City in the Center: A Collection of Writings by CCNY Alumni and Faculty*, ed. Betty Rizzo and Barry Wallenstein (New York: City College of New York, 1983), 50.
5 A. L. Shands, "The Cheder on the Hill: Some Notes on C.C.N.Y.," *Menorah Journal* (March, 1929), 267; Liben, "CCNY," 50.
6 For a strong sense, through interviews with CCNY alumni and others in New York, of what the 1950 triumph meant to the college, see "City Dump: The Story of the 1951 CCNY Basketball Scandal," George Roy and Steven Hillard Stern, directors [HBO, 1998].
7 Edward Shapiro, "The Shame of the City: CCNY Basketball, 1950–51," in *Jews, Sports and the Rites of Citizenship*, ed. Jack Kugelmaas (Urbana: University of Illinois Press, 2007), 175, 184–85, 187, 189–91. For memoirs of what the scandal meant to students as Jews, see Avery Corman's recollections in "City Dump."
8 Shapiro, "The Shame of the City: CCNY Basketball, 1950–51," 187. See also, "Cagers to Fly West in February on Unprecedented Trip to Coast," *Campus*, January 5, 1949, 4.
9 On recruitment successes by McGuire, see J. Samuel Walker, *ACC Basketball: The Story of the Rivalries, Traditions and Scandals of the Atlantic Coast Conference* (Chapel Hill: University of North Carolina Press, 2011), 106–7.
10 William Yardley, "Art Heyman, Star at Duke, Dies at 71," *New York Times*, August 20, 2012, online edition. For a listing of All-Americans, see basketball-reference.com.

CHAPTER 5
ROCK, RUBBER, 45S: B-BALL, KICKS, AND BEATS
Bobbito García

1 The New York Gauchos were established in 1967 as an Amateur Athletic Union (AAU) basketball program in New York City. It is one of the longest-running after-school basketball programs in the country and has four competitive divisions for boys and girls. The program's goal is to develop students who are not only competitive on the court, but also strong in the classroom and in life.
2 Booties Up was a game of 21. The player who finished with the lowest score had to go against the fence and bend over. All the other players would then line up at the foul line and take one turn throwing the ball at the low scorer's bottom, or "booty," most times as hard as possible to inflict pain. I know. It wasn't fun to get physically punished, and I'm glad the game eventually phased out. The game's history, background, and explanation can be found in the film, *Doin' It In The Park: Pick-Up Basketball, New York City* (2012).
3 "Kicks" is slang for sneakers.
4 In other words, I wanted to match my shoes with the color of my shirt.
5 The Spanish word *fuego* translates to "fire," or "hot," in terms of fashion.

CHAPTER 6
FIELDS OF ASPHALT: LOST IN THE CITY GAME
Thomas Beller

1 I always thought that "the key" was a mysterious and random term referring to the rectangle of space that stretches out from beneath the basket. It is mainly used to enforce the three-second rule, which keeps tall players from camping out in "the paint" (another term that refers to the key). However, no one would ever say, "He is camping out in the key." I had vaguely formulated the notion that the key referred to that important real estate near the basket where making a shot is most likely, and that getting to that spot with the ball was "the key" to winning, or at least scoring. That is about where I had landed, in terms of meaning, until I looked it up and discovered that what we call "the paint" actually used to be a narrow corridor of space topped by a circle. One look at an old image and it is immediately apparent why people say "top of the key": they mean the top of that circle, because it looks exactly like a keyhole. Did people used to say, "He took a shot from the top of the keyhole?" I don't know. Yet, I do feel confident that no other major other sport represents its field of play, and goal area, with so many circles and squares.
2 In theory, whoever calls "next" adds players on a first-come first-served basis. However, everyone usually wants the best players they can find. This is compounded by the fact that there are all sorts of allegiances, friendships, and enmities among the players. Even if they don't know you, they see you—and make assumptions. The answer to, "Who's got next?" is never straightforward.
3 "Minus a Player, the Game Goes On," letter from Carmelo Rodriguez to the Editor of the *New York Times*, May 25, 2003.
4 Frank Gehry's designs for the Barclays Center and the adjoining skyscrapers had, in the spring of 2008, just been unveiled. The skyscrapers were a glorious hodgepodge of unevenly stacked glass boxes; the arena was sheathed in an undulating steel wing reminiscent of the architect's famous design for the Guggenheim in Bilbao, Spain. That all went out the window when the money got tight. The buildings that have so far been built are uniform and drab. The Barclays Center, itself, now looks less like a dazzling piece of modern architecture and "more along the lines of a Kleenex box," as Malcolm Gladwell put it; see Gladwell, Malcom, "The Nets and NBA Economics," grantland.com, accessed September 23, 2019. I think it looks like a giant rusted sculpture of a turtle. Coming up the escalator from the subway onto the promenade out front is an impressive reveal.
5 Bruce Ratner did not build an arena to house his NBA franchise; he bought the Nets to build political support and provide a rationale for government concessions that would allow him to build an arena and accompanying buildings.
6 Roaming from court to court and proving yourself against strangers in other neighborhoods has been done for as long as players have taken street basketball seriously. This phenomenon has its own life and literature. The vehicle most directly connected to playground basketball, I feel, is the bicycle. As with playground basketball, there is an intimacy with asphalt, and the terra firma, itself. The city streets and the surface of a basketball court both appear, at first glance, to be a single color composed of a single substance. However, both are like a salad: asphalt is a mosaic of idiosyncratic pebble shapes glued together by tar; city streets, as seen from a bike, are an evolving jigsaw puzzle of additions and amendments—tar patched, dotted with manhole covers and iron grids, and freckled with little dots of blackened chewing gum. Sooner or later, you develop the same intimacy with the surface of a basketball court, even if only to make sure that you don't sit or put your hand down on not-yet-dried spit, sweat, or blood.
7 This statement is pure conjecture. There is no study that looks at a city through the lens of its basketball infrastructure. Yet based on the size of New York, the number of schools with indoor and outdoor hoops, and the number of playgrounds with basketball hoops, it's hard to argue the point if you limit the matter to America. If a scholar of urban design knows something about the hoop population of Beijing or Shanghai—or some other unforeseen challenger—and wishes to nominate them as global hoop leader, I would love to hear about it!
8 One feature of the 2019 basketball landscape should be noted: the game has never been as popular as it is now. To be interested in NBA basketball and the many tributaries that collect the talent of which the NBA is comprised is to be on an elevator going up, a feeling not unlike being invested in technology stocks that are doing well.
9 There are still many moments of random basketball discovery to be had, such as a recent afternoon when I found two tall and lanky Hasidic men standing around in black pants, white shirts, kippahs on their heads, and black shoes—one of them was about six feet, five inches tall, the other maybe six feet, two inches. We ended up playing in a half-court game together on the same team. They were good, even in shoes, but beyond that, the very nature of their game had the same lost-in-time quality that I associate with Talmudic study: their lanky flow—a lot of reaching reverses under the basket and elegant catch-and-shoot jumpers—was like playing with Hasidic versions of Alex English and George Gervin.
10 The phrase "Go down low" refers to when taller players set up near the basket, with their backs to it. This is also called "posting up."
11 Some of the game's most famously athletic wing players—Michael Jordan, Kobe Bryant, and LeBron James, among others—have invested a lot of time perfecting their footwork and technique in the post. However, part of the game has traditionally been about the preservation of the centers and power forwards, the biggest players on the court. Wing players, such as Jordan, developed postgame appearances as a tactic, part of the crafty, self-preserving, "old man's game" that elite players developed to extend their careers. These so-called "big men" have only recently been allowed to roam and shoot from the perimeter. This shift was shockingly fast—Brook Lopez was a starting-caliber center for the first eight seasons of his NBA career, during which he took almost no three-point shots. In the 2018–19 season, Lopez—playing the Milwaukee Bucks and now nicknamed "Splash Mountain"—averaged 6.2 three-point attempts a game and only 2.1 two-point attempts. Players who could shoot threes on offense and protect the rim on defense were once thought to be so rare that they were called "unicorns"; but in a shockingly brief amount of time, the conventions of the game at the highest level were upended. I find this to be joyously good news, although I am still usually the tallest player on the court and people yell at me to "go down low"!

CHAPTER 7
I GOT NEXT: GIRLS & STREETBALL
Priscilla Edwards

1 Tone-wap is a dance in which an individual jumps with feet together and apart in a rhythmic motion, while their arms either mimic the move or do something different, but on beat. For example, see Shawn Michels, "black tone wop," published on YouTube on June 14, 2006, https://www.youtube.com/watch?v=D6TMDB5Tez0.

2 A hesi is a basketball move in which the player dribbles the ball down the court, freezes, and then moves forward with the ball, in an attempt to score. For example, see *In The Lab*, "Learn Devin Williams Shot Hesi," published on YouTube on February 10, 2019, https://www.youtube.com/watch?v=cuB6a2H-wtrI.

3 A crossover is a maneuver that involves the player dribbling to switch the ball quickly from one hand to the other, in order to make a change in direction.

CHAPTER 8
TOO BIG FOR JUST ONE: KNICKS, NETS & LIBERTY
Jamal Murphy

1 "Clappin' 'boards" is a Brooklyn streetball phrase, play, and term unique to New York City. It involves a crossover dribble and then a layup, in which the player slaps the backboard, or metal backboard in a playground.

CHAPTER 9
CLYDE COOL
Theresa Runstedtler

1 Phil Pepe, "Walt Frazier," *Black Sports* 2, no. 10 (1973): 37.

2 Pete Forester, "Clyde Frazier on His Signature Shoes and Legendary Style," *Esquire*, March 31, 2017, https://www.esquire.com/style/mens-fashion/news/a54246/clyde-frazier-puma-sneakers-style/.

3 "PUMA Returns to Basketball with Lifetime Contract for the Legendary Walt Clyde Frazier," SneakerNews.com, last modified June 18, 2018, https://sneakernews.com/2018/06/18/puma-basketball-walt-clyde-frazier-lifetime-contract/.

4 Martin Bell, "'I Don't Text and I Don't Vex': A Few Minutes with Walt 'Clyde' Frazier," *New York Magazine*, December 8, 2010, http://nymag.com/daily/sports/2010/12/i_dont_text_and_i_dont_vex_a_f.html.

5 Edwin Kiester, Jr., "The Walt Frazier Style," *Sport* 51, no. 3 (1971): 65.

6 Ibid.

7 Ibid., 66. Also see "Legends profile: Walt Frazier," NBA.com, accessed April 19, 2019, https://www.nba.com/history/legends/profiles/walt-frazier.

8 "Legends profile: Walt Frazier," NBA.com, accessed April 19, 2019, https://www.nba.com/history/legends/profiles/walt-frazier.

9 Walt Frazier and Ira Berkow, *Rockin' Steady: A Guide to Basketball & Cool* (New York Warner Paperback Library, 1974), 19. Also see Pepe, "Walt Frazier," 37.

10 Frazier and Berkow, *Rockin' Steady*, 21, 24.

11 Ibid., 21.

12 Kiester, "The Walt Frazier Style," 65, 66. Also see Pepe, "Walt Frazier," 37.

13 Kiester, "The Walt Frazier Style," 69.

14 Rudy Langlais, "Frazier vs Chenier," *Black Sports* 4, no. 7 (1975): 52.

15 Pepe, "Walt Frazier," 39.

16 Frazier and Berkow, *Rockin' Steady*, 20, 204–05.

17 Ibid., 90, 91.

18 Ibid., 13.

19 "Sport Fashions: Walt Frazier," *Sport* 49, no. 6 (1970): 38–41.

20 Judy Klemesrud, "Clyde," *New York Times*, February 16, 1975, 16.

21 Kiester, "The Walt Frazier Style," 65; Pepe, "Walt Frazier," 38; Judy Klemesrud, "His Apartment Says 'Clyde'—As If You Couldn't Guess," *New York Times*, March 30, 1973, 44.

22 Frazier and Berkow, *Rockin' Steady*, 146, 53, 17.

23 Ibid., 117.

24 "From the Sidelines," *Black Sports* 5, no. 6 (1973): 8.

25 Published from April 1971 to June 1978 by African American computer software entrepreneur Allan P. Barron, *Black Sports* was a New York–based monthly. Barron hired mainly black journalists and had an all-black editorial staff. He saw the magazine as filling a void in the market by presenting stories of black athletic success and offering black men helpful health, business, and fashion tips. However, Barron had a hard time competing with mainstream magazines, and *Black Sports* only achieved limited success with a small circulation. Tracey Salisbury, "*Black Sports* Magazine," in *African Americans in Sports*, ed. David Kenneth Wiggins (New York: Routledge, 2015), 35.

26 Pat Gould, "Peacock Alley," *Black Sports* 3, no. 2 (1973): 44.

27 Pat Gould, "Changing Lifestyles: Today's Young Black Man," *Black Sports* 3, no. 3 (1973): 47.

28 Pepe, "Walt Frazier," 37, 38.

29 Ibid., 38.

30 Bob Powell, "Walt Frazier Still the Slickest Knick," *Basketball News* XII, no. 10 (1973): 2.

31 Klemesrud, "His Apartment Says 'Clyde'," 44.

32 Kiester, "The Walt Frazier Style," 65.

33 Pepe, "Walt Frazier," 38.

34 Wes Moon, "The Other Side of Walt Frazier," *Black Sports* 3, no. 5: 54.

35 "Locker-room Chatter: Clyde Who?," *Black Sports* 6, no. 11 (1977): 18.

36 NBA.com, "Legends profile: Walt Frazier," https://www.nba.com/history/legends/profiles/walt-frazier.

Additional Contributors:

Lilly Tuttle, Ph.D. (LT) is curator at the Museum of the City of New York and curator of the exhibition *City/Game*. Past projects include *Art in the Open: Fifty Years of Public Art in New York* and *New York at Its Core*. She holds a Ph.D. from New York University.

Marc Aronson, Ph.D. (MA) is consulting scholar for *City/Game*. He holds a doctorate in American History and teaches in the Rutgers School of Communication and Information. His next book is *Crush: A History of New York City in Four Streets and a Square* (2020).

Alexander "Sasha" Aronson (AA) is a Dean's list student at Tulane University and a manager of Tulane Men's Basketball team.

Eddie Hock (EH) is an undergraduate history and archaeology student at the University of Rochester.

PHOTO CREDITS

Pages 6: AP Photo/G. Paul Burnett; 8, 139, 141: Walter Iooss; 10: Copyright © The Richard Avedon Foundation; 12, 15, 60, 64, 68, 75, 93, 94, 191, 192: © Bobbito García; 13, 14, 16, 58, 66, 82, 84-85, 102, 179: New York City Parks Photo Archive; 17, 133 (top): Ron Turenne/NBAE via Getty Images; 18, 20, 22, 23, 39, 44 (top and bottom), 45, 46: Black Fives Foundation; 24, 26, 28, 29, 51 (all), 178 (middle column), 180 (left column, bottom): Archives, The City College of New York, CUNY; 30: AP Photo/Peter J. Carroll; 32: Used with permission of General Mills, Inc.; 33 (top): Everett Collection Historical/Alamy Stock Photo; 33 (bottom): Archive PL/Alamy Stock Photo; 34: AP Photo/The Herald-Sun, File; 35: North Carolina Collection, Wilson Library, UNC-Chapel Hill; 37: Museum of the City of New York, gift of Federal Works Agency, Work Projects Administration, Federal Art Project, 43.131.8.38; 38: Roman Catholic Diocese of Brooklyn; 38 (bottom): Kautz Family YMCA Archives, University of Minnesota Libraries, courtesy YMCA of Greater New York; 40: 92nd Street Y; 41 (all): images courtesy of The American Jewish Historical Society; 42-43: © Photography Collection, The New York Public Library; 47: National Gallery of Art, Washington, Corcoran Collection (The Evans-Tibbs Collection, Gift of Thurlow Evans Tibbs, Jr.), 2015.19. 4507/© Donna Van Der Zee; 48: Schomburg Center for Research in Black Culture, Prints and Photographs Division, The New York Public Library; 49: Black Fives Foundation/© Morgan and Marvin Smith; 50 (X2011.4.7099-57), 52 (X2011.4.7099-57), 132 (X2011.4.2770-53.50), 179 (left column, top, X2011.4.12385), 179 (right column, top, X2011.4.2770-53.72), 179 (right column, middle, X2011.4.10623): Museum of the City of New York, the LOOK Collection, gift of Cowles Magazines, Inc.; 53 (left and right), 54: Archives, The City College of New York, CUNY, photographs by John Halpern; 56, 181 (left column, top): Tyrone Dukes/The New York Times/Redux; 62: Puma; 63: PONY/image courtesy Bobbito García; 65: Pro-Keds; 68, 71, 73: Jeff Mermelstein; 76: AP Photo/Haraz Ghanbari; 79, 81, 83: Geoffrey Biddle; 86-87, 88, 89 (top and bottom): from the collection of John "Butch" Purcell; 90-91, 101, 106-111, 184, 190: © Kevin Couliau; 92 (top and bottom): Andre D. Wagner; 95, 96 (top and bottom): Dershiuan Ivy Lin; 103, 112: The La Guardia and Wagner Archives, La Guardia Community College/The City University of New York/© New York City Housing Authority; 113: Paul Hosefros/The New York Times/Redux; 114: © Lelani Hu/Sacramento Bee/ZUMA Wire/Alamy Stock Photo; 116: David Bergman/Sports Illustrated via Getty Images; 119: Dan Farrell/NY Daily News via Getty Images; 120, 167, 174: Jesse D. Garrabrant/NBAE via Getty Images; 122, 168 (top), 170, 171, 182 (middle column), 183 (left column, top): Nathaniel S. Butler/NBAE via Getty Images; 125: AP Photo/Ray Stubblebine; 126: AP Photo/Matt Slocum; 128: Jim McIsaac/Getty Images; 130: Ron Koch/NBAE via Getty Images; 133 (bottom): AP Photo/Fred Jewell; 134: Andy Hayt/NBAE via Getty Images; 135: AP Photo/Bill Kostroun; 136: Bettmann/Getty Images; 140: AP Photo/Richard Drew; 142: AP Photo/Dave Pickoff; 143, 145, 146, 147, 152, 155, 156-157, 181 (left column, bottom): from the lens of George Kalinsky; 148 (top and bottom), 149, 153 (top and bottom), 154 (left and right), 182 (left column, top): New York Knicks/Madison Square Garden/photographs by John Halpern; 150-151: Dick Raphael/NBAE via Getty Images; 158, 159, 160, 161 (bottom), 176, 182 (left column, bottom): George Kalinsky for Madison Square Garden; 161 (top), 169: Andrew D. Bernstein/NBAE via Getty Images; 162: Jeff Zelevansky/Getty Images; 163: Shot by Elena Parasco for the New York Knicks; 164-165: Garrett Ellwood/NBAE via Getty Images; 166: Jim Cummins/NBAE via Getty Images; 168 (bottom): Drew Hallowell/Getty Images; 172: Andrew D. Bernstein/WNBAE via Getty Images; 173: Museum of the City of New York, gift of the New York Liberty, 98.31.3; 175: Juan Ocampo/NBAE via Getty Images; 177 (top): AP Photo/Kathy Willens; 177 (bottom left): AP Photo/Amy Sancetta; 177 (bottom right): James Devaney/WireImage via Getty Images; 178 (left column): Museum of the City of New York, Byron Company Collection, gift of Percy Byron, 93.1.1.7991; 178 (right column): WorldPhotos/Alamy Stock Photo; 179 (middle column): New York World's Fair 1939-1940 Records, The New York Public Library; 180 (left column, top): AP Photo/John Lent; 180 (left column, middle): AP Photo/Robert Kradin; 180 (middle column, top): Vic DeLucia/The New York Times/Redux; 180 (middle column, bottom): AP Photo; 180 (right column, top), 181, 183 (left column, bottom): private collection; 180 (right column, bottom): Lelands Auctions; 181 (middle column, top): Joyce Dopkeen/The New York Times/Redux; 181 (middle column, middle): Larry Morris/The New York Times/Redux; 181 (middle column, bottom): AP Photo/Michael O'Brien; 181 (right column): AP Photo/Peter Morgan; 182 (right column, top): AP Photo/Frank Franklin II; 182 (right column, bottom): Scott Quintard/WNBAE via Getty Images; 183: Richard Levine/Alamy Stock Photo

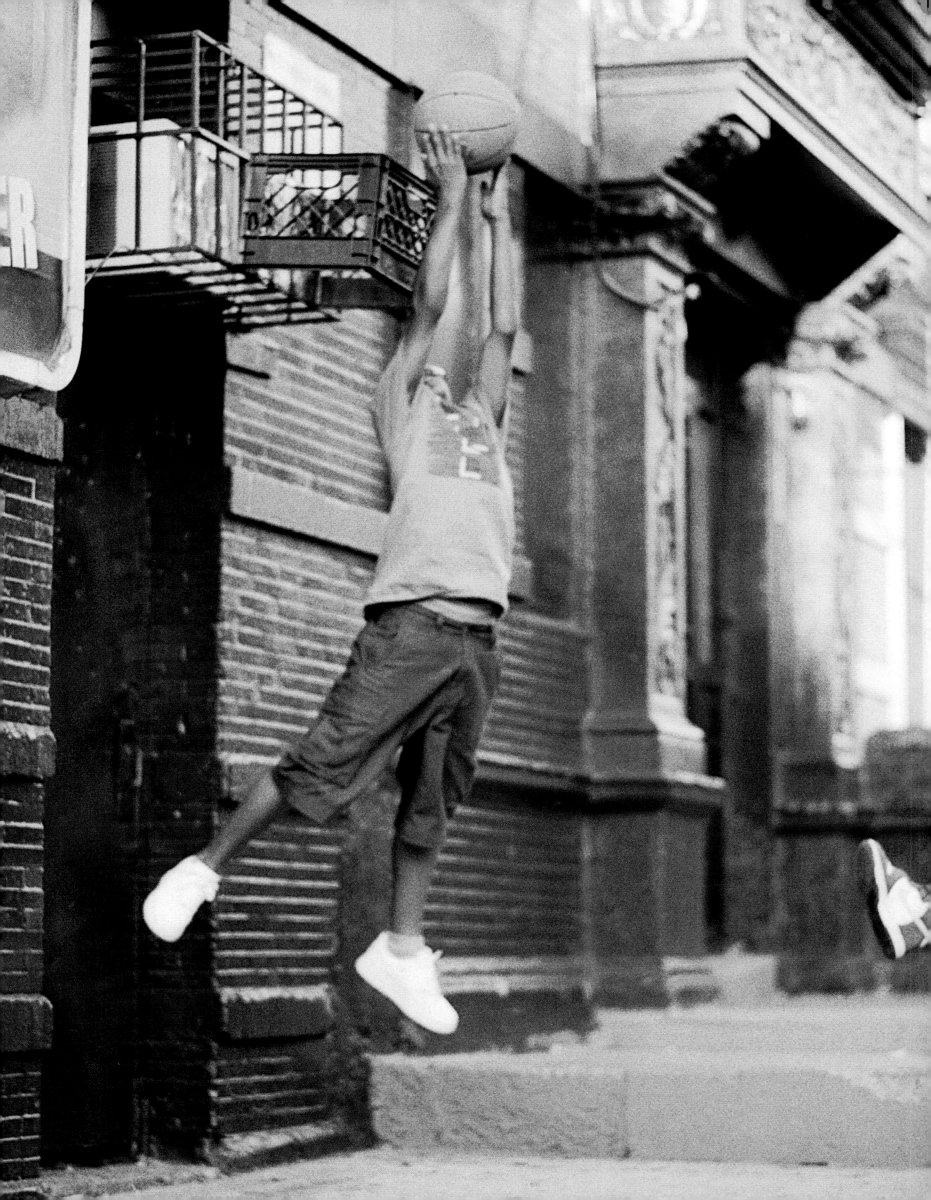

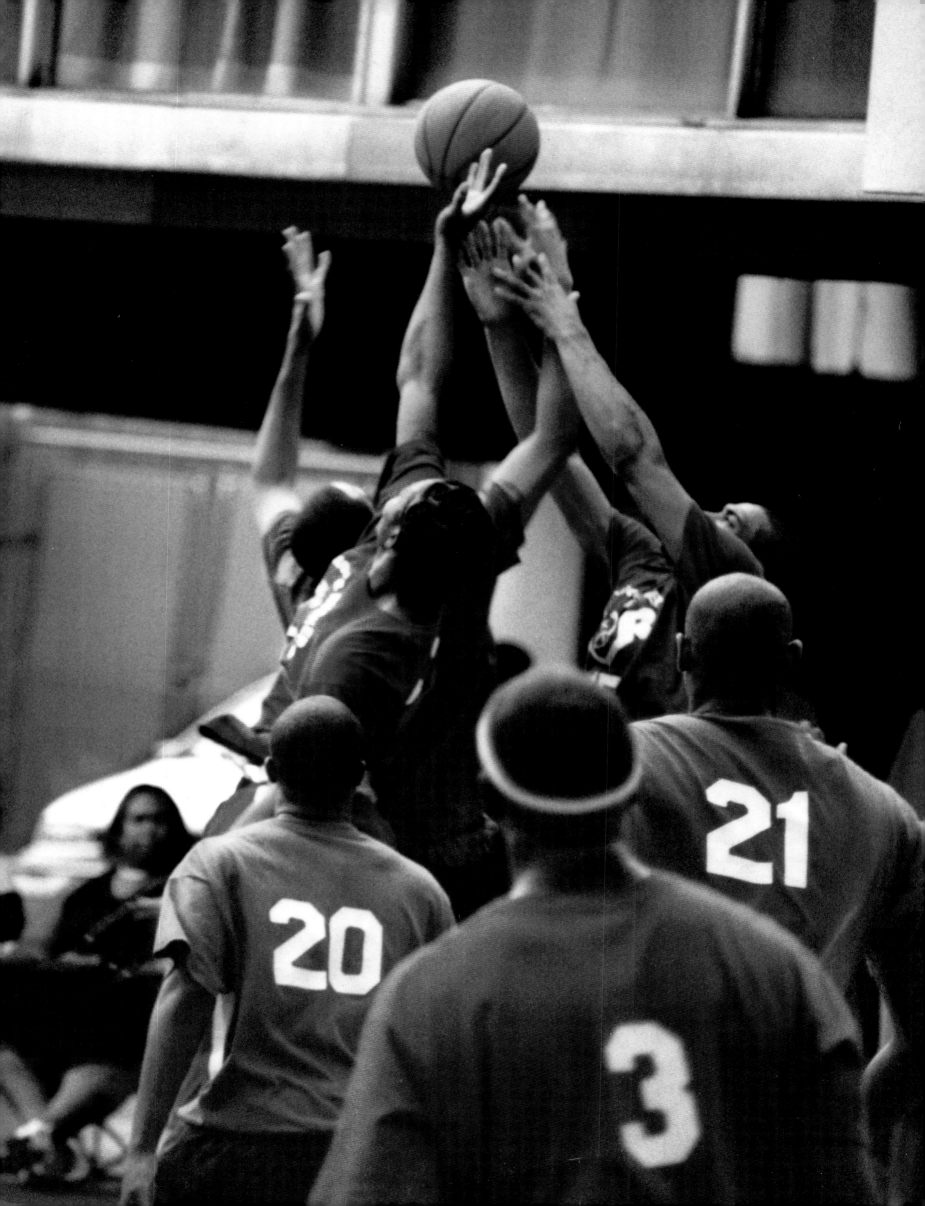